PRAISE FOR
Mistress of the Elgin Marbles

"A sympathetic and emotionally charged portrait of Mary, tracing in vivid detail the couple's travels, the diplomatic challenges they faced and their growing marital tensions. Elgin's acquisition of the notorious 'Elgin marbles' makes for dramatic reading, but the biography's chief merit is its wealth of domestic and intimate detail, and Nagel's ability to chart the course of an elite marriage with insight and compassion yet without sentimentality."
—*Publishers Weekly*

"A fascinating portrait of a woman thrust into one of history's great cultural contests: She might not have deserved the treasures of Greece, but Mary Nisbet and her narrator definitely earn the olive wreath."
—*Minneapolis Star Tribune*

"Absorbing. . . . The reconstruction of Lady Elgin's sparkling personality and her exciting life story makes required reading for anyone interested in cultural history as well as the art of biography."
—*Booklist*

"Susan Nagel may finally educate Americans to pronounce the name 'Elgin' correctly and like her own—with a hard 'g.' She brings off this feat by matching the tough to the tender, and by showing again that behind the most ginger guy there is a guilesome gal."
—Christopher Hitchens,
author of *The Elgin Marbles: Should They Be Returned to Greece?*

"Absorbing. . . . Required reading for anyone interested in cultural history as well as the art of biography."
—*Kirkus Reviews*

"Beautiful, calculating, devious, frivolous, a snob, highly intelligent, true to her family, yet at the end an adulteress and the object of a scandalous divorce, all before the age of thirty, thereafter a patron of the arts to her death at seventy-seven: Lady Elgin was one of the more exciting women of her day. Susan Nagel has skillfully extracted her character in this detailed account of her life. This is a story in which Nelson, Napoleon, the Turkish Sultan, and even the Elgin Marbles, which she helped her husband to rescue from further damage in Athens, seem to be just bit players in a tale too extraordinary to be fictional."

—John Boardman,
Lincoln Professor Emeritus of Classical Archaeology and Art at Oxford University and author of *The Archaeology of Nostalgia*

Andrew Brucker

About the Author

SUSAN NAGEL is the author of a critically acclaimed book on the novels of Jean Giraudoux. She has written for the stage, screen, scholarly journals, the Gannett newspaper chain, and *Town and Country*. She is a professor in the humanities department of Marymount Manhattan College and lives in New York City.

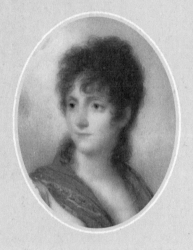

A BIOGRAPHY OF

Mary Nisbet,

COUNTESS OF ELGIN

MISTRESS

of the

ELGIN MARBLES

SUSAN NAGEL

HARPER
PERENNIAL

HARPER ● PERENNIAL

A hardcover edition of this book was published in 2004 by William Morrow, an imprint of HarperCollins Publishers.

HarperCollins books may be purchased for educational, business, or sales promotional use. For information please write: Special Markets Department, HarperCollins Publishers, 10 East 53rd Street, New York, NY 10022.

FIRST HARPER PERENNIAL EDITION PUBLISHED 2005.

Designed by Amy Hill
Map and family tree copyright © 2004 by Martie Holmer

The Library of Congress has catalogued the hardcover edition as follows:

Nagel, Susan
 Mistress of the Elgin Marbles: a biography of Mary Nisbet, Countess of Elgin / Susan Nagel.— 1st ed.
 p. cm.
 Includes bibliographical references (p.) and index.
 ISBN 0-06-054554-2
 1. Ferguson, Mary Nisbet, 1777–1855. 2. Diplomats' spouses—Great Britain—Biography. 3. Elgin, Thomas Bruce, Earl of, 1766–1841—Marriage. 4. Elgin marbles. I. Title.

NB92.N34 2004
941.07'092—dc22
[B] 2003068568

ISBN-10: 0-06-054555-0 (pbk.)
ISBN-13: 978-0-06-054555-0 (pbk.)

05 06 07 08 09 ❖/RRD 10 9 8 7 6 5 4 3 2 1

For Hadley,
my only and beloved child

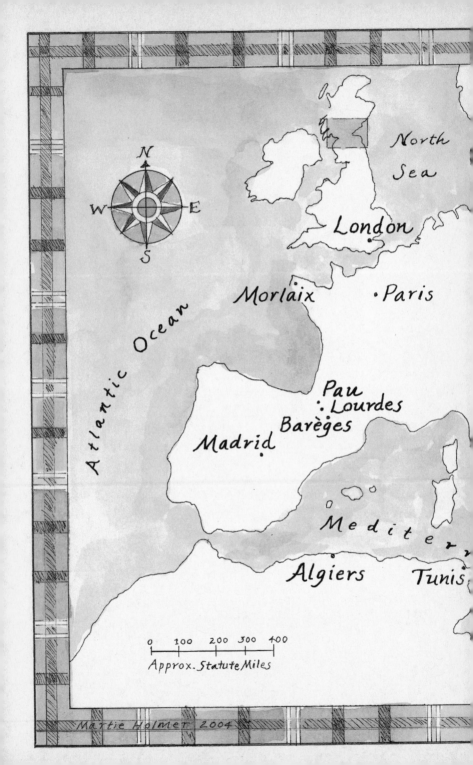

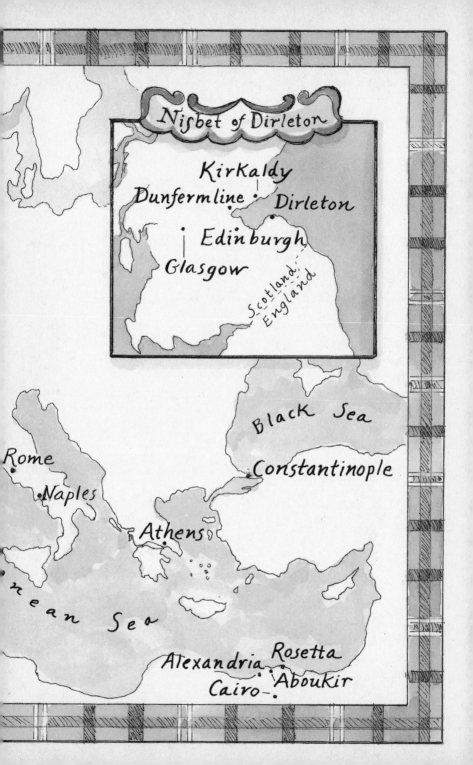

CONTENTS

Acknowledgments

Some 125 years ago, while their husbands were planning the Metropolitan Museum of New York, a group of ladies formed what is now the oldest ongoing literary society in America, the Causeries du Lundi. The name, meaning "Monday Chatterings," was an homage to the weekly contemplative newspaper column by French author Sainte-Beuve. It was at a Causeries meeting in the year 2000 when Polly Smith, once married to the uncle of the current Lord Elgin, introduced our group to the letters of Mary Nisbet. Like the proverbial dog with a bone, I could not get enough of Mary's story and wanted to know more. That began this adventure.

I am first and foremost grateful to Polly, grandmother of novelist Galaxy Craze, for giving unswerving support to writers and particular encouragement to me. Polly accompanied me to England and Scotland where we had some adventures of our own and she opened doors that I'm certain would have remained closed to an outsider.

In addition, I would like to thank my husband, Jon Nagel, and my daughter, Hadley Nagel, for their constant devotion and forbearance while I went on this all-consuming journey.

This book would not have been possible without the kindness, patience, and incredible generosity of Andrew, the 11th Earl of Elgin

and 15th Earl of Kincardine. I am grateful to him for so many things, least of all his climbing—with an old war injury—on a very high ladder to examine a painting for me. Although his knowledge of history is most impressive, his character as a gentleman is even more so. I would also like to thank Lord Elgin's very able and unflappable assistant, Mary Donnelly, who worked so very hard on my behalf.

I couldn't possibly begin to thank Julian Brooke—the real Cary Grant—and Gladys Brooke, whose gracious hospitality and tenacious efforts on my behalf turned this book from an idea into a reality. Julian Brooke, a direct descendant of the 7th Earl of Elgin and Mary Nisbet, had always believed that Mary had lived a fascinating life, and as the living patriarch and guardian of the family, he allowed me to be her messenger. I am forever grateful for his trust. Thank you, also, to Julian's nephew, Richard P. J. Blake, another direct descendant of the union between Mary Nisbet and the 7th Earl of Elgin, for his infectious enthusiasm and for providing me with Mary's diaries and pictures. I would also like to thank Richard H. M. Ferguson of Raith who, with very good humor, allowed me to invade his life with questions and bombard him with phone calls. He was most generous with his archival information and his staff. Thank you, Sir Francis Ogilvy, for allowing me the opportunity to touch and see firsthand so many of Mary's possessions at Winton House, and thank you, Robert Steadman and historian Stephen Bunyan, for shepherding that unforgettable experience.

All roads lead to Tina Brown—in publishing and in my own personal life—my mentor, my friend, and the human being I aspire to emulate every day. I am convinced that my daughter's "Auntie Tina" was sent to America, neither to run *Vanity Fair* nor *The New Yorker* nor *Talk* nor the airwaves, but to be my guardian angel, and no one can tell me otherwise. The other half of my "Tina B sandwich" is Tina Bennett, literary agent extraordinaire and my very own warrior, who put me in the path of Meaghan Dowling, a wonderful, visionary editor who guides with respect and intelligence. Thank you to the wonderful

HarperCollins–William Morrow team, including Rome Quezada and Betty Lew.

I have discovered, along the way, selfless professionals willing to walk an extra mile, find that accurate article, uncover that out-of-print source. Thank you to: David Smith, librarian to the stars, at the New York Public Library; Tammy Wofsey of the Shanahan Library, Marymount Manhattan College; Holly Quick of the Dirleton Historical Society; at the National Archives of Scotland: John McLintock, Robert Brown, Marilyn Mazs; Henry Vivian-Neal, Secretary to the Friends of Kensal Green Cemetery; and two very fine research assistants: in London, Louise Boone, and in Edinburgh, Elizabeth Jackson. Thank you to Dr. Donna Kurtz at the Ashmolean Museum for turning me over to Sir John Boardman, whose expertise on the subject of Greek antiquities is unparalleled, as are his patience and very good nature. Thank you to Murat and Nina Koprulu, and Patricia, Lady Daunt, for their helpful guidance on historic Constantinople; and to Ian Everard with Caledonian Heritable for his affable tour of Archerfield.

And last but not least, Marian and Richard Bott, Louise Duncan, Andrew Farkas, Karen Lauder, and Leila Hadley Luce, for their invaluable friendship.

Chronology

1707 Scotland unites with England

1715 Jacobite Rebellion

1720 South Sea Bubble bursts

1732 Society of the Dilettanti promoting interest in ancient Greece is founded

1745 Jacobite Rebellion led by Bonnie Prince Charlie

1754 England solidifies control over India

1756 Seven Years War begins

1757 William Blake born

1759 Robert Burns born

1760 George III becomes king; *Tristram Shandy* by Sterne; Josiah Wedgwood opens pottery factory in Staffordshire

1762 *Contrat Social* by Rousseau; *The Antiquities of Athens Measured and Delineated* by James Stuart and Nicholas Revett

1763 Treaty of Paris ends Seven Years War

1765 *Reflections on the Painting and Sculpture of the Greeks* by Winckelmann translated into English

1766 Thomas, 7th Earl of Elgin and 11th Earl of Kincardine born on July 20

1767 Townshend Act introduces tax on tea in American colonies

1769 James Watt invents and patents the steam engine; **Robert Ferguson born on September 8**

1770 Wordsworth born

1771 Sir Walter Scott born

1772 Coleridge born

1773 Boston Tea Party

1774 *Werther* by Goethe

1775 Battles of Lexington, Concord, and Bunker Hill; Jane Austen, Joseph Turner born

1776 American Declaration of Independence; *Wealth of Nations* by Adam Smith; *Decline and Fall of the Roman Empire* by Gibbon

1777 **William Nisbet of Dirleton marries Mary Manners, granddaughter of 2nd Duke of Rutland**

1778 *Mary Nisbet of Dirleton born on April 18*

1783 Fox-North coalition; Pitt the Younger's first ministry

1786 *Poems, Chiefly in the Scottish Dialect* by Robert Burns

1787 U.S. Constitution signed; *Thoughts on the Education of Daughters* by Wollstonecraft

1788 King George III incapacitated; Byron born

1789 Storming of the Bastille in Paris on July 14; King George III recovers; *Songs of Innocence* by Blake

1790 *Reflections on the Revolution in France* by Burke

1791 *Rights of Man* by Thomas Paine; *Life of Johnson* by Boswell

1793 Execution of the royal family in France; war between France and Britain; Scottish Treason Trials

1794 Robespierre executed; establishment of the Directorate in France; violent revolutions in Holland and Poland; *The Age of Reason* by Thomas Paine; *Songs of Experience* by Blake

1795 Keats born; **Charles, Count von Schall-Riaucour, born on October 27**

1796 Napoleon conquers Italy

1797 Bank of England suspends payments; **Henry Robert Ferguson born on May 2**

1798 Irish Rebellion; Nelson triumphant in Battle of Abukir

1799 French Directorate falls: Napoleon made first consul; **Mary Nisbet of Dirleton marries Thomas Bruce, 7th Earl of Elgin and 11th Earl of Kincardine and they depart for Turkey**

1800 England enacts Union with Ireland; Battles of Alexandria and Marengo; **George Constantine, Lord Bruce, born in Turkey on April 5**

1801 Thomas Jefferson inaugurated third president of the United States; Pitt the Younger resigns as prime minister of England; **Lady Mary Bruce born on August 31**

1802 Peace of Amiens with France (March); Napoleon named first consul for life; establishment of the *Edinburgh Review;* **Lady Matilda Harriet Bruce born on September 23**

1803 War resumes (May)

1804 **The Honorable William Hamilton Bruce born on March 5**

1805 Battles of Trafalgar and Austerlitz; **death of Lord William Hamilton Bruce on April 13;** first performance of Beethoven's *Eroica*

1806 Grenville elected prime minister; **Lady Lucy Bruce born on January 20**

1807 Abolition of slave trade; Grenville resigns over Catholic issue; **trial of Robert Ferguson for adultery with the Countess of Elgin in London; Lord Elgin obtains Act of Parliament to dissolve his marriage**

1808 Napoleon names himself king of Spain; **trial for adultery against the Countess of Elgin and Robert Ferguson in Edinburgh**

1809 Tennyson born

1810 *Lady of the Lake* by Scott

1811 The Regency; *Sense and Sensibility* by Jane Austen

1812 Napoleon invades Russia; U.S. declares war on Britain; British prime

minister Spencer Perceval assassinated, Lord Liverpool begins fifteen-year leadership; **The Curse of Minerva by Byron published to denounce Thomas Bruce, 7th Earl of Elgin and 11th Earl of Kincardine;** Charles Dickens born

1813 *Pride and Prejudice* by Jane Austen

1814 Abdication of Napoleon; British forces burn Washington, D.C.; Stephenson builds first steam-powered locomotive; Scott's *Waverley*

1815 Napoleon leaves Elba (the hundred days); Waterloo

1816 **Elgin Marbles sold to the British government;** Rossini's *The Barber of Seville*

1817 Princess Charlotte dies

1818 Prado Museum in Madrid founded; *Don Juan* by Byron

1819 Mary Ann Evans, "George Eliot," born; *The Bride of Lammermoor* by Scott

1820 King George III dies; King George IV accedes; trial of Queen Caroline

1821 Napoleon dies; Queen Caroline dies; Greek War of Liberation begins; **Mary and Lord Bruce reunite on February 5**

1823 Monroe Doctrine closes American continent to European powers

1824 Lord Byron dies in Greek war; John Quincy Adams elected president of the United States

1825 First passenger-carrying railroad begins service in England

1830 George IV dies; King William IV begins reign; Earl Grey becomes prime minister as Whigs return to power for eleven years

1831 Victor Hugo's *The Hunchback of Notre Dame*

1832 The Reform Act passes, changing voting laws in Britain

1834 Lord Melbourne named prime minister; Poor Law Amendment Act establishes workhouses and decrees mothers of illegitimate children solely responsible for their care

1835 Donizetti's opera *Lucia di Lammermoor* based on Scott's novel

1837 Victoria becomes queen of Great Britain; Samuel F. B. Morse demonstrates the telegraph

1838 Dickens's *Oliver Twist* and *Nicholas Nickleby;* National Gallery opens in London

1839 Custody of Infants Act permitting women living apart from their husbands to apply for custody of children under seven; Opium Wars with China begin

1840 Death of Lord Bruce on December 1; death of Robert Ferguson on December 3

1841 Death in Paris of Thomas Bruce, Lord Elgin, on November 14; Tory Sir Robert Peel elected prime minister of Britain

1842 Mines Act passed forbidding use of children and women in mines

1843 Dickens's *A Christmas Carol*

1846 Repeal of the Corn Laws; Lord Russell begins six-year Whig leadership

1847 Ten Hours Factory Act; Brontë sisters publish *Jane Eyre* and *Wuthering Heights*

1848 Queens College for Women founded in London; California gold rush

1849 Bedford College for Women founded

1850 Elizabeth Barrett Browning's *Sonnets from the Portuguese;* Wordsworth's "The Prelude"

1851 Underwater telegraph cable laid between Dover, England, and Calais, France

1852 Harriet Beecher Stowe publishes *Uncle Tom's Cabin,* 300,000 copies sell first year

1854 Britain and France declare war on Russia: the Crimean War begins

1855 The *London Times* publishes a speech by Napoleon III telegraphed to them by Reuter's man in Paris; **death of Mary Hamilton Nisbet Ferguson, onetime Countess of Elgin, on July 9;** Walt Whitman's *Leaves of Grass*

1857 Matrimonial Causes Act facilitating divorce in England; Flaubert's *Madame Bovary*

1859 Darwin's *Origin of Species;* Eliot's *Adam Bede*

1882 Married Women's Property Law

DISCITE IUSTICIAM

Nisbet of Dirleton

(1) Catherine Russell ——————

Duke of Rutland

William Hamilton Nisbet ——— Mary Manners
b. 1747 b. 1756
d. 1822 d. 1834

MARY NISBET ——— (1) Thomas Bruce ———
b. Apr. 18, 1778 7th Earl of Elgin
d. July 9, 1885 11th Earl of Kincardine
 b. July 20, 1766
 d. Nov. 14, 1841

George William Lady Mary Bruce ——— Robert Dundas
Constantine b. Aug. 31, 1801
"Lord Bruce" d. 1880
b. Apr. 5, 1800
d. Dec. 1, 1840

Mary Georgina Constance ——— Henry Ogilvy

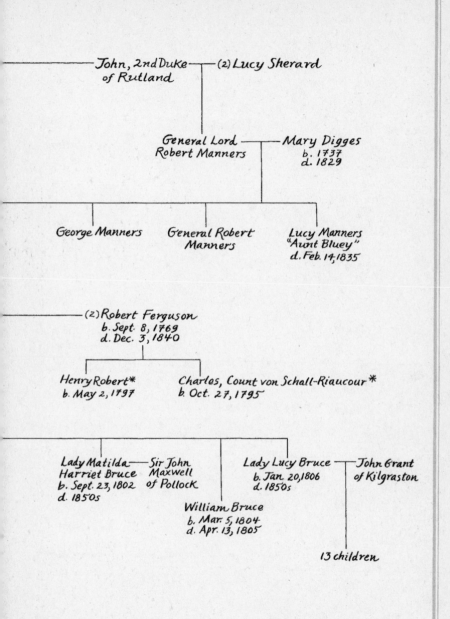

John, 2nd Duke of Rutland ── (2) Lucy Sherard

General Lord Robert Manners ── Mary Digges
b. 1737
d. 1829

George Manners

General Robert Manners

Lucy Manners "Aunt Bluey"
d. Feb. 14, 1835

(2) Robert Ferguson
b. Sept. 8, 1769
d. Dec. 3, 1840

Henry Robert*
b. May 2, 1797

Charles, Count von Schall-Riaucour*
b. Oct. 27, 1795

Lady Matilda Harriet Bruce
b. Sept. 23, 1802
d. 1850s

Sir John Maxwell of Pollock

William Bruce
b. Mar. 5, 1804
d. Apr. 13, 1805

Lady Lucy Bruce
b. Jan. 20, 1806
d. 1850s

John Grant of Kilgraston

13 children

*Robert Ferguson's sons with Henriette, Countess von Schall-Riaucour

MISTRESS

of the

ELGIN MARBLES

INTRODUCTION

Two hundred years ago, the two most powerful emperors on earth—Napoleon Bonaparte and Ottoman sultan Selim III—along with Queen Maria Carolina of Naples and Sicily (Queen Marie Antoinette's favorite sister) and British naval hero Admiral Horatio Nelson, were all burning with curiosity to meet the young Mary, Countess of Elgin. Mary was three years younger than Jane Austen and could have been the prototype for any number of Austen's literary heroines; her pedigree, femininity, and fortune were impeccable. Mary, however, was far more than just a beautifully wrapped package, and she proved to be far more daring, complicated, and fascinating than any of Austen's characters. She was regal and yet self-deprecatingly funny, acquisitive but also philanthropic, demure but quite assertive. This young woman relished making waves and, in fact, caused a significant historical tsunami.

Every year, some five million people visit the British Museum (and another eight million visit its Web site) to see the collection known as the Elgin marbles. For two hundred years, the alleged plunder of the marbles alternatively known as the Parthenon marbles or the Elgin collection, depending on which side of the fence you happen to stand, has caused intense and emotional international debate. Sometimes called

the greatest cultural property dispute of all time, the contention revolves around the well-documented removal of incomparable historic sculptures from Athens to Great Britain. The Greek government would like the statues back; the British government argues that they received them fairly, paid for them, and saved them from disintegration.

While the Earl of Elgin and his team of artists have shouldered the blame for purportedly despoiling the Parthenon, the improbable truth is that it was his twenty-one-year-old bride, Mary, who financed the project. In addition, it was Mary who cajoled a ship captain to carry the monumentally cumbersome pieces back to England on a British naval vessel and to boldly disobey a direct order from Admiral Nelson, who wanted every one of his ships ready for battle and not engaged in dangerous cargo transport. There is also ample evidence to suggest that among the reasons Selim III, known as Selim the Conqueror, granted permission to denude the Parthenon was that the devastatingly charismatic and glamorous young Lady Elgin had in fact conquered his affections.

In 1799, when Thomas Bruce, the 7th Earl of Elgin and 11th Earl of Kincardine, arrived in Constantinople as Great Britain's newly appointed ambassador extraordinaire, England's navy had just crushed Napoleon's forces in Egypt. To demonstrate their gratitude, the Turks regaled Elgin and his captivating bride with unprecedented fanfare and pageantry.

Ironically, the Turks themselves had been aggressive invaders, having been in control of Greece for over three hundred years. The Ottomans had no regard and less consideration for Hellenic culture. Europeans, on the other hand, were seized with a fever for the ancient world, especially classical Greece. Philosophers and artists of the day romanticized the early democracy of Athens and valued her art for its harmony and expression of beauty as a mirror to a refined age.

Various Napoleonic wars had heightened the competition to chronicle and even steal artifacts before they were destroyed. When Elgin

arrived in Asia Minor, he dispatched a contingent of artists to the Acropolis and other significant sites to copy and make molds of the antiquities for artists and museums back home. There, his team of artists discovered a prolapsed and derelict beauty. One only had to look in the fields to find that entire slabs had toppled, tumbled, and lay crumbled all about.

Elgin had no notion to remove any relics nor did his team have instruction to do so. On the other hand, French agents had been carting home great pieces of sculpture for twenty years, first for King Louis XVI and then for First Citizen Napoleon as well as many noblemen. Napoleon's persistent invasions of Ottoman territory infuriated the sultan. He accordingly confiscated the French Embassy overlooking the Bosporus Strait, imprisoned the entire staff, and gave the palace to Lord Elgin. After a second British victory in Egypt, Selim III gave Elgin written carte blanche to extract reliefs from the façade of the Parthenon, an act of gratitude—and revenge. Lord Elgin was a lucky archaeologist who was in the right place at the right time.

Elgin's own records show his careful intent *not* to destroy any antiquities that were still intact, and as the Parthenon was basically a wreck, he firmly believed that he was rescuing the sacred stones from ruin. His team of artists and architects studied, shaved, rigged, lowered, and hauled the massive wonders away from the site.

Controversy was immediate. Contemporaries such as Lord Byron expressed horror that these beautiful treasures had been torn from their homeland. Emperor Napoleon, desperate for the marbles, made Elgin his personal enemy.

Society in this most Byzantine and complicated city gossiped about another reason for the sultan's largesse: it was widely acknowledged that the young Countess of Elgin received unparalleled favor from the Turkish grandees. It was true. Selim III was besotted with Mary. At one particular festival, as fireworks blazed across the sky, Mary created her own sparks when she rowed her little boat directly across the sultan's

path. Any other mortal would have been decapitated for such an act, but Mary—"*had I known*"—in truth, relished the flirtation as Selim ogled her through his spyglass causing all eyes to divert their attention to this sideline sporting event.

The sultan, his mother—known as the Valida Sultana—the Grand Vizier (prime minister), and the Captain Pasha (military chief) and his family all broke very long-established rules of protocol just to spend time with Mary. She was that delightful.

She was the only Western woman invited to the Seraglio and Top-kapi Palace—"I go to visit . . . the Grand Seigneur's Mother which I am to do, and nobody ever did but me"—and she was invited repeatedly. "The jealousy this visit and the treatment I received, has caused here, is quite ridiculous. Edinburgh is a joke to it." And, "the whole town is up in arms, for on Saturday . . . the Captain Pasha [came] to visit us—a thing that was never before heard of . . . why should I mind a little jealousy?" Even the famous Islamic poet Abu Talib Khan joined in the empire's adoration and wrote a Persian ode to Mary, invoking her "sugar lips" and "smiles divine" that spread "heaven's shine." Women at the other embassies resented her—and she loved it.

Though only in her early twenties, Mary navigated the shark-infested diplomatic waters with finesse, proving to be a gold medalist in political swimming. She carried off her role on the international stage with dazzling skill and grace. How did one so young become so masterly? Although she was from the rural hamlet of Dirleton, east of Edinburgh, Mary Nisbet Bruce was not a small-town girl.

Mary Nisbet was the great-granddaughter of the 2nd Duke of Rutland of the legendary Manners family, who could trace their roots back to the Plantagenet kings of England. At birth, Mary was the richest heiress in Scotland. From her well-born pedestal, Mary Nisbet melted the hearts of two of history's most infamous tyrants and enemies—Selim III and Napoleon Bonaparte. At Winton, a home in East Lothian belonging to Mary's descendants, there are two miniatures of the

diminutive French general that he personally gave to Mary. These miniatures were the recognized equivalent of Napoleonic love letters.

We are fortunate that a huge trove of Mary's own letters and diaries survive; they reveal her innate intelligence, honesty, and humor. She and Elgin had five children in six years, they had all the money in the world through Mary's inheritance, and they had achieved one of the greatest archaeological coups of all time. When they left Turkey in public triumph and traveled homeward, there was every reason to anticipate a brilliant future together. Mary lived a rich and rewarding life until she died in 1855, at the age of seventy-seven. Destined to live a charmed life, why, then, was she buried in an unmarked grave at Kensal Green in London?

Through one heartrending choice, Mary transformed her life from one of welcome public attention to one in the unwelcome glare of scandal. She made a mistake and fell in love with another man. Although she was willing to sacrifice her passion to keep her family together, Elgin was not. He thought he could have it all without Mary, but he, too, gambled and lost. If Elgin had played his hand differently, the Elgin marbles would certainly have remained in the Bruce family instead of going to the British government. The Nisbets' great wealth had secured the marbles for the earl, but without his wife's continued financial support, he would be forced to sell them. Elgin decided to disentangle himself legally from his adulterous wife, which necessitated both judicial and legislative actions, including an Act of Parliament. He assumed incorrectly that, as in other aristocratic separations, he would quietly receive lavish compensation from Mary's inheritance; however, to his and everyone else's surprise, the Nisbet and Manners women closed ranks, waging the toughest divorce battle since *Catherine of Aragon v. Henry VIII.*

These remarkable women defied the social convention of the time by forming an impenetrable coterie: they had ironclad wills and very good lawyers. For all their success in safeguarding Mary's money, however,

they could not preserve her family. She lost custody of her children. The Elgin divorce ignited a new and highly emotional debate on the rights of women. Mary and Elgin were each pitied and despised, depending upon whose side you took. The sad truth was that both Mary and Elgin lost their purpose, for Mary's favorite job was mothering, and Elgin's career was over.

Should Elgin have known that his choice would be self-destructive? Eight years after their divorce, Lord Elgin was back before the English Parliament, embroiled in another controversy: Should the British government buy the marbles from him? If so, how much should be paid? Were they, in fact, priceless treasures or just broken blocks of stones, as some declared them to be? Throughout these proceedings, Mary remained silent. She had put her nine years as Lady Elgin behind her and had gone on to live the next chapter in her extraordinary life with a very distinguished man who happened to be her husband's dear friend.

There's an old adage—"There are three sides to every story—his side, her side, and the truth." The love triangle, of course, dispels this. The "love triangle" is really a square: her side, his side, his side, and the truth. And now, all sides of the story: the truth about Mary Nisbet, onetime countess of Elgin.

Chapter 1

LAUNCHED FROM
A SAFE HARBOR

In 1707, during the reign of Queen Anne, England and Scotland formally ratified an agreement officially creating the United Kingdom. This uneasy truce, which hoped to end centuries of violence between the two countries, was really established for the economic enrichment of both parties. Before 1707, Scotland's ancient royal, military, and commercial alliance with France, stemming from the 1295 Auld Alliance and various royal unions between the Scottish Stuarts and the French Bourbons, antagonized the English. The frequent insurrections by the Scots—an ongoing attempt to secure a Stuart on the throne of a united kingdom—and the belief by English noblemen that Scotland was an inferior stepsibling provided little reason for Englishmen to allocate their resources to Scottish businesses and alliances. With the new establishment of a legally protected partnership, the tide would now turn, making it more attractive for Scotland and England to settle their differences. England could now take advantage of Scotland's cheaper labor force and considerable supply of natural raw materials; from the Scottish point of view, once aligned with England, the expanding English colonial empire would provide tariff-free consumers.

In 1745, Bonnie Prince Charlie, the grandson of the deposed Stuart

and Catholic king James II, led one final insurgence to place, once again, a bona fide Scot on the English throne. Although some Highland factions, known as "Jacobites" for their loyalty to King James, supported the young pretender to the throne, Prince Charlie was defeated, causing the collapse of the Stuart schism. Despite the fact that the prince's five-month adventure, after he escaped and was supposedly hiding in the hills with the help of a lass named Flora Macdonald, made for a very romantic legend, his failure unintentionally furthered the stabilization of English-Scottish relations for a very practical reason: the British Empire was expanding, and the Scots did not wish to be left behind.[1] In 1754, England cemented its holdings and control over India, leading the way to immeasurable riches; and in 1763, victory over France as a result of the Seven Years War netted the United Kingdom vast territorial gains in America, and yet again additional wealth.

Empire empowerment brought another dividend: creativity at home. Inventions by James Watt (the steam engine), Josiah Wedgwood (division of labor in factories), Joseph Priestley (early studies of electricity), energized a new class of commerce on the scale of mass production.

The city of Edinburgh, a stunning and dramatic town built high on volcanic rock, bordered at one end by a gigantic seventh-century castle and at the other by the Crown's Holyrood Palace, became in the eighteenth century a stimulating center of modern achievement and progressive thought. Success was evident at the bottom of High Street, the Cannongate section of town, beside the newer Holyrood. Cannongate became the fashionable hub for prosperous merchants, Scottish baronets, architects like the Adams family firm, and philosophers like David Hume and Adam Smith. America's preeminent colonial doctor, Benjamin Rush, attended the University of Edinburgh's medical school to study the newest ideas and treatments. Perhaps by accident, Edinburgh had become an international city and its inhabitants quite cosmopolitan. Those prosperous Scots who journeyed frequently to London also made the Grand Tour, and some even traveled to the far-flung out-

posts of Great Britain's burgeoning empire. In the 1790s, the future French kings Louis XVIII and Charles X both resided at Holyrood Palace for a time after their brother and his family were guillotined.

New thought included debate on the God-given rights of man. The movement against tyranny resulted in campaigns such as the Society for the Abolition of the Slave Trade and the rebellion of the American colonies, which helped stir the Whig Party into action against the monarchy in England.

Barely six months after the ink had dried on the American Declaration of Independence a quiet but significant merger took place. On January 31, 1777, an illustrious daughter of England, Mary Manners, the twenty-year-old granddaughter of the 2nd Duke of Rutland,[2] married William Nisbet of Dirleton, a Scottish landowner. As the niece of the 3rd Duke of Rutland, who, in August 1762, was among less than a handful of people asked to witness the birth of the Prince of Wales, and first cousin to the then current 4th Duke of Rutland, Mary Manners Nisbet traveled in the most rarefied of British aristocratic circles. William Nisbet possessed the distinction of belonging to the small but enviable group of people who controlled the majority of land in Scotland. As the smallest percentage of people to control the largest amount of land in all of Europe, these Scots were richer than most European princes. In the eighteenth and nineteenth centuries—and some would argue it still exists today—this group of landowners formed its own close-knit aristocracy. One year and three months after the Manners-Nisbet wedding, Mary and William Nisbet had a daughter, Mary Hamilton Nisbet, born on April 18, 1778. Upon her birth, tiny Mary was immediately, though unofficially, crowned the royal princess of this landed association as one of the richest heiresses in the new United Kingdom of Great Britain. What was unusual about Mary's inheritance was that it would be passed to *her*, not to a male heir (under Scottish law, a brotherless daughter such as Mary inherited); and most of it would come to her via a matriarchal chain of ancestors.

Mary grew up in the fairy-tale, bucolic village of Dirleton, approximately thirty-six square miles of the country's most arable land, situated eighteen miles east of Edinburgh in the corner of Scotland known as East Lothian. Her home, called Archerfield, sat in what was once a sylvan, medieval, Benedictine sanctuary a few acres from the centuries-old ruins of Dirleton Castle, a reminder of Scotland's violent, bloody history, which was also part of the Nisbet estate. The name Dirleton meant "ton" (or "town") of "Dirl," or "trembling." The original battle site had evolved into so tranquil a place that its name took on a new meaning. Local people insisted that "Dirleton," or the place of "trembling," now referred to the stones that supposedly shook if a carriage rode through and dared disturb the peace of the twelve hundred inhabitants who quietly farmed, tended sheep, and fished.

Mary's father, William Hamilton Nisbet, chose not to reconstruct Dirleton's Scottish warring past and opted instead, emulating many English noblemen, to hire the much sought after Scottish architect Robert Adams. Adams, who had spent many years abroad studying classical architecture, was commissioned to create a home fit for a princess. It was here, where gently rolling links tumbled into the beaches of Aberlady Bay and flower-covered cottages dot the tiny town, that Mary Nisbet presided over all that she could see. She could look north toward Fidra Island, the inspiration for Robert Louis Stevenson's *Treasure Island* (Stevenson's own father was, at one point, the island's light keeper, and its topography matches Stevenson's fictional creation), and see, in the distance, the steeper terrains on the far side of the Firth of Forth. North of Edinburgh, where towns like Kirkcaldy and Dunfermline wind upward in the mountains in the county of Fife, the great estates of Raith and Broomhall loomed romantically, eerily foreshadowing her future. The Firth of Forth teemed with shellfish, whitefish, and mineral-rich seaweed used for fertilizer, and its mighty flow carried ships laden with coal, lime, linen, and wool out to sea and off to northern Europe and Scandinavia. A ferry

regularly crossed the Firth from its southern side at Gullane, the nearest point to the Fife coast. Gullane was also Mary's property.

Little Mary had chestnut-colored curly hair, sparkling hazel eyes, and an irresistible smile. She grew up amid simple, rural pleasures and abandon; Rousseau's glorification of innocent childhood (and noble savage) was not lost on the Nisbets. She played with her dogs, rode horses, and was tossed in laundry baskets by indulgent servants. On the other hand, there was also discipline. She lived a cosseted and cloistered life where neither dancing nor playing cards was acceptable on Sundays. Her still surviving pocket-size *papier à cuvé*–bound pamphlets reveal that her education was rigorous, equal to any boy's. She was eleven years old when she studied—in its original French—geography and history from the ten-volume *Ancient History* series written by University of Paris professor Charles Rollins. She learned about the exploits of Darius, the Persian invader of ancient Greece, and Pericles' rebuilding of the decimated city of Athens and his creation of the Parthenon.

In the early 1790s, her diaries reveal, on the left-side pages, a very busy social life, and, on the right, carefully kept financial records reporting expenditures—donations to the poor, purchases of flowers, and pennies given to "dancing dogs." She noted with enthusiasm the days when she was able to take "a charming ride" on a "poney" or a dip in the sea, or play a game of "foot Ball," which was apparently a favorite pastime in the early 1790s, and she "plaed" at "Lord Portmors."

A dutiful student, she was quite precise in recording the natural world around her: astronomical phenomena—"The Eclips of the Mone I saw it"—the weather patterns, and farm life. She was an excellent biologist and observed all the tiniest details about the behavior of her "dear cow," the care of her horses, and whether or not her canaries and nightingales were thriving—"another bird was hatched," "my dear little canary bird laid another Ege on Christmas Day, she has laid 29 Eges this Year," one "laid one ege," "I had one rotten ege." When any of her

birds died, she buried her own. She was quite active and rarely ill but described, quite clinically, the time when she was in her early teens and "measles declared . . . bled me for the first time in my life," a horrific experience that left her bedridden and on chicken broth for days—a cure far worse than the illness. Lessons aside, as she became a teenager, Mary lived the life of an older, very social, and very popular lady of great status, and her usual stamina was daunting.

When Mr. Nisbet was in Parliament, they traveled to London and maintained a home in Portman Square, within walking distance of the home of Mrs. Nisbet's parents. Family was all-important, and Mary made daily visits to see her grandmother, Lady Robert Manners, at Grosvenor Square (she called it "GS"), where she attended formal dinner parties in the company of government and social luminaries. Grosvenor Square was known to be the most opulent location in London, where staggeringly expensive town houses belonging to aristocrats came alive for merely a few weeks a year, "the season," when the truly rich and titled came to town to see and be seen. In London, Mary socialized daily with the Manners family, which included the Dukes and Duchesses of Montrose and Montague, the Duchess of Buccleugh (née Elizabeth Montague), and the Pelham family of prime ministers. Friends such as the Duke of Dorset, General Nisbet Balfour, Lady Rothe, wife of the Earl of Rothe, chief of the clan Leslie, Mr. Churchill, Lord Beaulieu, Lady Elgin, Lady Charlotte Bruce, and others would also come to Lady Robert's during Mary's teenage years in the mid-1790s.

At an early age, Mary displayed a keen interest in what the eighteenth century called "society"—that is, people—and she had a natural, friendly, and easy way with people of all classes. She followed and recorded the marriages of girls she knew and the deaths—by natural causes or accident—of people significant to her family. She had keen intuition and, in fact, claimed to experience "presentiments"—her term for a mild power of premonition. An only and beloved child, she was

very adult for one so young and often joined her doting parents at wedding parties and other grown-up gatherings. At fifteen, she stayed out dancing until three in the morning. She spent evenings at the new Pantheon Opera House in Haymarket as well as at the famed Sadler's Wells Theatre. She danced the minuet at Mr. "Pichinie's" (sometimes spelled "Puccini") Academy, played "dummy whist," "Casino," and attended the races. She also saw Hertel's comedic and charming new ballet *La Fille Mal Gardée*. (The story—a young woman, betrothed to an eminent man, succumbs to the charms of a neighbor and betrays her fiancé when she is left unchaperoned—delighted Mary at the time, but it was a chilling foreshadowing of her own similar predicament, which was far less amusing.)

Long before she made her debut, the usual moment when girls appeared on the scene entering society, Mary was already a very visible presence. She attended important balls at Gloucester House—home of the Duke of Gloucester, son of King George III—and at the home of the Tory hostess (and Robert Burns patroness) Jane, Duchess of Gordon, and soirées at Lady Cadogan's and the Duchess of Buccleugh's. She had been to Court, to Frogmore House, Queen Charlotte's—and later, Queen Victoria's—favorite country retreat on the grounds of Windsor Castle, and to Windsor Castle itself.

Mary was no stranger to protocol and the highest echelons of London aristocracy and was at ease in the most formal surroundings. She was on intimate terms with the British Empire's dukes and duchesses and military heroes because they were family, and she also possessed an innate fluidity, gracefully adapting to country customs: from an early age, she was *comme il faut* wherever she went. In London, she went to "church"—sometimes with her parents and sometimes with family friends, like the Duke of Athol. In East Lothian, she joined the local citizenry at "kirk." In London, she attended balls, and in East Lothian, she enjoyed "country dances."

In Scotland, she also enjoyed a whirlwind life, where there was a

constant stream of the Scottish landed gentry. Houseguests frequently included Lady Maitland, the Tweedales, and family members like the Hamiltons of Pencaitland and the Campbells of Shawfield. Mary hosted dances and dinners for Lord Ainslie, the Duke and Duchess of Hamilton, Lady Haddington, the Dalrymples, Durhams, Grants, Fraziers, Oswalds, Dundases, and Kinlochs. She, in turn, visited their great country estates, including the world-famous castles belonging to Lord Lauderdale, the Duchess of Hamilton, and the Nisbets of Berwick. Some of London's elite would visit her in Scotland, and Mary delighted in showing them the sights. The Duchess of Montrose spent a day drawing Dirleton Castle and its gardens. The ebb and flow of company was constant.

Her world was a safe, protected harbor of people who enjoyed her company and genuinely cared about her. She sailed, skirts rustling and billowing, from castle to castle, from town mansion to city palace, the center of attention of adoring parents and an extended family that cherished her. On the "finance" side of her diary, she noted that on March 27, 1794, when she was not quite sixteen, "'WG' Manners [her Uncle William] gave me the Diamond and red stoned ring" at Grosvenor Square. The men in her family indulged and pampered her, and she suffered through it good-naturedly.

From the day she was born, however, she had a network of women whose advice she sought and whose confidences she shared in person and through letters. The women on whom she would depend included her mother, the elegant Mary Manners Nisbet; her favorite aunt, Lucy Manners; her grandmother Lady Robert Manners; her paternal aunt, Mary Campbell; and her dear cousin and friend, Caro—Lady Caroline Montague. They remained her stalwart and lifelong allies.

Aunt Mary addressed her as "my sweet Mary" and "my beloved Mary," and complimented her for her "sensibility." Her great-aunt, the elderly Countess of Leven, wrote that her letter was a "Love Token, from your

Old affectionate Great, Great, Grand Aunt," and contained additional expressions of affection from cousins Lord Leven and Lady Ruthven.

She returned their affection, often inventing funny, tender—and mildly satirical—nicknames for those closest to her. Mr. Nisbet, the man who had created Mary's idyllic world at Archerfield and who was an elected politician, a member of the elite and dashing Grenadiers, a musician, a fabulous shot, and a man of great intellect who loved a good joke, became "Sir Philip O'Kettle." Aunt Lucy was always referred to as "Aunt Bluey," and Lady Sutton as "Suttie." Mary displayed a dry wit from early on and knew how to entertain her audience. In a letter written to Mr. Nisbet while he was in London, she playfully lamented, "Oh, Mary, Mary, where will my Willie be now," and amused him with a story of her mother walking the dogs around the property while the dogs "stake[d] out" their favorite trees. Mr. Nisbet replied, "Sweet little Pussy your funny scrole I have gott."

Her travel entries offer a unique glimpse into the eighteenth-century English party circuit, when the fastest way to travel was by sea. The aristocracy viewed travel not only as the time to experience and appraise others' hospitality but also as an opportunity to see historic sites and enjoy the beauties of their great country. As Mary and her family traveled leisurely by land, usually in a phaeton, for example, from Archerfield to Edinburgh, their servants went ahead, traveling by sea on the Firth of Forth to prepare for the Nisbets' arrival. She visited Durham Cathedral, "Blenham House" in Oxford, Broadway, Portsmouth, Glasgow, and other towns that were either en route or just a pleasant diversion. Again, with scientific precision, she kept records of how many miles a day they covered on their journeys and where they "staied," dined, or "drunk tea."

Mary made regular trips to Edinburgh to the Nisbets' town house on Cannongate, at Reid's Close, within walking distance of Holyrood Palace. The house, built by a Nisbet in 1624,[3] was imposing. Directly

across the street lived Adam Smith, author of the capitalist's bible, *The Wealth of Nations*. In town, she went to balls, and in the country, she participated in social evenings where either eight or sixteen young people would be invited to dance Scottish reels.

By 1799, when she had just turned twenty-one, Mary Nisbet was a star in the matrimonial whirl of the London and Edinburgh social scene. Being pretty, vivacious, and very good at card games, she was an asset to anyone's evening. She loved to dance and really enjoyed playing the pianoforte. Her impeccable pedigree and enormous fortune were additional attractions.

In the political arena, Mary was able to count most of her cousins among the two hundred peers in the House of Lords. Her grandfather and maternal uncle were both generals. Her maternal great-uncle, Henry Pelham, had been prime minister in the 1740s to 1750s. The current duke's younger brother, Lord Robert Manners, who would be tragically killed in the Battle of the Saintes in the Caribbean skirmish with the French, was a powerful member of Parliament—MP—as well.[4]

Her financial portfolio was equally impressive. She would inherit two major estates in England (Lincolnshire) once owned by her great-grandmother Lady Lucy Sherard, the second wife of the Duke of Rutland. In 1711, the South Sea Company was established to trade with the Spanish Americas; when shares of the stock escalated in 1720 and then plunged, much like the dot-com stock fiasco of the late twentieth century, the "South Sea Bubble" ruined many unfortunate investors. Lucky Lady Lucy, who had been a shareholder but who had sold and gotten out in time without any significant loss, turned some of her capital toward real estate. Her daughter, Lucy Manners, Mary's favorite "Aunt Bluey," would remain childless and unmarried, leaving Mary Nisbet the properties, which included Bloxholm in Lincolnshire. From the Nisbet side of the family, the properties that Mary would inherit constituted about two-thirds of East Lothian and included Dirleton

and Gullane, the estates of Pencaitland and Belhaven, once owned by her paternal grandmother, and Biel, located in Stenton Parish, which at one time was said to be the longest house in Europe. Stenton Parish, about nine square miles, was home to some 630 people in the early 1790s. In all of these towns, Mary would "have the living," collecting handsomely from farmer tenants while she was obliged by the Poor Law and the Presbytery to provide for the poor, support the schools, and select the ministers for the local churches. East Lothian, prized today for some of the greatest golf courses in the world, was at that time considered the most luxuriant farmland in Scotland.

If her fortune weren't enough to incite jealousy, Mary was also beautiful and lively. She could have been a boring, perfect, and dull young noblewoman, but she was not: she was screamingly funny. Mary was so comfortable with the rules that compliance was natural and no great burden; but this well-raised young lady knew how to have a good time. She was modern, outrageous, and irreverent—bringing fresh air into the stuffy drawing rooms of London and Edinburgh. Because of her engaging personality she was popular, in demand, the "it" girl of the day, and she had so many suitors to choose from that her Aunt Mary teased her about how difficult it must be to have so many boyfriends.

Mary genuinely enjoyed society and was in no rush to get married. She was most definitely a daddy's girl and understood that her fortune and family position were serious factors in any union she might consider. Besides, most of the men she knew were no match for her father—until Thomas Bruce came courting.

Chapter 2

NEW HORIZONS

M ost girls of Mary's status—and certainly with her fortune and family connections—would have taken the stylish Grand Tour of the Continent to complete their education as young women. There are no records, however, of her having done so—and with good reason. There was an unpredictable and uncontrollable power holding most of the Continent hostage. For a young Englishwoman, it was not a safe time to travel abroad.

For much of the 1790s, England lived in fear of invasion by Napoleon. By early 1798, he had already marched through Italy and Switzerland and had captured Vienna. The incomparable English Navy, with billowing sails snapping open like protective umbrellas, patrolled the Channel, poised for battle. In addressing the fate of England, however, Napoleon's genius became apparent when, instead of invading the mainland, he decided to cripple England by cutting off her sea route to the East, thereby eliminating a great source of her riches.

In May 1798, Napoleon commanded four hundred ships covering four square miles sailing south on the Mediterranean, their towering masts painting an ominous portrait on the horizon as they rolled on like a caravan of camels across the desert. Fifty-five thousand men,

more than one thousand cannon, field artillery, and horses were on board as the ships plowed through the stormy seas en route to Egypt. Napoleon's ship, *L'Orient*, had 120 guns and weighed over two thousand tons. At first, Napoleon's armada seemed invincible. The French gained Malta. They marched through Alexandria, on to Rosetta, and triumphed in the Battle of the Pyramids. Napoleon's conquest of Alexandria, ruled by Mameluke warriors who reported to the great sultan of the Ottoman Empire, destroyed a 350-year alliance between the Sublime Porte (Turkey) and France.[1]

In the summer of 1798, British Admiral Horatio Nelson, turning forty, one eyed, one armed, and a veteran sailor since his early teens, traversed the seas in search of Napoleon. He arrived on the Greek islands in pursuit but could not find the general and his forces. He sailed on to Palestine and back toward Italy. One lucky day, Nelson captured a French corvette, interrogated the crew, and learned of Napoleon's whereabouts. Nelson diverted the English navy to Aboukir Bay where, in a night attack, the bay became incandescent. *L'Orient* went up in flames, and the detonated gunpowder was heard forty miles away. Nelson crippled the French fleet, gaining Egypt, Malta, and the gratitude of the sultan of the Sublime Porte. The Battle of the Nile, which took place at Aboukir Bay and not on the Nile, made Nelson a hero, and Napoleon's resolve to topple the British became an obsession as he retreated into Egypt.

Like a caged animal, Napoleon was held captive and could not escape by sea; instead, he marched through the Suez peninsula, harassing Selim's subjects and Turkish soldiers in his path. Nine months later, in May 1799, the brash and romantic figure Sir Sidney Smith attacked Napoleon on the coast of Israel at Acre, causing another stupendous loss for the French. General Koehler, a seasoned British commander, led the ground forces along with thousands of Turkish warriors. In August 1799, Napoleon began a two-month cat-and-mouse retreat until he finally reached France in October, only to find political chaos back home.

After two stunning victories, the British were now poised at what they felt was an historic moment. Sir Robert Ainslie, England's minister to the court in Turkey, had previously made overtures of friendship to the sultan and was quite harshly rebuffed.[2] But Selim III, now enraged at Napoleon's betrayal, was on the verge of forging a new alliance with the British government and sent his foreign minister, Yusuf Aga Effendi, to pay his respects to the Court of St. James's. King George III and his Parliament already had Spencer Smith (brother of Sir Sidney Smith) and the Levant Company in Turkey for commerce, but a new ambassador was needed for more extensive negotiations. The king's personal choice for the job was Thomas Bruce, the 7th Earl of Elgin and 11th Earl of Kincardine, a thirty-two-year-old Scottish diplomat and politician.

Thomas Bruce was descended from Norman knights who arrived in Britain with William the Conqueror. The most notable member of the family was the revered Robert the Bruce, king of Scotland from 1306 to 1329. Bruce's victory over Edward II at Bannockburn in 1314 delivered independence to his people and an unshakable place in history for the family name. In 1603, Edward Bruce accompanied Scotland's King James VI to England (where he established himself as King James I) and there established the Earl of Ailesbury line. Edward's son George founded the extremely profitable salt works and coal mines at Culross and became the patriarch of a family that included the Earls of Ailesbury, Elgin, and Kincardine, as well as James Boswell[3] and the wife of Bonnie Prince Charlie.

Broomhall, a family estate outside Dunfermline in Fife, was built in 1702 in the austere style of the old Scottish castles. Dunfermline, the medieval capital of Scotland, was the home of the Bruce family for hundreds of years; Dunfermline was also the birthplace of national bard Robert Burns and, later, Andrew Carnegie. Born in 1732, Charles Bruce, whose father died when he was eight years old, inherited

Broomhall, both the Elgin and Kincardine titles, and the Bruce dream of turning Scotland's natural resources into thriving industry.

This young man with the imposing titles of 5th Earl of Elgin and 9th Earl of Kincardine had an equally grand dream. Why not develop the limestone deposits, transport them, and build a model town for his employees? His mother, Janet, who had served as custodian of Broomhall until Charles was of age, warned him against overspending, but he ignored her and incurred massive debt.

In 1759, Charles married Martha Whyte, daughter of a London banker. Martha's mother had died a few days after her birth, so Martha was sent to Kirkcaldy, near Dunfermline, to be raised by her uncle and his wife. Charles won Martha away from the Earl of Galloway, and they settled at Broomhall to manage their limestone quarry and raise their family. They shared the tragedy of the loss of an infant son, and in 1771, tragedy struck once again. Martha was pregnant with their eighth child when Charles suddenly died. William, their second and now eldest surviving boy, became the 6th Earl of Elgin and 10th Earl of Kincardine until only a few months later he, too, became ill and died. The titles now fell to Thomas, who was only five years old.

Young Thomas now became the 7th Earl of Elgin and 11th Earl of Kincardine, never again to be called "Thomas" but to be known as "Elgin," even to his own mother. Quite understandably, Martha became obsessed with the health of all of her children and placed them under lifelong neurotic watch. She was now a widow with six children, and she had great plans for all of them. The name Bruce was a grand one, but because of the scope of her husband's plans and his massive borrowing to finance them, Martha had very little money. So, not one to be pitied, the formidable Lady Elgin took over her family's affairs just as her mother-in-law had done.

She turned to the very rich Bruce cousins, the Marquess and Marchioness of Ailesbury, for help. The Ailesburys approached King

George III for Martha and her brood and secured a small annuity; they also handed over tuition money for the young Lord Elgin. For Elgin, there was no question about his duties; he became the hope of their entire family and understood that his weighty task was to procure the happiness and success of his five surviving siblings. In those days, boys' boarding schools were places of pervasive filth, and when stories of ringworm and lice reached Lady Elgin, she had her son transferred. He studied at Westminster, Harrow, and the University of St. Andrews, where he won the University Prize for an essay on tragedy. Interested in politics and the law, he headed for Paris to continue his education with the eminent legal lecturer Professor Bouchard, whom he impressed with his argument of why there should be no classes on Sundays. During this time, Elgin met the elderly Benjamin Franklin and read the recently published *Decline and Fall of the Roman Empire* while his mother kept an eye out for excess by keeping him on a very tight budget.

At home, Martha was busy planning Elgin's future. Through a high-ranking military relation, she obtained for Elgin a prestigious military commission that required no previous battle experience. In addition, she put out feelers, through the Ailesbury Bruces, as to whether or not Elgin could be a serious contender for a seat in Parliament. The only way for a Scot to gain a place in the Upper House was to win one of the sixteen peerages legislated by the Union of 1707.

For most of the second half of the eighteenth century, Henry Dundas[4] was Scotland's most powerful Tory "party boss." In 1790, a new group, led by Lord Selkirk and Lord Kinnaird, attempted to topple Dundas's influence. This group was quite liberal and seemed like a fresh wind. Elgin, a young man, flirted with their cause. His English Bruce cousins, loyal Tories, were horrified with his refusal to toe the line. They admonished Elgin, and he, displaying precocious diplomatic prowess, ran a shrewdly balanced campaign, impressing both the radicals and the established machine. Elgin realized not only that he enjoyed politics

but also that he excelled at it, and at twenty-four years old became a member of Parliament.

The following year, 1791, this attractive and clever young man was appointed envoy extraordinary to the newly crowned Austrian emperor, Leopold II. Based in Vienna, Elgin accompanied Leopold on trips around Austria and Italy until Leopold's death in 1792. Elgin was rewarded for his growing skill and reputation with subsequent appointments to Brussels and Berlin.

While Elgin was living abroad, the English royal family suffered an embarrassing scandal of its own when the Prince of Wales (later George IV) and his wife (née Caroline of Brunswick) separated, leaving their infant daughter, Princess Charlotte (their firstborn and only child and, therefore, heiress to the throne), in the custody of her grandfather, King George III. The king appointed Elgin's mother, Martha, the little girl's governess. Princess Charlotte adored Martha, Lady Elgin, and called her "Eggy." Lady Elgin, who taught the princess to love both her parents despite their despicable behavior, won the king's respect. Observing her wonderful relationship with his granddaughter, the king grew curious about Martha's own parenting. He inquired after the Bruce children, and after learning a bit about them, the king declared Lady Elgin to be a superlative mother. King George became interested in Lord Elgin's career, and when Elgin returned to London in 1798, it was the king himself who advised Elgin to petition the foreign minister, Lord Grenville, for the post of ambassador to Turkey.

Diplomacy, however, was a rich man's game. Much of an embassy's expenditure was expected to come from the private finances of the ambassador; it was imperative for the appointee to have a large fortune. There was much whispering in London that Elgin did not have the money for the post. At a ball in Weymouth in August 1798, Elgin danced with the king's daughter, Princess Augusta, and the king took Elgin aside to reiterate his support for Elgin's appointment to the post

in Turkey. The king had one further comment: he delicately suggested that Elgin would be a much stronger candidate if he found a wife—*the right wife* (in other words, one with money). In the fall, Elgin went home to visit Broomhall mindful of the king's directive and his own mother's ambition. With his family name, elegant appearance, and accomplishments, he was welcomed by all of the most important families as an eminently eligible bachelor.

For most of the 1790s, Elgin had been on the Continent while Broomhall was under expensive renovation. The young Lord Elgin had visions of completing his father's dreams as well as constructing a great estate that befitted his titles. Elgin's plans to build a new harbor in order to facilitate transport of the limestone worried his mother, who had been down that road before. She was extremely wary of her son's increasing debt and made it very clear to her son that he had to choose his bride wisely. As she was tied to the Court with her own duties, she did not accompany him to Scotland, assuming that local friends and family would assist him in his needs.

Mary Nisbet had not only known Lady Elgin and Elgin's sister, Charlotte, but they were all related through the Montagu line, descended from the Dukes of Rutland. Mary had dined with Lord Elgin's mother and sister in London and at Archerfield. Mary, mischievous and fun loving, could not have had a more opposite disposition from that of the intense Lord Elgin, who was prone to worry. He was exacting; she was forgiving. Elgin sought out the young woman with the outrageous manner and the widely known fortune, and he visited her for tea on December 8, 1798. Two days later he appeared again but he "went early," according to Mary. She was confounded. At the time, there were many other young men in pursuit of Mary, and their names were scribbled in her diary. Local friends and long-distance contestants threw their hats into the ring. On one day it was George, on another it was another George. When she was ill, they came anyway—just to show how much they cared. George Sommers came all the time. A Mr.

Ferguson of Pitford of the famed weaponry family was also quite persistent. They would certainly not be eager to leave her company "early."

Elgin disappeared during the Christmas holidays and reappeared on January 3 when he returned to Archerfield with Thomas Harrison, who was his friend and an architect. Mary was obviously falling under his spell because barely one week later, on January 10, her diary reflects a significant, emotional change. Here, Lord Elgin becomes "L'E"—"L'E went"—on the fifteenth, "L'E came," and from then on there was steady reference to his presence in Mary's life, and all contenders apparently lost to the ambitious, complicated Lord Elgin. He was calculating yet spontaneous, contemplative yet impassioned, and it was clear that he fascinated her. Her parents and family took notice.

On January 30, "Mr. & Mrs. H.N., L'E, Mr. Harrison and I dined at Rockvale." On Friday, February 1, "Mr. And Mrs. N, L'E and I dined in Edinburgh." On Saturday, February 2, the very next day, Elgin was again with Mary and her parents. "L'E, Mr. & Mrs. N & I returned to Archerfield to dinner." The following Thursday, February 8, they went out in a public way together, and she wrote, "L'E, Mr.& Mrs. N & I went to Edin: & to a Ball given by Col: Hamilton at St George's Square." Next, it was time for him to face the rest of the clan. On Monday, February 11, "L'E, Mr & Mrs N & I dined at Mrs. Campbell . . . went to the Play (Bluebeard)." Next it was on to Biel to be inspected by the Hamiltons.

Both families were eager to encourage the match. Elgin knew that this girl would please his mother in every way; William Nisbet, like Elgin, foresaw a dynasty. Mary did not miss the double entendre about the links of Gullane and the "link" to Broomhall made ever so subtly by her Aunt Mary (Campbell). The man who would "enchain" (another pun) himself to Mary would be a happy man, indeed, she wrote her niece. Her point was made more directly when she campaigned for Elgin: "he was a favorite of mine," "an incomparable young Man."

Elgin was twelve years older than Mary and was apparently proficient

in both his professional life and the bedroom. Word had circulated, after one near catastrophe in Paris with the wife of his law professor, that Lady Elgin had written to her son to beware the constant danger of sexually predatory women. Elgin fled Paris for a smaller town to avoid Madame Bouchard's advances, only to begin an affair with another married woman. This married woman, whom Elgin would not name, had been the kept mistress of a man long before she had wed. Lady Elgin believed that her innocent son was a victim of women who could not resist his charms, and she was alarmed.

Elgin, once experienced in the ways of the flesh, discovered that these encounters were best kept from his very nervous mother. He was a man of high testosterone and demonstrated a consistent pattern, preferring dalliances with married women who provided sexual pleasure without matrimonial consequences. In Berlin, Elgin enjoyed an affair with another older, married woman named Madame Ferchenbeck. In contrast to these married women who, to some degree, were able to come and go as they pleased, Mary was highly chaperoned, and her excursions would often include church outings.

Elgin behaved in a very correct manner and proceeded with all proper comportment to please the Nisbets. They, in turn, approved of his polish. He had an English accent, not a Scottish one, because he had spent very little time in Scotland—and his last name was Bruce. He had lived among royalty in Europe and was someone Mary could lean on, look up to, and be proud of. He had the kind of confidence and masculinity that came from experience, travel, and professional success. Mary, who had known from her youth that her marriage would have to be more than just a love match, in the end responded to Elgin from her heart and not just to his curriculum vitae.

Although theirs was an attraction of opposites, for better or worse, they had much in common. They could both be quite capricious, both were extremely close to their mothers, and both had periodic asthma attacks. Mary rarely took medicine. She would occasionally remain in

bed until her spasms subsided. Elgin, on the other hand, aggressively battled his ailments with onerous treatments. He would suffer through leeches, mercury treatment, and bleeding. This shared debilitating illness gave them great empathy for each other. Both Mary and Elgin, who had penetrating eyes, turned heads when they entered a room (Mary later wrote her mother-in-law from Turkey: "could you but see Elgin your *Heart would dance* for joy, he is such a pretty Boy"), and they both had an enormous sense of entitlement. Lady Elgin and Mrs. Nisbet raised their children with conflicting signals: on the one hand, they were strict Sabbatarians and instilled in their children a strong adherence to Christian doctrine; on the other hand, these women participated, for better or worse, in the world of high society and its foibles. While there was no dancing or card playing on Sundays, weekdays could be filled with frivolity.

Mary could enjoy her wealth without worry, but Elgin, who understood austerity, had been pushed into a world the Bruces could not afford and was intensely frustrated by the unhappy harness of financial constraint. Surrounded by the richest boys in England wherever he went to school, he spent his summers at Toppingham Park with his very rich cousins, the Ailesburys. Martha placed him in that milieu hoping he would benefit from the advantages, but the results were disastrous. Elgin longed to possess what he could not afford, and he began to borrow money carelessly. He acquired and spent and spent and borrowed. By the time Thomas Bruce met Mary Nisbet, he was looking for a way out of a financial mess.

As the newly appointed ambassador extraordinaire to the mighty Ottoman Empire, Elgin needed a wife who could perform with ease on the international stage. Mary could fulfill that role with style. If she could be lured from this harbor of hovering family, the two of them might prove a potent team. While Elgin was dreaming of making his mark in history, Mary, despite her Scottish sensibility, had been schooled on Blake, Wordsworth, and Rousseau and was looking for

romance. She was in love with the wunderkind and his devastating blue eyes, and her sweetness toward Elgin actually softened his heart.

Her diary entries reveal that on Sunday, March 3, "Mr. & Mrs. N, L'E & I went to Kirk," on Monday, March 4, they all dined at Pencaitland with the Hamiltons, and on Monday, March 11, they were, once again, before God.

Chapter 3

THE NEWLYWEDS
SET SAIL

Mary Nisbet of Dirleton became the Countess of Elgin on March 11, 1799. At the wedding, she had an attack of nerves— or perhaps, as she sometimes admitted to having, a presentiment— because at one point, she stopped the proceedings and withdrew to compose herself. Her sudden emotional outburst surprised the guests, because she was widely known as a very levelheaded young woman. The presiding clergyman, Bishop Sandford, asked Mary if she had anything to confide in him. She went on with the wedding. Mary noted in her diary that after the ceremony, the Nisbets, Colonel and Mrs. Hamilton, Bishop Sandford, and Elgin's good friend and neighbor Mr. Oswald joined the newlyweds for dinner. She scribbled, "Lady Elgin dined."

The Lady Elgin she was referring to was herself; as Martha, the Dowager Countess, was not present at the wedding. Whether it was her position at Court—often jealously sought—which enslaved her to the whims of the royal family, or her need to be with her own daughter, Lady Charlotte, whose own wedding was in two weeks, the Dowager Countess remained in London. She wrote loving notes to her son wishing him all happiness and offering her blessings, and notes to Mary and her parents attesting to her happiness from her London home on Downing Street, and notwithstanding her own limited funds, she sent

Mary a wreath of diamonds as a wedding present to make a very loud statement of approval. "My sons attachment was deeply rooted from the first visit he paid at Archerfield & it must prove a great delight to both Familys to think that neither could have any motive but affection for preferring each other."

Martha hoped that her son's new bride would ensure that his financial worries would be over. William Hamilton Nisbet, however, was too shrewd to turn significant funds over to his new son-in-law. He was well apprised of Elgin's disregard for budget and presented his new son-in-law with a £10,000 bond from which the young couple could receive only interest. The bond had been part of Mary's mother's own dowry, so in effect this cost Mr. Nisbet nothing. It was clear that Mr. Nisbet was not going to give Elgin free rein with Mary's fortune; and when the money would run out, as he knew it would, he would not have to wait long to hear from his favorite girl.

Elgin had already worn out his welcome in the financial community in Edinburgh, and his lawyer, James Dundas, warned his client that he would have to obtain financing in London, where people would charge him astronomical interest rates. Since the plan was to leave for the Middle East, Dundas and Mary urged Elgin to recruit trustees for Broomhall who could oversee his estate while he was away. So Elgin asked his mother, his new father-in-law, his uncle Erskine of Cardross, and his good friend Mr. Oswald of Dunnikier to take on that responsibility.

The couple stayed at Archerfield for their wedding night, and then on Thursday, March 14, they left for Broomhall. Dowager Countess Martha wrote, "I think you are gone to Broomhall. Much Happiness may You and my Son enjoy there, and in every place you go to." The Nisbets arrived two days later. Another letter arrived from Dowager Countess Elgin. She seemed to be swept away with emotion; however, in this note she also revealed an autocratic and meddling side that Elgin was familiar with. Recognizing that young Mary would now have a

great deal of sway with her son, she addressed the note to the new Countess of Elgin:

> Few Circumstances in this Life, ever gave me more real pleasure than I feel at this Moment, in addressing you as Mistress of Broomhall—How happy must my Son be and as You bear my Name, I hope you experience the Gratification I did, on going there, and finding myself the beloved Wife of his most Aimiable Father—I can hardly think of you my Dear Child, without Tears of joy, I think I see You and Elgin, walking about, & laying all You Plann s . . . [but it would] be a disagreeable Reflexion to Elgin, as long as he lives, if he don't come up to give his sister away—I trust to You my Dear Child for Granting this request.

The following Friday, the earl, his bride, and her parents were back at Archerfield, where the newlyweds said their good-byes and dutifully left for London. Unbeknownst to Mary, that would be the last time she would see Scotland for seven years.

On Tuesday, March 26, they arrived in London just in time for Lady Charlotte's wedding on Thursday, March 28. While the young Countess of Elgin was celebrating her twenty-first birthday amid the London social whirl on Monday, April 18, 1799, the British ground forces stationed thousands of miles away in the Middle East were witnessing another stupendous celebration in Constantinople, soon to be Mary's new home. In a sense, they were paving the way for her arrival.

At eleven o'clock in the morning on April 18, in Constantinople, the English soldiers and officers under the command of General Koehler arrived at the Sublime Porte. Standing under the grand gate of coronation at the Seraglio, the sultan's palace, a large body of Turks gathered for prayer inside the courtyard. A little before noon the Ottoman Empire's leading officers and officials of state, such as Foreign Minister Effendi, gathered and with much pomp, bearing their flag,

they marched to the bottom of the steps of the palace where the Muslim religious leaders conducted solemn worship. At precisely twelve o'clock, when the sun was at its highest, the flag was raised and planted. Twelve sheep were immolated and the foot of the flag was washed in their blood. This standard was to wave for forty days until the Grand Vizier led his troops across the desert in Koehler's battle charge. The English and the Turks were now joined as one military force against their common enemy, Napoleon.

On April 26, the sultan presided over the ceremony of the Captain Pasha's departure with Turkish and British forces. The sultan, surrounded by his fiercest guards, had a short conference with the Captain Pasha and then invested the warrior with a splendid caftan, a robe of honor. Six of the Captain Pasha's captains were also brought forward to receive robes. The Captain Pasha then proceeded, surrounded by saluting soldiers, to his gilded twenty-four-oared barge, the *Selim*. This ship was escorted ceremonially by four more barges, all departing to the music of gunshots.

Mary would later see and hear these same sights and sounds, but for the moment, in the spring of 1799, she remained a brand-new bride surrounded by her family and enjoying her usual London pastimes. The young couple lived at the Nisbets' house on Portman Square. They dined frequently with the Dowager Countess at Downing Street and with Mary's family at Grosvenor Square. On Saturday, April 30, all of the Bruces, the Dowager Lady Elgin, and the new Lady Elgin joined Lady Robert at Grosvenor Square for dinner, and the young count and countess went on to the opera.

As the couple of the moment, they were in demand and spent all spring and summer enjoying the whirlwind season of balls and parties at Court. On Tuesday, May 16, they attended the most coveted event of the year, the Queen's Ball, and were regulars at the city palaces of the Duchess of Bolton and the Duke of Cumberland, and at smaller gatherings with the Princess of Wales.

In July they took a trip, chaperoned by the Nisbets, to see Chichester Cathedral, visited the Dukes of Arundel and Richmond, and had a delightful time at Brighton, the seaside resort in the south of England.

Aside from all the gaiety, Lord Elgin had a mission to complete. Mary's diaries reveal a new dimension to their entertaining schedule at Portman Square that summer. These dinner guests were not quite as aristocratic and, in essence, came for job interviews. Their names include Mr. Morris, Mr. Hunt, Dr. Hall, Mr. Carlisle, and others who were going to be part of Elgin's embassy in Constantinople. Mary was beginning her new role as the ambassador's wife. Each of these men had a particular expertise and was thought to be valuable to her husband in his new post. She treated them with the same deference and hospitality as she did any duchess who came through their Portman Square door.

Mary had periodic bouts of asthma that summer, which Elgin believed to be psychological. Assuming that Mary's ill health was brought about by fear of going to Constantinople, he offered to decline the post. Mary wouldn't hear of it. She had married a diplomat and resolved to follow him in his career. Her job as a wife would have to take precedence over her interests as one of Britain's largest landowners.

Elgin's youngest brother, Charles "Andrew," returned from India that summer and regaled Mary with exotic stories. Apparently, they got along famously, as Mary wrote to her mother-in-law, "I really never saw any body that I felt so much affection for, on so short an acquaintance." Their summer fun, the London season, was coming to an end. Soon, they would leave for the East, and there was one additional complication. On August 1, Mary noted, "Dr. MacLean dined—The Child." She was pregnant. It would have made perfect sense for her to stay in England, but she chose to go with Elgin because she understood her husband's historic position and his great ambition. While the young Mr. Bruce entertained his new sister-in-law, Elgin dined with embassy appointees, lawyers, and politicians.

Mary, mindful that her impending journey was the result of Nelson's victory, noted its first anniversary, "L'Nelson's Victory," on August 10. On August 27, the Nisbets said good-bye to their pregnant daughter and returned to Scotland. "The last three days I was in London were indeed by far the most painful ones, I ever passed in my life . . . it is a severe thing parting with so many Friends at once," she wrote her mother-in-law. On August 31, Mary, Elgin, and Charles Andrew had dinner in Portsmouth.

On September 3, 1799, some ten months after Elgin's official appointment, the Elgins set sail from Portsmouth on the frigate HMS *Phaeton*. Parliament's instructions to Elgin were: persuade the Turks to open the Black Sea to trade, establish a postal station at Suez, get the French out of Egypt, and keep the Ottoman Empire on friendly terms with Great Britain.

Ironically, the HMS *Phaeton* was named for the arrogant, self-destructive son of Apollo whose voyage caused widespread ruin. Equipped with thirty-eight guns, it had only one deck and was ready in case of piracy or a Napoleonic attack. Mary, her lady's maid, who was named Masterman, two other maids, and a few other female servants were outnumbered and surrounded by a crew of rough, but skilled, English sailors and Lord Elgin's embassy entourage. Elgin's staff included the twenty-eight-year-old Reverend Philip Hunt, an antiquities scholar who was knowledgeable about archaeological sites; Professor Joseph Dacre Carlyle, who had held the chair in Arabic at Cambridge and whose personal mission was to convert Muslims by giving them the Christian Bible translated into Arabic; William Richard Hamilton, Elgin's first personal secretary; Dr. Hector McLean, who came along to be the embassy doctor but disappointed everyone because he was a drunk; and twenty-two-year-old John Morier, who had been born in Smyrna when his father had been consul there, so he was familiar with Ottoman grandees. Mary brought along some dogs, including Boxer and Coquette. She sent ahead carriages, heavy trunks, furniture, and

her pianoforte. The ship, far from luxurious, had tiny sleeping quarters divided by curtains of green baize, the feltlike fabric that covered billiard tables and was often used to separate servants' quarters in a grand home, making the interior extremely hot. The ship pitched and rocked through stormy weather for two days, and Mary, two months pregnant, was sick the entire time; "nothing but Laudnum [a mixture of opium and alcohol] eased me," she wrote her mother-in-law. Afterward, she claimed great satisfaction in reporting that even Captain Morris got sick.

Also on board was a twenty-five-year-old Irish lieutenant, Francis Beaufort, later Admiral Beaufort, who studied the rough gales on their journey, developing the wind force scale that was later named after him. Beaufort, desiring adventure and excitement, scoffed at his assignment as "an intolerable service," in essence providing a ferry service for a nobleman and his wife, and wrote with indignation in his diaries, "our passengers seeming to compare His M. ship to a stage coach in which they had nothing to do but take their place and be set down in safety at the place of destination." He also noted in his diaries that the Countess of Elgin spent most of their journey violently ill, but he decided, in fact, the aristocratic bride displayed a wonderful "good-natured, unaffected affable" temperament despite her seasickness. A rugged, scrappy, seafaring man, Beaufort found it entirely unusual that Lord Elgin was "most unfashionably attached to his wife," and although he would not go so far as to call Mary a beauty, he unexpectedly developed a fondness for the couple.

Beaufort was among the group accompanying Captain Morris and Elgin's staff as they went in search of antiquities around the Greek islands, and although he would spend a good deal of his life at sea, he gave Lord Elgin complete credit for igniting his own enthusiasm for ancient treasures, declaring his journeys on board the *Phaeton* to be a surprisingly wonderful experience. After helping Lord Elgin and his men to collect "4 Marble Stones in Cases" on the way to Turkey, he

noted in his journal, this time with wry humor, that they had at last arrived in Constantinople, the "troublesome cargo" safely delivered.

John Morier also kept diaries but recorded a less positive view of Lord Elgin. In his diaries, Morier wrote that Elgin was cold to people and had no intention of paying them, even though he had said that he would. According to Morier, once on board the ship, Elgin apprised his staff that they would all have to pay their own expenses until his term of ambassador was over—whenever that would be. The young chaplain, Reverend Hunt, came aboard with only pocket change and urgently wrote home for money. This started Elgin off on the wrong foot with his men. Mary admitted in her letters that if anyone mentioned money to her husband, he became irascible. Rather than subjecting herself to scenes and temper tantrums, she made a mental note that once they were in Constantinople, she would take over the accounting.

Mary couldn't wait to dock in Lisbon. They arrived on September 13, but from the moment she set foot onshore, where she mailed her first letter home, she hated it and was very blunt: "the filth and stink of this place you can form no idea of . . . they fling everything out of the windows . . . you can have no notion of anything so beastly." With her usual penchant for nicknames for those who are dear to her, she had rechristened her husband "Eggy" and referred to herself as "Poll." She was desperately homesick. "Today I calculate Lady Robert and Bluey will arrive at Archerfield. I have thought of that all day . . . Oh Mam, that I had a little of your butter and cream and bread."

Lisbon disgusted her despite her pretty view of the Tagus River. She was terrified of the local dogs because they were trained to eat trash—including discarded meat—and she thought her pets would get mauled. She, however, went ashore, as she felt it requisite to visit the local sites of interest like churches, the aqueduct with a notable echo under its central arch, and amphitheaters. She also felt it her duty to attend church services on Sunday morning, carefully recording the biblical narrative preached by Mr. Hunt, the group's chaplain. A bride herself,

she reported home with delight that Captain Morris was asked to permit a wedding on board for "a beauty" and her German lover and that Mr. Hunt was to perform the ceremony.

The Nisbets, Aunt Mary, her grandmother Lady Robert, Aunt Bluey, and her friends were all a thousand miles away. She hungered for news from home and sought out newspapers to find out bits about British maneuvers. In a private section addressed to her mother, she tried to assure her that despite her isolation,

> nobody can be happier than I am, for nothing can equal his [Elgin's] attention and anxiety for me and his wretchedness when he sees me suffering; and to hear him speak of you and my Father the way he does, is indeed comfortable. Before we left Portsmouth, we both went down upon our knees and prayed for our dear parents, Mam.

She pondered their departure: what would be worse, getting stuck in Lisbon or seasickness? Their ship was detained, "the only morning since we have been here that the ship could not get out," because they needed to "have an American Vessel going with us to Gibraltar, where it is going on a cruze, so if we are attacked by the Gun Boats, I shall be deposited in the American." Once under way, she complained that her head was swimming like the scum ("the Bratt") under the Tron Bridge in Edinburgh.

Their next stop, Gibraltar, was far more pleasant. In Gibraltar, Mary met the dashing governor general, the legendary ladies' man and highly esteemed soldier Charles O'Hara. O'Hara had earned his reputation for gallantry at the Battle of Yorktown when, handling the British surrender for an embittered Cornwallis, he, instead of his leader, dined with George Washington. O'Hara broke many women's hearts, most notably the Bluestocking and Horace Walpole protégée Mary Berry, who mourned him for some fifty years after his death. Berry, an excellent

travel writer, was second cousin to Elgin's neighbor Robert Ferguson, the man who would reenter Elgin's life and change it forever.

Mary, too, was smitten with the general. "If he were forty years yonger what a scrape Eggy would be in." In her opinion O'Hara would be "just the very thing for my Father, amazingly entertaining, famous stories not over correct but quite charming."

At O'Hara's home in Gibraltar, Mary had her first exposure to what life would be like as the wife of an important international figure. "We are treated in a most magnificent manner, for before we came on shore, Admiral Duckworth and all his Officers came and paid us a visit, and when we arrived here we were saluted, 17 Guns fired by the Guards at their posts saluting . . . it really almost makes up for my past hardships." She was invited to tour, with an entourage, St. Michael's Cave, which "is to be lighted up for me, a great compliment from the Governor, he hardly ever allows it to be lighted, it is such a great expense to the Government. . . . You would laugh could you see the grandeur I am treated with by everybody—they are A'Bowing!" Her international reputation, launched at the constant dinner parties and balls, was cemented: "I was the object of admiration."

They left Gibraltar on September 25 and headed for Sicily, having passed the Barbary Coast, which Mary thought "exceedingly beautiful." The "Mediterranean is much wider than people in England, I think, talk of; for Captain Morris intended to have taken us from Gibraltar to Palermo without our being able to see a bit of land." Sounding cheerful, she was, however, sick much of the time and admitted that she still did "detest a ship as much as ever." For the most part, she remained in her "cabin" where Masterman frequently bathed her face in vinegar. No one on board the *Phaeton* knew that at the same time they were heading east toward Palermo, Napoleon was on an escape route from North Africa and passed by within a few miles.

Chapter 4

A BATTLE OF BEAUTIES

Once in Sicily, Mary's letters sent home delicious gossip about British naval hero Horatio Nelson, his mistress, Emma Hamilton, and her cuckolded husband, Sir William Hamilton. Her lampoon would spread news all around London about Nelson's pretentious behavior:

How I shall make up to the Duke de Bronte when I arrive at Palermo. Now I will lay a bet you do not know who that is—Why no other than Lord Nelson! I saw an Officer at Gibraltar who assured me he had seen a letter signed by Lord Nelson "de Bronte & Nelson," in which letter he told his friend this was his title and £3000 a year with it. I was told the King of Naples had also given him a sword worth £3000 set with diamonds, which was left by Charles the V to the King of Naples, on condition that if ever Naples should be wrested from that family, the sword should be given to the person who reconquered it and delivered it up again to them. The King of Naples said the Duke de Bronte WS certainly the person for whom it was intended. Is this not very fine?

On the second of October, Mary encountered the beautiful Lady Hamilton, Nelson's married mistress, for the first time. Although both

women enjoyed the status of ambassadors' wives, their backgrounds were worlds apart. Emma Hamilton, born Amy Lyon, the daughter of a blacksmith, was thirteen years almost to the day older than Mary Nisbet. Amy had been a maid, an artist's model, and paid companion to many men. The painter George Romney, obsessed with Emma, immortalized her in seductive poses.

In the 1780s, "Emma," as she had restyled herself, lived with her mother in a small house in London where she was kept by Charles Greville. In 1785, Greville, suffering financial losses, offered his mistress to his elderly uncle, a recent widower. Sir William Hamilton was in his sixties and Emma was barely twenty when she joined him in Naples. Greville thought that Emma would delight the already besotted old man but that Emma's unsuitability as a wife would ensure his status as heir to his uncle's fortune. Much to his—and everybody else's—surprise, Sir William married her.

Emma was most definitely a woman and not a lady. Tongue firmly planted in cheek, Mary referred to Emma Hamilton as "her Ladyship." Lady Hamilton sent a servant to the *Phaeton* with a message for the young Elgins stating that she would have paid them a visit but the king (of Naples) was expecting her that evening. She intended to stop by the next morning on her way to the country, where she was supposed to be for four or five days. Coming as it did from the wife of Lord Hamilton, the British ambassador, this message was in flagrant disregard for protocol and completely unacceptable to Mary who, now fully aware of the kind of tribute due her as the wife of an important British ambassador, wrote with sarcasm, "A remarkable civil message, is it not?" She handled the situation by refusing to see "her Ladyship" on the ship, "as I said I was going on shore tonight." As no good Christian girl would stay in a home where adultery was ongoing, she "resolved not to take up by abode at Sir William Hamilton's."

Mary sprinkled her letters with spicy anecdotes illustrating Emma's lack of gentility.

[This] has just happened to Captain Morris. He has been on shore to speak to Lord Nelson; he went to Sir William Hamilton's house and a little old Woman with a white bed gown and black petticoat came out and said "What do you want Sir?" "Lord Nelson, M'am." (Old Woman) "and what do you want to say to Lord Nelson?" Captain, laughing. "Oh M'am you must excuse me telling you that." Upon this a servant said to him, "Sir I fancy you don't know that is Lady Hamilton's Mother." The Captain was surprized and said, "What! Does she act as Housekeeper?" "Why yes Sir, I believe she does sometimes."

On October 3, Mary and Elgin went onshore, and to honor her public duties, they attended a dinner party at the Hamiltons'. "I had the satisfaction of seeing her Ladyship, and what is still more, heard her sing." Emma was "vulgar" but "makes up amazingly, [she appeared] quite in undress;—my Father would say; 'There is a fine Woman for you, good flesh and blood.' She is indeed a Whapper! . . . It is really humiliating to see Lord Nelson, he seems quite dying and yet as if he had no other thought than her." The sexual term "whapper" was intended to make her father chuckle.

Lord Hamilton and Lord Elgin got along very well and found their love of antiques and art a common bond. Elgin discussed his plan to hire artists to sketch and make molds on the classical sites in Greece. They both agreed that the well-known Italian artist Giovanni Battista Lusieri would do a fine job. Mary wrote home that Sir William heartily approved of Elgin's plan to bring sketches and copies back to England for the use of art students and the museumgoing public. In fact, Hamilton used his influence to get a release from the king of Naples for Lusieri, who was an official court painter, to accompany Elgin for just such a project.

The financial arrangement was £200 per year and all work would remain the sole property of Lord Elgin. Lusieri agreed to remain in

Greece for the duration of Elgin's term as ambassador, but their collaboration would last twenty years, far beyond their stay in the Middle East. Elgin was thrilled that his artist came so much cheaper than anyone in England. Napoleon's campaigns had left much of Europe in upheaval, which affected the art world as well. At the beginning, Lusieri was retained only to sketch and make molds, and it was clear that at that time, Elgin had no thought about removing any sculptures. It was, in fact, Napoleon, and not Elgin, who waged a war on antiquities. From Italy to Rosetta and beyond, wherever Napoleon marched, he stripped museums, archaeological sites, and private collections, sending great treasures home.

Although both Mary and Elgin had great respect for Lord Hamilton's own accomplishments as an art connoisseur, the fact that Lady Hamilton openly committed adultery with Lord Nelson and later, in 1802, gave birth to Nelson's daughter, Horatia, made Sir William somewhat sad in both their opinions. Hamilton, the cuckold, routinely and bravely faced the public despite his wife's flagrant behavior.

Mary, too, observed that in this triangle Emma was the puppeteer. When Captain Morris went to the Hamiltons' before the dinner party to deliver some dispatches to Lord Nelson, according to Mary, Nelson "read them and then called Lady Hamilton out of the room. They had a conference, and when she came back, she said, 'Sir William we shall not go to the country today, you must dress yourself and go to Court after breakfast.' Poor Sir William asked, 'Why?' 'Oh I will tell you presently.' Is it not a pity a man who had gained so much credit should fling himself away in this shameful manner?" Emma coerced Nelson to "do many very foolish things," and Mary disapproved of "the absurdity of his conduct." Emma took complete advantage of her seat of power, demanding tribute. Whoever wished to procure Lord Nelson's favor must first kowtow to "her ladyship." "The Queen whenever she has any point to carry [to Lord Nelson], sends Lady H. some diamonds. I am

told positively she has given her to the amount of £15,000 worth; the quantity of jewells here is quite astonishing."

Lord Elgin, in his own letters home to his mother, the Dowager Countess, added the finishing touches to Mary's unflattering and pathetic portrait of England's great admiral. "He looks very old, has lost his upper teeth, sees ill of one eye, and has a film coming over both of them."

During the dinner at Lord Hamilton's, Lady Hamilton informed Mary that Maria Carolina, the queen of Naples (daughter of Empress Maria Theresa and sister of Marie Antoinette), was so eager to meet Lady Elgin that she didn't care what state of dress Mary was in. The queen wanted to meet her that very evening, and since Mary "did not chuse to spend all my time with Lady H," she was happy to oblige. The evening was pleasant, they "were the only people there," and the queen "flattered us beyond all credibility" and "made such thorough dupes of as Lady Hamilton, Sir William, and Lord Nelson."

Emma Hamilton did not like female competition, and she waged a battle of the beauties that provoked Mary's pen. Included in the grand gala day as a special guest of the queen, Mary wrote to her family that she dressed herself "in my blue and silver gown to which I have added my silver hops, all my diamonds, and at a quarter past 7, away we dash to a ball." Her illustration of the day's events reveals Lady Hamilton's very naughty behavior. It started pleasantly enough: "The moment the Queen saw us land, she sent Sir William Hamilton to hand me up to the private stand. This was a very particular mark of favor for all the Neapolitan Grandees were left below."

Lady H. Told me the evening before, that she should go quite in a common morning dress and that nobody would think of dressing till afterwards, instead of which when I arrived I found her in a fine gold and coloured silk worked gown and diamonds; the Queen and Princesses in fine dresses with pearls and diamonds. I apologized to

the Queen, who would not allow me to speak of it, and brought the King up to me, to insist upon it that I would not think of going home and changing my dress for the ball. However, that I was most determined upon. I find it is a constant trick of Lady H. To make everybody she can, go undressed. . . . I am told the Queen laughs very much at her to all her Neapolitans, but says her influence with Lord N. Makes it worth her while making up to her.

The festivities more than made up for Mary's irritation. "I never in England saw so fine a shew as the supper, it was out in a garden and everything completely Chinese . . . they say the fete cost £6000; the whole garden lit with colored lamps, one of the avenues I dare say at least a mile long, quite full of lamps, it really outdid the Arabian Nights." She wanted to share it all with her mother. "How I longed for you," she declared.

In Mary's fifth letter home, dated October 6, 1799, from Palermo, she apologized for the haste with which she wrote the last note; she had wanted to be sure that it went out "by the first conveyance." Wise beyond her years, Mary understood that great men do small things, and she suspected that Lord Nelson might open her mail. She worried that although he was adored in Palermo—and admired around the world— should he open her letter, he would learn that Mary, Countess of Elgin, remained unimpressed.

Chapter 5

LETTERS:
A LIFELINE

Before Mary and Elgin embarked for Constantinople, Mary consulted the letters of another British lady who, some ninety years before when her husband served as England's ambassador to Turkey, had written the illuminating *Turkish Embassy Letters*. Lady Mary Wortley Montagu's letters, written to friends and family, were published posthumously in 1763 and provided entertaining preparation for the young Lady Elgin. Montagu was much older than Mary when she lived in Constantinople and traveled by land to get there. She was also in constant fear and believed that she was going to die during the entire trip. In contrast to Lady Wortley Montagu, Mary was more excited about her adventure, both as a tourist and as a new wife, and was eager to please her bridegroom. Both women actually did face mortal danger in undertaking the voyage—but in Mary's case the constant threat from Napoleon's forces significantly added to the intrigue.

Both ladies have left a legacy of letters that provide a glimpse into each woman's personality as well as a rare look into the world of the Ottoman Empire from the vantage point of the ambassador's wife. Each woman most definitely understood the importance of her correspondence not only as a revelatory instrument of the self, but also as an important tool of communicating historical events for posterity. Lady

Elgin experienced firsthand exposure to the exotic world that Lady Montagu only dreamed about. In her letters, Lady Wortley Montagu imagined what life in a harem might be like, while Lady Elgin would actually visit the harem and witness its rituals firsthand.

In the eighteenth century, letter writing was an art with its own set of accepted rules. Entire families would read the letter. The letter would be passed to friends in order to relay news. Any personal information would be written on a separate insert to be removed by its intended party for no one else's eyes. Writers had to reveal their personalities, entertain, display intelligence, and offer information to create well-written letters. A person was not considered well reared if she couldn't write a letter with skill. This was a requirement especially important to young ladies because it was often the woman's role to communicate for the family—as the husband would be preoccupied with business. Mary knew that her job was to inform and entertain and often apologized in advance for "haste" or "a dismal ditty." She was consummately aware of others judging her, and she revealed a great deal of self-consciousness with remarks like "I am going to write down a description of everything exactly as it happened," "But I have left out the prettiest part of my story," and "But I am entering too much into particulars and then my little book will lose its charm." She marked "Private" on some letters and warned her mother-in-law,

> Now my Dear Lady Elgin *this Journal* is totally for yourself, for I asked E. before I sat down whether he thought if I wrote You a long History you would shew it: & assured me positively you would *not*— I can scribble very comfortably to you & not mind what I say, but I cannot write when I think my Letters are to be seen and criticized.

Her fifteenth letter home included the advisory "This is a family letter. It is nonsense writing tautology and I have said all I could think

of." The Dowager Countess of Elgin, upon returning a group of Mary's letters to Mrs. Nisbet, complimented her daughter-in-law's skill.

> Dear Lady Elgin's Tour . . . a very charming performance . . . may be shewn anywhere—so neat & so concise a description I don't think I ever saw, & I have many well wrote Travels—My ever Dear Lady Glenorchy's Travels Thro Italy are very well wrote, and I havae a very well wrote account of Italy & Swiserland by a once Dear Friend also—I mean Lady Morton—who writes well. But they are none of them equal to Our Dear Daughters—a sort of clearness & Simplicity & chearfullness that is through all her writings.

Mary carefully numbered her letters to each person for many reasons. First, mail delivery was erratic, and the numbers on the letters could indicate to the recipient the order in which they should be read. Second, the recipient would know when some mail had not been delivered and inform Mary of such; Mary, in turn, could then reiterate her news. Third, she could keep her own paper trail if she were accused of neglect and, in fact, could then go on the offensive when necessary. She paid methodical attention to detail and on one occasion chided her mother-in-law for inattention: "I keep a book in which I put down the letters I send and receive."

Mary's talent for satire makes for very humorous reading. Two days after arriving in Lisbon, she casually wrote that nothing really exciting had happened, then continued, "Bye the bye, I forgot to tell you . . . that we have had an earthquake the night before last. It was the most violent one they have had for these three years past." She often used the "afterthought" technique to deflate the dramatic; or she might write melodramatically about something very insignificant that she knew would amuse the Grosvenor Square assemblies like "Defend me from an Ambassador!" When her "choakings" (asthma) plagued her along the journey,

Elgin sent for a doctor who came some nineteen miles to see her. This was a serious asthma attack necessitating the attendance *not* by one of those foreign doctors, but by a man who knew her "People." He had even been to Archerfield and would not accept money for his troubles, and when she complained of a pain in her thumb, he reassured her that another patient had suffered similarly. "I was disappointed, for I really flattered myself mine was at least original."

On September 20, after having left Portugal for Gibraltar, she described a wild chase and skirmish with a gunboat, a life-threatening escapade that would have frightened most people. Recounting the intolerable heat, their exchange of fire, and their extraordinary escape, she dryly concluded, "I can assure you I have gained a wonderful character."

The Countess of Elgin's concern about her mail was not the result of paranoia or her heightened emotional state. Her suspicions were right on target. Many of her letters were opened, stolen, or perused by people seeking the kind of information that might further their careers, injure the career of another, or reveal some secrets of government or war. In one case, she commented on Lord Nelson desiring a peek; on another occasion, she even mentioned the unreliability of Sir William Hamilton: "perhaps the old Body has lost them." On March 24, 1800, from Constantinople, she actually accused him of tampering with her mail: "I daresay that my letters from Palermo and Messina, were opened by Sir William Hamilton, and I am sure he would not send them if he took a peep."

As if her own countrymen's curiosity wasn't enough, there was a greater danger that enemy spies would intercept her letters, or that her letters would not arrive at all owing to other difficulties. Mail delivery would certainly have been interrupted in wartime. Friends would often carry letters with them on journeys to assure their safe arrival. Mail itself, the lifeline for the young wife of the diplomat, caused an emotional roller coaster.[1]

In her tenth letter home, written from Constantinople, Mary

lamented, "I trust my letters to you have arrived safer than yours to me, for I know how wretched it is to lose any."

Her letters and the newspapers, the *Herald* and the *Sun,* which all arrived willy-nilly, were her lifeline to home, and she was ecstatic whenever she received them:

> Monday Night, Nov. 25th—My very dearest Mother, what Joy! Just as I was getting into my chair to go to the *Phaeton*'s boat, Smith came running with a large packet from Vienna, and I got my own Mother's No. 6. How happy it made me. I have got a letter from Bluey, and a nice one from Suzanne and Lady Elcho. Will you write 3 lines to Susan for me to say I have received both her letters? They still say I shall get your first Nos. 1–4 by Italy.

In January, she wrote:

> As I shall only have time to write one letter, of course I shall direct it to my Mam, tho' I hope she will not receive it. I am quite in the dumps, for two mails are arrived without any letters, excepting one, that I got from the General, at Windsor, 24th of November. The last mail has not even brought newspapers. It is indeed sadly vexing to have one's letters lost, particularly at this moment when I am so exceeding anxious to know whether you have left England.

In March, Mary wrote:

> The last post made me very happy indeed, for I got your Nos. 11, 12, & 13, Lady Robert's No. 1, and Bluey's No. 2—one from Lady Elgin, one from Mag, and two from Caro—only think what a treat.

The mail also became a cause of tension between Mary and her parents on a few occasions. Once, her mother criticized her for not being

original—a breach of etiquette—and Mary defended herself. Because of the constant possibility that the mail would be discarded or stolen, Mary sent multiple letters to different places, which contained the same information, in order to disperse as much information as she could. She wrote to those who adored her, worried about her safety, and would be very surprised if she suddenly became grandiose.

> I think you do me very ill, suspecting me of copying my letters. I write EVERYTHING to you and Grosvenor Square, so of course I extract the Quintessence of my stories for my other friends; I think that very fair.
>
> I, to be sure, wrote 5 letters very like one another; but I sent one to Russia, another to Palermo, the third to Holland, the fourth to England, and the fifth to Scotland; now how could I suppose they would ever meet? I cannot write you the particulars, as this letter goes by the German Post; and I think it will very probably be opened.

Another time, she defended Elgin when he and Mr. Nisbet had had a tiff over mail that had not been franked. As a man of privilege, William Nisbet could well afford to pay the necessary postage for packets sent to Britain, but apparently he did not offer his new son-in-law that privilege and economy, so the Elgins' letters arrived "C.O.D.," causing them embarrassment:

> I must now vindicate my Eggy's brains that you accuse so unjustly. For be it known unto you, that from Portsmouth he enclosed the heavy letter for my Father, to Frere—and desired him to frank it, which I find he did not do. Indeed I have now quite quarreled with Frere, for I suspect he has never franked my letters, and I have sent packets of nonsense to people that I should be very sorry had to pay for them.

The franked mail, a small financial matter, became a tiny symbol for a very big issue growing between the men. Mr. Nisbet, a trustee of Elgin's affairs, was constantly irritated by his son-in-law's spending. Mary was often placed in the middle and forced to wheedle money out of her parents. She often used the excuse that her husband was doing his duty for the Crown. When Elgin hired Lusieri, a foreigner, to accompany them on the journey to Constantinople, she argued that Elgin had made a sound investment on behalf of their museums: "I never in my life saw anything so beautiful as his drawings. My Father would be delighted with them—so very superior to any we saw in London." That comment was a dig at the British painter Turner, who had turned down the offer to be artist-in-residence in the East. (Elgin didn't offer him enough money, and the fee also covered art lessons for Lady Elgin, a prospect that the artist found insulting.) Mary parroted her husband's contention that since Lusieri was Italian, he would be more familiar with the classical world. They hoped that Mr. Nisbet would be satisfied with that theory. When all else failed, they reported how much cheaper the Italian was to get than any English painter. She lovingly flattered her father by comparing him with the other great men she met along their journey, and, of course, they never measured up. On one occasion, Elgin and his men shot partridges but missed all the birds. "I told them how differently I should have been treated had my Dad been there!"

Mary often hid her homesickness behind false frivolity. Under the strain of her pregnancy and great discomfort, she, first and foremost, tried to keep her parents from worrying about her and worked at cheerfulness. She was gay and breezy when describing dinner parties and the latest fashions; however, she reported important political events with the unflinching accuracy of a seasoned journalist. As an eyewitness to a skirmish between the Russian and Sicilian navies, she noted, "Sir William tells me that ever since he has lived in Italy, upon quite

a moderate computation there are never less than 4000 people killed privately by the stiletto every year."

How heartbreaking that she dreamt of the day she would return to Broomhall, for she had just left Scotland and her journey was only beginning:

> We dined at Mrs. Lock's to-day, and I have discovered Mrs. L. is not the affected Miss O. but her sister. . . . Now Mother, listen with attention to what I am going to say and write me an immediate answer because it is of consequence. I must begin, that silk here is as cheap as dirt!—Do you remember the blue silk chairs I shewed you at Broomhall? Now give me your opinion and lose no time about it, for I cannot settle without you. Do you not think it would be extremely handsome to hang the walls with blue silk, the same pattern with a gold border round it, both for the drawingroom and breakfast room?

After Palermo, the Elgins were feted in Messina. At one endless dinner party at the home of Italian nobleman Il Principo di Crito, a very bored Mary thought about home and wrote a letter. After the tiresome event, she dutifully sent home, wrapped in the letter, the prince's calling card.

> It was such a long business, dish after dish, walking round the table. . . . Only think of sitting whilst 26 dishes go round and everybody eats; it is beyond conception the quantity they consume, and the immense quantity of wine the ladies drink. I eat of a dozen dishes I believe, and yet they made such a splutter about my not eating, that Elgin had to apologize on account of my bad cold. . . . Oh how your poor Mary wished for her bit of Archerfield mutton.

In her sixth letter home, written on October 17 from Messina, she reminded her parents of their promise to join her in Turkey:

in spite of Elgin's kindness and affection for me, when we are sitting alone, we begin talking of Archerfield and we figure to ourselves what you are all about. Oh, pray, my dear Mother, come to us soon, and then everything will be comfortable.

Often disgusted by the gluttony of society both in Italy and the Middle East, she never displayed her dissatisfaction in public and earned a reputation as a charming guest; and for that, she sweetly thanked her mother for instilling in her good manners. Although she found decadence fascinating to report on, she would remain the good, simple (albeit rich), Christian Scottish lass they all knew and loved. Even halfway round the world, she consulted her group of important women on everything concerning small and great things. She longed for their approval and affection and got her strength from their loving notes from home. No whining for Mary. For no Scottish girl would be any less than brave; but to her mother, the closest person to her heart, she revealed her innermost sadness:

Mother, you know this is a private letter so I may acknowledge my faults; sometimes when I have to sit down to my bad breakfasts without cream, butter, or bread that I could eat, I have actually felt the tears get someway or another down my cheeks and then my poor Eggy looks so miserable.

After letting down her guard, she cheered herself up by enclosing a note Elgin tossed off to her father of "very bad stories" (smutty jokes).

One pleasant night, she attended the opera with the Marchesa di Palermo and her husband, who had gained Mary's favor by telling her how "uncommonly handsome" Lord Elgin was. Pleasantries dispensed with, she repeated her "query about which I am exceedingly anxious . . . do you think the hanging the drawingroom with blue silk (like the

chairs) with a broad gold border round it, would be prettier than paper?" Mary clearly was mentally focusing on returning to Scotland.

The Elgins boarded the *Phaeton* once again on Saturday, October 19. Eleven days later, on October 30, Mary wrote about their rough days at sea and once again she felt "all but dead!" Quite disgruntled at this point, she complained:

> we are now lying at anchor off Tenedos as it is impossible to get up the Dardanels, and here we may remain this month. . . . I have done nothing since I left England but tell you of my disappointments; now I shall croak more than ever, for all places the Archiipelago least answers the descriptions given it. There are plenty of islands, but Mytilene is the only one that had any green trees on it, all the others look a dismal brown burnt up desert.

On Tenedos, Mary tasted the two wines for which the island is known and received a gift of this lovely wine, and sheep. This animal was beautiful. "I wish you had it at Archerfield." The women wore their "nails painted a deep red."

As the winds were not favorable for their journey on to Constantinople, Elgin and his party went off to visit what Mary mistakenly called Troy, some twelve miles from shore. "They are to ride there so I had prudence enough to remain here, I hope you give me credit . . . I don't expect they will see anything." The next day she corrected herself, reporting what stories the gentlemen brought back from "Troas," which apparently included a visit to "an immense quantity of ruins. . . . Some people have mistaken this for Troy." (She poked fun at her own gaffe.)

At last, the *Phaeton* was ready to enter the straits of the Dardanelles, and they were "now alongside of the Captain Pasha's ship. . . . He sent his head man here early this morning to say he was coming to pay his respects to our Excellencys; we saluted him, 19 Guns, and then Elgin

went with Isaac Bay [a prince], the Pasha's Great Man." The Captain Pasha, named Hassan Bey, was called "the Sultan's brother-in-law" out of respect but was really a cousin. He was, however, the most powerful military man in the country and would in fact be brother-in-law to a subsequent sultan who reigned after Selim's assassination.[2] The Captain Pasha's sister, Hanum, was a favorite at the Seraglio, and that cemented the Captain Pasha's status and access to the Grand Seigneur and his mother, the Valida Sultana.

Although Mary personally reviled gluttony, a major sin, she had no problem observing her neighbors enjoy their excess. Throughout her time in the East, Mary described the hypnotic interiors, clothes, and jewels of Turkey's upper classes. She, in turn, made her own impression on them from the moment of her first foray into their Byzantine society.

Only half an hour after Elgin left, Isaac returned with golden stuffed cushions for her. Instead of remaining quietly in her place, Mary issued the first of what was to become many novel requests for this part of the world, where women were sequestered and veiled. She asked Isaac to take her on board the pasha's ship to join the men. Dr. William Wittman, a physician assigned to the British military legation, noted this extraordinary moment in his own memoirs: "His Excellency, together with Lady Elgin . . . accepted of the Captain Pacha's invitation to partake of a Turkish supper."[3] Wittman, not invited to attend, was left aboard his own sailing vessel as the *Phaeton*'s VIPs went on board the *Selim III*. Mary wrote her mother the details of the ship's inner sanctum.

Well, but now hear my story. . . . I dressed myself smart, and away in this fine Turkish boat did I sally (I took Masterman with me). On coming to the Selim, I found the best accommodation ladder I ever met with; Isaac handed me up; on deck I found all the troops drawn out for the Ambassadress Poll, as somebody dares to call me; they presented their arms and play'd English music—fifes and drums. At

the door of the cabin the Pasha and Elgin came to meet me, but all possible description must fall short of the magnificence of his cabin, beautiful embroidered sophas, made of yellow silk richly worked over with gold, guns, pistols, and swords and other arms embossed with gold . . . how I longed to have had you with me . . . I said I wished extremely to see the ship . . . [the pasha] took us all over it. . . . He made them exercise the guns, which part of the performance I resign all knowledge of . . . 1200 men on board. . . . After we had seen everything, he conducted us to his cabin again and in came coffee in beautiful Dresden china, excellent coffee and fine sugar for me, one attendant brought a large silver tray with a dozen diamond cups—(like what we have) only all rose diamonds. . . . During the whole time I can assure you the conversation was very lively and pleasant; he kept beging we would not go, and at last said that if I had no objection to return to his ship again and dine and sup with him, it would be doing the greatest favor in the world. . . . Isaac said he would make the cook dress some French dishes, and that every thing should be done to make it as comfortable as possible, and that we should have wine. . . . I was annoy'd I could not get at my gold muslin, but there being no help for that, I contented myself with putting on my diamond cross letting it hang on the outside of my handkerchief. . . . I must not forget to tell you the Shaw [pasha] saluted us with 19 Guns.

In contrast to the boring time she had among the grandees in Italy, Mary was infinitely more entertained and interested in learning about the customs of these people, so different from Europeans. She described dinner on the pasha's yacht:

table and chairs set with a nice table cloth, knives and forks, wine on the table and glasses, and the most beautiful set of Dresden for dinner and desert I ever beheld; all this was compliment, for he told

me they allways eat with their fingers. . . . I was in a sad hobble for I could hardly swallow anything, everything was so oiley; one dish was small mouthfuls of meat with strong butter and onions, there were not many dishes, but they seemed quite distressed at my not eating more.

Although she hated the cuisine, she was dazzled by the yacht's opulence:

We were shewed all the pretty things in the cabin, which really surpass everything in magnificence—the sophas of beautiful coloured damask, with cushions embroidered with gold. He had two Japan cabinets and the most elegant candlesticks, and two large glass bowls with gold fish. He then shewed his arms, and such a sword as he wore himself I fancy was never seen. Isaac . . . spoke to the Capt. Pasha who got up and went to a cabinet which he opened, took out a pretty gold enamelled box which he filled with perfumes and which he brought and presented to me. We sat a little longer, and when we took our leave, the Pasha said I had not enough on, as it was cold; he sent for a new Indian shawl . . . a red colour richly embroidered, very ugly but very valuable; they cost a great deal of money and are difficult to get. You would have been delighted at his manner of giving me these things, it was not like giving presents, but as the conversation turned upon perfumes and cold, he produced these different things.

This was just the beginning. Wherever the Elgins went, they received fabulous tribute. At Sigeum, Elgin was given the cherished boustrophedon inscription that even Louis XVI had failed to secure. Told by natives that the inscription contained magical healing powers, visitors would rub the piece, and therefore, the inscription was half-obliterated. There was an instant murmur of "curse," which Elgin dismissed as nonsense, and he left the island thrilled. Dr. Wittman

accompanied British officers to pay their respects to the sultan's local vassal, given the honored title of "bey." His name was Adam Oglu, and in the name of the sultan, the bey provided the English party with horses to gather the "celebrated Sigaeum inscription" and "a very curious bas-relief." The bey was made aware that Lord Elgin "was desirous to transmit them to England," and he was instructed to extend any kind of hospitality under his power to the ambassador and his bride.

Mary had certainly been an indulged young lady, but she was both astonished and amused at her sudden goddesslike status, and she received extravagant gifts from new acquaintances and strangers alike. Before leaving, the pasha sent an additional gift of six oxen and twenty-five sheep for the ship (they could not take the oxen because of their weight) and more beautiful presents for Mary. Mary joked about all the fanfare: "We saluted the Pashaw 19 guns which he returned. The salutations were most incessant; I own I was tired of them."

Never tired of adventure, however, she had spent the day before on a journey to what she thought was the site of ancient Troy:

> We rode ten miles across the plain, saw camels grazing, and arrived at a romantic spot where they shewed us the ruins of the outside walls. And compleat ruins it is, for there are not two stones left one upon another . . . think of my riding 22 miles on a Turkish saddle. . . . We did not get back to the ship till 9 o'clock, and never was I so hungry, for we had not a bit of anything to eat from 12 till past 9 at night, and we had a bad passage in the boat from the shore to the ship.

Pregnant and truly not fit for that kind of strenuous travel, Mary was trying hard to be a good sport and an exemplary wife, joining in her husband's pursuits. She admitted to a little crankiness: "I only permit Dad, Lady Robert, Rex, Bluey, and Mag to hear my descriptions,

because they will judge with mercy." She had sat, strained, and starved to visit a pile of dirt.

> I have just read over this long letter and really I feel the greatest inclination to pop it in the fire, the descriptions are so miserable; tho' I endeavoured to write plain matters of fact, yet they fall so far short of my wish that I am perfectly disgusted with what I have said. Yet I should not feel contented were I not to send you an account of all I see, but you can make nothing of it I am sure. All the descriptions in books of the different places I have been at, are completely unlike what I have found the places.

Understandably, the combination of discomfort and disappointment caused her ill humor. Her mood, however, would change when, on November 6, over two months after having left England, the *Phaeton* finally arrived in Constantinople, and she was carried ashore in a gilded chair.

Chapter 6

CONSTANTINOPLE: "AMBASSADRESS POLL" MAKES WAVES

The entrance to this place is certainly the finest and most beautiful view in the world, it surpasses all my expectation.

—MARY, IN A LETTER TO HER MOTHER

In 1799, about 100,000 people lived in Edinburgh, and about 860,000 people lived in London. Constantinople, which boasted a population of nearly 600,000 people, was, as the nexus of a great empire, a magnet that often drew its citizens from all over its vast territories. It was likely that you would hear Greek, Hebrew, Italian, German, Russian, and other Slavic languages spoken on the streets, in its cafés, in its places of worship and of business. In Europe, the commonly accepted language of diplomacy was French, but the Ottomans, suspicious of the West, would prepare documents for foreigners in Italian because Venice was, for centuries, under Ottoman control. As there had been very few dealings with the English, very little English was used, except by the Italians who served the sultan as translators.

From the moment Mary was carried up the heights of Pera to her new home, she was the object of intense scrutiny. The British, having had a hot and cold relationship with the Porte in the past, had never

invested in a palace, preferring to lease a residence for emissaries and for commercial representatives sent to the area by the Levant Company, England's trading enterprise in the eastern Mediterranean. The French, to the contrary, had great confidence in their strong political ties to the Ottomans and assembled an imposing presence in Constantinople. For the first time, however, a British ambassador and his wife would not live in a rented British embassy. Instead, Lord and Lady Elgin were hoisted up the cypress-covered mountain to the stunning French Embassy palace on La Grand' Rue,[1] which was, for all intents and purposes, embassy row. Shortly before their arrival, the French, thanks to Napoleon, had been forcibly evicted from their own palace and were now residing as guests of the sultan in the Yedikule prison. The infamously terrifying Yedikule prison, whose dungeons included the "well of blood" where decapitated heads were thrown, made even the bravest men shudder. For hundreds of years, tales had been told of the unimaginably barbarous acts that had transpired within the fortress. Although Elgin, immediately upon his arrival, pressed for the release and humane treatment of the French diplomats,[2] the French, for reasons of their own, preferred to blame him for the imprisonment of their ambassador and staff. This was a controversial beginning for the young couple. The spectacular setting of the home itself—with views of the mysterious Seraglio, the Golden Horn, and the Bosporus, which separates Europe from Asia—and, as Mary noted, its location in the Sublime Porte, gave the impression of power; and after all, the palaces along La Grand' Rue, official residences of the ambassadors from Venice, Sweden, and Russia for almost three hundred years, were built to impress and intimidate friends and enemies alike.

Mary marveled at her husband's enthusiasm for his work, and he assumed his responsibilities with a natural authority. Although the streets of Constantinople were teeming with unsavory characters and rogues, Elgin was unafraid to go about without bodyguards. Mary

wrote about one particular evening, a few weeks after their arrival, when Elgin went out at midnight to watch an enormous fire. He climbed into a little boat, and as the flames penetrated the darkness, he observed pigeons flying through the smoke. He was so affected by the scene he didn't realize that it was raining. Mary adored that romantic side of her husband.

She, however, focused on the practical: new wallpaper, furnishings, and the management of the embassy, including the care and feeding of some sixty in residence. Interior design and hotel management skills were no challenge for the young lady who would own at least five castles. She liked and kept the canopy and some of the gilt chairs but found the place uncomfortable. She fully understood that the embassy was about public space and entertaining.

> I have fixed Thursday as my public Evenings. . . . The Russian Minister's Wife is a very pleasant woman, I like her much the best; there are several other people whom I admit of an Evening to play at Whist, the door of the room which I set in opens into my Dressing room, so when E. has any business, or when he has any body he wishes to speak to, he takes them in there whilst I have my party.

Dr. Wittman reported on the Elgins' outstanding hospitality and recorded a number of balls, dinners, and public nights that he enjoyed in the company of Lord and Lady Elgin. Despite his account of the Elgins' kind treatment of all British citizens, Elgin's own retinue had nearly mutinied the minute they got to Turkey, most of them complaining that they wanted to return to England. Mary worked at smoothing things over with the staff and wrote that the only one behaving civilly was Hunt; although she thought his sermons weak, she forgave him because of his fine behavior. Mary herself, however, behaved with grace

despite her irritation with these men whom she thought whiny. "I have taken a good deal of pain to make every Body as comfortable as possible & I assure you every one of them have since thanked me . . . I have fixed a public Breakfast Room for *the Gentlemen* & Breakfast *on the Table* at 9 O'Clock, E & I enjoy our *private* breakfast."

Mary loved her private time with Elgin, confessing to his mother that "he never looked more captivating." She also worked at getting apartments ready for her parents and her baby, both expected in the spring. Like any new bride, she worried about her husband's diet, studied fabric swatches, and awaited the impending birth of her first child; but this newlywed had to give state dinners for hundreds almost the minute she arrived in town. She immediately got the message that there would have to be two Marys: the private, homesick girl and Ambassadress Poll, "as somebody dares to call me."

In the five short days since her arrival, she had sent home two letters lamenting her separation from her parents. "Oh Mam, that this letter may find you in London preparing for your journey—that is all I care about. Bring me all the pretty little new tunes you can find—and do come soon, dear dear Mother." As Ambassadress Poll, she had returned home at "2 O'clock in the morning, this letter will be short. . . . Love your Daughter dear Mother, and believe that she loves you and Dad with all her heart. Your own, M. Elgin."

Completely aware that whatever she did would be talked about, she immediately decided to play by her own rules. Mary Nisbet Bruce, brand-new Countess of Elgin, accomplished in two weeks what Napoleon, up to that time, could not: she was victorious in Asia Minor. A mere eleven days after their arrival, Mary wrote home that Elgin was going to be introduced to the Grand Vizier, and that on Thursday evening she was to give a supper and ball and, though very pregnant, she would undertake all that was expected of her. She acknowledged that she would probably be exhausted, begged for their arrival ("I wish you

could persuade Bluey to come with you . . . I shall soon have the rooms very comfortable"), and revealed her outrageous secret plan:

> I must go to bed because I am to be up early tomorrow morning to go to the Grand Vizier, Elgin has put me down in the List, Lord Bruce, a young nobleman. We sent a private message to the Vizier, by way of asking whether I might go. The dear creature sent back a most gallant answer, so, as he knows who I am, and as I am high up in the procession, I think I have a chance of a nice pelisse.[3]

Due to inclement weather, the ceremony and, therefore, her own party were to be postponed to Saturday. She dryly noted that, of course, the food would all be spoiled and that she would be eating chicken for lunch. The audience with the sultan was changed from Sunday to the following Tuesday, November 26, after which she would host another supper and ball. She joked that as she was offering dinner, and not merely dancing, she received an overwhelming and immediately positive response from the community. On Sunday, between their own exciting parties and court ceremonies, they were scheduled to attend a ball at the Russian Embassy in the evening. This very pregnant woman had very little time to rest.

On Saturday morning, a carriage belonging to Hanum, the pasha's sister, arrived to transport Mary to the court. The episode of Mary, five months pregnant, dressed as "Lord Bruce" (with her maid in tow dressed as her twin), who made her appearance at the Turkish court with the consent of the dragoman of the Porte (the court translator), the Captain Pasha, the Grand Vizier Yusuf Ziyauddin, and her husband, was unprecedented and immediately historic. Mary's adventure truly brought about one of the funniest—and groundbreaking— conspiracies in international diplomacy. No lady—much less her maid—had ever before been permitted to attend any political ceremonies at the court of the Ottomans, but Mary would not be treated as

an unequal. She sweetly but firmly demanded to observe her husband's presentation and induction as ambassador. "I had sent a private message to ask whether I might go, I knew I should not be refused!" but she coyly blamed her boldness on Elgin's sense of mischief—his "wickedness," as she wrote to her mother-in-law. Mary expected to be a spectator and thought she might end up with a trinket or two, but nearly fainted when she was summoned to participate in the ceremony.

With a twinkle in his eye, the usually terrifying Grand Vizier melted. He not only acknowledged "Lord Bruce" but apparently thought her lovely and favored him/her with special honors and presents. In fact, he was so amused by and smitten with the plucky young ambassadress that he spoke directly to Elgin, asking him if he had a daughter.

I dressed myself in my riding habit, and my great coat with epaulets over it, my little round beaver hat with a cockade, and black stock. (Masterman was the same.) I went in a chair down to the water . . . and got into a Turkish boat. On the opposite side, the Great Man had even sent one of his Sultana's carriages to carry me to the audience, so I had no riding or any one uncomfortable thing. I was shewn into the room where the Dragoman of the Porte was; he knew me. However I was introduced as *Lord Bruce,* and was regaled with coffee and sweetmeats. I sat there a long time before the procession arrived, and was exceedingly entertained. An innumberable number of people in beautiful dresses, and seeing the entrance of the procession into the Court was a very fine shew indeed. . . . The Caimacam had ordered every respect to be shewed me, and excepting first the rush into the audience room, owing to the immense number of people, I was perfectly comfortable. They placed me exactly behind Elgin's chair, so I saw everything. Oh, Mam, how my heart beat when he made his speech, tho' there was nobody but Smith and me who could understand a word he said . . . before the speech he and the Great

Man drank coffee, eat a spoonful of sweetmeat and then were perfumed. Then came the speech, and the delivery of the credentials.

The Caimacam got up, and went to meet the Grand Seigneur's letter, then all the Turks set up a dreadful yell, which I confess made me feel queer, till they told me it was only a prayer for the Grand Seigneur. You never saw so magnificent a pelisse as they adorned Elgin with—then Smith got one, and then *Lord Bruce* was called for. I find it was not a bad thing my asking the Great Man's leave to go, for he had a fine pelisse made on purpose for me, beautiful sable. I thought I should have droped with the weight and heat of it. What do you think was one of the questions he asked Elgin? Whether he had any daughters? When the audience was over, I went back into the dragoman's room, where I saw the whole of the procession, and a beautiful horse with magnificent gold embroidered furniture, which the Caimacam made E. a present of. I then got into my coach which was exactly a gold wagon, no seats, only a carpet and four little looking glasses in it, and arrived at my palace perfectly unmolested.

Constantinople was in a state of titillation. Everyone wanted to know this young woman, so adored by her husband that he threw tradition to the wind for her, and so immediately esteemed by the Grand Vizier that he indulged himself with a shockingly close look at this young beauty. Letters flew back to Europe about this thrilling new arrival, and this was just the beginning.

She cemented her notoriety when, at her own party that evening, she performed the Scottish reel to great applause. Bulging tummy and all, she danced until midnight and wryly joked, "I had had enough of them." Only a few days after her extraordinary firsthand glimpse of the court—Lady Wortley Montagu had only contemplated the palace—she broke the rules once again at the Russian Embassy. Mary, again, traveled in a gold chair; this time she was accompanied by a procession of Janissaries—the fiercest soldiers—four footmen, and a dragoman and

made her grand entrance to the palace, where she dined on magnificent china, drank from the most exquisite fine crystal, and

> I was of course asked to dance, but I immediately said I hoped they would excuse me as it was not the custom in England to dance of a Sunday, and therefore I neither danced or play'd at cards on Sunday. . . . Next Thursday, we dine at the Prussian, that is their last dancing day till January, they don't dance all Advent.

Although she and Elgin went to parties on Sundays in order not to offend anyone, she set a new tone at the British Embassy by banning card games and dancing on the Sabbath.

On Tuesday morning at five she got into her gold chair, escorted by Janissaries and "flambeaux," to board a boat at the waterside. At dawn she arrived at the Seraglio, the first Western woman ever to be invited inside its gates and see Topkapi (Cannonball) Palace. The Seraglio was a city unto itself with a maze of chapels, gardens, military barracks, slave quarters, and the legendary harem. The Elgins went through the Imperial Gate into the first court, through the Middle Gate and the Gate of Felicity to the third and fourth courts, and then into the sultan's private world. Countless images of dancing girls entertaining revelers in the sultan's Hall have been recorded by artists. Selim III, an extremely competent musician, liked to entertain his own audiences in the Hall by playing the *ney*, the small wooden flute of the dancing dervishes. The sad truth about the lack of male heirs caused the circumcision room at Topkapi to be used during Selim III's reign more frequently for conferences than religious ritual.

On this, their first visit, Lord Elgin dined with the Grand Vizier, and Mary with select dignitaries who recognized their guest as "Lord Bruce." After speeches and exchange of presents, they all finally withdrew to the sultan's apartments. His quarters included a magnificent

library and a music room with access through a tiny stairwell near his mother's quarters.

> His throne was like a good honest English bed, the counterpane on which the Monster sat was embroidered all over with immense large pearls. By him was an inkstand of one mass of large Diamonds, on his other side lay his saber studded all over with *thumping* Brilliants.
>
> In his turban he wore the famous Aigrette, his robe was of yellow satin with black sable, and in a window there were two turbans covered with diamonds. You can conceive nothing in the Arabian Nights equal to that room.

A poet and composer who wrote under the pseudonym Ilhami, "inspired," Selim consented to be painted in this same room on the same throne with similar accessories: the sword and the pens. He presented himself as the warrior-poet, the ruler of parallel empires, and his Xanadu was a complex city in itself—a pleasure dome where everything revolved around his own desires and commands.

The sultan's attendants "were dressed in India Stuffs of Gold embroidery & their Daggers covered with diamonds," Mary wrote the Dowager Lady Elgin. The satin on the throne was "embroidered all over with large pearls, over his head hung rows of immense Pearls to catch Flies." She reported that the sultan "looked at me which terrified me so dreadfully that I was obliged to put my hand to my Head to feel whether it was on or off."

Mary's spectacular debut in Constantinople launched her into immediate stardom. Invitations poured in, and she discovered that she needed more clothes. After all, a living legend has to make a fashion statement. She was stylish, but the problem was her expanding figure.

> I want you to bring with you some gauze stockings for me to wear under my silk, and some flannel socks. I have been sadly disap-

pointed in the fine muslins I expected to have got here. . . . I have
sent to India for some fine. The people here admire the coloured
muslins amazingly, you can have no notion how much applause your
blue muslin has met with. I advise you to bring plenty of coloured
muslins with you, they will be more thought of than white, and then
when we go they will sell wonderfully.

Despite the fact that she was incredibly rich, to Mary's credit, she
was a practical girl who paid close attention to value. Since Elgin had
no money, the embassy expenses—including refurbishing, lavish sup-
per balls, and reciprocal gifts—came straight out of the Nisbets'
money, as did their own visiting quarters. Mary impressed upon her
mother, however, that she always kept her eye on the bottom line.
This countess understood a balance sheet. For every *quid* there was a
quo, and Mary showed uncommon thriftiness. Every token was
appraised, some sent home to be sold. "I think I did not tell you that
the shawl the Captain Pasha gave me is a 70 Guinea one. His Sultana
is 22 years old, and her fortune is £30,000 a year." The Captain
Pasha's sister, who became very fond of Mary, gave her two Turkish
dresses: "they are the finest it was possible to make, and cost above
£400." She previewed the bargains her parents might enjoy upon their
arrival: "If you wish for green sattin for your London drawingroom . . .
or if you want any sort of silk, bring the patterns with you, and you
will get it as cheap as dirt!" Most revealing, she was shopping for
Broomhall, anticipating a happy homecoming. She asked for silver
candles that, she noted pointedly, had already been paid for and "a box
like the one we saw at Maillerdets, with a bird poping out and
singing" for the sultana.

Mary reported on a level of extravagance and luxury that even the
richest land-owning Scots would find unimaginable. Extravagant hos-
pitality even extended to servants. At a time when a male house servant
in Scotland would receive about £6 a year, and women house servants

approximately £2, she marveled when on one occasion Elgin sent employees over to the sultan's palace to deliver a chandelier, and

> they were treated with dinner on a silver gilt table with a beautiful embroidered cloath laid under it, and embroidred napkins. They had 40 people to wait on them, and 50 dishes. Besides which, they gave Duff £72, Molwitz £21, the Butler £21, Andrew £16, and Thomas £16. I wish you had heard Andrew's adscription of it; he could hardly articulate for joy. I assure you he talked more of the civil treatment and magnificent dinner than even of the money . . . [the Grand Seigneur put the chandelier] in the Sultana's apartments. He talks of building a room on purpose for it.

Her popularity was an asset and an expensive liability in more ways than one. Mary complained that their cost of living was enormous. "We have sixty people to feed every day, independent of the company at our own table, that we have almost constantly. We shall go into the country as soon as I am able, and then I shall get rid of as many people as I can." The number of times Mary wrote "tonight we are having 60 for dinner," or "tonight we have 30 Hottentots," is inestimable, however for all of her busyness and gaiety, Mary's heart weighed with worry about friends and loved ones engaged in the wars, and she grew distressed with reports of riots, beheadings, and the fickle behavior of despots. Yesterday's favorite minister was today's hanging corpse. And although she longed to hear firsthand reports of British victories from her uncle, General Robert Manners, she mourned the loss of men who so recently, in her memory, were boys.

She was not a depressive personality, but for all of her constant activity and lively company, she was lonely. She was anxious that the Nisbets might change their minds and stay at home. "My whole thoughts are taken up with the hopes of getting you and Dad here,

every thing would then be comfortable . . . you will have a bedroom and dressingroom, and my Father a dressingroom next you." She nervously enticed them promising "famous Whist players here." She was also extremely anxious, although she tried to minimize it, about the imminent birth of her child in a foreign country where the medical care was different from what she had been used to in Edinburgh and London. Childbirth was certainly dangerous anywhere in the world in 1800, and Mary wanted her mother by her side. Thus she would continue to plead for the speedy arrival of the Nisbets, luring them with phrases like "by the time you arrive we shall have the finest weather in the world. I declare I don't say this to take you in, everybody says the same thing" and "let Duff have the arrangement and he will land you at Constanti without your knowing you have left England." She even dangled prizes, presents for them from the Captain Pasha who "says it is impossible you can resist such a daughter." When she thought she had exhausted all of her arsenal, she used the ultimate weapon: they would soon be grandparents.

Without her parents for the first time that Christmas, 1799, she was desperately lonely. Elgin was sick in bed and sent a servant to her room with a beautiful emerald on a tray. It cheered her up—but not much. She presented a merry face to the crowd she entertained on Boxing Day, but her heart was wherever her parents were. She handled the "30 Hottentots" all alone because Elgin was still indisposed, having had leeches placed on his face to cure a "head rheumatism." "MacLean says he never saw such leeches in his life, so very violent. They bite much more than any he ever saw in England." Vicious leeches, a number of serious fires, and rampant disease (bodies were carried away in the middle of the night so that the populace would not panic) provided the backdrop to the toppling Ottoman Empire, gnawed away at by Napoleon, the Russians, and others aspiring to control its waterways and natural resources. Mary, thrown into this blight, chose instead to

focus on simple pleasures—the infrequent, quiet dinners with her "Eggy," the arrival of the Nisbets, her unborn baby—and a plethora of packages delivered on a constant basis from the adoring Captain Pasha.

After the New Year, on January 23, 1800, she "packed up my little traveling bed, with Adieu Eggy, took a very pleasant woman interpreter, and my three maids, and away I went to the C.P." She details her extraordinary visit to the harem as the guest of the Captain Pasha and his sister Hanum, who had ordered two magnificent Turkish dresses made for Mary. Elgin arrived for dinner and did not recognize his wife dressed "*à la Turque*," which caused a riotous joke. The Captain Pasha and his sister did not want to let her go home, and she livened up the party even more when she sent for her pianoforte and they all danced Scottish reels. Elgin's favorite tune, Mary wryly noted, was "The Battle for Prague," a lively, pounding march that told the story of Frederick of Prussia's victory over Bohemia.

After her visit, the Captain Pasha broke all precedence and reciprocated, appearing at the Elgins, "a thing that was never before heard of." She wore one of her new Turkish dresses to receive him, and he was charmed, giving Mary "the most beautiful sapphire set round with diamonds . . . it is the finest I ever saw." The Captain Pasha made no secret of his devotion to Mary. When she was going to be a godmother at a wedding, the "C.P." sent the bride "a fine diamond sprig for the hair, good large diamonds, which he said he gave her out of compliment to me . . . my three maids got packets of Indian stuffs . . . he left £40 to be divided amongst our servants, is he not a fine Fellow? His sister has sent to beg I will go there, tomorrow." They simply couldn't get enough of her, and everyone else was furious. "The foreign Ministers are as envious as they can hang in their skins; I really don't care what they say. I wonder what they will do, when I go to visit his Sultana and to the Seraglio, to visit the Grand Seigneur's Mother which I am to do, and nobody ever did but me?"

She visited the Captain Pasha's home regularly and even played

cards with the men. She noticed every curious custom and reported back to Grosvenor Square that before she sat down to dinner a vast number of women waited with silver basins containing warm, perfumed water to wash her hands. Silver ewers poured this soft, fragrant, and luxurious liquid onto the guests' hands before they began to eat. Once seated, she observed that her hosts did not know how to eat with a knife and fork. The servants had placed Dresden china and silver knives and forks on the table for Mary, but the Turks "make only use of a horn spoon." They all ate meat, "which they tear in pieces with their fingers in the neatest manner possible. . . . They never put more than one dish on the table at a time. We had about 32." To her London audience, Mary was a real-life Scheherazade, offering them spellbinding details they would never experience firsthand.

She liked holding an audience captive and was quite content. She was married to the man she loved, she was about to become a mother, and she was the toast of two continents—literally, since Constantinople straddled both Europe and Asia. Her popularity, however, was beginning to cast an ominous shadow on her husband's career. She easily dismissed controversy as jealousy; but Elgin had real enemies—and these enemies could do serious damage to his own credibility and the survival of the British Empire.

The powerful Smith brothers—Captain (later Admiral) Sidney and Levant Company representative Spencer—were angry about the arrival of the newly appointed ambassador extraordinaire. As the English had little opportunity in the past for political advancement with the Turks, most of their dealings with the Turks had been in commerce. Spencer Smith, as the Levant Company's local figure, had been able to operate with great freedom in the region. Sir Sidney Smith, a naval renegade who often flouted authority, never liked the idea of having anyone to report to. Elgin's authority would be supreme, and both brothers resented the diminishment of their positions. They targeted Elgin and circumvented his authority at every turn, and for a while they were indulged despite

their brashness because they were cousins of both Prime Minister William Pitt (the Younger) and Lord Grenville, the foreign minister. Spencer, who had great experience with the Turks, even waged a campaign against Mary in order to hurt Elgin. He sent false stories home to London about Mary. Although Spencer Smith was godson to Mary's own grandmother—and in a sense "family"—this mobilized the Nisbets and Bruces, who had significant clout of their own, into action. They immediately closed ranks against both Smith brothers, vigorously defending in London the Elgins. Elgin's own letters home to Grenville responded to the Levant Company man's injurious innuendos; but it was clear that Spencer Smith wanted Elgin off his turf. He caused Elgin daily migraine headaches, and in March 1800, Mary wrote home that "all intimacy between Mr. Smith and Us is over."

Mary supplied anecdotes to her mother-in-law, knowing, once again, that these letters would be passed around at Court. Her intent was to make the point crystal clear: Spencer Smith was a petty trouble-maker. "You would laugh could you see Mr. Smith's behavior to me, he is so prodigiously civil & attentive, the fondest Lover could not be more so." At one party, Elgin amused the crowd, who knew of their split, when he walked around the room with his arm around Smith, enjoying his own joke. Mary reported that her husband was in "highest spirits" after that prank.

An astute hostess who had learned the Jane Austen maxim "Important things happen at parties" at her mother's knee, Mary knew that if you feed them they will come. Instead of hosting dances, she hosted suppers with dancing, and she fed her guests so lavishly that an invitation from Lady Elgin became the most coveted in town. She especially enjoyed planning masked balls. Europeans could purchase exotic silks and trimmings in Constantinople, and the evenings would be pure fantasy. She stopped inviting Spencer Smith, but apparently he couldn't stay away from these fabulous balls and so he came anyway, uninvited. Mary knew exactly what she was doing. If anyone at Court or in the

government had an ounce of respect for Smith before, they certainly would change their perception of him once word got back that he crashed the Elgins' parties.

> I never invite the Smiths, but they force themselves in uninvited; he has been here two or three public Evenings without Elgin's taking any notice of him, every body sees that, so I wonder at Smith's affronterie; He tries to make up to me & whatever I say to him *civil* or *uncivil* he yelps out a loud laugh, to endeavor to make people believe we are great friends.

Spencer was eventually recalled—to Elgin's relief—but he was really the more benign of the two brothers, for it was his brother, Sidney, who practically ruined Elgin's credibility with Selim and caused a near massacre of the British Navy.

Sir Sidney Smith attained folk hero status when in 1798 he escaped from the Temple Prison in Paris. Songs were written about him, jugs were fashioned with his portrait on them, and babies were named for him. A theatrical, flamboyant personality, Smith, aboard his ship, the *Tigre,* once again achieved fame when he vanquished the French at Acre, the Israeli port where intense fighting had taken place during the Crusades. Smith's victory, evoking the romantic lore of Richard the Lionhearted, stole Nelson's thunder, and Nelson didn't much care for him despite (because of) public opinion.

Like his brother, who had overstepped when he tried to negotiate trade tariffs fully knowing it was Elgin's job to do so, Sidney Smith took it upon himself to negotiate a peace treaty, believing he had the authority to do so. After Napoleon had abandoned his own troops to return to France in late 1799, he had left Alsatian general Jean-Baptiste Kléber in charge. Kléber and Sidney Smith signed, in January 1800, the Treaty of El Arish, allowing for the safe passage home of French troops from the Middle East. Although Elgin's emissary, Carlyle, was

on board Smith's *Tigre* during the negotiations, he was an academic and not a politician; therefore, Elgin had no role in the discussions, even though he was the senior representative in the region. Had he been a participant, he would have known how to avert a diplomatic crisis that almost destroyed the new alliance between Britain and the Sublime Porte.[4]

First, Smith's discussions were originally approved of, but the situation had changed in Europe, unbeknownst to him, and his original instructions became contrary to the British government's position. Second, he had opened discussions based on information that was planted into his hands and was entirely false. Smith believed that the French forces were about to collapse, and thought the French were no longer much of a threat. Because of this, his terms did not include complete French surrender. Selim, happy to have the French out of his territory without much cost, had no problem accepting the compact of El Arish. En route to Elgin, however, was the letter from Parliament with instructions that any truce must include complete French capitulation.

Having thus far enjoyed an excellent and convivial relationship with the Grand Vizier, the Captain Pasha, and the sultan, Elgin now had to face these men to explain this diplomatic mess. He had to explain to Selim that Sidney Smith did not have the authority to deal on behalf of the king. The Turks could not understand the English waffling and became nervous about Lord Elgin and their new ally. Selim, wanting the French out of Ottoman territory at any cost, made a counterproposal: allow the French to depart under false pretense and then capture them! Elgin would not agree to this underhanded plan, but it made its way back to French officials who accused Elgin of masterminding it. Rethinking their position, the British government did another about-face, ordering Elgin to go ahead and accept the terms Smith had negotiated. Elgin's credibility was now diminished, and his embassy was in jeopardy. The Turks, believing that peace was no longer at hand, sent some 50,000 troops to face the French; General Kléber, unaware of the

second British about-face, battled the Grand Vizier and his men with a vengeance. The Turks blamed the wavering, indecisive British; for fifteen months, the carnage was horrific.

All through these battles of nerves, Mary, Countess of Elgin, remained steady. She continued to perform her duties with unflagging cheer and charm. Lord Elgin learned that his original hunch was right: his wife had become a star. Mary, Countess of Elgin, became her husband's toughest, staunchest ally, indeed, his partner, and by doing so became his most competent and most powerful weapon. Instead of shutting their doors on the Elgins, which was what their enemies had hoped for, the Captain Pasha, the Grand Vizier, and the sultan extended even more frequent invitations to the Seraglio. Although they were enraged at the British government, this powerful troika had no intention of depriving themselves of the pleasure of Mary Elgin's company—and it was due to his special affection for Mary that the Captain Pasha formed a singular and special alliance with another member of the Elgin clan.

Chapter 7

MOTHERHOOD:
MARY'S NORTH STAR

*My most esteemed friend. As the friendship and intimacy sub-
sisting between us is altogether extraordinary, and not to be
in comparison with what is the case with others, . . . I sin-
cerely wish you may be blessed with the enjoyment of a long
life. . . . I beg you will make my compliments acceptable first
to our much respected friend My Lady—and then to the most
honoured Ambassador our friend.*

—CAPTAIN PASHA IN AUGUST 1800
TO FOUR-MONTH-OLD LORD BRUCE

The tenderness between "Eggy" and "Poll" grew into deep devotion
as the couple celebrated their first anniversary. He called her his
"little Dot" and was extremely proud of her. In one letter to her mother,
she told of this, claiming that she had comported herself well, with
great sang-froid despite her fear, earning her husband's admiration:

E is all amazement at my courage for he says I never take fright at
any thing, but on I go; the only time I really felt alarmed was at a vio-
lent skirmish that took place at the Seraglio when the Kaftans (a sort
of Pelisse) were distributed to the Servants & Greeks; a *Turkish riot* I

did not feel up to, & they pressed on me so dreadfully had E & some of the Gentlemen not caught hold of me & helped me up on a high stand behind E's chair, I should immediately have been suffocated: even then I was complimented on my good behavior, as I only turned pale & *said nothing*.

Each genuinely suffered for the other whenever the other was ill. She was particularly upset about Elgin's migraine headaches caused by stress, what she perceived to be his excessive intake of alcohol, and the ongoing use of leeches and mercury, which began to inflate and irritate his nose. Elgin, in turn, expressed true helplessness and heartache whenever Mary suffered her "choakings." When George Charles Constantine, Lord Bruce, was born at two-thirty in the morning on April 5, 1800, after an excruciatingly difficult delivery, Elgin wrote home to his mother that his "beloved Mary was safely delivered" and that "Mary suffered a good deal after the birth" and was given laudanum for days. He couldn't bear having his Mary in such pain. He marveled at the sight of them together only a few minutes after the boy's birth, "with her little boy, nicely dressed laying by her—Her look on the occasion, was a kind of thing I could not have conceived."

The new parents were ecstatic. Elgin described his son as "the finest" ever born. "There never was a finer fellow," he declared, and instructed his mother to tell everyone in London the news, providing her with a list of people she should tell. The original name for the baby, Charles, after Elgin's father, was changed after some discussion with Mary. The couple decided on George for the king, Charles for the previous Lord Elgin, and Constantine in honor of his birthplace. They were going to ask the king and queen to be godparents. Quite a few letters went off to his mother discussing the christening. As they were in a foreign country where no one was Protestant, what was her opinion on persons not in the Anglican Church standing in for the king and queen at the chris-

tening? Elgin consulted with Reverend Hunt, and his mother consulted with the bishop of London. All of the Elgin children would have both a christening very soon after birth and a baptism a few months later, two separate ceremonies wherein they were given names, anointed with holy water, and declared Christ's own.

A few weeks after the birth, Elgin assured his mother that Mary had forgotten her pain, "lost in delight of her little brat." His letters to his mother were usually dry, boring notes about her health, his health, and discussions about doctors. The Dowager Lady Elgin received uncharacteristically effusive letters filled with almost a tipsy giddiness, a joyful silliness, when Elgin wrote that his newborn son, Lord Bruce, was the center of everyone's attention.

> You cannot conceive the cares which children bring along with them—I have now had this boy above three weeks and what with the variety of opinions, all equally respectable, on the fashionable-ness of his frocks, caps—the deliberations on the colour of his shirts—little flatulences—the expence of washing 27 cloths a day, in short, You can have no idea of the worry I am kept in—The fellow himself seems to leave all to the Old Gentleman; & cares for noth-ing, but eating and sleeping.

Mary, despite Elgin's comments to the contrary, had not forgotten her pains and was terribly ill after the delivery; nonetheless she declared, "I am the happiest of Creatures." She had been extremely anxious at the time of Lord Bruce's birth because she had no idea where in the world her parents were. In a very frail condition and with no Mrs. Nisbet in sight to take charge of the "Bab's Bab," Mary hired an experienced Greek baby nurse—a *"paramanna"*—to look after little Bruce. Lord Bruce was but thirteen days old when Mary turned twenty-two and she wrote to her mother-in-law, clearly smitten with her son and his very romantic father:

By the bye I must not forget to tell You a very pretty galanterie of my Son's! on the 18th of April he came into my room with a little Note in his hand which he gave me, on opening it I found a beautiful Emerald Ring, & this written, "My Dear Mama, Pray accept this ring from your affectionate Bab.—A Green Stone, in a ring, is an Emblam, that my Hopes can have no end, as long as your hand supports me." (Signed) *Little Bab*

What do you say of your Grandson? Is he not a dashing little Fellow?

In the middle of May, Lord and Lady Elgin and their brand-new "young Turk" or "Kutchuk," as she delightedly called him, left Pera for the summer. (The term *kuçuk,* which actually means "little," was often used by Mary in a joking way to mean "bigwig.") The Elgins traveled to the Belgrade forest area, where they planned to summer at Büyük Déré, a resort about fifteen miles from Constantinople. Lady Wortley Montagu had summered there as well, comparing it to paradise in a letter dated June 17, 1717.

I am ... in the middle of a wood consisting chiefly of fruit trees, watered by a vast number of fountains famous for the excellence of their water, and divided into many shaded walks with short grass—the pure work of nature—within view of the Black Sea from which we perpetually enjoy the refreshment of cool breezes which make us insensible to the heat of summer. . . . The Village is only inhabited by the richest amongst the Christians, who meet every night at a fountain,—forty paces from my house—to sing and dance. The beauty and dress of the women exactly resemble the ideas of the ancient nymphs, as they are given us by the representations of the poets and painters.

Elgin began a romance with the caïque, a long, multioared sailing vessel that navigated the upper shores of the European side of the

Bosporus past the *yalis,* the seaside palaces, with ease. On the Asian side of the Bosporus, he could see the Anadolu Hisari—the old Castle of Asia—and the Valida Sultana's fountain in the Meadow of the Sweet Waters of Asia. Describing it in a letter to his mother as "a pinnacle of oriental design," he brought one back to Fife. Mary, as usual, was thinking more practically—she could cut back on her entertaining expenses—adieu Hottentots—and spend extended time with her baby. Her summer of 1800 was, in fact, the closest to perfect happiness she had ever known. She also expressed relief that this summer in the country would keep Lord Bruce away from city-bred disease. Still anxiously awaiting her parents' arrival, she left a letter in town for them:

> I had almost forgot to ask you to be civil to the Turk, the bearer of this. After a long conversation with me, he said you were the Grand Signior's guests, and that he was told to look upon you as such, and that his head was to be answerable if any accident happened to you. Don't you think they would be a long time sawing it off?? It would at last hang by a string!—
>
> "Oh! Fye Mary. You make me shudder."
>
> "Oh dear Mama, I am so accustomed to taking off heads that I think nothing of it."—
>
> And he also said that if he came to any difficult pass, he would carry you on his turban. How I laughed. I can just figure to myself, You, seated on his head.
>
> > Farewell, my dear dear Mother. Kiss Dad, and Love Me.
> >
> > Your own Poll, the Ambassadress
> >
> > VERY EXTRAORDINARY!

She longed to have her parents at Lord Bruce's christening but felt she could not postpone her duty, so on May 30, little Lord Bruce was christened. Mary sent details to her mother-in-law and wrote that she found it hilarious that locals had begun to copy her English riding out-

fits. At the beginning of June, in a very frail state, she hosted a celebration in honor of the king's birthday with a grand fete and, once again, performed her duties beyond reproach. She described her own party to the Dowager Countess Elgin:

> We put up a large Canvas room in the Garden covered the walls with bows of Oak & wild Roses we had down the middle of the Table a bow with orchids of which was hid with moss full of Roses Carnations & c.: and you can have no idea what a good effect it had; we had exactly 100 people at dinner the King's health was drank with *three* times three, our Battery fired 21 rounds & then our Band play'd save the King: after dinner we came into the House & had a regular Concert & incomparably our Musicians play'd such music was never before heard here; when the Concert was done we had fireworks and then a Ball which I pique myself upon having kept up in a capital stile for when I once begin I believe I can tire most people & they had never capered so fast in their lives I danced every dance & what is more I taught them Reels, every body seemed pleased & contented.

On July 7 at seven o'clock in the morning, Mr. and Mrs. Nisbet finally arrived in Belgrade. It was nearly a year since they had left their daughter in London, at that time a very young new bride. When they greeted her in Turkey, she had blossomed into an internationally admired figure and one who was experiencing the bliss of having her firstborn child.

An extraordinary letter addressed to the infant Lord Bruce—as opposed to his cross-dressing mother—and dated August 15 arrived in Belgrade and was treasured by Mary and her parents. The Captain Pasha expressed his delight at the little boy's arrival and apprised the baby of the latest political developments so that he might pass the news along to his father, the ambassador. "Here, Here; here is a letter come to

me from the Capitan Pasha, who is so fond of me." The entire family was overjoyed with the new baby, and Mary was positively giddy, describing her mind as having "bees" flying inside. She wrote to her mother-in-law: "It is not only my blind partiality that admires him, for even my Mother says she never saw so fine a Child, tho I was much prettier, I think I have heard you say Elgin was ye ugliest Baby ever seen," she teased.

Mr. and Mrs. Nisbet adored being with their only child and grandson, and they also received many privileges and courtesies because their daughter was so admired. That summer, they attended balls at the Russian Embassy, and they, too, were invited to the home of the Captain Pasha and were received by his sister, Hanum. That, again, was a distinct honor. There they saw bestowed upon their little girl the "Chilinque Amathist," the massive jewel worn in the center of a turban at the front of one's head. Perhaps the most spectacular experience for the Nisbets was their invitation to accompany Mary to the summer apartments and gardens of the sultan and his sultana on August 13.

If anyone in London had believed Spencer Smith's stories that Lord and Lady Elgin were inept at or incapable of representing the king properly in Turkey—Mary wrote to her mother-in-law, "I suppose they wish to find fault in anything (he) does"—then the Nisbets could now return to refute any accusation. Their children were esteemed, welcomed everywhere, and Lord Elgin was particularly hardworking. Mary wrote to the Dowager Lady Elgin that her own son

> Kutchuk shall not be a Diplomattic for I think of all the drudgeries it
> is the worst; you cannot imagine what a Slave E is and the immense
> quantity of business he has to transact is beyond belief . . . when I
> dare say *You Englishers* thought he had nothing to do but to receive
> Diamond Snuff Boxes, &; from the Grand Signior; there was he poor
> Mortte setting at his writing Desk all day, & sometimes all night.

She wasn't complaining very seriously about diplomacy, as she also wrote to her mother-in-law that she hoped her little "Kutchuk" would be made the first English Knight of Malta. In a jolly mood, Mrs. Nisbet invested him for carrying in his tiny hands the letter to his father, ambassador extraordinaire, which brought the news of an English victory on that small but geographically strategic island.

The next few months brought great happiness for Mary and her parents as they shared the growth and progress of the little boy and many pleasant excursions. On August 26, they went to the top of Gants Mountain. They received an exclusive invitation to dine with the sultan's fifth wife on Monday, September 1. In November, Lord Bruce was baptized, and Mary hosted a magnificent ball and supper in honor of the occasion. Mary noted in her diary that on December 23, "Mrs HN Kutchuk and I went to the Captain Pasha's. . . . The Pasha gave Kutchuk the Diamond flower 23rd." Mary had begun to use the term "Kutchuk" to tease just about everyone, and the Nisbets, thanks to the absolute and unwavering admiration for their daughter, brought home an astonishing cache of presents themselves.

The Nisbets remained in Pera through the winter, but the following spring, on April 23, it was time to go home. "Oh, what I felt when I fairly lost sight of your ship round the Saraglio point; I really was very ill," Mary wrote on May 10, 1801. She reacted psychologically with another asthma attack, but there was more—they were leaving her and she was pregnant once again.

Their son-in-law had encouraged his in-laws to take advantage of a once-in-a-lifetime opportunity and visit the sites of ancient Greece and Turkey. Most Europeans never ventured to see the classical sites. Despite admiration for the achievements of ancient Greece, and fascination with the barbaric Turks, the region was not included on the Grand Tour agenda.

The reason: the prevalence of smallpox. The death toll was staggering, and it was common practice to detain and quarantine ships returning

to England in Malta or Gibraltar to prevent seamen from transmitting disease back home. Long before Dr. Edward Jenner's 1796 discovery of the cowpox vaccine, Lady Wortley Montagu had reported home in a letter dated April 1, 1717, to Miss Sarah Chiswell that the Turks had a method of inoculation that addressed the awful disease:

> The small-pox, so fatal, and so general amongst us, is here entirely harmless by the invention of ingrafting, which is the term they give it. . . . People send one another to know if any of their family has a mind to have the small-pox; they make great parties for this purpose, and when they are met (commonly fifteen or sixteen together), the old woman comes with a nutshell full of the matter of the best sort of small-pox, and asks what veins you please to have opened. She immediately rips open that you offer to her with a large needle (which gives you no more pain than a common scratch), and puts into the vein as much venom as can lie upon the head of the needle, and after binds up the little wound with a hollow bit of shell. . . . I am very well satisfied of the safety of this experiment, since I intend to try it on my dear little son. I am patriot enough to take pains to bring this useful invention into fashion in England; and I should not fail to write to some of our doctors very particularly about it.

When she returned to England in 1720, Lady Wortley Montagu did exactly that and opened up a significant dialogue among the doctors in the West.

The idea of inoculation, however, was quite new, and it was fortunate that the Nisbets and the Elgins were very up-to-date in their thinking; surrounded by progressive doctors at the University of Edinburgh who were in favor of inoculation, Mary's parents routinely consulted some of the best doctors in England and Scotland. It was the Dowager Lady Elgin, however, who galvanized them all. As Dr. Jen-

ner's father was Martha's own chaplain, she took a proprietary interest in the brand-new smallpox vaccine. She was convinced of the vaccination's effectiveness and dispatched a Dr. Scott, who brought vials of the vaccine with him to Turkey. When Sir Sidney Smith anchored in Constantinople, Dr. Wittman used this serum to inoculate the captain. Wittman praised the Elgins for their role in popularizing inoculation and, as a result, saving many lives. An additional source for the vaccine was made available to Mary when, on the way to Constantinople, the Nisbets met a Dr. De Carro in Vienna who offered to send their daughter vials of the vaccine. Mary proceeded to have her household staff inoculated, and in order to ensure her own son's safety had the little Lord Bruce vaccinated three times in October.

The Dowager Lady Elgin, intent on having her new grandson inoculated, wanted an immediate account that the little boy had received his vaccinations and upbraided her daughter-in-law for lack of communication. The criticism really irritated Mary, and she got quite defensive. As she was in the early stages of her second pregnancy and not feeling very well, she was quite unpleasant to her mother-in-law in a letter dated February 7, 1801: "I think you are very unfair imagining for one instant I had not written about the innoculation, since I left England I have hardly missed an opportunity of writing either to you or to Grosvenor Square; as you may see by the number: This is my *nineteenth* to you (& I have only received eight from you)." In fact, Mary was meticulous about recording every tooth the little boy cut and sending her mother-in-law reports on his progress. As her mother-in-law had taken it upon herself to meddle and dispatch Dr. Scott with quantities of the vaccine, Mary was annoyed and lashed out:

Doctor Scott is arrived at last, but Oh, O-H my Dearest Lady Elgin what a Tongue! he is clever . . . but such a monotonous voice as I never heard, and I am sorry to say he has already told us all about China, Japan &&&: . . . Woe's me he told the exact same Story

word for word this morning at Breakfast that he told me yesterday at the same hour. He absolutely drives me out of the room, I have not patience for it, for if he told us new stories every day at least it would be more bearable but when you come to *Ditto repeat*, Alas it is all over.

After that initial letter, Mary felt great remorse for her grumpiness and she repented, sweetly offering great—and deliberately thorough—details to her mother-in-law of the excellent care the dowager's pro-tégé, Dr. Scott, was providing to the entire family and the good work that he was doing for mankind while he was stationed in the East. Mindful to be sensitive to the Dowager Countess, who was quite wor-ried about her son's health, Mary reported that Dr. Scott prescribed regular "Sea bathing," and a change of habits. Elgin "eats a great deal plainer than he used to do, does not sleep *excepting in Bed*, and the greatest of all objects carried, has left off Suppers and the quantity of wine he used to drink after supper, he now only takes a Glass of Wine & Water." In the summer of 1801, after little Bruce had suffered "a most violent flux," she wrote the Dowager Countess, "the Doctor has quite gained my heart, he is so exceedingly attentive. He gives him Port Wine, Rice & chicken every day."

Mary was by nature an empathetic person, and motherhood turned her into a crusader on behalf of children's health care. "What a dreadful thing it is to see a poor little Child suffer," she wrote her mother-in-law, and she decided that she would at least try to protect all children from the ravages of smallpox. At the request of the twenty-two-year-old Countess of Elgin, a steady stream of deliveries containing vials of the smallpox vaccine began arriving at the British Embassy in Turkey. Despite the growing discomfort of her pregnancy, Mary worked tire-lessly to dispatch doctors and these vials to Baghdad, the Persian Gulf, and Bombay, where a vaccination board was established to coordinate the distribution of the medicine in India. In her letters home, she

would report on the numbers of people receiving treatment—in one letter she counted seventy people in Belgrade and hundreds of children in Smyrna who had been vaccinated.

About one year and five months after the birth of Lord Bruce, Mary's second child, Mary, was born on August 31, 1801, and she was just one week old when on September 6 she received the first of three injections of the smallpox vaccine.

Mary's heart as a mother propelled her to reach out to other mothers, and she became an ambassador in her own right.

Chapter 8

CAPTAIN OF
HER SHIP

Everyone in the family had been thrilled that Mary was pregnant with her second child in early 1801. Everyone, that is—except Mary. Despite her husband's claim to the contrary, she most certainly did not forget her pains. She wrote to her mother-in-law, "Alas! It is but too true; perhaps you will not believe me when I say that really I think Elgin is *almost* as sorry as myself, I suffer so dreadfully from sickness it is quite terrible to look forward to seven or eight months spent in this manner." Still, she hosted a number of masked balls, managed three houses—Broomhall, the embassy residence in Constantinople, and the house in Pera—and, like any mother of a toddler, was running after a very active little boy.

Mary and Elgin were delighted that little Lord Bruce spoke his first words in Greek. By late spring, he was walking about with confidence. An English ship captain had carved a carriage for the little boy, and Mary reported, "You cannot imagine his joy when he gets into it. The misfortune is, he will not get out again."

Without her mother by her side—her parents were traveling around Greece in May—Mary reached out once again to her grandmother, her aunts, and her mother-in-law for decorating tips and advice. She was bustling about getting the family, servants, and staff settled in the enor-

mous summer house in Büyük Déré, but the underlying longing for a home back in Scotland became evident as she chatted about buying fabrics for Broomhall. In Turkey, the ambassador and his wife could not travel light, and "setting up house" meant configuring an embassy, which was much like planning corporate offices—taking everyone else's needs into account:

> Excepting the Russians and Baron Hubsch's houses, it is, without any comparison the best in Bouyouk Dere. The drawing room is a famous large room, and besides that, we have 8 other good rooms on the first floor, all of which I mean to take possession of for myself and Bab. Below stairs there is a very large dining room, a writing room, and plenty of room for your gentlemen. At the top of the house are exceeding good garrets. We can put up all our people in it. . . . Do you recollect the house? . . . I think you must remember the flower pots on the top of a nice garden wall, and an odd shaped scraggy looking tree at the top of the hill, which was a market object from the Bosphorus; that tree, and a vineyard behind it, belongs to us. What a pity we had it not last year, for you would have been most capitally lodged; and then you would have had the amusement of seeing us make our wine . . . there are two or three large trees with benches under them, and from thence is the most beautiful view of the Bosphorus and Giant's Mountain, I have ever seen.

In early June, she hosted a grand fete in honor of King George's birthday. Smack in the middle of the festivities, Reverend Hunt arrived from Athens bearing letters from the Nisbets. That brought very good news for their son-in-law as well.

> Your letter put Elgin into the greatest glee, he was quite charmed at your entering so heartily into his cause; your visit would undoubtedly renovate the Artists and make them work with fresh spirit—Elgin is

going immediately to set about getting the proper Firman for Min-erva's Temple. I shall write you word if it succeeds.

Up to that point, the Nisbets had regarded Elgin's interest in repro-ducing classical artifacts an insignificant distraction and hobby. They changed their minds and caught his fever when the archbishop of Athens, as a token of respect for their daughter, presented them with the ancient gymnasiarch's chair, sat upon by one of the judges at the ancient Panathenaic games.[1] Viewing the priceless antiquities firsthand for the first time, Mr. and Mrs. Nisbet finally understood that these unique treasures, mementos of history, could be turned to dust by sol-diers. The Nisbets enjoyed the fun of bringing home a few souvenirs. In June 1801, Mary wrote to her father:

But now my Dearest Father prepare to hear with *extasy* what I am going to tell you! Captain Briggs, Commander of the *Salamine* Brigg has at this moment on board, one piece of Porphyry 4 foot and a half long, & 3 foot and ½ round. Another, 7 foot and a half long, & 3½ round. And another—Open Your Eyes! Eight feet long, & seven feet round!!! 'Pon honor, fact, Dear Sir!

As they headed home, the Nisbets faced great danger because of the continuous fighting all around the Mediterranean. Mary wrote to her mother-in-law that on March 21, General Menou led a French army of intoxicated soldiers and lost 2,000 men. In that skirmish, Sir Sidney Smith had been wounded, Sir Ralph Abercromby lost a limb and soon thereafter died, and Colonel Hope lost a finger. Elgin had been assist-ing Abercromby with a steady stream of financial support and supplies that he had obtained by convincing creditors that the British govern-ment would repay all debt. Because the money was necessary for the war effort, Elgin felt, as ambassador in the region, he should do all that was in his power to secure British victory. The borrowed money was

used to procure weaponry and build ships; however, when he petitioned the foreign minister for reimbursement, he was ignored. He and Mary were then held personally liable for a vast sum of money that had been turned over to the armed forces. Unfortunately for Elgin, his own patriotism caused serious financial reversals for his family that would affect generations to come. Abercromby's replacement, General Hutchinson, expressed his gratitude in a letter to Elgin:

> I do not know how we should have been able to have existed at all in this country had it not been for the great exertions which you have used to procure us money, and to administer to our other various wants. . . . I shall ever bear testimony to the zeal and ability with which you have exercised the most important public functions.

Another turn of events occurred when General Kléber was assassinated and Menou was named the new general in charge of the French forces. Menou boldly threatened, *"Nous ferons vigoureusement rebrousser chemin à Messieurs les Anglais."* ("We will make the Englishmen turn and run vigorously" could be loosely translated as "run for their lives.")[2]

The Nisbets made it to Malta for the requisite smallpox quarantine and went on to Italy. Mary waited anxiously for every letter that could substantiate their safety, and faithfully sent her usual, numbered letters with couriers and ship captains. On July 9, she reminded them sadly that one year ago "did my very dear Father and Mother kiss my Bab for the first time, what a different day did I pass to what this is. But I must not compare."

General Hutchinson, despite his kind words to Elgin, negotiated a treaty without Elgin's help, and Elgin was disappointed that he was not consulted. Much like the unsatisfactory El Arish agreement, it required no French surrender, just safe passage home. Elgin wrote a private letter critical of the bargain to Frederic, the Duke of York (King George III's second son), who had been appointed commander in chief of the army

in 1799. The duke allowed publication of this letter, causing great pain to Elgin. Mary wrote to her mother-in-law, "Poor Elgin he is also extremely annoy'd at his private letter to the duke of York being published," and she wrote of the betrayal to her parents on June 26:

> I will tell you one thing which is that Elgin is most amazingly hurt at finding a *private* letter he wrote to the Duke of York, published. He wrote both to the Duke and to Lord Hawkesbury [secretary of state for foreign affairs] yesterday very forcibly upon this subject, to say how exceedingly hurt he is to find his private letter published— particularly as he had been so much with the Army, he is always extremely cautious never to meddle with military details when he can possibly avoid it, knowing how much the least inaccuracy affects the characters of officers. E. says he has always been accustomed to correspond with the Duke of York privately, that makes it doubly unfair, him allowing it to be published. I hear the Opposition papers quiz E.'s intelligence.

Mary wrote that Elgin would face criticism for whatever he said or did. "I am afraid Elgin will be abused, but he has nothing to do with the conditions G.H. [General Hutchinson] has allowed the French, and in his private letters to Lord Hawkesbury and a Mr Somebody belonging to the Duke of York, he has not concealed his opinion that the terms are infamous." Mary was frustrated that important decisions concerning world events were being made without her husband's input. She felt that as he possessed considerable skill, he was being abused. Were they needed for their country only to serve as a pocketbook? When would her husband finally, truly be appreciated for his brilliance as a negotiator and politician?

Much to Elgin's and Mary's delight, word came that "Lord Keith and General Hutchinson have removed Sir Sydney for the command on the Nile" and "Mr. Straton was coming." Alexander Straton, Spencer

Smith's replacement, meant that Smith would not be returning despite persistent rumors to the contrary. Mary wrote to her mother-in-law:

> Elgin is writing to you so he will tell you how happy Mr. Straton's appointment to be Secretary of Legation has made him—I own it has given me the greatest satisfaction, as all the Germans and some of the English Merchants have been constantly declaring that Smith was to return here—& both the Russian and Prussian Ministers have expressed their astonishment at E's having so little influence—I dare say both Sir Sidney and his Brother will endeavor to do Elgin all the mischief they can when they get to England.

On their way back to London, the Nisbets began to hear rumors accusing their son-in-law of receiving bribes and participating in illegal trade. They were extremely irritated at having to defend him, but as they had seen his hard work and had been themselves the recipient of the sultan's largesse, due to his admiration of their daughter, they were extremely credible defendants. They had seen firsthand that despite England's bungling of foreign relations and the Ottomans' weariness with the British government, the Elgins *were* being treated like royalty. And although the Smith brothers headed home with tantalizing tales of the sultan's alleged bribery at the Elgin embassy, Mary and Elgin were busy using their own public relations to control the damage. Elgin reported back with ferocity to Grenville, to the new foreign minister, Lord Hawkesbury, to his mother, and to anyone who might shoulder his cause. Mary's own chronicles went to Lady Robert, Dowager Lady Elgin, the Duchess of Montrose, and other women who could "kiss and tell." She substantiated Elgin's hard work with phrases about his "scribbling," his "writing," meaning that he spent a lot of time writing in self-defense and reporting home. She herself had told everybody that the sultan had given her a sum of money to buy a beautiful adornment. If, in fact, this were a bribe, she would have kept the transaction a

secret. Instead she sent the money back to London to have something spectacular fashioned. On August 28, she wrote to her mother-in-law:

> I wrote to Bluey some time ago to send me a Diamond necklace, I hope it is on the road as I wish to exhibit it here, to shew the Grand Signior I have bought something handsome with his Money—I told Miss Manners she might spend Twelve or Thirteen hundred pound upon it, now as I have got more presents I do not care if she adds £100 or £200 more provided it is required to make the Necklace very handsome.

This was a young woman who could buy herself anything she wanted. She understood that this was not money to spend on something practical, rather it was a token of admiration from a forty-year-old man to a twenty-three-year-old woman, and she knew it was important to dazzle this "Kutchuk."

Her baby was overdue and Mary was quite grumpy when she wrote to her mother-in-law that she had hoped to have an addition to the family by now to write about. She hurled a complaint against her husband in this letter to the Dowager Countess—"your Son . . . to let you into a secret is *no* comfort to me for he is always *scribbling*"—which, of course, was really a backhanded compliment: her way of communicating how hard he was working. She signed off, "Farewell my Dearest Lady Elgin I am really so uncomfortable I can hardly write."

In a long letter to her parents written throughout the summer, which she finally concluded—also—on August 28, she remarked that although she had intended to have her message delivered by a German carrier, she decided that because it contained gossip about the Smiths, she'd have it reach them another way. Mary was thrilled that she was able to share the splendors of the East with her parents for the past year, and her letters contained a new kind of shorthand: "You remember the old-fashioned gigish pieces of furniture we saw in the Seraglio?

Now what I want is little tables, a good deal ornamented, inlaid boxes
and drawers: dear Mother will you see about this?" She playfully chris-
tened her correspondence "the Bouyouk Dere Scandalous Gazette"—
including spicy anecdotes about the "little Spaniard," the Prussians, the
Russians, the papal emissary, whom she called "the Internonce," his
"yellow wigged sister," and other local characters. Sprinkled in with war
news and political public relations, she sent on entertaining tidbits
about the little Prussian's attachment to an English Major Bromley—
an alias for M. de Tromelin, a Frenchman who had been Sidney Smith's
accomplice in his escape from the Temple Prison. Forced to flee France
for his life, he went to England to serve His Majesty King George.
Apparently, the little Prussian's husband, the big Prussian, was furious
with jealousy over his wife's infatuation. Mary also reported on a young
Miss Abbott and her crush on the wrong man. Apparently, Miss
Abbott's trustees in London had gotten wind of her romance and they
asked Elgin to interfere; Mary gleefully told how Elgin wrote back,
insisting he was much too busy to wreck anybody's dalliances. Mary
forwarded the hilarious incident concerning a Mademoiselle Leiger
and her lover, a musician named Beldi. Miss Leiger, in an effort to find
her amour, covered herself in a burka and went out on the street incog-
nito. She was paid back for all of her effort when she found her Mr.
Beldi—with another woman.

Mary also felt that now that her parents had been converted to
Elgin's artistic cause, she could also share with them detailed accounts
of the artists' progress in Greece and the exciting news that "Elgin has
had letters from Hunt [from Athens] and all has been managed better
than we could have expected at the Temple of Minerva. Free access is
given to the Artists into the Citadel from sunrise to sunset." After all, it
was now clear that this was to be a very expensive undertaking, and any
and all Nisbet money was certainly welcome. The Nisbets began to fund
Elgin's artists in their endeavors, and they all wanted to make sure that
Mary's parents knew how grateful they were. Mary's long, long letter

completed on August 28 went out before she could tell them about the next bit of exciting news.

Three days later, on August 31, Mary's first daughter, the Nisbets' goddaughter, Mary, was born—and Alexandria fell to the British. There was great rejoicing in the personal and public lives of Lord and Lady Elgin. It was the beginning of an unimaginably heady time for the young Lady Elgin as the Ottoman Empire placed itself at her feet.

Chapter 9

FAVORABLE WINDS

L ittle Mary, "Lady Mary Bruce," came into the world with far less trouble than did her brother. Elgin reported his joy to his mother, noting that his daughter was lovely and that "by her roar, the Lungs perfect." Her older brother—"Your old acquaintance, George"—all of one year and nearly five months, "was a most astonished & delighted gentleman, on seeing his sister." Once again, the Elgins prepared for the rituals of baptism and christening. Philip Hunt was in Greece at the end of the summer, so another chaplain baptized little Mary; the christening was arranged for his return. When he arrived in Constantinople, he was enchanted with the baby. Mary wrote to her mother that the baby "has the prettiest shaped head and the most delightful mouth you ever saw; Hunt declares her ancle [ankle] is perfection. She must have taken that from Bluey."

The baby, to Mary's relief, sailed through the smallpox inoculation without reaction, and Mary was even more determined to make this medicine available in the East. "I think we shall completely establish the vaxine in this country; the small pox is so dreadfully fatal here." Word spread of Mary's work, and she wrote home that "Elgin has had many letters from Smyrna intreating him to send some vaxine there." On October 8, the christening celebration was performed by Reverend

Hunt with substitutes standing in for the godparents, Mr. and Mrs. Nisbet and the Dowager Lady Elgin. Colonel Graham proposed the toast: to "Lady Mary Bruce!"

Although Alexandria was recaptured from the French at the end of August, the Elgins did not receive word of the victory until September 20. Much of the infighting and confusion among all the military leaders and diplomats of course occurred because of the time lapse in communication. Just as instructions arrived with one solution, situations would change elsewhere affecting the previous order. Many of Sir Sidney's attempts to conclude a peace treaty and Elgin's own negotiations were derailed by activities in Europe that they had not yet heard about. For example, once the Austrians and Russians expressed horror to the English Parliament that Napoleon's troops might be permitted to evacuate Egypt without surrender, fearing a rerouting of the troops to their own borders, the allies protested. That, more than anything, had caused the English Parliament's about-face. Neither Elgin nor Sir Sidney had been apprised of that delicate concern. Often it would take months for Elgin's embassy to learn about disaster and progress in Egypt, leaving him in doubt as to what news to report to the sultan and to his own government. Communication caused as many problems as did the egos of the men involved.

Mary's friend the Captain Pasha had duped General Hutchinson into sending his brother, Christopher, a lawyer, with the news of victory in Alexandria instead of dispatching an officer to Constantinople. The Captain Pasha decided that if he were going to receive complete credit for the victory in Alexandria from his sultan, he would need to tell the story his way: he wanted Selim to look upon the Captain Pasha as the officer in charge instead of the other way around. Sending Christopher Hutchinson would accomplish the Captain Pasha's own mission in two ways: first, a civilian would alienate the soldiers, and second, a man without official commission from the British government would no doubt insult the Sultan. Naively, General Hutchinson fol-

lowed the Captain Pasha's suggestion and dispatched his brother with the Captain Pasha's letter. Whether it was due to his innocence or ignorance of protocol and of the contents of the letter he was carrying, or for some reason thinking he would be rewarded handsomely by the sultan, Christopher Hutchinson did not head for his own embassy upon his arrival in Constantinople. Instead, he went directly to the Caimacam and next to the Seraglio. He delivered the letter from the Captain Pasha, which claimed that he, the Captain Pasha, had been solely responsible for the victory in Egypt. That was a very good joke, but, of course, it was not the truth. Hutchinson had simultaneously made a fool of himself, his brother, and the English government. Had he first consulted with Elgin, he might have avoided humiliating himself, his brother, and the entire English Army. When the ruse was uncovered, Christopher Hutchinson made excuses, claiming to be merely "a traveler."

Mary observed how the uninitiated could potentially cause serious problems in the world of diplomatic relations. There were definite skills required in this world of delicate and precarious dealings among countries:

What a rage the Sultan will be in, when he knows the man he has treated with such unheard-of attention, is a lawyer, and has nothing to do with the Army. . . . I daresay General Hutchinson did not know of what real importance it was, to send somebody who knew what had passed in Egypt. I cannot think he did it merely on account of the presents and honor.

She was quite knowledgeable about the inner workings of the British armed forces. She was the granddaughter and niece of generals; she entertained and had been to dinner with heroes and was very sensitive to the delicate—but quite oversize—egos of men like Hutchinson, Nelson, and Lord Keith. She had a soft spot in her heart for the ship

captains who brought her mail from home and transported her own dear parents back to England. She had great respect for the soldiers, and—except for the Smith brothers—her door in Turkey was always open for any man in uniform serving His Majesty. To Mary, they were heroes in their world, and Elgin was a hero to her in the world of diplomacy. Elgin, of course, was right, and Mary sent one more tale home that showed how essential Elgin's experience and leadership was to the empire:

> [When] the Dragoman began reading the speech which the Grand Signior made Mr. Hutchinson, he commenced by calling him Colonel Hutchinson, upon which Elgin said he had made a mistake, for that Mr. Hutchinson had no rank in the Army. He says upon that the Prince's face turned all the coulours of the rainbow, he asked E. who he was, or what rank he had? E. told him, he was the General's brother and came there as a traveler, but had nothing to do with military affairs. . . . He seemed perfectly astonished . . . the Captain Pasha did not tell the Sultan that; I wonder what he will say when he knows he has chilinquied and paid such uncommon attention to a person who was not engaged in the expedition. However, all this is nothing to *us*.

The Captain Pasha had arranged for Mr. Hutchinson to stay at his house; once again, Hutchinson, a naive civilian, blundered and accepted the pasha's hospitality instead of staying at the British embassy. When he realized that he had been the puppet for a very wily manipulator—whom Mary was, of course, very fond of—the lawyer bolted for the Elgins' house, where Lady Elgin welcomed him with sympathy. Mary felt completely vindicated. After all of Elgin's hard work, he was at last recognized as the man truly responsible for maintaining good relations with the Ottomans—and she was no small part of that, she knew. One

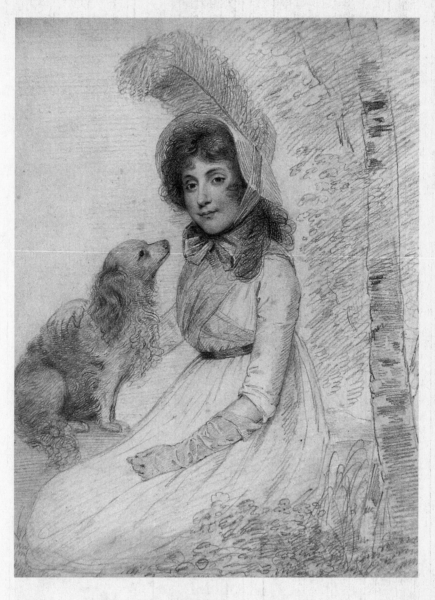

Mary Nisbet as a young girl, by William Staveley

(Richard P. J. Blake)

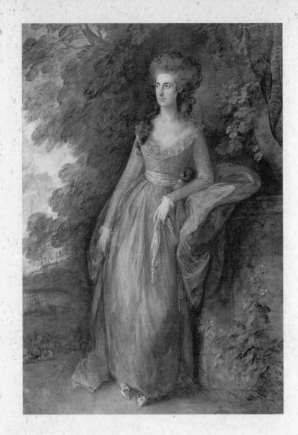

Mary's mother, Mrs. Hamilton Nisbet, by Thomas Gainsborough

Archerfield (SIR FRANCIS OGILVY, 14TH BARONET OF INVERQUHARITY)

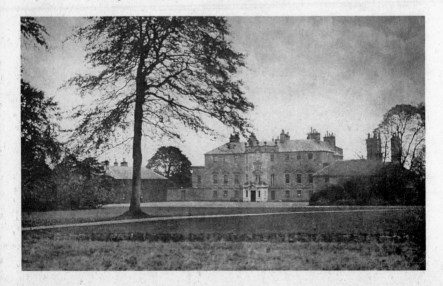

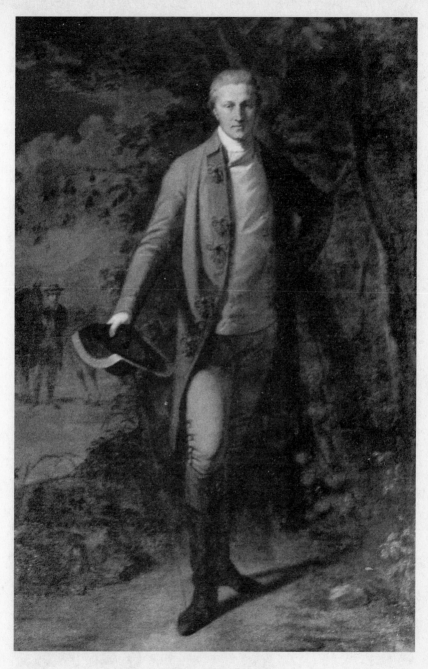

Mary's father, Mr. William Hamilton Nisbet

(SIR FRANCIS OGILVY, 14TH BARONET OF INVERQUHARITY)

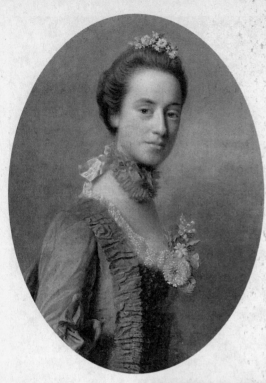

Mary's maternal grandmother, Mary Digges, Lady Robert Manners, by Allan Ramsay

(NATIONAL GALLERY OF SCOTLAND)

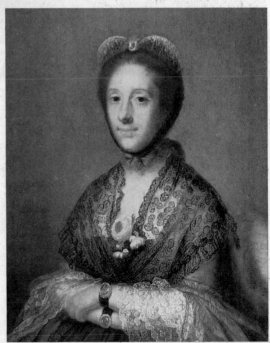

Mary's paternal grandmother, Mary Hamilton of Pencaitland

(SIR FRANCIS OGILVY, 14TH BARONET OF INVERQUHARITY)

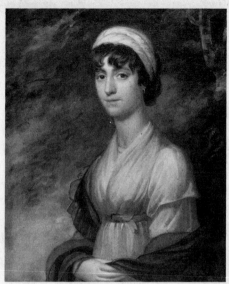

*Mary Hamilton Nisbet
of Dirleton, by Hoppner*

(Sir Francis Ogilvy,
14th Baronet of
Inverquharity)

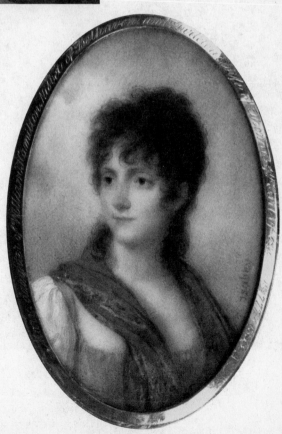

*Mary Hamilton
Nisbet as a young
woman painted in
the romantic style*

(Sir Francis Ogilvy,
14th Baronet of
Inverquharity)

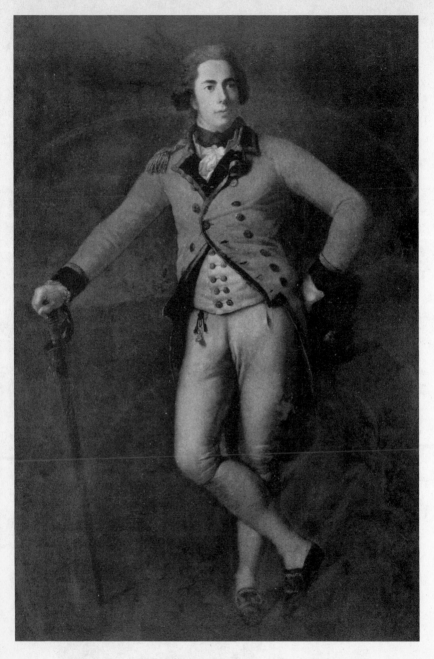

*Thomas Bruce, 7th Earl of Elgin and 11th Earl of Kincardine,
c. 1799 by Van Graff* (Andrew Bruce, 11th Earl of Elgin and 15th Earl of
Kincardine, from the Broomhall archives)

Martha, Dowager Countess of Elgin, c. 1762 by Allan Ramsay

<small>(ANDREW BRUCE, 11TH EARL OF ELGIN AND 15TH EARL OF KINCARDINE, FROM THE BROOMHALL ARCHIVES)</small>

Lord and Lady Elgin playing whist with the Captain Pasha by Giovanni Battista Lusieri (ANDREW BRUCE, 11TH EARL OF ELGIN AND 15TH EARL OF KINCARDINE, FROM THE BROOMHALL ARCHIVES)

*The Monument at Philopappos
on the Acropolis by Lusieri*

(ANDREW BRUCE, 11TH EARL OF ELGIN
AND 15TH EARL OF KINCARDINE, FROM
THE BROOMHALL ARCHIVES)

Sultan Selim III

(INAN KIRAÇ)

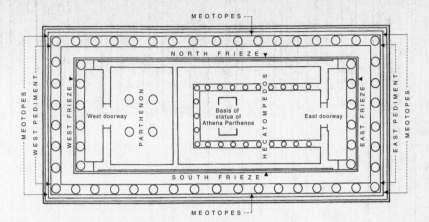

MEOTOPES

NORTH FRIEZE

MEOTOPES

WEST PEDIMENT

WEST FRIEZE

West doorway

PARTHENON

HECATOMPEDOS

Basis of
statue of
Athena Parthenos

East doorway

EAST FRIEZE

EAST PEDIMENT

MEOTOPES

SOUTH FRIEZE

MEOTOPES

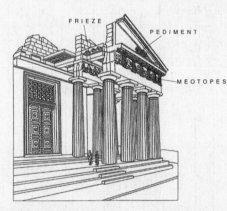

FRIEZE

PEDIMENT

MEOTOPES

The Parthenon design

*The Biel Chair,
now at the British Museum*

(JULIAN BROOKE)

LADY ELGIN'S COURTSHIP—REEL.

Sheet music written in Mary's honor; Lady Elgin's Courtship—Reel

LADY ELGIN'S—STRATHSPEY.

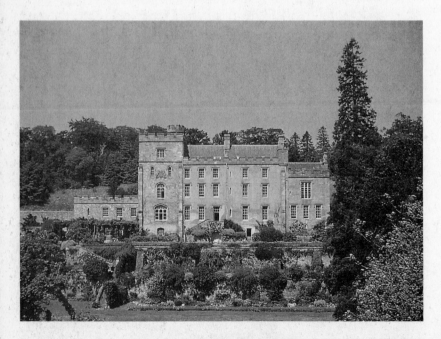

Sheet music written in Mary's honor; Lady Elgin's—Strathspey

Biel, built in 1805 (Julian Brooke)

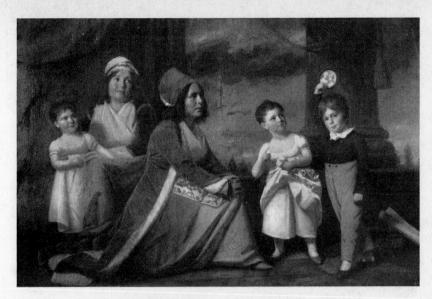

*Lord Bruce and Ladies Mary and Matilda Bruce with their
paramannas at Biel, c. 1805* (ANDREW BRUCE, 11TH EARL OF ELGIN
AND 15TH EARL OF KINCARDINE, FROM THE BROOMHALL ARCHIVES)

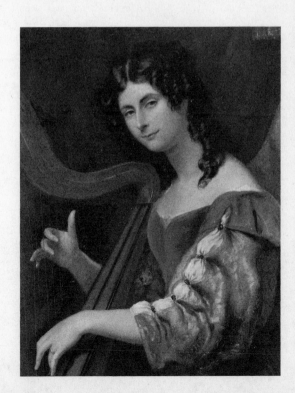

Lady Mary Bruce

(SIR FRANCIS OGILVY,
14TH BARONET OF
INVERQUHARITY)

Mary's diaries (RICHARD P. J. BLAKE)

Robert Ferguson's diaries (RICHARD H. L. MUNRO FERGUSON)

5. rattle I made him stare with more astonishment
than usual – but it is a cruel thing to give him
sweetmeats. – I have seen the Babs eat their dinner
and very well he eat, I find it is much better
to make him wait sometime after his sleep before
he goes to dinner, for they used to give it him
the moment he open his eyes when he is always
cross – I hide the meat & bring it in second course.
I think I have now hit upon the right method. –
 Wigs has just put on a new ribbon, he
has been washed this morning & Oh! how
beautiful he looks! –

 (Tuesday night 25th of May) What perfect
delight I feel at thinking that this is the last
letter I shall write to my own Elgin; Now You are
coming back I will tell you truly I am wretched
without You, Elgin, we are not made to be
separated my whole thoughts are taken up
about you & if I had not felt that I was
working for you & about things you were
much interested in: I am certain I should
have done nothing but indulged in complete
melancholy – Come back quick Dearest Elgin.
– I got your letter last night but you do not
say Why your intended expedition to Yarmia
is given up. – how delighted am I to think

A letter from Mary to her husband, Lord Elgin

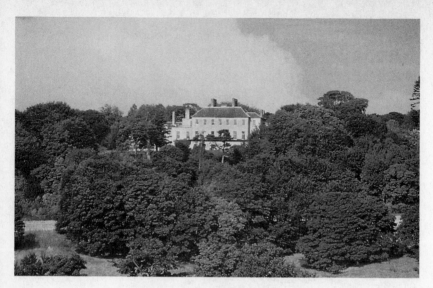

Raith, the home of Mr. and Mrs. Robert Ferguson

(RICHARD H. L. MUNRO FERGUSON)

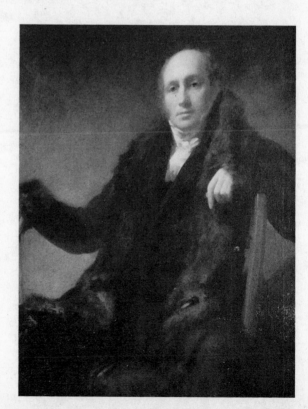

*Robert Ferguson
at age fifty*

(RICHARD H. L.
MUNRO FERGUSON)

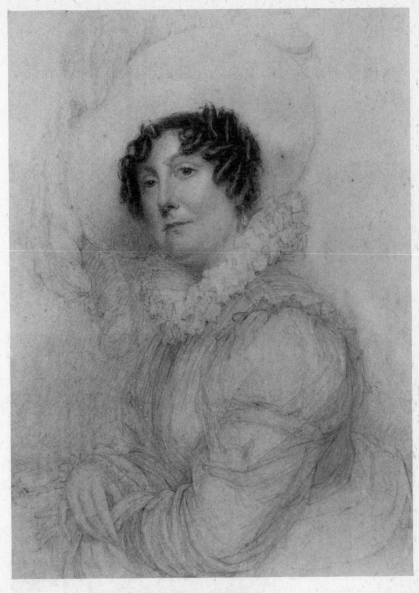

*Mary Hamilton Nisbet Ferguson, a grande dame at fifty,
by Sir Francis Grant, president of the Royal Academy*

(Richard P. J. Blake)

*Statue of Robert Ferguson
in Haddington*

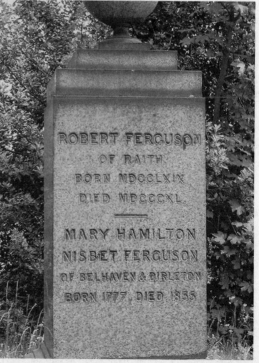

*Kensal Green tombs of
Robert and Mary
bearing incorrect
birth date*

(HENRY VIVIAN-NEAL)

more seemingly small, but we now know not insignificant, delicious victory occurred when after having been removed from Egypt, Sir Sidney Smith took a detour to Greece to see what booty he could take home. Mary gleefully told her parents that Smith's chances for treasures had been dashed—as Lord Elgin had already beaten him to the punch:

> Dearest Mother, you must, as soon as ever you arrive in England, write me fully upon *every subject;* tell me what *you* think, and what others think. What is said about Elgin, *good* or *bad,* and what impression Sir Sidney Smith gives. . . . Smith was 45 days going from Rhodes to Coron, from thence he sent to the Consul at Athens, desiring he would send him any medals or pieces of antiquity he had collected for him. The Consul sent him word that our Artists had taken possession of everything of the sort, so away Smith sailed without anything. I hope you will be in England before he arrives, it would be better for us.

The Turks recovered from their confusion and began a weeklong celebration of the victory, ignoring Hutchinson's presence and focusing instead on honoring the sultan, who received that week the "appellation of *Selim the Conqueror* from the Priests."

> The Turks are in the greatest glee at the taking of Alexandria, they are firing canon all day and all night, they have also begun to illuminate. I am told it is to last seven days. . . . The Grand Signior . . . has sent the Dragoman of the Porte in State to Elgin, this morning, we are all in gala; their conference lasted two hours and a half, a famous thing for the Good Folks here to talk of.

So much merriment among the populace resulted in nonstop noise and commotion. "I think they might have conquered Egypt over and

over again, had they but fired half the number of cannon in earnest they are now firing in joke," she wrote. The raucousness even made its way into the embassy and her household staff. Her servant Andrew, whom she knew to have a drinking problem, went out of control.

I have just been scolding most violently, upon the stairs, I met Andrew with Bruce. Upon seeing me, he (Bruce) put out his arms, and began calling out wine, wine, in Greek! As my friend [Bruce] does not understand English, I was obliged to kiss him, and woeful to tell, such a whif of white wine as he treated me with, I never before met with. I immediately attacked Andrew, who of course denied the charge, I have had all the servants up, and given them such a rattle as they never had before. I am convinced it was Andrew, but it is a most unpardonable thing to give a Child wine at ten o'clock in the morning.

There was a steady ebb and flow of people and requests. People arrived asking Elgin for financial assistance from the British government, thinking he had Parliament's open checking account when, in fact, he was kept on a very short fiscal rein. People wrote letters asking him to locate their sons—dead or alive. Dr. Wittman reported that on two separate occasions, Elgin intervened in death sentences ordered for Turkish soldiers. The ambassador extraordinaire earned wonderment and godlike status among the locals who had heard of his humanity.

Elgin's own staff was dispatched around the globe with the hope that they would extend his good work, and sometimes they disappointed him. Joseph Carlyle wrote home complaints that he had not found literary treasures; Elgin was shocked, as he wrote his mother, that Carlyle received access to the libraries at Topkapi solely because of his, Elgin's, own facilitation for the scholar. John Morier carried letters to London, and while he was there he published personal information

about his term at Elgin's embassy. Elgin wrote to his mother that Morier's "opinion of Sr S. Smith's conduct, was wholly erroneous— He had not seen the true historical papers, I have in my possession."

On the other hand, Elgin was very pleased with Hunt, who was scouting for antique sites of beauty and merit for the artists to draw. Although Hunt occasionally expressed fear about traveling in the area, he did go back and forth from Athens, dealing with local officials. Elgin was especially pleased with his staff member William Hamilton who, sent to Egypt, negotiated on behalf of Elgin, for the British to receive the Rosetta stone (now in the British Museum) from Napoleon as part of the spoils of victory. Elgin wrote to his mother: "Mr. Hamilton is a very uncommon young man. So much ability . . . so much solidity & application—with such life & spirit. . . . He is equally respected & beloved by all persons." Christopher Hutchinson remained in residence, and Sidney's aide-de-camp, Major Bromley, also stayed. When Bromley had arrived on their doorstep, Mary was annoyed because of his loyalty to Smith, and although she was skeptical about his friendliness, she treated him with kindness and encouraged him to enjoy their hospitality: she shrewdly practiced the game of keeping your friends close and your enemies closer. Like everyone who met her, he developed a great deal of affection for her and would later come to her aid.

Selim the Conqueror, as he was now called, established an order of knighthood called the Order of the Crescent for service to his empire. He knighted with diamonds Elgin, Lord Keith, and a handful of other military leaders, but not Sir Sidney Smith.

That September, Mary's Russian friends had to return home for the coronation of a new czar. Alexander I was crowned after the assassination of his father, Emperor Paul. Despite this sad news calling her friends away, there was a constant stream of jubilation. The sultan, wishing to honor Lord Elgin, offered to pay for a new embassy. The British had never owned their own embassy in Turkey—unstable relationships

made the British rent in the past. Selim paid £9,000 for the land, and £8,000 for the edifice. Elgin was to direct the design of the house, and he chose to copy Broomhall. Everyone gave balls. Everyone gave fireworks. Everyone got presents from the sultan—but only Mary got to meet the power behind the throne.

Chapter 10

THE STRONGER
VESSEL

Sultans usually came to the throne amid the tradition of fratricide. Nephews, brothers, and any other threats to ascendancy were generally imprisoned and killed. Selim III, nephew of Abdulhamid I, had had an unusually easy time of it and lived in the Kafe, the princes' prison, for only fifteen years before he became leader of the empire. His mother, Mihrisah ("ruler of the sun"), was born in Georgia (Caucasus) and lived in the Palace of Tears, where widowed sultanas lived without men, until her son became the sultan in 1789. She was then liberated as well and became the power behind the throne.

On October 3, 1801, Mary, dressed "as splendid as possible," traveled incognito on a plain ferry on the Bosporus to meet Mihrisah, the Valida Sultana. "Do you recollect how anxious I was to see her last year, and could not succeed? They are so delighted with the taking of Alexandria, we could make them do anything just now," she wrote her mother. Since the time of Suleiman the Magnificent, the Turkish sultans had always placed their favorite wife in the position of importance, but their mothers were sacred. An introduction to the Valida Sultana was the rarest honor any sultan would bestow. Mihrisah had already acknowledged Lady Elgin with flattering communications and presents sent through Hanum, but strict protocol prevented her from

meeting Mary in person. As the true confidante of her son and ultimate symbol of the Ottoman regime (and the symbol for Muslim feminine piety and purity), the Valida Sultana was not supposed to consort with or "play favorites" with foreigners; however, Mihrisah longed to meet Mary, and she defied a very long tradition and risked possible criticism in order to do so.

The Valida Sultana was always incredibly wealthy, receiving vast sums of money from the empire's coffers. This particular Valida held the jointure for Athens; therefore, any activity on the Acropolis needed her approval. She ruled over officials who courted her to get close to her son and the hundreds of people who lived inside the Seraglio's walls. She supervised the harem, watched over her grandchildren, and thus had the role of directing the dynasty. She lived a life of luxury and was the focus of the obeisance of millions of subjects—a position unique in the world—yet she was never seen in public. Part of her mystique was, in fact, her cloistered existence in the Seraglio, where anything she wished for was delivered.

Lady Wortley Montagu had written to friends in London that no Christian woman had ever been invited to this hallowed place. That wasn't entirely true. There had been thrilling and frightening tales of Christian girls who had been kidnapped and placed in the sultan's harem never to be seen again. In the 1782 Mozart opera *Die Entführung aus dem Serail,* a young Spanish girl, Konstanze, is abducted by pirates and sold into slavery to Pasha Selim; she is rescued by Belmonte, her lover. Was Mozart's opera based on the tale of Aimée Dubucq de Rivery, the cousin of Empress Josephine? Aimée, like her cousin, was born in Martinique. On the open ocean, she was kidnapped by pirates and offered as a gift to Sultan Abdulhamid I and renamed Nakshedil. The sultan's favorite, she entranced him with her fair beauty. She brought French style—symmetrical gardens and baroque interior design—to Topkapi Palace. In 1789, after Abdulhamid's death, she was whisked off to the Palace of Tears where she remained until her own

son, Mahmut II, became sultan in 1808. Another story with this plot, but with a twist, was Lord Byron's *Don Juan*, wherein the protagonist, a Spanish man named Juan, is smuggled into the Seraglio as a slave of the sultana.

Women in the sultan's harem came from the far corners of the empire; concubines arrived as slaves, and whoever was chosen the sultan's favorite was the mother of the future ruler. There were wives, slaves, concubines, and *kadins*. *Kadins*, though not legal wives, were treated above the others and offered money, clothing, and servants of their own. To be sure, Western women would today view the harem's tiny rooms with their lack of light as prisons of sadness. In 1801, a Hindustani poet, Mirza Abu Talib Khan, wrote a defense of the Asian woman that appeared in the 1802 London journal *Asiatic Annual Register*, arguing that if the Asian woman did not attend balls and go out in society, as did the Englishwoman, that did not make her a second-class citizen. The reason, he explained, why women lived under such strict protection was that "people of various nations dwell in the same city . . . there is such danger of corruption." The court records of Galata in eighteenth-century Constantinople reveal that, in fact, Turkish women often received quite better treatment than their European counterparts. They were entitled to inherit half of what any man could, and that created significant female-controlled wealth. As there was no aristocracy in the Ottoman Empire—princes and their sons were routinely killed—money was power, and women often controlled purse strings.

Contrary to English law at the time, when a woman married, her property did not automatically become her husband's. Abu Talib Khan argued that men customarily turned over their wealth to their wives who could "annihilate in one day the products of a whole life." He argued that in Asia husband and wife "share in the children by law . . . if a divorce happens, the sons go to the father, and the daughters to the mother." He pointed out the cruel reality that in England, should a

divorce occur, the mother, "who for twenty years may have toiled and consumed herself in bringing up her children, has to abandon all to the father." Asian women, he added, "have separate apartments for themselves, and have not to make their time and convenience suit that of their husbands." Their ultimate power, Abu Talib Khan reminded the world, was that, paralleling the Valida Sultana, women had charge over the children, who were the future.

Mary's arrival at the Seraglio to meet the Valida Sultana was orchestrated to perfection except for one slipup caused by the jealous interference of the black eunuchs. These black eunuchs, who guarded the women ensconced in the harem, escorted Mary from the sea to the palace. There, women in beautiful gowns bearing incense led the way, and she was offered a private moment to compose herself before her meeting with the Grand Seigneur's mother. Hanum joined Mary, offering moral support. Mary was handed a looking glass and noticed that it was covered with large pearls and diamonds. She studied her appearance and was offered refreshments before she was conducted to the Valida's chambers. According to protocol, the sultana, like her son, would not directly address any visitor. Mary was prepared for this custom. She made three bows and instructed Madame Pisani, the wife of the embassy translator, to read her speech.[1] Hanum then repeated the speech to the Valida Sultana. The Valida had prepared a speech, and the same process was reversed. The Valida then asked Mary to sit on a little sofa opposite her.

The Valida then astonished the ladies by speaking directly to Mary. Mihrisah explained to all in attendance that she had requested this unprecedented meeting. The first thing Mary was made aware of was that, as with her experience with Lady Hamilton in Sicily, jealousy had interfered with her day. The Valida Sultana was furious that Mary had traveled in a small ferry when she herself had expected Mary in her state boat. Apparently, the eunuchs had tried to sabotage their meeting by giving Madame Pisani incorrect instructions. The Valida Sultana

said she wanted all the world to know of the Ottomans' "obligations to the English . . . that they hoped Elgin was to remain here, for that his superior sense, prudence, and abilities, added to his friendship for them, had been of the greatest utility to her Son."

Dinner was served in the gardens. Mary was served on fine Dresden china with gold knife, spoon, and fork. The other women sat on low cushions and all waited on her as a sign of respect. Aware of the intricate etiquette, she explained that her lunch was quite unusual in that

even Yousouf Aga's wife waited upon me; I hope you remember Yousouf Aga is the Valida's Favorite. . . . She is his favorite wife, altho' he has six others, but he has promised if her son lived till he is ten years old, he will divorce and send away all the others. She has had eleven children, but only one is alive, the others almost all died of the smallpox; . . . I talked to her, and to another woman who is a great favorite, and confidential Key Keeper of the Grand Signior's, and really took a great deal of pains to explain to them all about the vaxine . . . and it ended by her saying if Yousouf would consent, she will send to me for Doctor Scott, and inoculate her son! What say you to that? If so great a person as her were to set the fashion amongst the Turks, it would certainly take.

The harem was notorious for its jealousy and gossip. The Key Keeper revealed to Mary that the harem rumor mill had spread the word that she and Elgin were "very fond" of (sexy with) each other. The women were longing to get a close look at her, and they understood from the sultana's own behavior that each and every Head Maid of Honor was to take a turn serving the beautiful young Englishwoman. When luncheon was concluded, the women returned to the Valida Sultana's quarters on the third floor, where Mary received another unexpected act of kindness and deference. The Valida Sultana asked Mary to put on a shawl. As no person was ever allowed to appear

before the Valida Sultana in a shawl, the women were aghast. Mary described the scene:

> She was dressed in an ermine pelisse on a pink silk . . . with a beautiful scarlet shawl embroidered with gold spangles flung over her. . . . The Valida had not an immense quantity of diamonds on, but what she had were thumpers; she had about eight excessively large table diamonds on her head, I never saw any near as large, and on her little finger, she wore the finest and largest brilliant by far, that I ever saw—much larger I think (excuse a traveler!) than the 12,000 pounder we saw at Bridge and Rundles! On a cushion by her, lay a watch covered with diamonds, and an inkstand, and a large portfolio studded all over with rubies and diamonds, also a smallish round thing covered with precious stones, which I fancy was a looking glass.

The ladies of the court were also finely dressed. Out of respect for their Valida Sultana, etiquette required that they not dress more splendidly than she, but they did wear gold- and silver-embroidered dresses. Many of the women wore large, round emerald drop earrings. They gave her packages for herself and Elgin, and her servants received money.

Once the sultana afforded Mary these uncustomary courtesies, her son followed suit. A few days later Elgin, too, was honored in front of the sultan who, in a clearly calculated break with tradition that mimicked his own mother's, stunned his audience when he spoke directly to Elgin.

> A thing that was never done before—looking at E. and making an inclination of his head. His speech was the most flattering thing possible, saying how much he was indebted to the English, and spoke very handsomely of all the officers and men who served in Egypt; desired E. would express his thanks to the King for having sent such

an Army, and then he paid E. a compliment approving highly of his conduct etc. etc. . . . E. was taken unawares, and had to return an answer to the Dragoman of the Porte in French, and he repeated it in Turkish; E. was then desired to make his made speech, which the Grand Signior answered, and then after that was finished, the Sultan again addressed himself to E.; paying him a very handsome compliment. . . . We had a great ball and supper after the audience, which went off wonderfully well, for the dancing continued till past 3 in the morning.

After the peace treaties were signed, Selim III ordered a weeklong celebration with fireworks reenacting the battle of Alexandria. Mary watched from her tiny boat, and she in turn attracted a good deal of attention:

I rowed about and looked at everything; the Caimacam, etc. etc. who were all in separate tents, bowed to me as I passed. . . . On the famous silver sofa, lay the Grand Signior, surrounded by an immense number of attendants. . . . I did not know that all boats were prevented passing near him . . . I was in Captain Hilliar's boat, Elgin was in his tent, having a diplomatic conference with the Dragoman of the Porte . . . the Sultan looked amiable at us, and as soon as we had gone by, he took up his spying glass and looked at us. . . . In going by some of the kiosks in the Seraglio, the women pushed up the blinds and waved their lily hands at me . . . I suppose it was some of the women I knew; every creak was filled with Blacks, all over the Seraglio walls. . . . The last night of the fireworks, the Grand Signior sent all the Ministers a supper in their tents . . . he sent all the Corps presents. Elgin got three shawls and eight pieces of Indian Stuff; was not that very gallant? . . . I dare not write all in these publick letters. You cannot imagine what a dashy necklace mine is.

Elgin got shawls. Mary got a "dashy necklace." The climate was so friendly that Mary took it upon herself to go out among the populace and shop, sightsee, and experience the everyday life of Constantinople without fear. She climbed the Galata Tower ("a fag") and began to entertain Frenchmen released from prison. Among them was Colonel Sébastiani, a count and marshal; previously an enemy, and even more dangerous because he was Napoleon's cousin, Sébastiani was, Mary thought, handsome and *"tout a fait a la Mode."* After meeting this charmer, she decided that being "Ambassadrice" to Paris might actually be fun. Realizing that their wartime embassy would probably come to an end soon, they began to dream of visiting the sites they had been excluded from because of war. Mary wrote to her mother, "As for our stay here, we know nothing about it. I suppose we shall not remain much longer; I would rather be Madame L'Ambassadrice a Paris, I should really like that."

As autumn turned to winter, many British travelers arrived at the embassy, sharing in the mood of victory. The Elgins welcomed their dear brother Andrew, from India; he had married an English girl he had met there, Miss Dashwood. Elgin and Mary had permission to visit Egypt, which excited Mary, though she was tormented because she would have to leave her children in Istanbul, but that plan was dashed because the sultan begged them to stay. They sent an envoy instead and continued to enjoy Selim's hospitality. Mary realized that Sultan Selim III knew that only a diplomat of Elgin's skill could handle this shifting political climate. Relations with the European countries, now that peace with France had been struck, had become sensitive. For Elgin, there was additional stress. Not only did he have his professional duties with the ministers from Prussia, Russia, and Spain, but he also had to contend with their sensitive wives, who all wanted Elgin's attention and certainly Mary's presence at their dinners. Mary wrote home that Madame l'Internonce came to her in tears one evening when Elgin,

whom all the ladies thought handsome, escorted Madame Tamara to dinner instead of her. Mary explained their own protocol and comforted this woman with the explanation of "duty." She found great humor in their infantile squabbling.

Mary, once again, went into practical mode. They left the French palace and returned it to its former occupants. With stabilized relations, the ever changing winds of English politics, and the feeling that his job had been accomplished, Elgin began to think about returning to England. Mary began to dispose of things—including the house they had purchased in Büyük Déré. She negotiated with the Levant Company to purchase it for their representatives. She did regret that they would probably not get to live in the "Broomhall" they had created. It would take years to complete, and some other English ambassador would get that privilege. She received communiqués and letters about the Nisbets and sent notes to her mother to select china, fabric, and furniture for their return to the Broomhall in Fife, longing for the day that she would live peacefully back home with her husband, children, and family around her.

Mary had one more favor to ask of the Ottoman rulers. It was an audacious request but it meant more to her than necklaces and gowns—which she could have purchased herself. She wanted the release of 136 Maltese slaves whom the Turks had held in captivity for over thirty years, and on January 17, 1802, she was granted that extraordinary gift. "I never felt so delighted in my life; what perfect happiness to redeem so many poor creatures from everlasting slavery. I could not sleep all night for joy. Oh! Mother it is worth being in this situation to do such an act; it is a thing which will be a comfort to one all one's life." To the Dowager Countess she wisely gave her husband the credit for this remarkable event and respectfully bowed to his accomplishments. She knew her mother-in-law would be justifiably proud when she supplied this older lady with the account. Elgin had shrewdly made it seem as though it was the Captain Pasha's own idea

when they presented the petition for the release of the Maltese slaves. Mary was overcome with emotion when the slaves appeared at her palace to pay tribute.

Masterman took Bruce to the window and they all with one accord took off their Hats to him and he kissed his hand to them. Elgin spoke to them and sent them to Mass, people who were there said it was the most affecting sight they had ever witnessed seeing them go into the Church. Afterwards they ranged themselves on the English Palace ground, and when we went in state to lay the foundation followed by all the English & our Servants in full Livery, they gave us three Cheers with every possible expression of delight . . . even the Russians who are particularly jealous of our success in anything, came & really wished us Joy as if they meant it. . . . It is a pleasing reflection that in consequence of this act of the Pasha's he has been induced to liberate near Twenty more Slaves for whom different Ministers have applied and paid for . . . their freedom may be looked upon as an additional Compliment to us.

Elgin and Mary gave each of the freed slaves a hat, trousers, and a jacket. She wrote her mother afterward, on Monday, January 25, "I have just finished my Italian lesson. Dearest Mother, you desired me to do two things; one was to liberate the Maltese and the other was to learn Italian. The Maltese are free! And I am learning Italian."

In February 1802, the Elgins' new house nearly burned to the ground, but fortunately, "we have made the most narrow escape," she wrote. Always finding the humor in every situation, Mary completed the picture of the entire embassy fleeing the flames: "Their attire bespoke more of the innocent simplicity of nature, than the gaudy luxury of an Ambassador's Court." She wryly noted that *now* she would have some good conversation material for the ball she was going to

attend that evening as "fifty buckets of water distributed with more zeal than judgement as much upon the carpet and furniture as upon the fire." Most of the houses in Constantinople did not have fireplaces and instead burned coals during the winter. Fires were an everyday occurrence. Mary had witnessed both the terror and beauty of fire in Constantinople: the regular destruction of wooden palaces called *yalis* along the Bosporus and the many fireworks that illuminated the sky to celebrate happy times. A thousand years before their arrival the forty-foot ivory and gold statue of the goddess Athena, taken from the Parthenon, had gone up in smoke when it arrived in Constantinople; some thirty years after the Elgins' tenure in Turkey, the British Embassy they had designed, and the French Embassy they had lived in, would also burn to the ground during the morning of August 22, 1831, when most of Pera's majestic Grand' Rue was enveloped in an "amphitheatre of flames."[2]

Mary was good-natured about the damage to the house because they had finally received permission from the British government to spend some time away from their duties. Despite all of the double-crosses, backstabbings, and incendiary accusations that had been hurled at Elgin during the Egypt campaigns, Mary wrote to her mother that he received

a very flattering letter from Lord Hawkesbury [the new foreign minister] saying how much Elgin's conduct was approved of etc. etc. etc.; and Colonel Murray says this last business that he has been engaged in with the Turks, relative to the French, will gain him great credit. It was a most difficult affair. . . . We might have seen the Seven Towers after all.

For two and a half years, they had dreamed of visiting the ancient sites where Elgin's artists were busy working, but had been denied the

pleasure. Elgin felt this trip would be his true reward—a bonus—for all of his hard work. This time, Mary decided to take the children with them. With peace established in the area,[3] and two robust babies in tow, they anticipated smooth sailing ahead. The fire, perhaps, had been a warning—smoke signals from the gods.

Chapter 11

SCUTTLED

The weather in Constantinople, surrounded by water, ranged from hot and damp to cold and damp. Mary reported that by October, the weather in Büyük Déré, on the Bosporus and near the Black Sea, was unpleasant. She wrote to her mother-in-law, "here the walls being of wood both the heat and the cold penetrate most shockingly & there are no Chimneys in the House." In *Travels in Turkey*, Dr. Wittman recalled that the winter of 1799–1800 in Constantinople was

warm and remarkably fine, similar to the weather in England in the months of May and June, but on [December] 27th, the chilling rains again set in. These sudden transitions are very frequent in Turkey, and certainly have a strong tendency to the production of disease. The rains continued to fall at intervals for several succeeding days, and the air became cold and raw . . . on the day of the new year, I was seized with rigors, accompanied by symptoms of fever. . . . Owing to the unusual severity of the weather, and the want of fireplaces, the practice of burning charcoal in the apartments to heat them . . . [people suffered from] headache, vertigo, nausea, and a violent throbbing pain in the temples [if they didn't perish from smoke inhalation]. (78–79)

Elgin wrote to his mother on February 13, 1802, "I cannot bear this climate—I have been confined the whole of three winters by inflammation in my head: effecting all of my face." In addition to his usual bouts of asthma, Elgin had suffered from relentless migraine headaches, rheumatism, and colds. Mary often had to conduct their public evenings alone while Elgin remained in bed. For the three winters, doctors had treated Elgin with the most popular remedy of the day—mercury.

The history of the use of mercury for medicinal purposes actually began in the East. The early Greeks did not use it. An Arabian physician known as Rhazes is identified as the proponent of using mercury externally; it was used as an ointment for everything from pimples to the boils resulting from sexually transmitted diseases. During the beginning of the sixteenth century, a doctor called Paracelsus introduced the internal use of mercury for the treatment of syphilis. Despite contemporary theory, mercury, when ingested, did not cure sexually transmitted diseases. Syphilitics continued to transmit the disease, exhibit symptoms, and die.

British doctor Thomas Dover liked to claim responsibility for popularizing the use of mercury internally. Dover, the first Englishman to receive an honorary M.D. from Yale University, in 1723, had wide credibility, but he had actually been preceded by another English doctor, Dr. Turner, who in 1717 introduced internal use of massive doses of mercury for all kinds of chronic illnesses. As Dr. S. O. Habershon wrote in his book, *On the Injurious Effects of Mercury in the Treatment of Disease* (1860), "our text-books recommend mercury in almost every disease." England received its mercury from the East Indies. It was offered in many ways: "mercurius saccharatus" (mercury with sugar); "pitulae mercuriales" (with honey); a blue ointment called "mercurial cerate" (with balsam), favored by doctors at London College; and a green plaster, the preference of doctors in Edinburgh.

At the end of the eighteenth century and the beginning of the early

nineteenth, other frequent treatments for "whatever ailed you" included amputation and bleeding, often using leeches. Mary wrote to her mother-in-law that a well-known doctor stationed in Constantinople, a friend of Elgin's sister, Charlotte, had "remedies . . . much more alarming than the complaints, he talks of cutting off legs & arms and scooping an Eye out of its socket as quite a matter of course." Mercury, then, seemed to be the most benign treatment. Like the other two procedures, mercury was thought to have purgative properties—and it did. It, too, cleansed the body. Much like pouring acid into the tank of a car, mercury burned the insides, causing the patient to sweat, produce stools, and urinate profusely. In addition, this corrosive effect caused membranes to collapse, boils to appear on the skin, and in more severe cases, where there was prolonged exposure to the metal, convulsions, memory loss, an enfeebled nervous system, epilepsy, and occasionally death.

Despite rumors spread by Elgin's enemies, his reason for taking mercury had nothing to do with having contracted syphilis. He lived a long and very sane life, and his wife, Mary, showed no signs of ever having contracted syphilis from her husband. She continued to maintain sexual relations with him, and, in fact, in early 1802 she was pregnant again.

Not feeling very well herself in the early stages of her third pregnancy, Mary wrote to her mother-in-law the dreaded news that her son had suffered "one violent cold after another [and] not-withstanding every precaution has been used an inflamation has settled in his nose." The mercury had begun to eat away at it. Mary wrote to her mother-in-law, "He is amazingly reduced by the constant blistering and bleeding at this moment he has got on his throat two blisters that are to be kept open; he lives entirely upon Milk." Elgin wrote to his mother that "my health inevitably gone for-Ever—I speak after a hard fight of five months during which I have not been out above a few times, and latterly very ill." He confided to his mother again that he was anxious to leave Constantinople. He thought that travel to a warmer climate

might help him recuperate. In fact, Dr. Wittman accompanied a group
to the temperate island of Scio (Chios), where

> we paid our respects to the Turkish commandant, and to the British
> consul, Signor Giovanni Giudiuchi, who was so obliging to procure
> us an excellent house belonging to the Franciscan convent, which
> had been selected for the residence of Lord Elgin, his Lordship
> being shortly expected at this island for the recovery of his health.

On March 11, 1802—their third wedding anniversary—Mary wrote
to her parents that the handsome young Elgin had become permanently
disfigured. To cure his blistering nose, the doctors cut off the tip. "I am
very miserable about Elgin I dread his nose will be marked, as yet the
Doctors do not think the bone is touched, and they hope to prevent but
they do not say they positively can save it. The idea alone of such a thing
makes one wretched."

On March 25, she wrote the Dowager Lady Elgin, "The under part
of his nose is cut, I think a small mask must always remain."

Again, proving false the rumors that Elgin's nose had fallen off as
a result of a venereal disease, Mary's letters documented that Elgin's
unfortunate deformity was caused by what we would today denounce
as medical barbarism: first, the prescription of mercury, which caused
the blistering, and then, the amputation of the tip of his nose as a
preventive.

Tragically, Elgin continued to follow his doctors' advice and drink
mercury, "and they think it agrees with him," Mary wrote her parents.
She insisted that everyone thought that the best medicine would be
leaving for that warmer climate, "but I dread his catching cold going on
board." On March 31, they packed up the children for this long-desired
excursion and sailed through the Straits of the Dardanelles, leaving
Constantinople. The whole family was on board—Lord and Lady

Elgin and their two small children, Lord Bruce—who was just about to turn two—and little Mary, barely six months old. Little Mary was, as Mary liked to write, fat and robust. Little Lord Bruce, on the other hand, often suffered from colds and asthma like both his parents. He was treated with "sweet mercury."

Chapter 12

AWASH IN
ANTIQUITIES

Mary was devastated by her husband's disfigurement. She wrote to her mother that she was "perfectly unhappy about Elgin. . . . My only comfort is my Bratts." As they traveled to Athens, Mary longed to be her parents' shadow, to feel their comforting presence and be where they had been the year before. She wrote to her mother that they had sailed with a small flotilla, as pirates were everywhere. The Maltese slaves, soon to veer off on their way home, were on one boat. She, Elgin, the children, their *paramannas*, her maid, Masterman, and Dr. Scott went in another vessel, and Mr. Hunt, Colonel Murray, and others went in an English brig. When she could stand no more of the rocking, Mary got off her ship for one night, leaving the children on board with their *paramannas* and the doctor. Elgin would not leave her side, and they pitched a tent, lit a fire, and slept in a cave, which she confided was "very romantic." On land, they journeyed by ass—quite difficult for a pregnant woman—and apparently impossibly uncomfortable for little Mary's *paramanna*, whom Mary, in her letter, named "Fatty." Fatty, Elgin, and Dr. Scott walked, and somehow six hours later they all converged in a village where they spent another adventurous night assailed by fleas.

Finally, on Saturday, April 3, they arrived in Athens at eight o'clock in the evening and stayed at the English consulate. The English consul had been given the title Logotheti, which allowed him to collect revenue for the church. His real name was Ioannis Stamou Khondrodimas, but the Elgins called him "Logotheti" and his wife "Madame Logotheti." Mr. and Mrs. "Logotheti" offered the consulate to his excellency the ambassador extraordinaire, and the ambassador's family and staff while they looked for temporary quarters elsewhere. That gesture was one not only of tribute but also of strict protocol; and one year earlier, out of respect for Lady Elgin, the Logothetis had extended the same hospitality to the Nisbets, and that visit was commemorated with portraits. Mary was thrilled to arrive at a house where she felt her parents' presence. "Do you remember the pictures in the room next to your bedroom here? Bruce always shews us Grand-Papa and Grand-Mama; he never fails drinking your health every day." She wrote, "I am now writing in the very room my own dear Mother used to write to me from." On April 8, she hosted a Grecian Ball and, once again, was instantaneously popular. "We had a ball here the other night like those you used to have; how I like to hear them talk of you and my Father, they are really fond of you; Madame Logotheti wears your locket constantly, it is such an old friend of mine; I think I feel rather jealous when I see it on her neck." She reported on how she had arranged them all comfortably into the house:

I have made Hammerton's room the nursery; did you ever go up the outside flight of stairs? We have repaired the long room and put my piano forte into it, and we breakfast and sit reading, writing, or arranging medals in the gallery; I have put a gate upon the top of the stairs, so there is a fine airy run for Bruce . . . tonight we drove to the Monastery of Daphne where you rode, and went all over it; I feel to know everything you thought and did here.

Mary tried to trace the Nisbets' footsteps and visited the Bath as they had done. Afterward, she inquired, "Had you dancers, singers, and tambourine players . . . the dancing was too indecent, beyond anything—Mary shall not go to a Turkish Bath!" She met with their artists working in Athens on Elgin's behalf, and they, too, reported on where the Nisbets had gone, so that Mary could continue in their shadow. Lusieri told Mary that Mrs. Nisbet liked to "go almost every day to the Pnyx," a hill to the southwest of Athens. On her twenty-fourth birthday, she wrote that she would see everything she could, go everywhere she could, and get all the work done that her husband required as "I feel no inclination to pay a second visit to Greece." She wanted to go home and return to the comfort of her own family back in England.

Once again, she observed everything on her tour in order to provide her family with the requisite entertaining travelogue. She went to Corinth, Argos, Delphi, the Cave of Trophonius in Lebadea, and stopped at the plain of Marathon. She enjoyed visiting the "wonders," the Island of Salamis and Mount Aegaleus where Xerxes' throne was placed, Eleusis, and the ruins of the Temple of Ceres; "the Statue of Ceres," she wrote, "which was in the town, was sent to England last year by Mr. Clarke." She rode "round the walls of Megara from whence we had a very good view of Parnassus covered with snow." They dined at Crommyon where Theseus killed "the Sow," and then stayed at the palace of the governor of Corinth, where they viewed the

commencement of the wall which crosses the Isthmus, separating Greece from the Peloponnesus . . . we then went to the Amphitheatre, and entered the Caverns under the seats where the wild beasts used in the combats, used to be kept . . . we saw seven columns of the Doric Order, some say they belonged to the Temple of Venus, and others call it the Sisypheum.

Her reputation had preceded her. When they arrived at the bey's palace, women of two harems, Bekyr Bey and Nouri Bey, had assembled in

> kind of covered boxes, two of which are slung across a mule like Gypsies panniers, with a lady in each; over them are curtains of scarlet cloth to prevent the people seeing them. . . . The women got hold of Masterman, took her into the Harem and begged of her to persuade me to go to them. . . . I went and was most graciously received by them. I was deluged with rose-water, then perfumed, and afterwards presented by a woman upon her knees with sweetmeats, water and coffee.

On the sixth of May, they left Corinth and reached the Temple of the Nemean Jupiter, where she observed that *"we antiquarians"* believed that entire blocks of stone that had fallen to the floor must have done so during an earthquake. As she had made notations in her childhood diary of the natural world around her, Mary now reacted to the impact of time and weather on the ancient sites. In fact, she was a natural archaeologist.

She was some five months pregnant as she traveled over mountains and very rugged terrain in very hot weather to see some sites (whose fame had varying stories at best). After visiting the plains of Argos, she traveled to "a stupendous vault, which is supposed by some to be the Tomb of Agamemnon, and by others, the Treasury of the Kings of Mycenae." In her condition, she crawled through the hole to enter and reported that they actually measured "the architrave of the door . . . twenty four feet long, seventeen feet thick and near five feet high." In contrast to her daring, Logotheti's son, who was charged with accompanying her Ladyship and her maid into the wilds of Greece, "refused to follow me into the second vault—I saw the bristles on his skull were erect at crawling into the first vault."

Accompanied by "very numerous Turkish and Greek Escort, as well

as an Albanian guard in the dress of the ancient Macedonians," Lady Elgin arrived at Aklatho-Cambo, a picturesque, "exquisitely beautiful" place, replete with nightingale-filled groves and lovely "lassies." These lovely young ladies, however, "possess none of the native simplicity you would have expected to have met with in such an out of the way place; they are declared to be the most dissipated ladies in the Peloponnesus." On the ninth of May, a covered litter arrived to carry Mary; a gift from the pasha, it was the kind of transport only used by the pasha's sultanas. Mary, Countess of Elgin, reacted to all of this reverence with her typical irreverence. Her van

was carried between two mules and guided by six men in the manner of a Sedan Chair; in some of the very bad places the men actually took the mules up in their arms and lifted them over. I was in it once at this manoeuvre which I did not at all admire, and begged to be let out the next time.

Masterman and I lay in it our full length, vis-à-vis to one another (like a sofa with fine embroidered scarlet cushions in it, covered all over with scarlet cloth trimmed with gold fringe, and ornamented with large gold tassels)—with two large lattice windows which I took the liberty of opening.

A Black, who was the principal manager of this tarta-a-van, seeing Elgin coming up to speak to me, beckoned to him not to come up on that side because it was opened but to go to the other where the lattice was closed. Blacky took great care of me and did not allow the foxes to peep.

The method of getting into the tarta-a-van is, a man lays down and one steps on his back—would you like that? In Turkish they call him "The Step"!

As they forged on to Mycenae and the ancient theater of Epidaurus, Elgin received permission from the pasha of Nauplia to remove antiq-

uities from Mycenae, Corinth, and Olympia. At Elis, they were given parade horses, sable and ermine pelisses, and other luxurious offerings. She acknowledged, "I can assure you such a journey is an amazing undertaking for a woman . . . one day we were 11 hours over roads you would think it impossible a horse could keep his feet, upon the side of steep precipices with immense stones. I am much gratified I had the courage to do it." Lady Elgin's travelogue was certainly like none other. Other Western travelers had written of and sketched the sites of villages and ancient ruins, but Lady Elgin's vantage point was unique, like the view from Mount Olympus, because everywhere she went, she was treated like a goddess.

Deeply moved by it all, she decided nonetheless that when they returned to Athens, she would remain there instead of accompanying Elgin on to Thebes. Elgin's lifetime dream of a journey into the past consumed his heart, but Mary's own heart lay in the present. Despite worldwide public adoration, the celebrated Lady Elgin longed to hold her own "dear Babs"—to fuss over them at mealtime, playtime, and bedtime. So Mary "persuaded him to go, as I think it will be a pleasure to him all his life afterwards; but he did not like leaving his Dot!" Good thing he did though, as the ever practical Mary was probably the only person on earth who, at this point, could make his dreams come true.

THE ACROPOLIS:
CAUTION TO THE WIND

In the middle of May, Mary was once again in Athens, where she performed her duties as wife, mother, and ambassadress with her usual energy and cheer. British ships came and went and, although Elgin was away, Mary hosted every visiting captain at the consulate. One in particular, Captain Hoste of the *Mutine*, was about Mary's age, a frequent guest in Constantinople, and a favorite of Lord Nelson. He arrived in Athens near death, and Mary, genuinely fond of him and concerned for his health, thought him poignant as he chatted with her about his parents, whom he had not seen for nine years. She felt great sympathy for him because he, like she, was homesick, and so she continued to send him notes of encouragement until, almost miraculously, he recovered. Her friendship and thoughtfulness would not be forgotten. Alone in Athens, she focused on her children and her role as a helpmate to her husband, whose artistic venture on the Acropolis had mushroomed. Elgin's artists, who had arrived to draw and record the beauties of the ancient world, were now in the process of dismantling it. Mary would call on her friendship with Captain Hoste to help her in a labor of love.

In 1802, while the population in Constantinople was in the hundreds of thousands, there were barely one thousand people living in Athens. The Acropolis was largely a slum with shacks festooning its hillside. To

assert that the Parthenon stood serenely at the summit of the Acropolis untouched for two thousand years until that time is simply untrue. In fact, this gleaming white Pentelic marble temple, the heavenward symbol of triumph, superiority, and divine protection, stood over nearly two thousand years of debris and had become the premier target of invaders almost from the moment she crowned the Acropolis.

The Parthenon was erected in the fifth century BC to celebrate the end of a period of struggle with Persia. The temple was dedicated to Athena, the protector of Athens and its artisans. Every year in July, Athena's birthday was celebrated with a festival called the Panathenaia, and every four years, the Great Panathenaia, whose thrilling procession of chariots and champions is commemorated on the Parthenon frieze, drew the finest competitors in horsemanship and athletics.

At the end of the fourth century AD, Alaric the Visigoth and his soldiers sacked Athens and caused huge destruction to the Acropolis some twenty years before their pillage of Rome. In the fifth century AD, Christians gutted the east end of the Parthenon to create an apse and constructed a bell tower. In 1458, the Turks attacked and reconfigured the church into a mosque, transforming the bell tower into a minaret. The Turks used the sacred site as a powder magazine, and when, on September 26, 1687, Venetian soldiers shelled her, the Parthenon exploded. General Morosini and his soldiers seized the moment and sacked the place. Even the Danes lopped the heads off metopes in 1688, and these can still be seen in the museum in Copenhagen. The Vatican has chunks from the west pediment; the French have an entire collection in the Louvre and some in Strasbourg. Pieces of the Parthenon are on display in museums in Würzburg, Heidelberg, and Munich; the Austrians host a collection in Vienna. The Parthenon was eviscerated by target practice, ravaged by storms and earthquakes, and used as a bathroom; tourists frequently vandalized portions by carving their names or hacking off souvenir fragments.

In the seventeenth century collections of Greek antiquities began to

appear in some of the great country homes of England. The Earl of Arundel, the Duke of Buckingham, the Earl of Pembroke, the first Duke of Devonshire, and even King Charles I were avid Hellenophiles. The French, led by the Marquis de Nointel, joined in this interest in classical Athens. Nointel preceded Elgin by almost 130 years when he brought his own artist, Jacques Carrey, to sketch the Acropolis. Carrey's illustrations, executed around 1674, predated the Venetian bombardment by some thirteen years, and thus he provided the world with a fairly accurate record of what the Parthenon looked like before the explosion. Englishman George Wheler wrote a detailed account of his own journey to Greece in 1682. In 1697, John Potter, later the archbishop of Canterbury, published *Archaeologia Graeca*, which was republished again and again, the seventh edition appearing in 1751.

In the early eighteenth century, Lady Wortley Montagu wrote to her friends advising them that the rush was on to bring home pieces of ancient artifacts from the classical world. In one letter to Abbé Conti (written on May 17, 1717), she informs him that "you will expect I should say something to you of the antiquities of this country; but there are few remains of ancient Greece." She was amused and annoyed that local entrepreneurs would try to convince Christian travelers that pagan relics were Christian icons in order to make a sale. Lady Wortley Montagu wrote that she had purchased some for the fun of the acquisition:

I have a porphyry head finely cut, of the true Greek sculpture; but who it represents, is to be guessed at by the learned when I return. For you are not to suppose these antiquaries (who are all Greek) know anything. Their trade is only to sell. . . . They get the best price they can for any of them, without knowing those that are valuable from those that are not.

In 1732, the Society of Dilettanti was founded in London by a group of prominent men who were also interested in classical Greece.

Among its members were the Duke of Buckingham, the Earls of Oxford, Carlisle, Burlington, and Harcourt, the first Baron Carteret, Sir Andrew Fontaine, Lord Robert Montagu, Sir James Gray, and William Ponsoby. These men were able to spend small fortunes on the study and acquisition of artifacts. The society sponsored the adventures of James Stuart and Nicholas Revett who published, in 1748, *Proposals for Publishing an Accurate Description of the Antiquities of Athens* and, in 1762, *The Antiquities of Athens,* which were so widely and well received that a second volume of *The Antiquities of Athens* came out in 1787. In 1764, the Dilettanti established a fund expressly for archaeological study in Greece. Other notable collectors of Greek classical art included Prime Minister Robert Walpole and King George III. The Comte de Choiseul-Gouffier, a French marquis, published *Voyage Pittoresque de la Grèce* in 1782, which also fueled interest in traveling to places not included on the Grand Tour. Choiseul-Gouffier, as Louis XVI's ambassador to the Ottoman court, received permission for his own artists to investigate the Acropolis. In 1786, the English Countess of Craven traveled throughout the Ottoman Empire recording her impressions in a collection of letters to her future husband, the Margrave of Anspach. Three years later, these letters were published as *A Journey Through the Crimea to Constantinople.* During her visit to the Sublime Porte, Lady Craven was a guest of Ambassador Choiseul-Gouffier and was escorted around the sites for her pleasure. At the Acropolis, noted that a "quantity of beautiful sculptures" were in pieces all about the ground, and she longed

to have permission to pick up the broken pieces on the ground—but, alas, Sir, I cannot even have a little finger or a toe . . . the Ambassador . . . had been a whole year negotiating for permission to convey to Constantinople a fragment he had pitched upon. . . . The sailors were prepared with cranes, and everything necessary to convey this beautiful relick on board the Tarleton; when after the governor of

the citadel, a Turk, had received us with great politeness, he took Mr.
de Truguet aside, and told him unless he chooses to endanger his life
he must give up the thoughts of touching anything.

When Lord Elgin arrived as the new ambassador to the Ottoman
Empire, he requested the same courtesy that had been extended to the
French ambassador. He wanted permission for his artists to examine
the Acropolis and sketch what they observed.

Although the Elgins had arrived in Turkey in November 1799, it
was two and a half years before they were able to visit their own work-
ing artists in Athens; it was, in fact, the Nisbets who, in the summer of
1801, after having spent a year in Turkey, first made the rounds on their
way back to England on behalf of their daughter and son-in-law. Hav-
ing been less than lukewarm about Elgin's project until they actually got
to the ruins, they began to immerse themselves in their son-in-law's
undertaking, and all three became his cultural collaborators. On July 9,
1801, Mary wrote to her parents that they had received permission, a
signed "firman," from the sultan authorizing Elgin to remove marbles
from the Acropolis. The firman was a well-known letter from the sul-
tan to all local pashas with instructions to provide its bearer safe pas-
sage and any other particular necessities detailed within.

I am happy to tell you Pisani has succeeded *a merveille* in his *firman*
from the Porte. Hunt is in raptures, for the *firman* is perfection, and
P. says he will answer with his whiskers that it is exact. It allows all
our artists to go into the citadel, to copy and model everything in it,
to erect scaffolds all round the Temple, to dig and discover all the
ancient foundations, and to bring away any marbles that may be
deemed curious by their having inscriptions on them, and that they
are not to be disturbed by the soldiers, etc., under any pretence what-
ever. Don't you think this will do? I am in the greatest glee, for it

would have been a great pity to have failed in the principal part, after having been at such an expence.

Thanks to the encouragement and prompting of the Reverend Philip Hunt and Mr. and Mrs. Nisbet, Elgin's project took on a wider scope. Since the Nisbets were willing to add their financial support, additional monies could be used to erect scaffolds and pay local workers to help remove sculpture. The removal and transport of the pediment sculptures, metopes, and friezes from the Parthenon resulted in loads that most captains were unwilling to deal with. They were so heavy that naval officers frowned and refused to haul them on board. Lord Nelson, for that very reason, told Elgin to use his own ship, the *Mentor*, which Elgin had constructed from his own (Mary's) funds and placed at the British Navy's disposal for the Mediterranean wars. Despite Elgin's generosity, Nelson would not provide one single ship in His Majesty's navy to carry home any bit of marble. Mary decided to override Nelson's veto and called on her old friend Captain Hoste. She was happy to report to her husband on May 19, 1802:

In the morning I sent a *very civil* message to Capt. Hoste. . . . I then coaxed over the Lieut. To prevaile upon the Captain to take the Three large Cases you saw in the Magazine, I told him they were seven feet long he gave me little hopes, as it was impossible to put any thing above 3 feet long in the hold—I then found it necessary to use my persuasive powers, so I began by saying as the Capt. Was going straight to Malta & there being no Enemies to encounter I ventured to propose his taking them it would be doing me a very great favor as you were extremely anxious to get them off & I sh. Feel so proud to tell you how well I had succeeded during your absence—Female eloquence as *usual* succeeded, the Capt. Sent me a very polite answer & by peep of Day I send down the 3 Cases!

As the captain could not ride due to his weakened condition, Mary sent her carriage to bring him to her own home, where she placed him on the sofa, gave him a novel to read, and served him warm milk. Her solicitous treatment worked. She wrote, "He saw the 3 Cases at ye waterside when he came up; having got them safely off my Hands, I next set to work to see if I could not contrive to get away something *more*. What say You to Dot?" She continued, "I have sent for Lusieri to know if he has any thing that we can send on Board if there is I shall set to work with the greatest vigor you may trust me for not being indifferent to any thing I now think my Elgin would like." Elgin was well aware that when his wife set her sights on accomplishing something, it was always done "with the greatest vigor" and usually completed with a higher degree of success than most any other person's attempts. Mary knew how to get things done. He had seen that time and again in Constantinople when she stood in for him, stood up for him, and stood by him.

Mary let him know that one day there was a holiday and no one wanted to work. She offered the men "Backcheses" (baksheesh—gratuities) which did the trick. She succeeded once again, astonishing Lusieri, whom she instructed to "pack up the Horse's head [the famous Horse of the Moon], the Urn & the stone that is in this house ahead, and the Captain will take that also for me."

Longing for her husband to appear in person, she wrote to him, "Give me credit for my exertion dearest Elgin for I have been very anxious to do as much as possible. . . . I love you with all my heart. Oh, never let us part again." She suffered an asthma attack as a result of his departure, took opium pills to relieve the pain, and persisted on his behalf. "I have got another large Case packed up this Day a long piece of the Baso Relievo from ye Temple of Minerva, I forgot the proper term, so I have by my management go on board 4 immense long heavy packages, & tomorrow the Horses head. . . . The two last Cases is

entirely my doing & I feel proud Elgin." Although she told him to enjoy his tour, she missed him desperately and felt that their hearts would be closer if she took charge in his absence. Ships were arriving daily, and Mary, determined to fulfill her husband's wishes, supervised the packing up of as many cases as could possibly fit on board the *Mutine*. She wanted Elgin to be removed from all anxiety about the project and assured him that "C.H. [Captain Hoste] is thoroughly convinced all your things will be taken great care of. . . . Do you think of me Elgin?" This letter was written over a two-day period and then followed by another letter begun soon after she dispatched the first. "Tho it is only four hours ago since I sent off a very long Letter to my beloved dear Elgin, yet I cannot resist saying again I love you dearly and I think if possible I love you better than I did the 11th of March [their wedding day]."

The following day, May 22, 1802, she began her updated correspondence with "Best & Dearest of Husbands" and reported that the *Anson* had arrived in Piraeus and it was larger than the *Phaeton*. She invited its Captain Cracraft to dine, and he arrived "without his Wig & looked like a young Man." Captain Hoste advised Mary not to place the marbles on merchant ships, as they would cost a fortune to send. "He thinks your Cases will be sent home in King's Ships." The job of circumventing Nelson was now remitted to Mary, and she proceeded to charm and to cajole His Majesty's naval heroes into loading the boxes on their ships. She wrote her mother-in-law, "You cannot think how well our Artists works have turned out & almost all our immence packages have gone on board Men of War, consequently have pd nothing. I thought all Elgin's Marbles got in free of the 3d a pound."

There was one more very important task for Mary. The local officials, the *voivode* and the *disdar*, were getting nervous. They saw the enormous quantities of cases at the dock and wanted to be assured that the sultan had authorized their excavation. Mary was in possession of a

second firman from the sultan that authorized further activity. "I told Lusieri of the firmans, he says nothing can be going on better than every thing, so for the present I shall lock them up." She was doing a splendid job for Elgin, but she missed him: "Come back to your Mary as fast as possible," she wrote, and added, "my mother says, Come home before there is a Willy on the road—Little she knows."

It was clear to Mrs. Nisbet, as it was to most people, that her daughter and son-in-law had a very sexually charged marriage, and although she hadn't yet received notice that Mary would have another baby in the early fall, she suspected that her daughter would be pregnant often. Mary, exhausted with her third pregnancy in three years, would have liked to return to England. Although the horse's head and cases from the Parthenon were on their way home, Mary could not make the journey quite yet. She had a job to do and there would be no other time to do it. It was getting very expensive for Mary, who had to draw continually from her bank account at Coutts in London, and that May she wrote for £10,000.

On May 25 she apprised her husband, "Know that beside the 5 Cases I have already told you of I have prevailed on Capt. Hoste to take *Three more* . . . do you love me better for it Elgin?" In the meantime, the local *disdar* was making noise about all of the marbles leaving the mountain. Mary assured Lusieri that he might, at the appropriate moment, advise the *disdar* that if the *voivode,* his superior, was at all uncomfortable with the activity on the Acropolis, Mary had the new firman and would show it to him. As these officials were well aware of the special favor accorded Elgin since the great victory and because of the unprecedented relationship Mary had cultivated with the Valida Sultana and Selim III, there was no reason to doubt her veracity; they were merely protecting their own interests. So the British consul, Logotheti, went to the *voivoide*'s to pay him £170 for a statue, and in return, the *voivode* sent Logotheti back to Mary with his compliments and the statue. She, in turn, sent a ring to the *voivoide* with her best wishes. She then wrapped up the statue and

some pots and pans and sent them all on their way. As the artists began
dismantling the caryatids, a column arrived from Corinth, which

> [I] had the impudence to ask Capt. H. to take on board. . . . I beg
> you will show delight/Lay aside the Diplomatic Character. . . . I am
> now *satisfied* of what I always thought; which is how much *more*
> Women can do if they set about it, than Men.—I will lay any bet had
> you been here you would not have got half so much on board as I
> have. . . . Come quickly back to your Mary she *Longs* for You.

While Elgin was still on his tour, Captain Hoste and the *Mutine*
sailed for Malta on May 29, and on June 2, Mary wrote to her mother,
"We yesterday got down the last thing we want from the Acropolis, so
now we may boldly bid defiance to our enemies. Captain Donnelly is to
take all our remaining cases on board the *Narcissus*." Unblinking and in
fact staring in the eye of controversy, Mary wrapped up Elgin's marbles
and sent them home, using her charm, her wit, and her own money. She
paid the artists and laborers, massaged the local—and very anxious—
politicians, took charge of her children, and involved herself in the wel-
fare of every visiting British citizen. Before her efforts in May 1802,
the only ship that had begun to carry home the massive pieces was
Elgin's own *Mentor*. Now, despite Nelson's dictate and the risk involved
to their own ships, Mary had established a precedent for other military
officers to carry the marbles on board. No one wanted to refuse Lady
Elgin.

Over the years, debate on the marbles would divide tastemakers, law-
makers, and average citizens. In 1806, American statesman and financier
Nicholas Biddle, himself a leading figure in a new democracy, bemoaned
the fate of Athens, once the shining light of freedom and now under
tyranny. On his visit, he observed intolerable cruelty perpetrated against
its citizens on behalf of the sultan and cried, "Where is her freedom?
Where are her orators?" to rise up against injustice. Biddle, who made

the acquaintance of both Lusieri and his French rival, Fauvel, proposed that the "little Turkish despot" gave both parties permission to remove artifacts with strategic forethought: a form of psychological warfare. Remove the heart of the city and you humble its people and demonstrate who is in control.

Athens presents every visage of desolation & despair. When I walk amongst her ruins & first recalling her ancient greatness meditate on her fall, the mind sickens over the melancholy picture . . . when I see her temple of Theseus which teaches us to admire the grand simplicity of a great people, her temple of Jupiter the most stupendous of all ruins; when I see all this I feel for the decline of human greatness.[1]

Biddle was furious with Lord Elgin for what he felt was taking advantage of a downtrodden people. Biddle further claimed that Elgin, might have redeemed himself if he had presented the marbles to Great Britain as a gift instead of later offering to sell them. Later, Biddle would make very unkind personal remarks about the Earl of Elgin, claiming that he should have drowned with his marbles when the *Mentor*, transporting a collection of them, went down at sea. He wasn't alone.

Some of Lord Elgin's own countrymen abhorred the deed the earl had done. In his diatribe against Lord Elgin, "The Curse of Minerva," Lord Byron, himself a Scot, advised the gods of ancient Greece, "Frown not on England; England owns him not:/Athena, no! thy plunderer was a Scot." He called Caledonia a "bastard land," which, as we have seen, was not an unpopular thought before the union of the two countries in 1707 and was naturally thought by some long afterward. The 1707 union had paved the way for alliances in industry and politics, but perhaps nothing pointed more to the success of the actual

merger of its people than the subconscious commingling and appro-
priation of cultural values. The hearts and minds that expressed the
notions of the Romantic Age included Sir Henry Raeburn, Lord
Byron, Robert Burns, and Sir Walter Scott, proving that the Scots
could suffer the same impractical excesses and enjoy the same passions
as any Englishman. In their grand, romantic, and excessive gesture,
Lord and Lady Elgin served as living examples of the intellectual trend
of the day.

William Hazlitt (whom Simon Schama calls "the greatest essayist in
the English language")[2] wrote that before the arrival in Britain of the
Elgin marbles, "Scotland seems to have been hitherto the country of
the Useful rather than of the Fine Arts."[3] Hazlitt, enamored of the
marbles, expressed the widely held opinion that the Elgins, who were
both Scots, had contradicted the expected. For if they, the Scots, were a
practical people who had little regard for beauty, why then would a
practical Scottish girl and her practical Scottish husband, schooled in
diplomatic restraint, undertake the wildly impractical and hitherto
unimaginable program of dismantling a six-story, two-thousand-year-
old landmark? What would make them throw all good sense to the
wind and move improbably colossal figures around two continents and
across an ocean? The answer is they were both romantics, products of
their times.

Elgin's own reason for collecting the artifacts was that he had an
intellectual and visceral passion for these timeless treasures. He felt that
by bringing the great works of art to Britain, he was rescuing history,
and instead of leaving them to wither and disintegrate, uncared for, he
was serving mankind. His intent was to make these great works of art
available to artists and educators and in a sense become a messenger of
time. That was certainly a romantic notion, and he appeared to be a
very romantic figure, a weathered warrior for Britain, slings and arrows
to his reputation, health, and appearance. Mary's reason was simple: the

Elgin marbles were sailing home because one young determined woman adored her husband. (For an account of Lord Elgin's activities on the Acropolis, see the appendix, the letter from the Reverend Philip Hunt to Mr. and Mrs. Nisbet published here in its entirety for the first time.)

Chapter 14

SAILING, SAILING

In the summer of 1802, Constantinople lay under the siege of warring pashas and the plague. The Elgins decided to alter their original plan of returning to a new house in Büyük Déré and wait out the storm. Instead they would continue, together, to visit sites of ancient import. On June 15, they left Athens for a cruise in the archipelago. On the sixteenth, they dined on the promontory of Sunium and saw the Temple of Minerva, whose "walls having fallen down, the light passing through the columns gives it a very lively look. It is built of white marble, the whiteness of which surpassed anything I had seen before," she wrote to her parents. On June 17, they saw the Isle of Helen, where Paris took Helen when he escaped from Sparta to Troy.

They visited Zea and were the guests of honor at the consul's house and slept at the home of the Neapolitan consul, "his house being the best in the place." The consul's daughters sang songs in Greek, Italian, and French and even danced the minuet to amuse Mary. Seven months pregnant, she mounted a donkey to ride the steep hills, for, as she described the place, "the City is bid on the summit of an almost perpendicular mountain, and in many places we rode up a regular stair cut out in the rock and hanging over a precipice." They went on to Marathon, where they visited Fauvel's excavations, sponsored by the

Comte de Choiseul-Gouffier. Even their sailors got the archaeological bug, and Mary reported that they went digging and came back to the ship with fragments of pottery and silver. Also in Marathon, they visited the cave of Pan whose nearby stream surrounded by oleanders and myrtles in flower wafted a lovely scent that made their visit remarkable. Elgin examined the plain of Marathon where so many Persians had perished in the famous battle in 490 BC. In July, they went on to Teno and Mycenae, where they were feted by local dignitaries. The trip seemed to agree with Elgin, and Mary wrote home to his mother that his health was greatly improving.

On the way to Delos, they were attacked by pirates who fired at the *Narcissus,* and Captain Donnelly fired above three hundred shots back. Mary reported that they were all delighted when the pirate galley sank and were relieved that no one on board the *Narcissus* was injured. They scoured the island for the bandits and captured their captain, Zachary, and twenty-three of their thirty-four-member crew. The Elgins and their companions took a tour of Delos, which Mary dismissed as "a desert, not even a shepherd on it." They sailed through a storm that made Mary sick, and she was very happy to disembark at Paros, where she saw orange groves, myrtle trees, fountains, and cascades. Elgin went to see the grotto of Antiparos, but the journey was too much for Mary, now in her eighth month.

On August 2, Mary wrote to her mother-in-law that when they arrived at Smyrna they found that Sidney Smith had spread negative propaganda about her and her husband. She was not happy to remain there, and as soon as she learned that the plague was over in Constantinople, she made plans to depart for their house in Büyük Déré. She wrote to her mother, "Such a number of children are dying of the hoping cough . . . I see numbers of poor little things go by every day; they dress them up with flowers and carry them open," and told Mrs. Nisbet the poignant story of one little girl on her deathbed. The little girl's father, an important Turk, was so beyond despair that he called the

Catholic priest, Père Luigi, and begged him to read the Christian Bible in hopes that the Christian God could cure his child if his own Muslim God would not.

She received the happy news that her parents had arrived in Calais and excitedly wrote home for suggestions on shopping in Paris for when she made her own journey home. Although Elgin yet had business to do in Smyrna and needed to stay there, Mary was determined to get out of the heat that Captain Cracraft had pronounced worse than that in India. Much to her dismay, the ships were being ordered to Alexandria and her journey would be over land, which for a very pregnant woman was a nightmare of discomfort.

Mary wanted to look forward and prepare for the birth of their third child. She and Elgin had decided to ask Lady Robert, Lady Charlotte, and Mr. Bruce to be godparents. Ever conscious of her public appearances, despite her extreme discomfort—on many occasions she came close to fainting—she decided to conquer Sidney Smith and his nasty stories with her usual panache. She sent for her diamonds, which Mr. Morier delivered, in order to dazzle the locals, and rising to the occasion, she entertained in great style. She, in turn, gained everyone's affection and became the guest of honor at the consulates and in the homes of local society. She reported with glee that at one party a handsome Englishman, captain of a merchant sailing ship, flirted with her profusely, to which Elgin responded, "Captain Francis, remember *I* am here."

She left Smyrna and, sadly, Elgin on the eighteenth of August, traveling with her maid, Masterman, the children, and their caravan of attachés, officials, artists, and secretaries in carriages. Elgin surprised Mary with the delivery of a letter for her to read on her journey. Just one day after they parted, she wrote to him, "Do you think of Me? Do you miss poor Dotty in the room when you go to bed?" En route, the heat was punishable and their vans turned over at least twice, but amazingly, Mary was unharmed. "Pray tell Father *I* manoeuvred the troops

consisting of 50 people for five days; the fifth day Elgin joined our party. . . . Hunt will tell you I am the best General ever was seen." The only enjoyable part of the trip was the hot baths at Brusa and their brief stay in Magnesia at the enchanting palace of Zaria Osmon Ogla, who waited to lavish Mary with hospitality.

On Saturday, September 4, they arrived at Büyük Déré. "We had not been in the house two minutes, before it was full of visitors," she wrote her mother, and now that the French were free, because of the peace, she wanted to inspect the prison where they had resided. She was invited to the fabulous new palace the sultan had built for Hanum, and in his happiness to see Elgin, the Captain Pasha presented him with the dagger that Napoleon had given to Murad Bey (the ruler of the Mamelukes). Murad Bey had, on his deathbed, presented the dagger to Osman Bey Tambourgi, whom he had wished to succeed him. It was set with rubies, diamonds, and pearls, but Mary pretended to dismiss its importance. "It is the oddest shaped thing I ever saw . . . I shall have a glass case made for it and put it on a pretty table." On September 23, Matilda Harriet, whom Mary would call "Harriet," was born, and at last Elgin received word that he could return to England.

Almost simultaneously with the birth of Harriet came the hideous news that Elgin's ship, the *Mentor*, had sunk off the coast of Cythera, the island where, according to legend, Aphrodite was born. On board were the Nisbets' gymnasiarch chair and other wonderful treasures. Elgin was frantic and communicated with ships in the Mediterranean, commanding their captains to come to the aid of his vessel. Hamilton had offered local sailors huge amounts of money, and divers went down to search for the antiquities. As they celebrated Harriet's christening with an underlying sadness, Mary noticed that in fact the plague had not disappeared from Constantinople. "By way of hiding it, they carry the dead bodies in Pera, by in the night time, which is so far lucky, one has the less chance of meeting them."

At Christmas, she wrote to her mother of her hope that "next

Christmas Eve we shall be all together—what perfect happiness that idea carries with it." She assured her mother-in-law that Harriet, like the other children, had been vaccinated. On January 17, 1803, the Elgin family boarded the *Diane* and left Constantinople for the last time. They sailed back through the Dardanelles and westward toward home. It had been three years and two months since they had arrived in Turkey. They were now a family of five, and they were returning with irreplaceable memories.

They stopped at Athens and said good-bye to the Logothetis after attending, in full jeweled splendor, the wedding of the Logothetis' daughter. They were pleased to see the progress that Captain Clarke of the *Braakel* was making with their cases. Clarke had remained in Athens for five weeks just to transport the Elgins' artifacts. Elgin's team of artists joined them for the return trip, but Lusieri remained in Greece to finish his drawings. Contrary winds sent them to Candia, where Mary saw lepers living in the streets. She had seen all the wonders and the terrors and was more than ready to go home.

As they passed the wreckage of their own *Mentor,* Captain Maling remarked to Mary that the ship would never again be seaworthy. While Elgin wanted to raise the ship and retrieve its contents at any cost, Mary was ambivalent. She confided to her mother that the search had "already cost an immense deal" and that any future diving scheduled for the spring would "cost a sad sum of money." When they disembarked at Malta, Elgin was ebullient and wrote his mother that he was thrilled to arrive in "Christendom." The moment they had all passed quarantine, they would be on their way back to Broomhall—where Mary had been mistress of the house for only one week four years earlier.

Chapter 15

THE CALM BEFORE
THE STORM

In the early nineteenth century Malta was, indeed, the outpost of Christendom. The Knights of St. John, also called the Hospitalers of St. John, had long served Christianity and were world renowned for building incomparable hospitals in places like Jerusalem and Venice. When in 1522, Muslim conqueror Suleiman the Magnificent expelled the Knights of St. John from Rhodes in order to irritate the Catholic Emperor Charles V of Spain, Charles responded by presenting the tiny but strategically located island of Malta to the Knights, who relocated there. Once settled on Malta, the Knights of St. John became simply known as "The Knights of Malta" and proceeded to build another hospital, their most famous. The island, under Napoleonic protection until Nelson's victory in Egypt, became a junction for English military, commercial, and political travelers. There, they would receive the excellent care of the doctors at the Knights of Malta hospital after having been exposed to exotic diseases contracted in Turkey, India, and Africa.

Quarantine on Malta became a kind of social event for English travelers, and when Mary and Elgin arrived with their children, they met old friends. In the two weeks they were there, Elgin's health grew stronger and he decided to change their plans; he informed Mary that they would not, in fact, return directly to England but travel through

Italy and France. This tour, denied English travelers for a decade, was now possible thanks to the March 1802 Treaty of Amiens. Elgin had been in contact with the foreign secretary, Lord Hawkesbury, who assured him that there would be clear sailing ahead. Elgin decided that this journey would be better spent without the children, so he arranged for them to proceed home by ship on the *Diana* with Captain Maling. Mary was furious and wrote to her mother that she hoped that Mrs. Nisbet would be "tempted" to travel to Portsmouth to claim the three young children—Harriet being only six months old. Dr. Scott was sent along. Mary instructed her mother to send all correspondence through Ambassador Lord Whitworth in Paris.

The Elgins blithely traveled to Naples and Rome, where they visited Lady Beverly, an old family friend. They headed north to Leghorn (Livorno) and Florence and crossed the Alps into France. Tension, however, was growing between England and France. Immediately after the treaty signing, Napoleon seized the advantageous moment and waged a public relations campaign with the Turks. He sent Sébastiani back to the East to resume relations, pointing a finger at the British who remained on Malta. As Napoleon wanted the British out of Malta in accord with the Treaty of Amiens, he used Sébastiani to make the Turks uncomfortable with their English allies. Sébastiani spread propaganda to the Turks implying that since the British would not evacuate Malta, they would probably invade Turkish territory next. The British countered by pointing out that Napoleon had violated not only the 1797 Treaty of Campo Formio by refusing to evacuate Germanic and lowland territories but also the 1801 Treaty of Luneville by annexing Piedmont and Elba. The British were not leaving Malta unless and until Napoleon demonstrated his intent to comply with his promises.

At the same time the Elgins were touring France, Napoleon began seizing British ships in French waters and confiscating their contents. In London, French Royalists and Bourbon sympathizers were taking advantage of the growing sentiment against Napoleon and published a

French-language newspaper called *L'Ambigu,* which featured a satirical portrait of Napoleon's head placed on the body of the Sphinx as its emblem. Napoleon was furious and ordered the publication of anti-British articles in the government-sponsored newspaper, *Moniteur.* In February, he summoned Ambassador Whitworth to a meeting where he screamed at the seasoned—and apparently unflappable—diplomat for two hours. In April, the first consul decided to settle his differences with the United States in the form of a practical real estate deal. On April 30, the Louisiana Purchase contract was signed by France and the United States, turning over some 565 million acres for less than three cents an acre. This act freed Napoleon of his responsibilities in the West, allowing him to focus on Europe and the East, and it also replenished his coffers with fifteen million dollars—money the young American government had negotiated through British bankers. In safe possession of the British-financed enhancement to his treasury, two weeks after the deal was struck Napoleon renewed his attempt to intimidate Lord Whitworth with histrionic rage. Once again, Whitworth responded coolly. He packed his bags and left Paris on May 12. Later, Napoleon reflected on that meeting and claimed that he had learned an important lesson. From then on, he would dispatch emissaries to talk with foreign ministers instead of dealing directly with them himself.

The consulate made no effort to notify British citizens traveling in France of impending war or of Whitworth's departure. On May 17, the British government ordered the detention of French ships in British waters, and on the following day, they declared war. The approximately fourteen hundred Englishmen who had been traveling or stationed in France were then prohibited from leaving France. Mary wrote to her parents that on May 27 Elgin surrendered himself as a *Prisonnier de Guerre.* The fourteen hundred or so *détenus* (detainees) were removed to twelve depots around the countryside—at Verdun, Sarre Louis, Givet, Arras, Valenciennes, Longwy, Briançon, Mont Dauphin, Cambrai, Sedan, Auxonne, and Bitche, whose horrible Castle

of Tears was anathema to frightened English captives. Of the entire group, there were about four hundred wealthy English tourists who were encouraged to spend their money in the towns where they were deposited, and for the most part they were treated as guests, but they could not leave France. Napoleon singled out about twenty VIP captives, mostly those with noble titles or political positions who he knew could be held for various kinds of ransom. These prisoners were allowed for the moment to live luxuriously in Paris until Napoleon decided their fate. Elgin was of particular interest to the first consul: he was both an aristocrat and a person of considerable political position, had a very high profile as ambassador to Constantinople, and was already controversial because of his excavation of the Parthenon. Lord Elgin thus became the object of Napoleon's especial vindictiveness.

Chapter 16

SHANGHAIED

The arrest of innocent civilians and a distinguished ambassador outraged the British and most of Europe. Parliament protested to Napoleon, but their complaints fell on deaf ears. The British scored a coup, however, gaining Bonaparte's attention, when they captured General Boyer, one of Napoleon's most talented officers. A rumor filtered across the English Channel to the French that Boyer was being tortured in an English dungeon. The French demanded revenge.

Napoleon sprang into action, making Elgin his scapegoat. There was a public relations opportunity here that the first consul did not want to miss. Napoleon and his foreign minister, Charles-Maurice de Talleyrand, had been made well aware of Elgin's persistent requests for the humane treatment of French citizens in Turkey through the testimony of Napoleon's own cousin, Colonel Sébastiani, now General Sébastiani, who had actually been among those thrown into the Yedikule prison. Talleyrand, however, advised Napoleon to disseminate false information to the public. The French public received a daily dose in the *Moniteur* of the evildoings of Lord Elgin. Rightfully indignant about this smear on his character, Elgin had nowhere to turn. Certainly Napoleon's propaganda machine would not print Elgin's side of the story, and all of his letters written home were opened by French authorities. Elgin

explained to Mary that any attempt on his part to try to smuggle any correspondence on the person of a friend would be counterproductive, ruining his already dim chances of returning home.

Mary received word that the children had arrived safely in England. She begged her parents to take them home to Archerfield, give them sweet mercury when they were ill, and have them tossed in the laundry baskets on the sand dunes on the bay as she had been when she was a girl. Mrs. Nisbet wrote that she was horrified at the lack of civility of the Greek *paramannas*, but Mary insisted that the children retain their beloved nurses until she herself returned. She also instructed her mother to encourage Bruce to speak Greek with his nanny and not broken English. The Dowager Countess of Elgin, who had never before laid eyes on her grandchildren, was so enchanted with the brood that she presented them all, Greek "savages" in tow, to King George III.

If there were any pleasures to be had that summer in Paris by Lord and Lady Elgin, they were the discovery that Mary was once again pregnant and Elgin's reunion with a childhood friend and neighbor, Robert Ferguson of Raith. Ferguson was three years younger than Elgin. Throughout the 1790s, while Elgin lived in Europe in service of his king, Ferguson had also expatriated, but for other reasons. A raging antimonarchist who believed devoutly in the works of Thomas Paine and Madame de Staël, Ferguson scribbled passionate invectives in his journals against the king and the tyranny of rulers. Although he had deep political convictions and often considered running for political office back in Scotland, he fled both what he considered an intolerable system and an uncomfortable family feud.

Ferguson and his younger brother, Colonel Ronald Ferguson, were the sons of William Ferguson, formerly called William Berry. Berry, the younger brother of Robert Berry, father of the well-known ladies Agnes and Mary Berry, inherited a family fortune from a rich uncle Ferguson that was intended for the girls' father. Robert Berry and his daughters were left only £10,000 of their uncle's vast £300,000 hold-

ings. Although William magnanimously added another £1,000 a year to their legacy, they called him "the usurper" and disdainfully accused him of undue influence. The truth was that Uncle Ferguson preferred leaving his money to the nephew who had sons. William changed his name from Berry to Ferguson in honor of the vast £300,000 legacy.

Young Robert and Ronald were raised on the great estate of Raith in Kirkcaldy, just a few miles northeast of Elgin's home, Broomhall. The vast Raith House stands on a five-hundred-foot-high hilltop reputed to have been the site of one of Macduff's castles. Its grand stables by Playfair rival the ones at Chantilly, France, and the commanding view across the Firth of Forth to the south, where the Nisbets' properties lay, stretched all the way to the Lammermuirs. Ostensibly, Robert could look across the river and see the beaches at Archerfield where Mary romped as a young girl.

Robert Ferguson was extremely fond of his female cousins and was very unhappy over the strained feelings between the two families. Already in frequent dispute with his father over what William Ferguson considered to be radical political ideas and declaring he had no intention of being "laird" of Raith, socializing with what he considered to be a vapid community of idle rich people, Robert Ferguson deserted them all and moved to Europe in 1793 to pursue his own professional interests.

Ferguson was a geologist and earned the respect of many leading European men of science, including the honor of having a mineral named after him. He traveled throughout Germany, Switzerland, Poland, Bohemia, Italy, and Austria, consulting with colleagues and observing engineering advancements in each country. One of his mentors was Georges Cuvier, France's most celebrated paleontologist and founder of "functional anatomy." Cuvier was also renowned in scientific circles for developing a new classification system that extended the work of Linnaeus by grouping related classes into phyla. Because Cuvier was so revered in France, he had considerable influence with

Napoleon. Emulating the monarchs of France, the first consul presided over *levées,* morning gatherings of the most interesting and accomplished men around him. Cuvier obtained entrée for Ferguson to attend these assemblies, which exposed Robert to the highest circles of intellectuals in France, and he relished spirited debates on all topics, from philosophy and history to politics, with men of such great mental prowess.

Although Ferguson and Elgin stood on completely opposite sides of the political spectrum, each man had great respect for the other. Both had achieved international acclaim in different fields, and although their reunion took place under less ideal circumstances, they were delighted to rekindle their old friendship. Mary wrote to Mrs. Nisbet that Ferguson was with them night and day. He was a bachelor with exquisite taste and, to please his frequent hostess, he bought her lovely porcelain cups. Mary, in turn, bought him gifts, taking special care in their selection because she felt he was exigent and "grand." Shopping and parties helped ease the tensions for the English aristocrats who convened in Paris that summer because they were, in fact, in limbo. Many of them went to Robert Ferguson for information and his opinion, and he proved a solid and knowledgeable adviser.

Among Napoleon's prized hostages were the Dowager Duchess of Newcastle, who was married to Colonel Craufurd; Lord and Lady Yarmouth; and an entire group of Scots: the Livingstons, the Tweeddales, Mrs. Dundas, a young Mr. John Craufurd, and a handful of others who constituted a tight-knit group of *détenus.* They banded together for social as well as political expediency. The Elgins took rooms at the Hôtel de Richelieu, where they, as always, entertained in great style. Sensibly, however, they decided that if their stay was prolonged, they would prefer to lease a house, which would be less costly. Daily walks, dinner parties, and visits to French people of influence became routine. Mary sent Masterman home and began to scout for local servants. Other Englishmen, who did not have considerable for-

tunes to turn over to French shopkeepers and craftsmen, were held in less esteem and placed in situations of considerable deprivation in the depots in Verdun and elsewhere.

Napoleon privately acknowledged that he knew of Elgin's fairness in Turkey but that he "was now convinced that it was of importance to keep E. . . . he was a great hostage to have. He swore positively that there was not the least ill will to E. personally," Mary wrote to her parents; and as she had gotten along so famously with Sébastiani, "S. said for his own part he would declare whenever he was called upon, that E.'s behavior to the French was certainly handsome." Sébastiani, despite his closeness to Napoleon and his important role in the government of the enemy, visited Mary almost daily at the Hôtel de Richelieu. He confided that Madame Bonaparte—Josephine—was thoroughly intrigued with Mary and wanted to hear every detail that he could provide about her. Sébastiani assured Mary that Madame Bonaparte promised to use all of her considerable influence with her husband to procure fair treatment.

Mary had another visitor who caused controversy. This visitor actually risked his own life to come to her assistance while she was in France. Sir Sidney Smith's accomplice in his daring escape from the Temple Prison, "de Tromelin" (alias Major John Bromley), sneaked back into France and reappeared on Mary's doorstep. The police kept his visits under surveillance, but once again, the wily Frenchman slipped away.

The Elgins' doctor, who had accompanied the children back to England, petitioned the French government for a passport to join their parents in Paris. Napoleon granted Dr. Scott permission to tend to the lovely young countess for the birth of her fourth child.

Elgin's fragile health and Mary's pregnancy were of the utmost concern to both of them as usual. An idea began to interest Elgin, and he thought that if he were going to "be stuck" in France, why not benefit from the waters at Barèges? In 1742, the English doctor C. Meighan wrote a pamphlet on the curative powers of the waters in this particular

town in the Pyrenees. Dr. Meighan claimed these waters could heal everything from gunshot wounds to ulcers and tumors. His report inspired English travelers to visit the southwest corner of France, including *Tristram Shandy* author Laurence Sterne and, later, Victorian poet Algernon Charles Swinburne. They used their considerable literary talents to add to the lore, describing the beauties of the area. Elgin received permission for himself, Mary, Robert Ferguson, and Reverend Hunt, who had been at Montmélian, to enjoy the waters. The French could find no fault with Napoleon for offering to show off the pleasures of France to Englishmen; besides, it seems that General Boyer was not in fact incarcerated but in Bath, enjoying English thermal waters, through the courtesy of his own enemy captors: quid pro quo.

The Elgins left Paris on the twentieth of July after having witnessed the Bastille Day celebrations. They arrived in Bordeaux six days later and at Barèges at the beginning of August. Elgin was delighted to be there and thrived in the wonderful climate. Mary was bored, angry with her husband, and wanted to be with her babies: "Since we must be separated what signifies whether we are at Bareges or Paris?" While Elgin filled his days antique shopping and going for "the cure," Mary wrote letters and grew more and more uncomfortable as her pregnancy progressed. She complained to Elgin that this would be her last pregnancy, and hungered even more than ever before for news from home. Her own notes revealed her constant worry about her children: "Pray do not let them touch sweet things. . . . Have you taught them to eat vegetables yet?" "Do you give the Bratts boiled rice before their meat. . . . Have you put Harriet on the anodyne necklace?" She, who had cherished every tooth her first two children had cut, was miserable that she was unable to comfort the little teething Harriet. "I never in my life was so compleatly tired of any place as this."

She had no pianoforte, no whist, and no children. Elgin went to the baths two hours every day leaving her with "nobody to speak to. . . . I never thought I could be so tired of my own amiable company."

A surprise visit changed their humdrum routine. The Comte de Choiseul-Gouffier, who had been the French ambassador to the Ottoman Empire for Louis XIV—and Elgin's prime rival in the collection of antiquities from ancient Turkey and Greece—appeared one day, confident that although they had been enemies, he could rely on Elgin as a gentleman to come to his assistance. When the French Revolution had broken out, all of this nobleman's properties were confiscated. His collection of marbles, however, remained hidden in Athens until Napoleon agreed to transport them back to France. Choiseul-Gouffier, completely broke, was hoping to receive remuneration for the marbles, or at the very least, recognition from the new government. The count explained to Elgin that on their way back to France, the cases containing his sculptures had been seized by the British Navy. The Frenchman, with tears in his eyes, begged Lord Elgin to write to Lord Nelson for their release. Elgin completely understood this man's obsession, had experienced a similar loss, and complied. Unfortunately it was too late. The ship, *L'Arabe*, had been sold at Malta, and the marbles had already arrived in England.

Elgin had received better news about his own drowned collection. Divers were beginning to recover them, piece by piece. The expense of the expedition would be almost incalculable, but Elgin was stubborn and assumed that his wife's fortune would be his own and that he would be able to rely on it for his own demands for the future. Mary had already instructed her father to simply pay for whatever the children's needs were back in Scotland. Mary's summer and autumn in Barèges remained dreary except for the benefits of the climate for her husband. "Kiss my Bratts and tell my Father to love his poor Prisoner as much as she loves him," she wrote, ever mindful that he was, in fact, removing a good deal of her anxiety by footing the bills for everyone. Mary wrote them mournfully on September 22, "I hope you remember the 23rd is Harriet's birthday"—her first, and Mary would not be there. She continued, dutifully, to try to amuse her parents in her letters with

local folklore, superstitions, and peasant color. Despite the fact that Mary herself found the place unbearably dull, word spread that the glamorous Lady Elgin had visited Barèges and Pau, giving them allure. Both towns became favorite spots for Englishmen to visit for generations to come, and some one hundred years after the Elgins' memorable visit, American authors Edith Wharton and Henry James traveled there together by motorcar.

Mary, however, couldn't wait to leave. She and Elgin agreed that Ferguson, whose papers allowed him less constriction than Elgin, would accompany her to Paris, where she believed a passport would be waiting for her so that she could travel home to have her baby. After the baby was born, if Elgin was still hostage in France, she would return to him with or without their children, depending on the political climate.

Mary arrived in Paris and once again stayed at the Richelieu. When she arrived, she discovered that no passport was waiting. She contacted Napoleon and received a letter in return declaring that he had issued a passport for her to have her baby in England and that he had no idea why it was being delayed. Now experienced with the bureaucratic "red tape" of government, she patiently waited for the proper channels to come forth with the document. While she waited, a letter crossed the Channel that would have great impact on her plans. This was a letter informing Napoleon and Talleyrand that General Boyer was now taken into custody and imprisoned in Scotland. Retaliating swiftly, Napoleon ordered the arrest and incarceration of Thomas Bruce, Earl of Elgin.

Elgin was taken to the fortress of Lourdes, an ancient and terrible place located on an isolated and intimidating promontory. Long before any miracles were spoken of in the valley, the towering fortress whispered of many tortured deaths within its impenetrable walls. Not only was Elgin physically confined, but the French also waged a campaign of psychological warfare on the nobleman. Presiding officers, previously cordial to the British gentleman, were instructed to wear him down

emotionally. They were determined to disgrace him, to prove that he was partaking in espionage. The commandant and his lieutenant, whom Elgin had known, were his jailors. When they exhibited a complete change of character and behaved coldly toward him, he was unnerved. They staged situations to entrap him. For example, one day a sergeant of the guard delivered a letter to Elgin purportedly written by another prisoner. The sergeant explained to Elgin that this inmate was secluded in a dungeon and could not therefore visit his fellow inmate. Elgin gave the guard a tip and destroyed the letter in front of the man, explaining that if any more so-called secret notes were passed to him, he would do the same again. Shortly afterward this fellow prisoner was allowed exercise in the yard, and he walked directly toward Elgin. Lord Elgin would not engage in conversation; he knew that it was a setup. The guards continued to play mind games, but Elgin never fell for any of their tricks.

It was a time of great psychological stress for Elgin. He had learned that there was to be an attempt on his life but that it was quashed by his captors. Emotions began to run high throughout the family. The Dowager Countess of Elgin wrote to her son that his wife was running gaily around Paris without his protection and that her daughter-in-law should come home; she also hurled deeply wounding criticism at her son, repeating what his enemies were saying about him in London. The Nisbets began accusing their daughter of abandoning her own children. Elgin, under great duress, viewed Mary's gay and bright letters, intended to cheer him, as insensitive, and he began to question her devotion.

Despite all the criticism, Mary tried to maintain her focus on the task of getting her husband released and returned to her in Paris. She knew at that moment that if she could not be by Elgin's side inside the awful fortress at Lourdes, she would at the very least do all in her power to help secure his freedom. After her experience as ambassadress in Turkey, she understood her own powers and effectiveness. She would

not return to London; rather, she would remain in Paris to work on Elgin's behalf in the way she knew best. Once again, this determined young woman would not take no for an answer.

At the beginning of December, Mary went to Talleyrand, now grand chamberlain and vice elector of the Empire, and they struck an incredible bargain. She got Napoleon and his Machiavellian minister, whom Napoleon himself had called "a pile of shit in a silk stocking," to agree that if the English government would release and return General Boyer, Elgin could go home.[1] Mary was elated and urged her mother to speak directly with the king. She herself petitioned Lord Hawkesbury and comforted her husband with daily letters. Mary was devastated when the British government would not agree to this exchange, explaining that whereas Boyer was a legitimate prisoner of war, Elgin was not. Elgin, who had been less optimistic than Mary, was nonetheless disappointed. In a grand, romantic gesture, Mary commissioned a portrait of herself by Gérard for Elgin's cell wall. Gérard was a superb artist who would later paint Napoleon and Josephine's official coronation portraits. She had a miniature made for her parents, who were literally growing sick with worry for their daughter.

On Christmas Day in 1803, Mary found herself alone in Paris entering her last trimester, and she was terrified of having her child without the presence of her husband. The Count and Countess of Elgin, who defended each other and put on a brave and united front for all the world, including their families, were, unbeknownst to even those closest to them, actually experiencing a private crisis in their marriage.

Chapter 17

IN IRONS

Mary wanted her husband to be by her side by the time their fourth child was born. If Napoleon had met with Lady Elgin in public, his credibility would have been damaged. She was after all the wife of his most important prisoner. The first consul nonetheless expressed a personal interest in Mary, sending her miniatures of himself as tokens of appreciation, and they not only exchanged formal communiqués but also less formal messages via Talleyrand, Sébastiani, and Senator Fargues. Fargues, the representative to Napoleon's government from the southwest district of France, had made her acquaintance when she had been his region's most fashionable guest the previous summer. Fargues was quite taken with Lady Elgin and actually spent a good deal of his time working behind the scenes on her behalf.

Napoleon wanted to accommodate Lady Elgin, but he had a problem. How could he accomplish her request and not lose face with his own people? This was a question that he privately posed to Talleyrand, Fargues, and Robert Ferguson. Since the British had turned down the offer of an exchange between Boyer and Elgin, and since he himself had made the earl persona non grata, it would be virtually impossible to free him and allow the Elgins to live in Paris, where they would have high visibility. Mary, who was truly unable to travel due to severe back

pains and swelling, would have to remain in Paris; she also hoped that these men would surrender to her charms. Would they yield, however, in time for her delivery?

In January, the Hôtel de Richelieu went bankrupt, forcing all lodgers to relocate. Mary moved to the Hôtel Prince de Galles on the rue Saint-Honoré with the assistance of Robert Ferguson, who felt pity and somewhat responsible for the plucky, elegant, and very pregnant wife of his friend. There she began, once again, to create a comfortable home, this time in anticipation of her husband's arrival. She got half her wish. Elgin was allowed to leave the awful fortress, but Napoleon, still uncomfortable with Elgin's appearance in Paris, only granted him permission to remain in the Pyrenees. The minute he was released, as Napoleon had predicted, it was "reported all over Paris that Elgin is at liberty," and conversations at embassies in Paris and London buzzed with the talk of Elgin's next role in foreign affairs. One evening at the American Embassy, a dignitary expressed his own opinion to Mary that he believed Lord Elgin would be England's next ambassador to Vienna. When pressed, the American confided to Mary that it was actually not so much his own opinion as a rumor that had spread among the foreign diplomats. Mary secretly believed that her husband would be sent to Russia.

Meanwhile, Napoleon kept Elgin under constant surveillance. Permission for Elgin to live in Pau was granted, but local officials were secretly encouraged to try to ensnare him if possible in some kind of fraudulent activity. One morning, a woman who worked at the inn where Elgin was staying brought him a packet which she said had been left by a local peasant woman. This country girl was waiting for an answer to the packet, claimed the female porter. Elgin opened the packet in front of the woman, read aloud the contents—explosive information concerning plots to burn the French fleet and letters to the Comte d'Artois and other members of the French aristocracy who were trying to remove Napoleon from office—threw the letters in the

fire, and called in the prefect to report the entire incident. Lord Elgin informed both the hotel employee and the local prefect that he would not receive any letters that were sent in any way other than ordinary post. Elgin was simply too canny to fall for any ruse formulated by members of the French government.

While he was being watched and tested, Mary was trying her best to mingle with and charm the most influential people in Paris. On the arm of Robert Ferguson, she attended dinners and the opera, where she could see and be seen by Napoleon and Josephine. Mary was lovely and pregnant; all of Paris may have held a grudge against her husband, but they had developed soft hearts for this very elegant and charming young mother who scored a public relations coup of her own when she ordered her bankers at Coutts to send money to every English prisoner at Verdun.

Mary's letters to Elgin were filled with amusing anecdotes of all of her comings and goings. Now that he was to some degree free, Elgin expected her to join him. He was not only afraid of her having the child without proper medical attention, as Dr. Scott had not yet arrived in Paris, but he was also convinced that Paris society would totally corrupt his wife. He had lived in Paris; he knew its social world and believed that his high-spirited Mary would be swept away by harmful pleasures. He was also sensitive to his mother's letters admonishing him because people in London were incredulous that Lady Elgin would continue to live alone in the city of excess while her poor husband was languishing in prison. Mary wrote home immediately to let everyone know that her good friends had obtained Elgin's release and that he was living quite comfortably in a spa town where his health was improving. She also pressed the point that it would be inadvisable for her to undertake a long journey in a carriage so far along in her pregnancy. Elgin, who had miscalculated her due date, made plans of his own.

In Pau, he met with a man called Monsieur Brouquens, a Bordeaux businessman who suggested that a Monsieur Dupouy would be the per-

fect doctor to deliver the Elgins' baby. Monsieur Dupouy had delivered the children of Madame de la Tour du Pin, a young favorite of Queen Marie Antoinette. Forced to flee the guillotine, the young Madame de la Tour du Pin arrived at her country château in Bordeaux, where Dupouy delivered her daughter Séraphine in 1793. In 1794, the de la Tour du Pin family sailed to Boston on an American ship called the *Diana*. Back in Paris in 1796, and pregnant once again, the noblewoman begged Dupouy to travel from Bordeaux to Paris to deliver her baby. Another daughter, Alix Charlotte, was born. Monsieur Brouquens relayed all this to Lord Elgin in order to assure him that Lady Elgin would be in the best of hands upon her delivery when she arrived in Pau. Elgin, in turn, dispatched all of these wonderful references to Mary and lovingly advised her to travel to Pau immediately in a quilted and well-cushioned coach. As for Madame de la Tour du Pin, generations have now read and enjoyed her posthumously published memoirs of her life in America and subsequent return to France, where she became indispensable to Madame Bonaparte.

When Mary wrote that she had no intention of risking the journey and that she was working, instead, to bring Elgin to Paris, he accused her of gross misbehavior. He admonished her for surrounding herself with too many men, declared her an unfit wife, and commanded her to be by his side. "I don't grudge your being amused—But God knows, it [is] not natural," he wrote in February 1804. He told her that her behavior hurt him more than his prison stay in Lourdes, and that he was appalled she was "receiving and going about with men alone." Mary explained that she was only going about with very old men and Robert Ferguson, whom Elgin himself had asked to look after her. She wrote, "Ferg. Is a most extraordinary being . . . without joking Elgin I can never repay what he has done for me."

Elgin expected his good friend to watch over his wife and work behind the scenes on his behalf, and when he bombarded Mary with extensive shopping requests for clothes, books, and gastronomic

delicacies, he knew very well that Mary would need Ferguson's assistance in their procurement; but Elgin drew the line and became quite irritated when Mary and Ferguson went on shopping expeditions together and she allowed Ferguson to assist her in letter writing. Elgin considered that far too personal. He was appalled that Mary would allow Ferguson to be privy to what Elgin perceived to be their private marital business, and he chastised his wife.

Elgin persisted in attacking Mary for committing what he believed were improprieties, including "having constantly men & seldom woman's company." These accusations were off the mark. Mary had many female friends, as she was a very social creature. She also sought out women whose husbands could be of help to Elgin. In Paris, she had become very friendly with Madame de Talleyrand for obvious reasons and enjoyed the company of some of the dowagers from Britain who served as substitutes for her much missed mother, aunt, and grandmother. In her letters she omitted mentioning her episodes with her female friends, dismissing those stories as "female chatter," which she thought would bore Elgin. She tried to keep to the point of what she thought he wanted to know. She was therefore truly affronted by his accusations. When she inquired as to where on earth he had gotten such impressions, his answer stunned her. He did not explain that her letters mentioned nothing of ladies' teas; instead, he was intentionally vague, implying something sinister. "I cannot specify all that has come to my knowledge. . . . You would not believe the *facts* I have learnt since we parted."

Some women adored Mary, but there were also those who were envious. Mary suspected that these so-called facts Elgin believed he was in possession of had been maliciously supplied to him by one of Mary's jealous rivals. While Mary went out and about in Paris, as much as she could in her discomfort, Lady Yarmouth, a formidable gossip and controversial woman in her own right, was most definitely not thrilled by Mary's popularity. Mary demanded that Elgin reveal the

source of his news, certain that it was Lady Yarmouth who had invented these stories, and she went on the offense, attacking Elgin for believing anything provided by a woman of such dubious character. It was true that Lady Yarmouth's background and adulterous affairs were well known in English and French society, and as the "love child" of the famously debauched Duke of Queensbury and a married Italian *marchesa*, Maria Emily Fagnani, she had grown up outside convention and was indulged with the attitude that she need not comply with other peoples' rules. Her father, the duke, arranged a marriage of convenience for "Mie-Mie," as she was known, with the feckless Lord Yarmouth, who enjoyed his father-in-law's money and turned a blind eye on his wife's extramarital love life. At the time she was accusing a very pregnant Lady Elgin of infidelity, she herself became pregnant by Comte Casimir de Montrond. Yarmouth passed himself off as the father of Lord Henry Seymour, but no one was fooled. While her husband remained in England, Lady Yarmouth lived in France until her death in 1856.

Mary wrote to her husband that his accusations caused her to become physically sick. She persisted in defending her own good intentions. Had she not been the one who had secured his release through the deal, which through no fault of her own, was not acceptable to the British government? How could he think she was not completely on his side? All she wanted was to see him and return together to their children. He, too, was weary and vulnerable. In one letter, he would write that he had decided to stay in France to avoid his enemies back home, then in the next letter would expound on his frustration that he was being kept from Broomhall and their children. In the very next letter, he would instruct her to go to Germany, where they would live in peace and harmony. Mary was truly frantic, and yet she carried on, accomplishing the impossible.

At the beginning of February, with the help of Talleyrand and Senator Fargues, the congenial efforts of Lady Elgin, and even the pleas of

his own brother, Joseph Bonaparte, Napoleon agreed to issue a passport to Elgin for him to travel to Orléans, not far from Paris. Elgin was to travel incognito under the name "Monsieur Robert." Mary wrote with joy that Elgin and she would be together for the birth of their child and that he had been misinformed about her conduct. She insisted that she had, in fact, done honor to Englishwomen with her glamorous gowns and, by French standards, rather prim behavior. Her triumph was short-lived, however, when she learned, as she had in Constantinople, that her popularity could be turned on her. As the weeks went by and once again a passport disappeared into the French bureaucratic jumble, Mary discovered that the very jealous Lady Yarmouth was "doing every thing in her power to prevent my getting it. That is good natured, is it not?"

Frustrated and exhausted as she herself was, she understood Elgin's growing impatience and made a valiant effort to subdue her husband, teasing him out of his bad temper. She wrote that she thought he must be surrounded by pretty women in Pau, which she knew was true, and in response to his criticism of her remaining in Paris, surrounded by the customs of "modern French manners," she lightly responded that society in Paris "is quite changed to what it was formerly—It is now the fashion to be fond of Husbands & Children." She swore her undying love and assured Elgin that she was completely indifferent to society and that her only desire was to be with him. "If I have a horror in the world it is the idea of being confined without having you near me." She tried again and again to explain to him that she was unwell and that travel would be dangerous. Elgin was equally intransigent, ordered her to let Ferguson handle matters in Paris, and exploded, "If you can move, it is your Duty to come!"

He continued his tirade, berating her for impropriety, and she persisted in demanding that he produce his proof. "If you don't tell me who is sending you letters with gossip about me, I accuse you of inventing it." She wrote these letters during the day and, because she was so

upset, even during the middle of the night. "Farewell Elgin," she told him when she had had enough. "What a scandalous thing to say of me that I am losing my character as a Woman & as an Englishwoman." When she still received no satisfaction as to who was spreading vicious rumors about her to her husband, she wrote, "If your kind and friendly advisers knew what I suffer they would be gratified—I never expected such unkindness almost cruelty from you . . . I was . . . so totally unused to one unkind word from either my Father or Mother that it quite overpowers me—"

Elgin's accusations and mistrust had wounded her and caused her additional strain during her pregnancy. She took the position that she would not have any more of his children and that they could never heal the rift between them: "what dreadful anxiety I have gone through on your account." To the public, she was the vivacious Lady Elgin, but in her rooms at the Hôtel Prince de Galles, she cried herself to sleep every night. This heiress refused to be pushed around: "What a wonderful stile of writing *ordering* me to leave Paris *today* or *tomorrow*." Finally, she wrote, "Your Letter has hurt me too much in every respect to be able to answer it."

To Mary's great relief, Dr. Scott arrived in Paris and became her ally. She could tell Elgin that she was under doctor's orders to stay put. Elgin's emphatic preoccupation with decorum suffered a stunning blow when the Countess of Elgin demonstrated, once again, that she would take control of her own regime. Nothing whatsoever could have prepared him for the unfathomable bombshell she dropped when she announced to him that since the French population did not submit to the smallpox vaccine, she would not engage the requisite wet nurse and would instead breast-feed her own baby when it was born—an unheard-of undertaking for an aristocratic woman. Mary's parents had always been engaged by her outrageous sense of humor and supportive of her plans, but when this bit of news was gingerly imparted to the Nisbets, they were not at all amused. As for the Dowager Countess

Elgin, King George's own paragon of correct comportment, she recalled with disapproval Elgin's youthful days spent not too innocently in Paris and she began to worry that too much Bordeaux had gone to Mary's head.

The simple decision, which confounded her parents, her husband, and her mother-in-law, was in a way Mary's own declaration of independence. In the past, she had welcomed their advice, but she had spread her wings over the four and a half years since she had left England and had become a magnificent woman ready to make her own choices. At this point in her life, she resented their interference and felt assaulted by their efforts to control her. Only one person offered her unconditional friendship, free from judgment. She wrote Elgin that his very dear friend, Robert Ferguson, had become "to me like a brother."

Chapter 18

RUDDERLESS

By February 23, 1804, Elgin was on his way to Orléans. When he received his traveling papers, he realized that Mary had been true to her word and had not been spending her time frivolously. Elgin began down the long, uncomfortable road of groveling to regain her affection. With much contrition he wrote, "My dearest angel . . . I most sincerely will do all in my power & anything to make up for it." He pleaded for her forgiveness, insisting that all he wanted in the world was "to have you in my arms." Mary had been very proud of Elgin's great humanity toward others. He had walked among lepers in Greece, begged English naval officials for the release of a French sailor whose brother he had befriended, and when he arrived in Orléans, Elgin accompanied a Dr. Hewitson to visit English prisoners in the Orléans jail. She was aware that he could exhibit a harsh side when the subject of money was discussed among his employees, but he had never before lashed out at her. Whether it was some kind of delusional suffering from the psychological tricks being played on him or, in fact, slander on the part of Lady Yarmouth that fueled his jealousy, Elgin was excessively punitive, and Mary could not shake a pervasive feeling of dread brought about by Elgin's severity toward her. Once again, she felt an uncomfortable "presentiment."

She buried those feelings when, on Monday, March 5, at 8:30 a.m., William Bruce was born, and she was thrilled at the birth of her second son. Elgin, who had not expected the baby's arrival so soon, was still in Orléans with no hope of reaching her in Paris. News reached him faster than it would have in Barèges, however, and by the next morning he knew that he had another son, his French-born "little frog." The distance between them made him unaware of how weak Mary truly was, and right after William was born, Elgin proceeded on to other business. Although Mary could not yet get out of bed, he bombarded her with demands for her to have tea, good food, servants, and other comforts delivered to him at the inn Trois Empereurs in Orléans. As she grew more and more exasperated with Elgin's self-centeredness, she relied more and more on Robert, who kindly volunteered to absolve her of her responsibilities fulfilling Elgin's demands while she convalesced. Incorrectly assuming that Mary was well enough to resume her duties, Elgin sent Mary financial reports, asking her to handle the bankers, and he reminded her to write to his mother, although she was a far more consistent correspondent than he was. Using the baby's health as a pretense, he advised her, as a nursing mother, to "shut yourself up hermetically." Weak and bedridden, she had no intention of going anywhere and was rather annoyed that he was still on the same tack. She dropped her tearful defenses and in her letters focused instead on the baby's progress, including the mention that on Monday, March 26, Robert Ferguson stood in for Elgin at William's baptism.

Elgin recovered from the shock of Mary nursing their baby and, in fact, became sexually aroused by the image of it. He fantasized about his wife and wrote her very erotic letters: "What wd. I not give to see you & the Dear Willy suckling? You must be a monstrous treat. . . . I dread you'll glut my boy," "Give the little fellow a very nice kiss . . . lick his lips after his dinner," "I think I see the female centaur suckling its little one," and addressed her as "My Dear Nurse."

Their fifth anniversary passed and so did Mary's twenty-sixth birthday, and they were still apart. In April, Mary wrote to her mother that she had been "separated from my poor Turks almost twelve months," and she dealt with her longing to be with her other children by now focusing all of her attention on William. Mary regained her strength with daily walks in the parks of Paris, accompanied by Ferguson, where she strolled with the baby as if he were theirs. She went one more time to Talleyrand to see if her husband would be permitted to join her in Paris. When the answer was a regrettable no, Mary resigned herself to leave for Orléans.

That May, Napoleon declared himself emperor, and the Elgins' stalwart friend, Robert Ferguson, returned to Scotland for the first time in years. In 1804, the Whigs had returned to power in the British Parliament, enabling some of Ferguson's sympathizers, including Charles James Fox, to intercede with Napoleon on his behalf. In addition, the president of the Royal Society, famed explorer and botanist Sir Joseph Banks, had also petitioned the emperor for the release of the esteemed scientist. Napoleon had the highest regard for the Royal Society as a fraternity of great educational distinction, and he yielded. Ferguson left Mary behind in Paris with the assurance that he would use his considerable contacts in the new British government and his friendship with Banks to help gain Lord Elgin's release.

Without her friend and still in Paris in June, Mary wrote to Elgin that "every Body loves the Child he is so good." She exhibited her usual sense of fun when she played a joke on the Livingstons. Mrs. Livingston kept asking Mary to see the baby. One day, Mary brought him to them but "they were out, so I wrote upon a bit of paper Mr. William Bruce—*First Visit*—Mrs. Livingston has enquired of *every* person who calls upon her if they know *who* Mr. W. Bruce is!" William was ill for much of June with bowel problems and fever. Mary knew that Elgin was always nervous about health and to soothe his "anxiety," she

apprised him of the baby's health daily. Finally, when William made a complete recovery at the end of June, Mary was finally able to travel with him to Orléans.

William was nearly four months old when Elgin laid eyes on him. The Elgins had no wish to remain in Orléans, but Napoleon had made it clear that Elgin would not be permitted to enter Paris. Elgin wished to return to the Pyrenees for the waters, and although Mary faced boredom, she returned to Paris to ask for the papers that would permit them to do so. While they were briefly in Orléans, their good friend General Sébastiani came to visit, and in early July, they set out for the Pyrenees, arriving in Bordeaux on July 16, 1804. Although the Elgins had reunited and had resumed their customary roles, Mary had not fully recovered from the sting of Elgin's nastiness. She tried her best to remain merry, assuring her mother that this time she would have a better time because "there will be an amazing number of people at Barèges this year, it is even reported the Empress is going." William was christened on August 27 with his proud father in attendance for this momentous event. Elgin had no official capacity and spent his time shopping for antiques and riding.

As usual, Mary waited for the mail every day and eagerly hoped for a letter from her own parents, who were a bit more sensitive to her situation than her chastising mother-in-law. Mrs. Nisbet concentrated on news of the children and the progress being made on the Nisbets' new manor house, Biel, in Stenton Parish, a few miles from Archerfield. Mr. Nisbet had succeeded in securing additional parcels of adjoining land, enhancing the estate, and he began supervising the design of Tivoli-like terraced gardens to adorn the house. Like many British men who had traveled abroad, his son-in-law included, William Hamilton Nisbet borrowed and brought home the best of what he had seen in Europe. The gardens were spectacular, the house was a masterpiece, and he was now the proprietor of most of East Lothian. He took his grandson Lord Bruce and the two tiny girls to

visit Broomhall, pointing out to Bruce that he would one day inherit his father's title, the Dunfermline property, and Mr. Nisbet's own fiefdom which, through his mother would include, in addition to Biel, the properties of Barncleugh, Belhaven, Wynton, and Pencaitland, all in the vicinity of Dirleton and Stenton Parish. These properties, lush and ripe for golf, were some of the most valuable in Scotland. Mary wrote back that Elgin was thrilled to hear of this journey but not quite so thrilled to hear the unpleasant financial news about Broomhall that kept coming his way from Mr. Nisbet, Mr. Oswald, and Mr. Dundas.

Part of Elgin's emotional distress was caused by the continual arrival of dismal accounts of his financial state of affairs. He had asked Parliament for his salary to continue, but the government denied his request, claiming that he had traveled to France on his own, independent of official service. Despite the government's rebuff, Elgin acted as ambassador on behalf of other British citizens in France who sought his intervention for some cause or other, and he provided small sums of money to indigent compatriots. As for his own concerns, he felt that his father-in-law and trustees should have been able to manage well enough without disaster striking.

The Nisbets were under the impression that Mary could leave France at any time, and they repeatedly advised her to return to her children at once. Mary was very relieved to hear that Ferguson had visited the Nisbets at Archerfield, pleading her case, explaining that she really had to remain by her husband's side. Far removed from the pomp and circumstance of Napoleon's coronation in Paris in November of 1804, Mary and Elgin had now been the emperor's prisoners for one and a half years. They remained in Pau, waiting anxiously for Napoleon to release them; but the emperor had other things on his mind. He was embroiled in battles across Europe.

Their protracted detention left the Elgins with only one source of happiness, baby William. In December, Mary reported:

[William] has cut his first tooth without the least fever. . . . He is really the finest child I ever saw, such long eye lashes, so firm, so good a skin—and then he has such a merry little intelligent face of his own, as would quite captivate you I am sure. I don't know what we should do without him he is the life of the whole house, and I assure that is saying a good deal. For we are sadly inclined to the blue devils, or perhaps a more elegant expression and an equally true one would be, we are as low as cats.

In February 1805, the usually buoyant Mary wrote to her mother that in truth she had been feeling "low and dismal" and had begun a letter days earlier but "had not courage to continue." She then reassured her mother that her little boy had restored her mood.

[He] can toddle all round the room, can clap his hands, can smell them when Mama puts a little lavender water on them, can say "Hark" with one finger up like a Statue of Silence when Dragon barks, can hold up his little mouth when one says "Embrassez moi, Monsieur." ["Kiss me, sir."] In short, imagine to yourself Perfection, and then you will know what William is.

With her other three children, Mary had retained Greek nannies to look after them a good part of each day. With no nanny for William, she herself spent every moment with him and grew closer to this child than to any of her others. Local townspeople would inquire of her who was tending to the baby and were quite stunned to learn that this world-famous countess was acting as nanny and wet nurse to her own child. She became, as always, an object of great curiosity. Preferring to ignore those who gawked at her and whispered about her "odd behavior," she doted on her baby, and he became the true love of her life.

Elgin's relationship with his own mother was in a very bad state. She felt it was her duty, in each and every letter, to keep him abreast of the

charges brought against him by his enemies in London, most notably Sir Sidney Smith, and he wrote her back stating that all he expected of her was to stand by him, and "for God's sake, don't embitter my life." Some of his collection of marbles had arrived at the East India docks in London. He had been corresponding with his mother for months about the fees, the transportation, and other issues involved in what to do with the pieces now that they had arrived. He had instructed her to engage John Flaxman, called the English Phidias, to restore the pieces. The cost would be enormous, £20,000. As he had already invested a fortune in recovering the sunken marbles, he decided to shelve the idea of altering them, and he advised her of his decision.

His trusted assistant, William Hamilton, who had returned to London, was working on a public exhibition of the extraordinary pieces, which the Dowager Countess argued would only place her son in the path of increased criticism. Further, she felt that it was a vulgar undertaking. Elgin contradicted his mother. "An exhibition of things so peculiarly of public interest as mine are, far from being improper, is requisite." No matter what requests or assignments he proposed, his mother simply could not or would not assume her usual helpful, proactive role. In the past, the Dowager Countess had, like her daughter-in-law, always been ready to take charge, but at this point her inexplicable inaction frustrated her son to distraction. The Dowager Countess was actually hiding the fact that she was ill. Not wanting to upset her son any more than he already was, she did not explain to him the full extent of her bad health. She had resigned her post at Court owing to a severe case of the gout and was in much discomfort, curtailing her activities. Elgin believed that Martha was being stubborn, and so he asked her, as he had advised his wife, to seek Robert Ferguson's help. Elgin told his mother that Ferguson had turned out to be the most loyal and wonderful man and could be of invaluable assistance.

When Robert Ferguson had said good-bye to Mary in 1804, he was without a doubt on an altruistic mission, but he also left knowing that

he had fallen in love with his best friend's wife. Whether she pretended ignorance of his feelings or was uncharacteristically unaware, Mary only admitted and acknowledged that she would miss him as a dear friend. There had been many men who had been infatuated with her. It flattered her, and she expected it. This time, it troubled her a bit, as the two had developed an emotional intimacy. Whereas Elgin had become plaintive and needy, Robert was capable and calm. One man dependent, one dependable, one man steeped in the rigid customs of the past, one man hungry for change and the future. Mary knew, in all fairness to Elgin, that he had been placed in an untenable situation, and she believed that the man whom she had seen lead men would fully recover when he was allowed his freedom. For now, he had no direction and felt powerless; he had, however, alleviated some of the tension between them by softening his rebukes over the ten months they had spent together.

In late March 1805, they traveled listlessly to Toulouse, Narbonne, Montpélier, Nîmes, and arrived in Paris on Monday, April 1, where Robert Ferguson was there to greet them. He had returned to Europe to settle some personal business. Ferguson, who had moved away from Britain to partake of the growing political shift toward democracy on the Continent, had one more reason for remaining abroad for so many years. He had been keeping a secret. He wished now to include Mary in his conspiracy, and he revealed his story to her and Dr. Scott, who came to his aid.

In 1793, Robert Ferguson had fallen deeply in love with a married German countess thirteen years his senior. Henriette, the Countess von Riaucour, was the daughter and heiress of Andreas, Count von Riaucour—she was also the wife of Count Carl Theodor Schall, whom she had married in 1777. For thirteen years, the count and his wife had a comfortable if not exciting marriage, Henriette often traveling to fashionable places without him. When she met Robert, she and he both believed that they had found in each a soul mate, "our

hearts are so attached," he wrote in his diary. Henriette even wore a locket containing a piece of Robert's hair. Robert effused, "I would rather be placed in a dreary desert than be obliged to remain here without her."

Robert and Henriette enjoyed a passionate affair for years, known as a couple by many important people in Europe but, as far as they knew, kept secret from Count Carl, Ferguson deciding that "her husband [was] literally a beast." On April 13, 1795, Henriette informed Robert that he was going to be a father. Since she had recently been with her husband, she was able to convince the count that the baby was his. Robert was ecstatic and longed to claim his son as his very own, but he accepted Henriette's duplicitous charade.

Robert was a romantic idealist and believed that his passion for Henriette was perfection. Together they visited the museums in Italy, quoted Rousseau to each other—Robert particularly focusing on *Emile,* now that he was going to be a father. They went to concerts and sought beauty in the Swiss Alps. He proved all too human, however, when he contracted a sexually transmitted disease from a prostitute who, he angrily wrote in his diary, had "clapped" him. He was furious, blaming his weakness on the whore. The doctor gave him a "tisane," a hot herbal tea, a painful injection, and recommended that Robert avoid sexual relations for ten days. Robert was terrified that Henriette would find out and swore that he would never again be unfaithful to his "beloved friend."

On Tuesday, October 27, 1795, their son Charles, who would become the Count von Schall-Riaucour, was born. Robert was overjoyed. "Good God what comfort what joy . . . my joy is extreme," he effused. "We are completely happy," he noted in his journal, and he referred to the baby he could never raise as "the dear souvenir." Over the next hundred years, the descendants of Charles, Count von Schall-Riaucour, would include Hohenzollerns, von Furstenbergs, and Lobkoviczs. All of these princely families contain the blood of Robert Ferguson.

In 1796, the lovers traveled to Italy. In September, Henriette suspected that she was pregnant again. "Heavens how I love her how all my existence is in her," he felt. This time, not having been near her husband in a very long time, Henriette was in trouble. She could not pass this second baby off as her husband's, so she remained in Italy where she delivered their second son on May 2, 1797. Henriette returned to her husband, who was growing suspicious about her extended absence. Robert kept their son, "a fine healthy boy," named Henry Robert, and gave the baby to the Abbé La Roche in Sienna. The abbé was to keep the boy sequestered from the world until Robert and Henriette could devise a solution.

Robert returned home to tell his father and brother his news. He had been away four years, had two sons, and had become a respected scientist in Europe. He enjoyed his reconciliation with his father, who was extremely kind and understanding. The following summer he returned to Europe and immediately reunited with Henriette. They lived blissfully together in Warsaw, throughout the winter, but they had to face the fact that their happiness could not go on indefinitely. Henriette had to return to her husband. Like so many men of his day, Henriette's father, Andreas, had left his money to his son-in-law, foolishly ensuring that his own daughter's only legacy would be at her husband's mercy.

Six years later, when Mary, Countess of Elgin, gave birth to her fourth child, William, and her husband was unable to be with her in Paris, Robert Ferguson assumed the role of "father by proxy" for his good friend. He visited Mary, took care of her every wish, and took mother and baby for walks in the fresh air of the parks of Paris. Although he experienced a secondhand paternal joy for the Elgins, Robert, without his beloved Henriette, who was living in Prague, was not able to be a father to his own sons. He therefore felt a special tie to the baby he had known since birth and was filled with almost a pater-

nal pride on seeing William a year later, a robust healthy toddler. He was not, however, William's father, and he yearned for his own sons.

One week after their arrival in Paris, William suddenly developed a high fever and suffered pulmonary failure. On Saturday, April 13, ten years to the day when Robert learned that he was to be a father for the first time, William succumbed to his illness and died. All of the *détenus* in Paris mourned the tiny boy who had brought them all so much pleasure during their time of tribulation. Both men—"uncle" and father—were devastated, and Mary was inconsolable. "I lost my Dear William at 12 o'clock at night," she wrote shakily in her diary, and five days later, on her twenty-seventh birthday, she wrote to her mother:

> Pray for me, my dearest Mother, take me in your arms; Your prayers will be heard tho' mine were not listened to. I have lost my William, my angel William—my soul doated on him, I was wrapt up in my child. From the moment of his birth, to the fatal night it pleased God to call him, I have devoted myself to him.
>
> I am resigned to the Will of the Almighty, but my happiness is destroyed for ever . . . *My William, my adored William is gone . . . gone . . . and left me here.*

Chapter 19

AT SEA

Behind her stoic appearance as she made the rounds in the spring and summer of 1805, Mary was a bewildered, empty shell, a lethargic shadow of herself. All of her duties were performed perfunctorily without her usual effervescence, so profound was her sadness. The Elgins dined with General Sébastiani, visited Napoleon at Saint-Cloud, dined at the palace of Versailles, saw Malmaison, and toured the Sèvres porcelain factory. In all the years of keeping her diary, even though no one else was ever meant to see it, Mary always referred to even her closest family members with formality. Her parents were "Mr. and Mrs. Nisbet," her grandmother, "Lady Robert," her uncle, "The General," and her husband, who began as "Lord Elgin," became "Elgin." Distracted with grief, she made a revealing entry that subconsciously demonstrated her growing closeness to Robert Ferguson, who had become her salvation. On one Monday in May, she wrote simply and out of character, "we dined at Robert's."

She relied on Robert, and she and Elgin asked him to undertake the somber task of bringing little William in his tiny casket home to Scotland. Robert, in turn, decided to ask Dr. Scott to escort and enroll his own son, Henry, in Dr. Glennie's School in Dulwich, in the Southwark section of London. Lord Byron had been a student there five years

past. Robert Ferguson was going to be a father regardless of world opinion. He had lost one boy whom he loved, and he was not going to miss a moment more of Henry's life. Ferguson was going back to Scotland, this time for good, where he would stake his claim in politics and raise his son. He was no longer running away.

Lord Elgin poured his grief into fashioning an elaborate tomb for his son. The extravagant burial scheme required the repositioning of ancestors and would have resulted in a rather large expenditure, which Mr. Oswald and Mr. Nisbet opposed. Elgin's lawyer, James Dundas, his estate manager, Mr. Wotherspoon, and the local magistrate, Mr. Black, all worked with the cemetery representatives at Dunfermline Abbey to accommodate the earl's wishes, but it was simply too big a job. On September 3, 1805, at four o'clock in the afternoon, the tiny boy was laid to rest. Only Robert Ferguson, family surgeon Dr. Gibb, and Wotherspoon were in attendance. William was placed above his father's eldest brother, also named William, who had been the 6th Earl of Elgin and 10th Earl of Kincardine for six months before his own death in childhood. In a letter to James Dundas, Wotherspoon reported that when he went into the vault, he discovered that the 6th Earl, who had died in 1771, was lying without his casket—it had been removed. Strangely enough, the body was well intact, and Wotherspoon immediately ordered a new coffin.

Although she felt like an empty vessel during the summer of 1805, Mary was once again containing life within her. She expected the baby in January, and despite the fact that she wanted no more children, Elgin, who had lost three brothers, was intent on increasing the family, ensuring the dynasty. She was too numb to dissuade him and proceeded through the early stages of her pregnancy as if in a trance, almost unaware that it was happening once again.

The political situation between England and France worsened, and on September 27, Elgin was arrested and forcibly sent to Melun. The last time Elgin had been incarcerated, Mary had remained in Paris,

where she felt she could not only pursue her husband's best interests but also be close to him. Mary hoped that once again she could effect Elgin's release if she were allowed to meet with Talleyrand. This time Elgin overruled his wife, listening instead to the voice in his head that was his mother's, and he ordered her home. Out of pity for the young mother who had lost her son, Napoleon and Talleyrand complied and issued her a passport on the spot. She argued bitterly with Elgin, pouring forth all of her grief in anger.

Entering the third trimester of her pregnancy, Mary tearfully left Paris on October 9, in absolute disagreement with her husband. She refused to believe that Elgin had sent her home for her own good. She wondered if he still loved her, and this time it was she who hurled accusations. The bumpy ride in her cabriolet caused the baby to drop, and she dispatched passionate and poignant letters to Elgin, claiming she longed for him and she loathed him at the same time. She was heartbroken that he had sent her away. On October 13, she wrote from Brieux:

How does my Beloved Elgin do? Does he think of his Mary? Does he say God Bless her? Does he regret her absence? I should like to know all that . . . and my imagination is not the most tranquile in the world—If I thought you could forget me for *one moment* Elgin— What would become of me?

She truly believed that he had once again wrongly and ill-advisedly listened to other people's opinions regarding her fate, and she was very hurt. She could most definitely remain on her own and wait for his release, as she had proved in the past, and she did not need "protection." She was determined to return to France as soon as she had the baby, and she wanted no interference with that plan: "I trust you will not write to my people to prevent my returning—write me what you please but if you do anything under hand in the true Scotch stile depend upon it, it will not do for some how or another if I live, I will get away." On

the fifteenth, she was in Morlaix and chided him: "You allowed yourself to be directed."

Mary's overwrought emotional landscape mirrored the storms that raged across the Channel delaying her homecoming. She remained in Morlaix in great discomfort and she accused Elgin of ruining her health. On the seventeenth she wrote to him: "I am in a great deal of pain . . . I have sacrificed every thing—others have decided my fate, not myself. It was impossible to stand such a journey—I knew it before I set off." Hurling all her fury at him, she warned that "one can hardly expect the child to live," but "if it prevents my having any more Babs I shall bless the day all my life." She stated that she had another one of her "presentiments" that if she were to have the baby in England without him, "we never were to meet more." "Why marry, if one is to separate upon the first appearance of difficulty—I never was frightened when I was with you." She unburdened her heart, telling him that she simultaneously hated every fiber of his being and still loved him. "I drank my beloved Elgin's health. May God Bless him."

Lingering at a small inn with only her servant, Gosling, to assist her, she was relieved to sell her carriage for two hundred francs before sailing, and although she was pleased with the transaction, she remained dispirited. Her usually chatty, witty, and entertaining letters became diatribes, and at one point she ordered her husband to tear them up. She was going to make him suffer with every moment of her own unhappiness. "I am in very great pain, I can hardly walk from one room to another"; yet she longed for him. "Oh how I wish myself with you!" On the eighteenth, still in Morlaix, she wrote:

> I feel dreadfully low today my Elgin. I can think of nothing but our Angel Willy—pray God we may join him hereafter what can ever make up his loss dear dear Creature. I trust Elgin the Almighty will pardon our faults and that we shall be joined to our William never more to part—what would life be without that hope? How I doated

on that child and how he was snatched from us. . . . God Bless you my Beloved Elgin, never did you do so wrong as making me leave you, for my mind and heart are quite horrified.

Their marriage had not been the fairy tale she had expected—"we have been so unhappy for a long time"—and all of her insecurities surfaced. She wondered if he had married her for her money, as other people had, but she had dismissed that idea, "for I did think you liked me for myself." She spitefully reported that her traveling companion "is a fine old man, you need not be jealous Elgin." On Monday, October 21, the night before she was to board the ship for England, unbeknownst to Mary or Elgin, their old friend Admiral Nelson was mortally wounded at the Battle of Trafalgar off the coast of Spain; it was a bittersweet victory for the English. Mary, too, felt at war writing to Elgin—"you have destroyed me." At the same time she pleaded for him to send her a lock of his hair for her ring, she burst forth with all of the violence of a gale, her most hateful and most pathetic censure: she accused him of infidelity. She ranted and seethed yet swore that she would love him until the day she died.

I am convinced you have had any pretty girl . . . sometimes I think you wished me away on purpose . . . fifty times I have thought you had people when I was away last time . . . but say you love me and that you will love me all my life. . . . Are you not sorry I am away from you? I declare I do not believe you are . . . you write very well but you do not act as if you cared for me; for what obliged us to part—Nothing earthly!

She fumed that she would not live one moment longer than necessary without him and commanded him to obtain a passport for her immediate return. "If you do not I shall come over by some means or another." At one o'clock in the morning, seven hours before her sched-

uled departure on October 22, she wrote, "I wish I knew what you are doing Dear Elgin have you got any body with you, or are you all alone?"

The next morning, the weather had not improved and she remained in Morlaix. "I think this is the unhappiest day of my life dear Elgin . . . today I feel as if my existance was over. . . . When shall we meet again my Elgin? I dare not give way to my presentiments—I feel very ill . . . my heart is broken." She tried to make him feel guilty. "May God Almighty Bless you, my Beloved Elgin, if any thing happens to me those will be my last words—my attachment to you is sincere and unchangeable. . . . Elgin your heart would bleed did you know what I have suffered in mind and body. This journey not only risks my life but another being's." She declared her eternal love before boarding the ship—"be for Ever assured of your Mary's Love"—yet she was truly horrified at his lack of compassion for her feelings and admonished, "Elgin you don't know me yet."

Finally, on October 23, Mary boarded the *Elizabeth*. The following day she reached the shores of Plymouth after having lived six years abroad. When she had left England in 1799, she was an excited and nervous young bride, wildly in love with her husband and expecting their first child. She had been accompanied by an entourage of minions to serve her every need. Wherever she disembarked there were panoplies of fireworks and gun salutes. In 1805, she returned to England, an internationally celebrated woman, pregnant with her fifth child, yet to Mary these blessings were eclipsed by weariness. The newspapers announced her arrival, alerting friends and relatives. Lady Robert, Aunt Bluey, and Uncle George Manners were at Bloxholm and scrambled to greet her in London, but she simply could not face them immediately. Besides, she was "hardly able to beat the motion of a Carriage," so she proceeded slowly. She stayed in Plymouth for three days and then traveled to Bath, where bells pealed for an entire morning to welcome her. In London on October 31, the first social obligation she fulfilled was a much dreaded dinner with her mother-in-law. The following day, Lady Robert arrived at Grosvenor Square, which filled

Mary with more mixed emotions; Lady Robert had grown frailer, and Mary blamed herself for causing her grandmother to worry. For the past six years, as Mary's universe had expanded with the vitality of being around her children, Lady Robert had grown old. On November 10, Mary wrote to Elgin that her father and mother also "have been much shook by age and illness since I last saw them: and I fear that an absence . . . and the apprehension of never seeing me more have added to their sufferings."

Mary did not have the heart to put her parents through further anxiety, and she made the controversial decision to find her own house in London. She felt it would be horrible for her parents to suffer alongside her when she went into labor that winter. She most certainly did want them to be near their grandchildren, so she spent her first two weeks in London scouring the Portman Square vicinity and found a pleasant place at 60 Baker Street just nearby. When she offered the excuse that the children's boisterousness would tax their patience, her parents argued with her. The truth was that she wanted to regain control of her children's care, and as she had been *maîtresse de maison* of her own homes for six years, she did not want to resume the role as daughter in someone else's house. She wanted to come and go as she pleased, and she knew that if she were going to campaign for Elgin's release, it would take quite a bit of traffic.

On November 26, Mrs. Nisbet and the children arrived in London. Mary awaited their arrival with mixed feelings. She wrote to Elgin, "My mother with the Bratts leaves Biel today, so I may hope to have them in my arms next Saturday.—Dear Elgin, what a painful meeting to me, how it will recall my beloved William to my mind; but indeed he is never out of it." It had been two and a half years since she had seen Bruce, now five and a half, his sister Mary, now four, and Harriet, the infant she had placed aboard the *Diana*, now three. When they arrived, she marveled at them, gaining back her strength. "They took so violently to me from the very instant they saw me, it was wonderful."

Laughter rang in Mary's heart once again. She wrote to Elgin that little Harriet had sat upon her grandfather's knee and the two of them sang "God Save the King" together. Bruce was the image of his father, "the finest manly, healthy Boy I ever saw, tall uncommonly well made, excessively active climbing up everything"; Mary was "as elegant a little thing as you can see"; and Harriet, "a perfect beauty, and so engaging a quiet mild manner she is irresistible; she is precisely what our William was, sometimes I can hardly look at her, only he had Bruce's Eyes instead of Harriet's." She sweetly assured Elgin that all of his children prayed for his return.

Mary's letters resumed a cheerful tone, full of sparkle and mischief. The future earl was a little hellion, she reported. One day at Broomhall, when his grandfather was in the cellar gathering some wine, little Bruce ran amok, screaming at the top of his lungs, "All this is mine!" Grandfather Nisbet scolded the obstreperous boy, but Bruce continued his "hollowing." Mr. Nisbet, who didn't appreciate the boy's arrogance, whacked him on his bottom. Bruce lowered his pants, flashing his bottom at his grandfather, and shouted, "You may kiss my backside! *That* is mine, too!" Mary howled with delight. "What say you to that specimen of elegance?—really I never saw a finer boy than he is, what unspeakable delight you would have with them."

William's death had caused a void that would never be filled and had increased Elgin's anxiety about the health of his children. Mary assured and reassured him in every letter that these children were robust and perfect.

Oh yes my Elgin, our beloved William is eternally happy; if one had not that feel what would become of us? But nothing in this world can ever make up his loss, dreadfully I feel it when I see the others. But indeed it is impossible to see more lovely children than those we have left—pray God Bless them to us.

As for Bruce, he will be your favorite, he is so wonderfully active

& wellmade . . . he can place the map of Europe perfectly . . . he knows all the countries thoroughly, & many of the principal rivers.

Mary is certainly uncommonly clever, tall & remarkably elegant, her head is beautifully shaped . . . dear things they have excellent hearts . . . it is quite astonishing the violent attachment Bruce & Mary have for one another . . . Harriet is the mildest little beauty I ever beheld . . . she told me what one of my old friends said to her at Biel, "Oh you bonny Creature you are like your Mother."

Mary filled her moments with her children but still felt the pangs of "the dear dear Angel we have lost." She attended dinner parties and went to the opera with family members. Elgin's former attaché, William Hamilton, was now an undersecretary at the Foreign Office, and he was working with Mary to facilitate Elgin's release. Alexander Straton, Elgin's former embassy secretary, was also writing letters pleading Elgin's case. Mary had a very easy time attracting other people to meet her as well.

While she had been abroad, London had been agog with stories of her adventures. Gossip about her husband's collection, her visits to the Seraglio, and their romantic travels had filled drawing rooms around Britain, and now that she was home, everyone wanted to talk with her. As always, she enjoyed the attention and wrote to Elgin that as usual she was the much-sought-after object of curiosity. Once again, Elgin wrote of his displeasure with her behavior. He thought it unseemly that she was not under her father's roof. It was the Dowager Lady Elgin who had incited his ire, and Mary resented her mother-in-law's meddling.

I will tell you how I manage—I seldom get out of my bed till between 11 and 12. at one I go to Portman Square & lunch whilst the Children Dine I remain there to Dinner tea & Supper! And have a regular whist party every evening as I had at Paris—so you see my visitors I receive at my Father's—I really think what several Women

have told me since I have been here—"That you are extremely Jealous." . . . What say you?—was it your idea, or your Mama's? . . . if at 27 one does not know how to act, it is all over, watched or not.—Do you know my Mother gave me the front room below stairs to receive my Company in, separate from her!—so you see she has more confidence in her Mary, than you have in your Wife. Nothing provokes me in your Letters but your astonishment at my liking a house to myself—I am sure some of your people must have put that idea into your head Elgin.

"I most willingly will pay it out of my own money," she wrote, and reminded him that once again, he misconstrued her actions. "I have worked like a slave for you ever since I have been here—there is nothing I would not do." She repeatedly told him that the minute the baby was born, she would head back to France to be with him, but she had little faith that he was of the same mind, and she persisted in worrying that he was being unfaithful in her absence. "Have you ever enquired about my getting back again. I dare say not."

In the meantime, as she prepared for the baby's delivery, she turned her attention to another crucial matter. Try as they did, the trustees of Broomhall, including Mr. Nisbet, had not been able to rectify the earl's financial situation. Broomhall's lime and coal works had brought in money, but as Elgin had encumbered the property in the past, there were loans to be paid. Try as she did, Mary could not stop her husband's reckless spending. She was grateful that her parents had assumed all responsibility for the children's expenses, but she knew that radical measures had to be taken if Broomhall were to survive. Mary boldly decided that once again, she could do the job if she put her mind to it. "Will you appoint me your Man of Business?" she wrote Elgin. "I am upon a grand Plan of settling my accounts as well as yours."

Chapter 20

DROWNING
IN DEBT

The cash is going to the *Dogs*," Mary wrote to Elgin on December 3, 1805. The cash meant his cash, as her own fortune remained intact; her Scottish holdings would, upon her father's death, yield her over £18,000 a year, and Aunt Bluey would leave her Bloxholm Hall in Lincolnshire, adding another considerable fortune to that. Elgin's own annual income for 1806, Mary reported, after his debts were paid, would leave them a paltry £500 to live on. To be considered a gentleman, a man living in the United Kingdom in the early nineteenth century needed, among other attributes, to possess an annual income of at least £150. The sum of £500 per annum was not at all paltry to most of the world, but to a girl of Mary's background it was frighteningly low. She warned him, "Dear Elgin beware of buying—little do you know all the trouble and anxiety I have had about your accounts. . . . Bills which were really disgraceful . . . you have really nothing to live upon this year."

Considering the fact that Mary was among the richest girls in the world, that statement seemed a paradox. From the time of her marriage, however, she monitored the family finances, learning very early on that her husband was a spontaneous spendthrift who could not live on any semblance of a budget. The Elgins' first Christmas in Constantinople, which

was Mary's first Christmas away from her parents, was when she received the emerald the size of an egg on a tray from her husband. She also received some presents and a letter from her parents. It was her mother and not her husband who jolted Mary into the reality of her husband's precarious finances. She inferred from her mother's comments that all was not well at Broomhall. Mrs. Nisbet, a very wise woman, let Mary know, in case her son-in-law had not, that Mr. Nisbet and Mr. Oswald, two of Elgin's trustees for Broomhall, had been writing to Elgin with gloomy news. As Mrs. Nisbet had suspected, Elgin had not forwarded this bad news to his young bride, nor did he impart the constant warnings from his own mother that he needed to cut back on his expenses if he were going to keep Broomhall. Elgin ignored them all and spent lavishly.

It was clear, however, that Mary, while maintaining her customary humorous tone, understood the gravity of her mother's news. She sprinkled her notes with messages revealing her anxiety about the serious spending going on; serious money was needed to feed sixty for dinner every night and all those "Hottentots." Elgin's salary from the British Parliament was somewhere in the £6,000 range, £1,000 of that subsidized by the Levant Company to further its interests. In 1800, the embassy costs totaled more than £8,472. In 1801, Mary reduced their expenses to £4,847. She worked at cutting back on some of Elgin's extravagances, for example, by dispensing with his chamber orchestra, although its leader, Belotti, was allowed to stay on without pay but with food. Mary knew that what she didn't say (or what her parents would read between the lines when she told them she was economizing) would result in their sending her money.

On the eleventh of March, their first wedding anniversary and just four months after their arrival in Turkey, Mary confided to her mother:

I am rather annoy'd about our expenses, for they are enormous; we must knock off some, and we know not what. We have sixty people to feed every day, independent of the company at our own table, that

we have almost constantly. We shall go into the country as soon as I
am able, and then I shall get rid of as many people as I can.

The British government paid almost none of these expenses, and
the staff was often not paid until the term was over, when Elgin would
submit his expenses for approval. Mary often dug into her own
accounts to keep them from getting stranded. It was Mary Nisbet
whose money kept the embassy afloat while Elgin made grand and
extravagant public gestures to other ambassadors and his host govern-
ment. Elgin himself borrowed heavily to build the *Mentor*, and as it was
of indispensable use to the Royal Navy, he thought surely the govern-
ment would defray the costs of its own militia. He frequently arranged
for supplies for the army that had to be financed. The British govern-
ment was not forthcoming, and that was a stunning blow.

Much as she adored luxury, Mary displayed a hardheaded practical-
ity about her gifts, often sending trinkets home to be appraised and
sold. She was in frequent contact with her favorite jewelers, Rundell &
Bridge, asking them to mount stones, sell medals, and send unusual
pieces for her to offer as gifts. As early as 1799, without even knowing
the entire scenario of her husband's financial quagmire, Mary tried to
control their budget.

I have written to Rundell & Bridge to tell them I have endeavored to
dispose of the ornament for the Head & Arms but I have not suc-
ceeded which I am sorry for. I did not let Elgin buy it because it was
too dear . . . I hope it will not make Bridge uncomfortable my send-
ing it back . . . I should have been happy to have taken it but really
that thing would have been extravagant, & I am turned Economist!

She had a sensible attitude toward money and understood the value
of things. Waiting for her parents' arrival in Constantinople, she wrote
a note to her father congratulating him: "The General says you are cer-

tain of coming, and that my Father has let his grass at £8 an acre!" To
her mother-in-law she wrote:

The Sublime Porte sent me a very ugly . . . Egrette, saying at the
same time I was to have so much money with it. Upon this I said I
would rather order a Necklace from London; they immediately sent
me the whole Sum & begged I would do what I pleased with it—
now my idea was that it was best for me to take ye Cash in the mean-
time, and then on my return to England I may do what I like with
it.—Elgin you may be sure was against this as he is always clear for
my having any fine thing; but you see I am become *prudent!*

She was also generous to those in need, exhibiting a kind heart and
Christian attitude toward her money when she took "a poor little En-
glish girl into the house; she is a soldier's daughter. Her mother died a
few months ago, and her Father died last week; she is 14 years old, and
works very neatly. I make her work, milk my cow, and feed the poultry."

The Dowager Lady Elgin understood the enormous expense involved
in her son's accepting his great role as a public servant—having to feed
and shelter any number of British staff, servants, and military visitors; she
had asked the Prince of Wales to forward some money to the young
Elgins on behalf of the British people. In early 1801, Mary wrote her
mother-in-law stating that she would wait for the prince's answer before
she dug into her own capital. When the king sent the young couple a pal-
try £100, Mary thanked her mother-in-law and said she would use the
money to tip her staff, especially the female employees, who were not
receiving as many extra gratuities around town as the men were.

It didn't take Mary long to realize that the Crown and Parliament
expected young Lady Elgin, an heiress, to "pony up" for king and coun-
try. Mary was a bit less prepared to be the embassy's pocketbook than
was her own father, who had been in politics and understood its ways.
The usual procedure for an embassy was that its ambassador would

receive a certain salary, and then further expenditures—if legitimate and approved—would be reimbursed upon completion of the ambassador's term. Mr. Nisbet, as the rich father-in-law of a poor son-in-law in service to His Majesty, accepted the fact that he was expected to fund certain expenses until the time—whenever that would be—when Elgin would be called back to England. Mrs. Nisbet, thrilled at the opportunity for her daughter to serve the Empire, also viewed such expenditures as a necessary evil.

Expenses for the Elgins were so far above their allotment that they were constantly petitioning for funds and salary increases. Mary's bankers, the Coutts, regularly dispensed money. The Dowager Lady Elgin and Lord Elgin were compulsive about retaining the best and most expensive doctors, and although Mary agreed with proper medical care, she thought their obsession was excessive: "I scolded poor Tommy most dreadfully I think I completely alarmed him with the rattle I gave him upon Economy!!! What *said I* Tommy a Guinea a day for a pulse feeler! Shame! Shame! After I had vented my spleen upon your trembling Tommy," Mary reluctantly made the best of what agreements Elgin had already made. He knew that Mary was a woman of honor, and he counted on her to make good when he overspent.

Before Elgin left for Turkey, Parliament made it clear to Elgin that his archaeological program was to be privately funded. The Nisbets at first viewed Elgin's artistic interest as a frivolous hobby, and they, too, made it clear to him that in that arena he was financially on his own. With hopes of eventually being reimbursed by the government for government expenditures, Mary's parents did not mind opening their checkbooks for the good of their country, but they slammed shut their pocketbooks for his cultural project. In May 1801, however, they did a volte-face when, on their voyage home, they received the ancient gymnasiarch's throne. This chair was of such historical import that the Nisbets were awed, and as with Elgin when he received his inscription, their passion was ignited for acquisition. They then began to urge their

daughter to collect as much memorabilia as she possibly could. The Nisbets began to enjoy the idea of competing with such collectors as the Duke of Arundel, King Louis, the pope, and Napoleon and proceeded to fund their son-in-law to a degree they all could not have foreseen. Elgin's original plan to pay his artists totaled about £600 per year. When the project ballooned into one of excavation, so did the costs.

Elgin perceived his wife's inheritance as limitless and paid no attention to the consequences of his spending. It wasn't until years later, when his expenditures were, in fact, finally tallied, that he learned the full extent of his debt. Instead of the nominal amount expected, his undertaking cost him around £40,000, a truly staggering sum. The salvage operation of the *Mentor* alone cost over £5,000. He admitted later, "All the money I had drawn upon public account, the whole proceeds of my patrimonial estate, my wife's fortune, and every private fund at my disposal had been absorbed; and a debt was awaiting me of about £27,000 accumulated during my foreign life."

Mary, on the other hand, was acutely aware of their dwindling accounts, and she urged him to restrain his shopping impulses. When they were detained in France, Mary wrote to Mrs. Nisbet, "I wish E. would think a little more about money" and "Of all things on earth, I most wish to clear off all debts." Elgin, on the other hand, perceived their stay as an antique-buying opportunity, as the revolution had caused tremendous hardship for the nobility. Through an agent called Quinton Crawford, he bought vases, furniture, and trinkets. He bought cases of French wine and purchased some fifty-four old master paintings.

When Mary returned to London, she found things in a worse state than she could have imagined. She consulted Coutts once again to find a way to pay Elgin's French debts. Unless he could buy cheaply and sell in London at a profit, as with the much desired furniture made by Charles Boulle, she warned, "for Heaven's Sake buy nothing in the world more. . . . You know I am sure my dear Elgin I like pretty things

as much as any body. . . . Only think of all the stock being gone . . . there are Bills owing here to the amount of three thousand pounds & the people are always asking of their money & indeed it looks disgraceful not to pay them." She did, however, give him permission to pick up her almond paste from the Faubourg-Saint-Honoré perfumer Houbigant, when he once again arrived in Paris, and she herself had bought some articles for Madame de Talleyrand, who had given her a shopping list.

Most of Elgin's stock had been sold to pay off loans that had been called in. What remained of his portfolio contained investments worth only £600. In addition, Mr. Dundas juggled one loan to pay another. Elgin had borrowed money not only from his own brother but also £2,000 from Lady Robert, "which annoys me," Mary admitted. There were only two remaining avenues of income, and Mary thought these were both, at best, precarious. One was reimbursement from the British government, and the hope for a full pension in gratitude for her husband's fine services. She pointed out to her mother that the government had, in fact, offered full pensions in other cases. She also began, unfortunately for her children, an aggressive program of selling off jewels, medals, porphyry, furs, horses, and whatever gifts from the Turks she could dispose of. Still, neither one of these sources would solve their problem for the long term.

Mary was disgusted that Elgin had even alienated his closest advisers—his own father-in-law, Mr. Nisbet, Mr. Oswald of Dunnikier, and his attorney, Mr. Dundas—when he refused to take their expert advice concerning Broomhall. Mary saw this as a terrible tactical error, and she, therefore, assumed the role of go-between attempting to smooth all the feathers Elgin had ruffled. "Write kindly to Oswald, he is really your friend," she advised him. "Now Elgin if you recollect, you provoked both my Father & Mr. Oswald." Mr. Nisbet was "piqued," furious with his son-in-law for representing that his annual income was some £7,000 when he had come to Archerfield to propose marriage to

Mary. This, of course, was an omission of his liabilities and was therefore a gross overstatement. Mary, too, acknowledged a fault in his character: "Elgin I have been often told & indeed it is true, you quickly make friends but you as quickly let them down." Rumors had spread around London, and the Nisbets had heard them as far off as Malta on their return home, that Elgin had involved himself in some underhanded trading. While she defended her husband to everyone, she privately accused him of keeping secrets from her. The ever disgruntled Smith brothers had led people to believe that in the course of transporting food to the British militia on his ship, the *Mentor*, Elgin had engaged in profiteering, when the exact opposite was true. The cash records painstakingly detailed the quantities of grain going to feed England's soldiers at war and all payments and costs involved in the transactions. To the general public, Mary dismissed the Smiths' charges as jealous nonsense and appeared to brush the charges aside as insignificant; privately, however, she confided to her husband that she was suffering from the daily trial of having to face the ugly innuendos without him and she once again faulted him for sending her home alone. She was willing to face any scandal, she told him, as long as they were together.

In the winter of 1805–6, for the first time in history, a newly appointed lord mayor of London was going to be a Scot. All of the Scottish nobility and English royals were to attend grand inauguration festivities. The unsinkable Countess of Elgin planned to valiantly put her best foot forward despite her personal difficulties and attend the events wearing all her diamonds: "You have no idea of any thing more beautiful than my Diamonds, I intend to make a grand shew and one of my Paris gowns, I put one on the other night, you would be astonished the immense admiration it met with." Her husband, who wanted her sequestered quietly in her father's house and out of the social limelight, felt threatened by the power of her charisma. She chose to believe that he was not threatened but was merely convinced that a woman could not

do the job of a man. As she had proved him wrong in the past, she understood her own capabilities were limitless, and she boldly seized the reins: "I have no doubt but that with proper management we may do well & handsomely. I have one or two plans in my head, for I am always ploding."

Elgin had plans of his own, and in December 1804 he had written to his aide William Hamilton instructing him to find a spectacular town house in London that would display the collection of marbles. Elgin informed Hamilton that money was no object because his wife would pay for the house out of her own account. Hamilton made discreet enquiries and suggested Buckingham House, later the core of Buckingham Palace. When the topic was reintroduced to Mary, as she had already dug into her own capital to bail out her husband's often grandiose plans, she sidestepped the issue and the matter was dropped. As the marbles began arriving in London, a home had to be found, and Elgin insisted that no ordinary, simple place would do. Through the Dowager Lady Elgin's connections he was able to display the marbles for a while at the enormous and imposing Gloucester House on Green Park, today the home of the Hard Rock Café. Mary sincerely understood, and even admired, Elgin's passion to preserve the treasures, but when import duties began to mount, she asked him the practical question "Where is the money to come from?" Elgin dismissed Mary's concern, assuming that the question was rhetorical. He expected his financial needs to be met by the heiress he had married. She begged him:

Oh my dear Elgin, if you would let me manage matters as I wish, I really think bad as every thing has turned out, I could bring things into some degree of order—you know not what I am capable of when I take things in hand—but then you must give me *unlimited* powers till I have got all in order & above all things you must buy not another article—Elgin take my advice, listen to me, if you know what I have done since I have been home, and how much I have gone

through and suffered from vexation and I may almost say despair, in finding everything in such a desperate state.

An offer was extended to Mary, while Elgin was still in France, to dispose of their extensive marble collection, and she shrewdly placed the ball back in the opposition's court, revealing a total canniness for negotiation with the toughest politicians whose own skills were considered fierce: "This very day I have had proposals from Govt. about the Antiquities, I desire them to make their offer, that it is impossible for me to fix any sum—I shall see what is said, it is always well to have that in ones power."

As she herself admitted, she had no idea of their worth, so before she would consent to selling the marbles to the British government, she wanted to estimate their cost. She consulted two very knowledgeable men whose opinions she valued, Robert Ferguson and Sir Joseph Banks.

Mary knew that Elgin would be relieved to learn that Robert Ferguson had, indeed, arrived in London to welcome her and come to her rescue, orchestrating the quiet sale of horses and pictures. Elgin vacillated in his confidence in Mary, but he had every confidence in Robert Ferguson's abilities to negotiate fair prices for his livestock and *objets;* he placed so much trust in Ferguson that he even appointed Robert guardian of the children in his absence. Robert, true to his word, introduced Mary to his mentor and friend, Sir Joseph Banks, and she deemed the elderly Banks kindhearted. Banks, internationally famous for accompanying Cook on his first voyage to Australia, had generated much excitement when he returned from his journey bringing back thousands of species of flora that were new and exotic to European scientists and agriculturalists. He had proved influential with Napoleon in the past on Ferguson's behalf, and Ferguson and Mary, who wisely befriended Lady Banks, persuaded Banks to now wage a letter-writing campaign to Napoleon and Talleyrand on Elgin's behalf. "Ferguson is a great friend of Sir J.B. [Joseph Banks] the plan will now immediately

be settled." Sir Joseph also took his colleagues to view some of the Elgins' collection of antique drawings, which were deemed lovely. Mary, interested in an appraisal of the Greek marble collection, sought the opinions of these experts as to the value of the collection.

Ferguson was thrown into an unenviable position. Mindful of his great friendship with Elgin, he was, unfortunately for him, still in love with Lady Elgin, and he had a very hard time fighting his feelings for her. Referring to her as "*" in his diaries, he visited her often at her 60 Baker Street address and not at gatherings at the Nisbets' house, where most other people saw her. He came daily on the pretense of discussing her finances, her children, and his efforts to get Elgin home. Their meetings were most often late in the evening after the children had gone to bed. When he arrived in London, Mary was in the final stages of her fifth pregnancy and was extremely uncomfortable, often changing into loose-fitting robes from her constricting party attire. In this informal and intimate setting, the two remained alone until the early hours of the morning. Mary would let him out before dawn while the servants were still asleep.

Chapter 21

BREAKWATER

E lgin I will never have any more Bratts I cannot bear this suffering—
and this time I have been much worse than ever—my mother
entreats no more babies. I would upon my word if I had my choice rather
die," Mary wrote her husband on New Year's Day, 1806. On January 18,
she continued:

> My Elgin I never suffered so much in all my life—any thing on earth
> would I do for you, but I solemly declare you I cannot cannot
> undergo this suffering again: life is a burthen to me at this rate—
> Elgin say you will harken to my prayer, this is the fifth time I have
> suffered, I am worn out & would rather shut myself up in a nunnery
> for life—my life is in your hands—you must decide my fate— . . . I
> will live where you like and never see a Soul, but this agony I will not
> encounter.

Two days later, on January 20, their fifth child, a daughter named
Lucy, was born. Mary had been hoping for a boy, not only because she
missed William, but also because his death had intensified Elgin's
urgency for more sons. Mary had suffered through labor in the middle
of the night and had the baby on her own before Dr. Croft could arrive.

Once the doctor saw Mary, he gave her "twice Brandy, a good deal of Opium and bread soaked in White Wine." Four days later, she was still given large quantities of opium:

Elgin I solemnly declare to you if you wish to preserve my life, or if you wish a being even common happiness—you must promise sacredly promise not to put me at least for a few years into this situation—answer me my Elgin fairly & honestly, all my future happiness is now in your hands—every person here says they never saw *any* body human being suffer like me—I would before Heaven I declare it, sooner die than look forward to such suffering—but answer me—

. . . what I suffered afterwards is beyond describing—the after pains still continue pretty violent & Croft gives me Opium to appease them & make me sleep.

Mary wanted her husband to practice birth control from then on or she wanted no sex at all. Elgin's greatest fear, sharpened by the death of their son William, emanated from his childhood. He wanted to ensure that he had an heir to the eminent titles and estate. He would never agree to birth control, even though various methods were available. The most popular method of birth control in the early nineteenth century was coitus interruptus, or withdrawal; but since the days of King Charles II, when the court doctor, Dr. Condum, supposedly introduced the condom to His Majesty and society, the condom was widely available as well. In 1717, a well-known treatise by Daniel Turner insisted that the condom was the best protection against syphilis. Casanova used the term *redingote anglaise*. By the late eighteenth century, handbills in London advertised the sale of condoms, and they could be easily purchased by any gentleman. Birth control was entirely the gentleman's option.

As Mary recuperated, she experienced the bittersweet pleasure of this new little child while memories of William flooded her emotions.

She received visitors, mostly family, who came to meet Lucy and to look in on her very frail mother. Aunt Bluey helped Mary with her correspondence except for those letters to Elgin. (Mary unhappily remembered Elgin's severity when she allowed Ferguson to write for her.) Ferguson also came to rally Mary's spirits with reports on his progress on Elgin's behalf, and indeed, Elgin had now moved to a more comfortable situation in Paris while negotiations concerning his liberty resumed. "I trust my dearest Elgin when the Emperor returns to Paris, you will get leave. I cannot doubt it if Seb. [Sébastiani] is there," Mary wrote. She joked that since she had already shown off all of her Paris gowns once, she needed to return to Paris to buy some more, but she also threatened, once again, to take matters into her own hands should Elgin not proceed. She was determined to see Elgin in Paris once she was on her feet and was angry that he had not sent her the proper papers. "How I can return to France, if you will not send one an answer," she wrote to Elgin, and in desperation warned him that to be near him she would make her own way without his cooperation and "go to Holland & wait there till I hear from Paris." For an English person, because of the war with Napoleon, entering the Netherlands—still the Batavian Republic until later in the year when Napoleon placed his brother, Louis-Napoleon, on the throne of Holland—was a far less labyrinthine feat than procuring a safe passage to France. She was convinced that once in Europe, Napoleon would be easier to persuade than her husband, and she would return to Paris. Mary's fighting spirit was subdued, however, because she was unable to rise until Friday, February 7, when she went out of doors for the first time since her confinement.

She had ample time in bed to decide with much regret not to nurse her little girl because she felt to do so would worsen the hourly pain of William's loss. Lucy had not taken his place, could not take his place, and Mary begrudgingly admitted that none of her children ever would. She admitted that she had felt closest to her deceased son and thought it might have had something to do with the fact that she had nursed

him. Although she adored her other children, he had been her favorite. She understood to her core that Elgin feared the possibility that another of their children would die, and especially since Lord Bruce was now his only male heir, Mary repeatedly tried to reassure her husband that their four surviving children enjoyed robust good health. She urged him to be satisfied with their brood as complete, and declared a moratorium on further pregnancies.

Mary barraged Elgin with her new position on the matter. She was sincerely terrified of having to go through one more pregnancy. To ensure her happiness, she told him, she would no longer sleep with him. She wanted her own bedroom. She wanted to live with him as "friends" and she wanted him to agree to this arrangement. In April, she wrote:

> I am determined to have a room to myself, I am serious nothing can alter me—my health & happiness requires it. . . . My resolution is fixed, I do not care where I live, but I will not run the risk of suffering as I have done, any more. Why will you not answer me? You might make me comfortable by saying you will agree to my having a room to myself, tell me what I am to expect.

He did not reply to these demands nor did he take them seriously, believing them to be a temporary reaction to yet another difficult pregnancy and delivery.

Mary had not stopped loving him, calling him "my beloved Elgin," wondering if he were being unfaithful, and asking him forlornly if he remembered his "little Dot." She reminded him that it was he who sent her away, and she reiterated that she would rather remain in "a hole" anywhere in the world if it were with him. She simply wanted no more pregnancies. A month after Lucy's birth, Mary still experienced severe contractions. She was also experiencing another kind of pain.

At the beginning of February, barely two weeks after Mary had given birth to Lucy and at a time when she was physically still very

frail, Robert Ferguson left London. He and Mary had grown even closer. Although he was deeply in love with Mary, he was confident that he had committed no objectionable action against his friend Lord Elgin and, in fact, believed that the Elgins would shortly be reunited. Robert had loved twice, and both of the women he had loved had been married to other men. He, once again, returned a woman he loved to the arms of her husband and proceeded with his own plans.

For years, Ferguson had wanted reform in government and had often quarreled with others, even in his own family, on behalf of his progressive views. He had never, however, put his beliefs into action. He decided to head home to Scotland to try his luck in politics. He was going to run for a seat in Parliament as a Whig to try to promote his ideas and implement those changes he thought essential toward creating a better Britain. Although Mary encouraged her friend, she secretly thought that his ideas would not be very popular with the large landowners who constituted and controlled the electorate, and she was convinced that he had very little chance of winning. The Whigs, at that time, had, in fact, gained control and had begun to exert their recently won power, flexing their muscle with all their might against the Scottish Tory leader Henry Dundas, now known as Lord Melville. Robert's friends in Parliament accused Melville of financial misdeeds and brought impeachment proceedings against him in the spring of 1806. Lord Melville would eventually emerge victorious, but the trial dragged on a painful month and a half—enough time for Ferguson to secure his election, as opinion rested for the moment against the old Tory party boss. All of London was caught up in the unpleasant trial, and Mary wrote Elgin daily about the details.

She also wrote cheery letters to her husband of the happy home life he would return to. She resumed the lighthearted, entertaining stories and reported that she and her father had enjoyed a practical joke one day when they went shopping together, filling their carriage with cheese. They aimlessly drove around London, waving at friends, beckoning

them to approach the carriage and greet them. After the friends would depart, desperately trying to pretend indifference to the awful smell before running away, Mary and Mr. Nisbet would laugh with abandon. Her Baker Street house was full of life and the noise of children, "mad as March Horses tonight," promising him contentment. She described the hilarious scene at Lucy's christening in March when the aristocracy was treated to complete havoc courtesy of the Bruce children and their wild Greek *paramannas*. In addition, she demurely offered him the news that she had given up attending balls in favor of a new strategy: "Keeping back makes one the more sought after—I believe that is a good plan."

In truth, she was hoping to impress Elgin with the kind of restrained behavior he could find no fault with. She was trying to walk the straight and narrow path so that when he came home he would agree to his "little Dot's" demands. The underlying meaning was that when he came home, she would please him perfectly in every way except one. She would have no more children. The very model of the low-profile and dutiful wife, Mary had dinner at the bishop of London's, at her grandmother's house at "GS," with her parents, who were footing all the bills, and with the Dowager Lady Elgin, whom Mary accompanied to the opera. She visited his marble collection at the West India Docks on June 3, and on Thursday, June 5, Lord Elgin arrived in London.

Robert Ferguson and Sir Joseph Banks had actually succeeded in getting the French to release Elgin. The cunning Talleyrand, however, made Elgin sign a pledge stating that Elgin agreed to return to France as a prisoner if requested to do so. Elgin, therefore, received his parole, and it was just that—not complete freedom, but a parole. As a man who could be recalled at any moment to live in France, there would be little chance that the British government would offer him another diplomatic post. Elgin returned to London and asked the Foreign Office to reimburse him for the huge amounts of money he had laid out. They agreed to his salary plus some small amount that fell far short of his

outlay. He was furious and argued with the Foreign Office. After all the success he had enjoyed in Turkey, he felt that the British government should have paid him respect and expenses. He stubbornly resisted facing the widely accepted practice that diplomacy was a rich man's game.

Elgin paid little mind to Mary's letters, and he had not anticipated her absolute and complete resolve to cease sexual intercourse with him. All through June, they made public appearances, dazzling society in London. They went to dinner at Lady Durham's house. They dined at the home of Lord Grenville, who was now prime minister. They went to the opera. They entertained Robert Ferguson, who had, to Mary's surprise, been victorious in the election. To the outside world, they seemed like the perfect, happy couple, and indeed it all seemed perfect until July 2, when Mary took the children home to Archerfield and left her husband in London. He refused to live in a sexless marriage, and she, then, refused to live with him under the same roof.

Mary and the children lived between Archerfield and Biel for the next five months while Elgin and she existed in a tumultuous limbo. While her emotions were in a confused and strained state, Robert Ferguson decided that the moment was right to stake his own claim. He wrote passionate love letters to Mary and, perhaps to his detriment as a man of honor, actually waged a campaign of denigration against Lord Elgin, whom he now challenged as a rival. Ferguson promised devotion, fidelity, and no more children. He promised her a life free of anxiety where her every wish was his command. Aroused by his urgency, Mary felt assaulted on all fronts: she had fallen in love with Robert, and at the same time she was trying to decide which path to take with her own husband. Elgin claimed he would live with her on her own terms, and on November 30, he arrived at Archerfield to take Mary and the children to Broomhall. Above all, Mary wanted to keep her family together, and she agreed to go. Despite their efforts, events unfolded that drove them further apart. Mary and the children stayed at Broomhall through Christmas but returned to Archerfield before the

New Year. Since his childhood, Elgin had mentally pictured and longed for the enviable life of the country squire; his fantasy had been to fill Broomhall with his children, with lovely things, and with an adoring wife. Mary, too, had planned for years for her return as mistress of her husband's house. She had shopped for fabrics and furniture, she had commissioned portraits, and she had intended to spend the rest of her life as Lady Elgin, surrounded by her brood. Both of their fantasies lasted less than one month.

One day in December, a badly addressed envelope, written by a servant, arrived at Broomhall. The envelope read simply "M. Elgin." This abbreviation spelled disaster. Lord Elgin, decoding the shorthand to mean "Milord," as he had just been a prisoner in France, and *not* Mary, opened the note only to discover that he was not its intended recipient. The letter contained passionate explosions of sentiment and ardor for his wife from Robert Ferguson:

> my Mary loves me more than ever—will love me . . . till she sinks into the grave . . . most adored of beings . . . we shall for ever, and long already we have enjoyed that delight, that happiness, which only hearts united like ours can feel, in the blessed certainty of loving and adoring one another, in the perfect, total conviction that to one another we eternally belong

and:

> we shall now enjoy that feel of belonging to one another with a love, with an adoration never surpassed; united by the tenderest ties of the human heart, by every feeling of our natures . . . ever repeat to me, that my Mary lives but in me—loves me beyond example, and will ever, ever prove it—will effectuate her escape the moment she can, and then we shall venture to look forward to bliss unheard of.

Elgin was stunned. He and Mary had an explosive confrontation, and he further learned that various friends, like his former secretary Alexander Straton, had assisted in passing notes between Ferguson and his wife. Elgin felt the profound sting of betrayal from the two people he had trusted most, and began to question many things about their life. In one letter that was discovered, Mary had told Ferguson that she felt as though William had been theirs. Elgin then charged: if this affair had been going on for years, was it possible that William and Lucy were not his own children? Although Mary swore to Elgin that the children were his, the seeds of doubt were now planted so firmly in his mind that he decided he would tear Mary out of his life forever and give her the separation she and her lover seemed to desire. In January, Lord Elgin went to London and began a plan propelled by anger and jealousy, placing his own wife in an adversarial position. Overcome with rage and jealousy, Elgin determined that if she would have no more children with him and would allow another man to love her, he would divorce the Countess of Elgin.

There had been other aristocratic separations in the past where money had exchanged hands in order to keep all parties quiet. Though on the one hand Mary did, in fact, love Robert Ferguson, she was horrified at the thought of an actual divorce. She fought back with whatever ammunition she possessed in order to avoid losing her children and her reputation, so she offered Elgin money; Elgin, at that point, agreed that if Mary's trustees would relieve some of his debt, he would not pursue a public trial. She arranged for the money; he used it and duped her. He left for London, after having received a good deal of money from her trustees, stayed at the Nisbets' house on Portman Square, ostensibly to oversee some business about his marble collection—which was partially true—but at the same time he began divorce proceedings in London against his wife. As she had accused him in the past of being a secretive "Scot," he proved that he was, in fact, quite able to keep a secret. Mary knew nothing of his double-dealing until June 22, 1807, when the sheriff arrived on Mary's

doorstep with an order to remove her children from her custody. He then took the children to Broomhall and formally charged Mary with being an adulteress and unfit mother; until proven otherwise in a court of law, Mary would no longer be permitted to see her own children.

Robert Ferguson, unhappy that Mary was suffering, but for his own cause quite thrilled with Elgin's decision, stepped in, writing Mary beautiful love notes, referring to her as "adored angel"; he appeared at Archerfield and Biel, and offered marriage the very moment Mary was free.

Once Elgin's lawyers began their motions and depositions, it was clear that he was not turning back. In August 1807, Mary's lawyers responded to the charges that Elgin had learned of Ferguson's attraction to the Countess of Elgin but that he held her blameless, living with his wife for months after the discovery of these letters. The Nisbets' lawyers stated that Elgin

did also solicit and obtain from her, an order upon her trustees for *a very large sum of money*. . . . It was in this manner and on these terms that they lived together after the pretended discovery of her infidelity upon which this action is founded, during the months of December and January last [1807]—and in this course of conduct he persevered till he set off for London on the 20th of that month, after passing sometime in her bed chamber and bidding her adieu with many affectionate embraces. He desired her to enquire at the same time whether it would be convenient for him to lodge at her father's house in London—and left his four children with her, and entirely under her management, where indeed they were allowed to remain till this action had been several months in defendence.

In other words, Mary's lawyers recriminated, Elgin had falsely trumped up the infidelity charge, stating that he had continued to live with her and allow her contact with their children for months after his

knowledge of a so-called love affair and that his reasons for suing for divorce had nothing really to do with adultery. Mary believed that Elgin would have forgiven her if she had agreed to have more children, but on that subject she stood firm. If there were to be a separation, she wanted it on her terms; instead, she was put in the position of having the courts decide her future. She now had to face the prospect that whereas in the past, her difficulties had always remained private, this time she would have no protection from public scrutiny. Divorce in the early nineteenth century was uncustomary and irregular, and even worse for Mary, divorce among the envied aristocracy was fodder for everyone's imagination.

The Nisbets and even Robert Ferguson told Elgin that they would do anything they could to avoid a public scandal. At first, the Nisbets were horrified at Robert Ferguson and their own daughter's behavior, but as Elgin grew more and more intractable, they grew increasingly angry with their son-in-law, who refused to spare them public humiliation. No matter what kind of behavior a monarch maintained himself, and there was ample evidence of very gross conduct on the part of the Prince of Wales, later King George IV, a divorcée would never be invited to Court and would be for all intents and purposes shunned by all as an "untouchable." Robert, irreverent as usual, had no qualms about marrying a divorcée and believed that in the long run Elgin's thirst for the disgrace of his wife would affect the children and his own career, making him very unpopular in both Scotland and England. Robert assured Mary that he loved her and would marry her, but Mary protested that if he married a notorious woman, it would ruin his own political career. Robert, who had so long desired a chance to make a difference in Great Britain, nevertheless declared that he was willing to renounce his career—if it came to that—if he could spend the rest of his life with the woman he loved. He wrote of his hopes in his diary.

It will not be very long before . . . she [is] at last FREE from the Brute & Beast—then she is to become mine . . . our hearts & souls

so much alike . . . she is yet with her Father & Mother—who love & adore her—& who now feeling the greatest indignation toward *his* conduct throughout to *her* & to *them*—will in a little time rejoice that she is freed from him—& though so miserable with this disgrace, will forgive & forget all, when once the Divorce is procured—& once united with the Being in whom she loves—& who will devote every hour of his existence to her Happiness & Comfort.

Robert also understood that Mary loved being a mother and that no matter how much he loved her, his love could never fill the void created by the loss of her children; he offered up his own son, the motherless Henry Robert Ferguson, whom Mary took to her heart. "She loves him—& will ever be kind to him as if he were our own," Robert reflected.

All through the summer and fall of 1807, Mary still hoped that Elgin would back down. The legalities of obtaining a divorce were complicated, and as the affair drew on and on, Mr. Nisbet continued to negotiate with Elgin, advising that a public scandal would injure all of them. Elgin ignored all pleas, and just as doggedly as he had stared down challenges in the past, he forged on full speed ahead. He wanted nothing less than an Act of Parliament, which would forever in the annals of the history of Great Britain brand the Countess of Elgin an adulteress.

Chapter 22

SHIPWRECKED

In December 1807, the King's Bench Court in London assembled a jury of twenty-two men to hear the petition of the Earl of Elgin against Robert Ferguson of Nottingham Place, London, to ask for relief in the amount of £20,000. Elgin accused Robert Ferguson of "criminal conversation," or "crim. con." as it was commonly called, with his wife. In a "crim. con." case, it was not necessary to prove that a wife had responded or had succumbed to an affair. This was one way of maintaining some modicum of chivalry. True to his word, rather than airing the details of his love for Mary in public court, Robert Ferguson allowed the plaintiff, the Earl of Elgin, to present his case, but Ferguson offered no defense, except a statement by his lawyer, Mr. Topping, that simply because Mr. Ferguson, in a frenzy, had written the Countess of Elgin passionate notes, it did not mean that she had committed adultery, and in essence Ferguson defaulted. This default judgment meant that in the eyes of a civil court, Robert Ferguson was guilty of seducing Lady Elgin.

Elgin's lawyers, led by Mr. Garrow, were serious about collecting monetary damages on behalf of their client. Their strategy was to assert that Mary had, in fact, been a model wife, a Christian girl and a very good mother. It was Robert Ferguson, they argued, tempted by

her beauty and charms (and what man wouldn't be), who had pursued this good woman and had ruined her. Elgin's lawyers proposed the notion that although Robert Ferguson could not be blamed for falling under Lady Elgin's spell, he was nonetheless responsible for recompensing the suffering Earl of Elgin for the alienation of his wife's affections. In order to obtain their requested monetary award, Elgin's lawyers intended to show that £20,000 was inconsequential to Robert Ferguson.

Elgin's lawyers provided information about the estate of Raith, which was entailed on Robert Ferguson. In Great Britain, estate laws protected landowners from losing their property, and if an estate was "entailed," that meant that the estate was exempt from foreclosure through a legally recorded document providing for the estate's succession. The estate of Raith was unalterably due to pass to Robert Ferguson upon his father's death. In that regard, Elgin's lawyers succeeded in showing that Robert Ferguson was a man of valuable property and could therefore sustain a judgment for the amount of £20,000 as punitive damages. To assist in demonstrating Ferguson's culpability, they offered testimony by William Hamilton, John Morier, and Captain Donnelly to impress upon the jury that the Elgins had enjoyed an affectionate marriage, as they had so witnessed. The jury heard the one-sided evidence and cut the damages requested in half. The Earl of Elgin and Kincardine was awarded £10,000 against his friend and neighbor.

Although the trial ran smoothly for lack of defense, the case was immediately recorded by the London *Times,* which noted that Lord Elgin was "the representative of one of the most ancient houses of Nobility in the United Kingdom." In its article, the *Times* described Mary as an exemplary wife and mother "living a pattern to her sex." It stated that both Elgins indisputably set "the best example of the best English manners. In the center of a Mahometan Court, services of the Christian religion were daily performed by the Chaplain of the estab-

lishment and all the laws of decorum were assiduously regarded." In Paris, the story continued, "her Ladyship conducted herself in the most meritorious manner . . . and she thus obtained an absolute promise from M. Talleyrand that her husband should be exchanged for General Boyer." All of this information, gleaned from the uncontested proceedings, painted Ferguson as a villainous home wrecker and Mary as the model wife despite the fact that Elgin, in reality, had argued bitterly with Mary about her conduct in Paris. This was, once again, a strategy used by Elgin's lawyers to collect money from Ferguson.

A Fleet Street pamphlet—the equivalent of today's tabloids, and sold on the street for one shilling—entitled *The Trial of R. J. Fergusson, Esquire, for ADULTERY with the COUNTESS OF ELGIN, WIFE OF THE EARL OF ELGIN,* reported that no one disputed the revelations that Lady Elgin had refused sexual intercourse with her husband upon his return from France and that Lord Elgin had opened a love letter to his wife from Mr. Ferguson. It seemed that this Lord Elgin could not stay out of the glare of controversy. The pamphlet was immediately snapped up by gentlemen for their libraries, and discussion about the divorce became an immediate topic of conversation around Great Britain and Europe. Sir Walter Scott, in a letter written in Edinburgh and dated January 22, 1808, to Lady Abercorn, mentioned "the celebrated familiar epistles of Mr. Robert Ferguson to Lady Elgin."[1] The widely read gossip column "Domestic Intelligence," which appeared in the *European Magazine and London Review,* reported: "This Mr. Ferguson (Lord Elgin being still a prisoner in France) seduced a woman until that time esteemed one of the most virtuous, religious and amiable of her sex.—Lady Elgin's name was Nisbet, a Scotch family of much respectability."[2]

A wider dialogue on the very nature of the civil court divorce proceedings appeared in the very first volume of *The Satirist,* published in January 1808. The column, penned by a man called "The Loiterer," was an open letter to the so-called figure Mr. Satirist. The Loiterer, referring

to the trial of Robert Ferguson, declared the whole procedure involving a civil divorce for damages distasteful, as it was demeaning to women: "A wife is no longer like an estate in tail, which the possessor cannot dispose of but is as transferable as any other personal chattel; and an action for crim. con. is the established mode of ascertaining her value." In England at that time, a wife could not sue her husband for adultery. She could only sue her husband for a separation based on nonconsummation or terrible cruelty before the London Consistory Court, the ecclesiastical court popularly known as "Doctors" Commons, where the court resided. Once a canonical separation was decided, a husband could proceed with the legal equivalent that required adjudication by Parliament. Very few, however, sought this route because of the enormous expense involved in the proceedings.

The Act of Parliament was basically a method for the aristocracy to gain a legally sanctioned divorce that would guarantee that an estate would be passed on to its proper heirs—but it also necessitated civil and ecclesiastic one-sided disclosure of misconduct on the part of the wife, who would inevitably lose her children and endure lifelong shame. Elgin received his Act of Parliament with no contestation from either Robert Ferguson, who resigned from the House of Commons and remained mute in order to deflate the already inflamed public scandal, or Mary, who basically had no legal right to do so under British law.

In an effort to reinforce what he thought were his own interests in Mary's eventual inheritance, Elgin next sued for divorce in Edinburgh and this time his lawyers waged an aggressive offense against Lady Elgin. Ironically, the trial took place on March 11, 1808, their ninth wedding anniversary. This time, in Scotland's civil court, Mary could and did defend herself, and in trying to protect her assets from her former husband, the argument got ugly. As the father of their four surviving children, Elgin wanted to show that left in Mary's hands, the vast Hamilton, Nisbet, and Manners estates would be placed at risk because she was unfit, unworthy, and immoral. Trying to prove to the world

that their client was a cuckold, Elgin's lawyers needed "infallible criteria" to do so. They produced a letter Mary had written to Robert Ferguson, dated December 18, 1807, which read:

Yesterday the doctor went away so E & I had the evening alone. He was very much agitated indeed, but he said nothing. After tea he got up suddenly and went into his room for a couple of hours. He coughed dreadfully which he always does when he is annoyed. I told him my wish to go and see where my beloved William is laid—and that I wished to go alone. Friend it was you that placed that adored Angel there—He is happier far than us. If he can hear & know what is passing in this world, friend he will intercede for us. There is something sombering with that infant I cannot account for but I feel as if he was our own. I went out early this morning. I have not seen him. I must do him the justice to say he has taken upon himself to keep his promise. But I hardly think it possible he can go on with it. For your sake I hope he will not. You know my fixed position. I need not always repeat it, need I? No power on earth shall ever make me fail you. Friend, this I know, you must feel desperately at the moment yet I am convinced you have entire confidence in me—you know I am as much wrapped up in you as you are in me—love we are united by the tenderest ties of nature. Nothing but death can separate us. We know how happy we can be together. Friend I wish a better fate awaits us. We shall yet be happy. Take care of yourself. I dread your giving way too violently to your feelings, & then you will get those dreadful cramps in your stomach and no Mary to take care of you. A friend in heart and soul, I am never away from you—every instant of the day my thoughts are with you. You can never think of me but at the same instant your Mary is thinking of you. I told S exactly how matters were between E & me.

What a desperately horrible idea that nothing but death can

make me free. I shudder when I dare think of it. And too thoroughly I feel I cannot live without you. Friend mind let me know more exactly whether you receive all my numbers safe. No. 1, 2 went to Edin. which you got. No. 3 I sent on y 13th Dec under cover to Mr. Taylor near Ferrybridge—then on the same day I sent without numbers. Sent to Straton under Sir F.N. cover. Two letters I got from my mother which I wished you to read. No. 4 I enclosed to Straton & Chrisn. put it into the Post office at Dunfermline. No. 5 I enclosed to S. & Sir. F.N. and sent from there yesterday morning—Oh beloved friend that my letter could but give you comfort; feel &believe that you are adored by a heart that is forever unalterably yours, that exists in you & never can beat but for you. The whole world besides is blank to me.

I have just got a letter from My Mother wishing to send Gosling into Edin. tomorrow as the Hadington surgeon thinks she has had some hurt. I know poor soul she was hurt when the wheel came off the carriage at Pau: I driving & she holding my beloved William. I am going to write to her & tell her to write immediately to you when it is fixed when she goes to Edinb. I shall tell her to direct to Mr. F— You can then write constantly to her to be left at the Post Office, Edinburgh till called for. Oh friend, I shall thus be able to hear from you—have you a mind to put Mrs. Johnstone on the letters or Gosling. The first of course you will direct to Gosling. Write to herself as well as write to me—

After Dinner—Three of four people are Here, I have not articulated two words, but there is a man whose manner I like. Your Father's fortune has been the topic. Thank God I never hear but good I know not how I should bear one slighting word. I will tonight direct this under cover to S or Sir F.N.—let me know if it vexes Straton.

Do not write to Edinb. till you hear from Gosling when she is to be there. I will not write more now because I must write to my Mother and Gosling. I have heard from Pahlen today. Friend I can-

not bear the idea that people should imagine I live with E.—But remember you need and receive the world. I would like much to know *how & when* I may direct to your *own name*. You know I am an *economist* & I cannot make you pay for my nonsense now you are M.P.

Friend, I love you more than Ever and for Ever and Ever. I enclose this bit of my mother's letter. Do you not see that she hates E.?

God in heaven blesses & honours you. Your own *own* Mary.

oooooooooooooooo

xxx

This letter proved without a doubt that Mary was, indeed, in love with Robert Ferguson, but it still did not prove that she had committed adultery. Elgin's lawyers called on Constantinople embassy employees who had not been present in Paris when Elgin and his friend had reunited and could not offer evidence to the growing affection between Mary and Robert Ferguson. At most, the staff members conceded one after another that they supposed that once Elgin had lost his nose, his wife must have been repulsed by the sight of him. The lawyers also produced a letter from Robert Ferguson referring in a very nasty way to Elgin's deformity, stating that Elgin's "horrible presence must eternally disgust and poison" her. Elgin's disfigurement immediately became ghoulishly fascinating to the public, as many who had never seen him began to wonder if he were a monster. Further, servant after servant was called to the stand as each detailed the couple's most personal and most intimate business.

Mary Ruper, a servant at 60 Baker Street, who had also worked at Broomhall, testified: "The next day, I mentioned to Mrs. Gosling that Lady Elgin's dog had dirtied a green cushion which was on the sopha. Mrs. Gosling shook her head and said it was not the dog who had dirtied the cushion, but that rogue, Mr. Ferguson." Elgin, after having deposed various servants, wanted to hear from Sarah Gosling. The Nisbets arranged for Miss Gosling to disappear for some time on the excuse

that she needed medical care; eventually, she was deposed, but her testimony did not offer the injurious details that Elgin had hoped for. At its worst, Gosling offered her opinion that Lady Elgin had behaved improperly instructing her, instead of the footman, to show Mr. Ferguson out. This was highly irregular, and showed a lack of judgment on the defendant's part. Miss Gosling did admit that one evening Mary's mother came by while Mr. Ferguson waited in Mary's apartment, unbeknownst to Mrs. Nisbet. This event took place very late in the evening, as the countess often went out, the servant explained. Another servant claimed that Miss Gosling was aware of certain signals exchanged between Ferguson and Lady Elgin as if to motion "all clear," and then he would arrive. As far as she knew, testified Miss Gosling, she did not ever see the Countess of Elgin signal Mr. Ferguson in any way.

Elgin's team tried to convince the jury that Mary had committed adultery between January and June 1806, when he returned from France. This was highly improbable, because in December 1805, when Robert arrived in London, Mary was very ill, experiencing early and severe contractions, and in January she gave birth to Lucy. By the time she could sit up in bed, Robert Ferguson was gone.

Despite the facts surrounding her difficult pregnancy and long period of recuperation, Elgin's lawyers continued in their chase. They called Thomas Willey, a former footman of Lady Elgin's in London who had been discharged for drunkenness, to the stand. Willey stated, "I saw Lady Elgin at full length on the Sopha, and upon my coming in, Mr. Ferguson took hold of a shawl and in great confusion threw it over Lady Elgin's legs." *"WERE HER LADYSHIP'S PETTICOATS UP?"* bellowed Elgin's attorney, and the feeble response that he couldn't say for sure because of a writing table that blocked his view was immediately irrelevant. The question posed by Elgin's lawyers echoed in every newspaper, at every breakfast table, and at every whist party around the globe. The lawyer had accomplished the stunning visual and the very picture of Her Ladyship, the great-granddaughter of the second Duke

of Rutland, having sex on the sofa with her lover, which titillated even the most jaded and cynical sophisticates. Intent on finding out every salacious detail, even Sir Walter Scott, in a letter to Lady Abercorn from Edinburgh on June 9, 1808, admitted, "I am endeavoring to get a copy of the Elgin Letters by my interest with little Jeffrey, the Reviewer, who was the fair Lady's counsel in the case."[3]

Elgin's career in politics, already in doubt due to Napoleon's harsh parole terms, was now with certainty truncated. As a man who would bring disgrace to his family, he not only lost any sympathy from the public but also publicly lost honor, and when some of his recriminations were proved unfounded, he lost credibility. Elgin also lost the very thing he was after. As the now sole guardian and, ostensibly, protector of his children, he wanted the court to place Mary's assets in his trust. Mary was not yet thirty when the court determined that she had no actual possession of these properties until the deaths of her antecedents and therefore refused Elgin's petition for any kind of fiduciary control over Mary's eventual inheritance. Mary had battled hard, denying her husband's charges as "libel," claiming that they had reconciled any differences they might have had, and made sure the court understood that Elgin was totally irresponsible with money and would be an awful risk as guardian of their children's financial future. The trial, their ninth anniversary present to each other, resulted in a Pyrrhic victory. Elgin lost his hold on Mary's money, and Mary lost her children. Robert Ferguson had relinquished his dearly coveted seat in Parliament. On December 22, 1807, after the initial civil trial had taken place in London, Robert Ferguson scribbled, clearly with great emotion, "£10,000!!!!!" in unusually large penmanship when compared with the rest of his journal. The damages, his cost for Mary's defection, would turn out to be a small sum for the price they would all pay.

Mary had demonstrated time and again that her breezy manner belied an iron will; Lord Elgin, too, possessed a contradictory nature.

As talented a diplomat as he was, which required tremendous self-discipline and restraint, in his personal life he was rash. Elgin and Mary were actually very similar: both were stubborn and ungovernable, and when they confronted each other, the contretemps, like the love they had shared, was explosive. These strong-willed, prodigiously passionate people achieved together an unsurpassed archaeological coup, and if the Earl of Elgin had controlled his impulsive and emotional behavior and had not proceeded with his divorce, there is no doubt that the marble collection removed from the Acropolis would have remained in the private hands of the Bruce family. Without Mary's fortune, which increased spectacularly in the nineteenth century, Elgin was unable to sustain the mounting costs of excavating, shipping, storing, and paying duties on the marbles, and in dire financial straits, he was forced in 1816 to sell the collection to the British Museum. His family's inestimable loss, however, was the public's priceless gain.

Elgin claimed that when he had been a prisoner in France, he could have at any time offered his collection to Napoleon in exchange for his freedom;[4] his refusal to relinquish the marbles certainly caused his family great anguish. When he initiated the divorce trial, whose uncertain outcome would certainly impact the future of his collection, he revealed that there was something more important to him after all. To Elgin, if there was one unpardonable act, it was not Mary's affair with Robert Ferguson, which, though unsettling, was less important to him than Mary's refusal to bear him more children. Mary's singular stand for control over her own body in defiance of her husband was unheard of according to social mores and under British law in 1807.

The year 1807 was a volatile one as Napoleon marched across Spain, having already placed his brothers on the thrones of Naples and Holland. When the French invaded Portugal, fifteen thousand Portuguese, including the entire royal court, fled to Brazil under the leadership of Elgin's old adversary adventurer Sir Sidney Smith. The Ottomans were embroiled in yet another war with their longtime antagonists the Rus-

sians; Mary's old friend Selim III was deposed and murdered the following year.

In 1807, a dialogue on individual freedom pervaded Great Britain, causing political, economic, and ideological upheaval. In that year, Parliament abolished the slave trade and Prime Minister Grenville resigned when King George III interfered with the emancipation of the Catholics in Ireland. In her own life, as the lawyers volleyed for the future of the Elgin family, Mary lived in emotional upheaval as she waged her own war of independence. Her refusal to bear more children was the couple's real bone of contention, and Elgin's every attempt to control her bred defiance rather than quiescence. The charges of adultery were a convenient by-product that Elgin thought would result in a profitable divorce for him; Mary, however, who neither initiated nor initially sought freedom, by the end of 1807 wanted nothing else. She never counterclaimed for the value of the marbles, despite her role in financing, shipping, and participating in the initial discussions with Parliament.

Friday, March 11, 1808, was obviously a significant, memorable day for all parties involved in this triangle. In Mary's diary, she wrote with uncustomary boldness, marking the day's singularity in her life: "**FREE***.**" Robert, in his own diary wrote in thick, heavy script, "******11th March *1808* on that day she was freed from him for EVER.**" If the object of Lord Elgin's insatiable revenge was the evanescence of the Countess of Elgin, the lovely, complex, and charismatic woman who had presided over adoring crowds, had grabbed the hearts of intrinsically heartless despots, and had been at the nexus of power and historic events, he sadly misjudged the endgame. She had created her own fame; he was solely responsible for creating her notoriety. As Mary had traveled the world and had been exposed to and had reflected on foreign cultures—present and past—she had metamorphosed, during her journey as Countess of Elgin, from a pampered, young member of the aristocracy to a forward-thinking and early champion of women's property and reproductive rights.

Ironically, it was not in her own country, considered the most powerful and advanced society in the world, where Mary had witnessed the legally humane treatment of divorced women. It was in Turkey, a place most Englishmen considered barbaric. In Turkey, divorced women were allowed to keep their children and property after separating from their husbands. As early as 1795, when Jane Austen began to write *Pride and Prejudice* (although it was not published until 1813), the subjugation of women through unfair property laws was not an unknown topic in Britain. The treatment of mothers was equally heinous. In the eighteenth century, if a woman bore an illegitimate child, she was whipped in public. In 1834, Britain amended its centuries-old poor laws to state that the mothers, not the fathers, of illegitimate children would be solely responsible for their care until the age of sixteen, and it was not until 1839, two years after Queen Victoria's accession, that Great Britain passed the Custody of Infants Act, giving women who were going to live apart from their husbands the right to apply for custody of their own children under the age of seven. In 1882, nearly a century after Austen's microscopic look at the rights of women in England, the British Parliament would finally pass the Married Women's Property Law, giving women the legal authority over their own property. When, in 1807–8, Mary, Countess of Elgin, decided to challenge the laws of a so-called civilized society, waging a battle for her own inheritance and her children, refusing to abide by those unjust laws, she judiciously determined her own worth, setting a shining example for the empowerment of women. Her boldness, predating the suffragette movement in England by some one hundred years, freed her to chart her own course for the next part of life's voyage.

Lord Elgin's marbles continued to arrive in London without Mary's assistance or involvement. In 1810, two years after the divorce, the Dowager Lady Elgin died and Elgin remarried on September 21. His bride was Elizabeth Oswald, the very young, innocent daughter of his longtime friend James Oswald of Dunnikier. Elizabeth was not the

social creature that Mary had been, and she was twelve years younger, less than half Elgin's age. She was the complete opposite of Mary in temperament and would bear Elgin eight more children. Although he was Elgin's great friend, Mr. Oswald opposed the marriage because of Elgin's financial irresponsibility. As a cost-cutting economy, Elgin and his new bride would, after a time, move to France for a good deal of their married life. Elgin—and his sister, Charlotte, Lady Durham— infused the first set of Elgin children—Bruce, Mary, Matilda, Harriet, and Lucy—with daily spoonfuls of brainwashing, instructing them to believe that their mother's shameful behavior had stained them, damaging their eventual marriage prospects. They grew up hating Mary.

Ironically, Elizabeth Oswald's own estate was adjacent to Raith, Robert Ferguson's home. One day, while out taking a carriage ride, Elizabeth, the new Countess of Elgin, spotted Mary. According to someone in the carriage with the very young countess, Elizabeth eyed her husband's former wife and, sighing, said, "That poor lady once loved my husband," and, in fact, after that day in the Edinburgh court-room on March 11, 1808, Mary Nisbet would never again lay eyes on Thomas Bruce, the 7th Earl of Elgin and 11th Earl of Kincardine.

RESCUED

After the divorce trial in Edinburgh, Mary went home to Archer-field, where she received a visit from her Aunt Mary Campbell of Shawfield who had, nine years since, encouraged Mary to marry Lord Elgin. Aunt Mary had always been one of Mary's most reliable support-ers, and now, during this time of pubic censure, Aunt Mary stood by her favorite niece. Mary tried to look forward rather than behind her, but she was now without her children. She stayed at Archerfield through the weekend and then on Tuesday, March 15, she left for Berwick, another Nisbet home, a castle in fact, but one that would be passed down through another branch of the Nisbet family. She stayed a few days and then left Scotland for England, where she arrived the day after her thirtieth birthday. Waiting for her at Aunt Bluey's manor house, Blox-holm Hall, was Robert Ferguson. He wrote in his diary that on April 20, 1808, "[I] married my Mary at Bloxholm Church, her uncle General Manners giving her away." *Gentleman's Magazine* reported simply that on April 20, 1808, the following marriage took place: "At Bloxholm co. Lincoln, Robert Ferguson, esq. of Nottingham place to Mary, only daughter of William Hamilton, esq. of Dirleton."

The couple left immediately for London, stopping overnight at Eaton, and arrived in London on the twenty-first, where they stayed at

Robert's house on Nottingham Place. Mary extended invitations to members of her family, Robert's family, and her longtime Scottish friends. In London for business, Parliament, or pleasure, Robert's brother, General Ronald Ferguson, Dr. Scott, Mr. Munro of Novar, and others showed no qualms about appearing at the home of the divorced woman and her second husband and, in fact, visited repeatedly. Among all of the people who came to Nottingham Place, however, Mary had one favorite. On Thursday, May 12, "we brought Henry home," she wrote in her diary. Henry, attending Dr. Glennie's School in Dulwich, consumed Mary's attention, and instead of hiding the illegitimate child, as most women would have been forced to according to propriety, in her own conspiracy of outcasts, she took him everywhere and did, as Robert had predicted, treat him as if he were her own child. Mary also understood that her new husband was unaccustomed to married life and remarked with amusement that he continued to do as he pleased: "Ferguson went fishing," she noted in her diary, and Ferguson went fishing often. Mary would no longer be invited to certain gatherings, though to some she was invited for the fascination factor and was smart enough to avoid them. So Robert went to dinners at his men's associations, leaving her at home with Henry. She was delighted to remain at home with him; she had not had her own children for almost a year and longed for the joy of taking care of a child.

That summer, they traveled around some of Scotland's most beautiful natural sights that would later be known as "Ruskin country," after the also scandalously divorced Victorian art critic John Ruskin. Devil's Bridge, the Falls of the Maynock, and other places seized Mary's imagination as she began to enjoy the simple, God-made pleasures so contrary to the artifice and sophistication she had known in the palaces of Europe and the East. She was genuinely happiest when eleven-year-old Henry joined them on holiday. He and Robert were now her family. Henry grew so attached to Mary that in December, when she had to return him to school after a short holiday, she "carried Henry to Dulwich." When

he returned for the Christmas holidays, he was the center of boisterous family fun that Mary created around him. General Ferguson, Mr. Munro, and other close family members and friends gathered around the little boy, the divorcée, and the scientist to offer them seasonal camaraderie. Mary showered all of her energy, kindness, and sense of fun on this little boy, who had been hidden in a monastery in Italy, raised with so little. Mary, starved for her own children, and Henry apparently needed each other.

Although many doors were closed to this now notorious woman in London, European friends were unfazed by the scandal that surrounded her. The Fergusons received visits from Comte Grimaldi, Comte Bournon, Comte Sierackowski, Comte General de Krukowiecki, Comtesse de Rumford, Comte de Flahault, and others who continued to pay their respects. On Tuesday, January 17, 1809, the Ferguson family made their very public debut at the Olympic Pavilion, and that April, a little over a year after the Edinburgh trial, Mary attended a play at the Opera House, knowing that she would face stares and whispers. Ferguson would often go out for the evening by himself to the Geological Society, the Angling Club, the Royal Institution, the Neapolitan Club, the Alfred Club, and the homes of fellow scientists or Whig politicians. Mary sometimes went out those same nights to her grandmother's house, sometimes to the house of Lady Roselyn, or she would entertain old friends like Alexander Straton at home. Together, Robert and Mary would often visit Robert's cousins, the Miss Berrys.

Both Mary and Robert enjoyed their time in London and remained there for long periods of time to be near Henry. Mary took him to see Dover Castle, and they walked the white cliffs; and she brought him to Canterbury Cathedral. By early 1810, it was clear that Mary and Robert had hatched another plan; London was fine for a time, but they were yearning to put their talents and resources to use in Scotland. The Napoleonic wars had created a boom for Mary's properties in East Lothian. The British Army was in desperate need of food and clothing;

Sidney Smith's grateful Portuguese settlers opened a profitable trading haven for the British in Rio. New inventions like the spinning jenny, the use of steam, crop rotation, the use of lime as fertilizer, a new plow, and the trend to remove cottars in favor of larger leaseholders were changing the methods of farming, mining, and manufacturing. Both Mary and Robert needed to oversee their considerable assets. Mary's parents were growing older, and as she had fought hard to keep her inheritance, she wanted to manage it properly. Robert's father died on October 31, 1810, plunging him now into the life of the country laird he had chaffed against for so many years.

Mary's high spirits remained with her all her life, but the peaceful cocoon that Robert fashioned around his beloved wife lent her a new tranquillity. She enjoyed, as always, being the object of praise and tribute, but her emotions began to level to a more even keel. Neither Robert nor Mary, who had displayed her brilliance in Constantinople, could suffer dullness. They began to turn Raith House into what painter Sir David Wilkie called the "Holland House of Scotland," referring to the house in London, first occupied by Whig prime minister Charles James Fox, and then by his nephew, the third Lord Holland. Robert Ferguson was known to toast a portrait of Fox by Opie that hung in his dining room at Raith. He admired the activity that took place at Holland House, which was the center for all Whig party politics. Holland House salons drew the most respected scientists, artists, and literary figures of the day. A small book published at the time entitled *Mystifications,* by Graham, reported that dinners at Raith were never less than twenty brilliant minds gathered around one table. Despite the fact that Mrs. Ferguson was a divorced woman, once again, everybody came; Mary always knew how to make people covet her invitations.

Among the guests at Raith House were inventors like James Watt and Sir Humphry Davy; educators like Dr. Glennie and provosts Ford and Pitcairn; artists like famed animal painter Landseer, who left an

amusing gift for his hosts, the Fergusons—two pigs: a pretty English one and an unattractive French pig, clearly underlining sentiments at the time—and literary figures like the Ferguson relative Mary Berry; and architects like Playfair, who designed the stables at Raith. The same members of the Scottish nobility that Queen Victoria would later host and write about in her own Scottish journals—Wallace, Buccleuch, Montrose, Moncrief, Stirling, Maitland, Roselyn, Erskine, Kinnaird, Dundas, Lauderdale, Hamilton, Oliphant, Baillie, Balfour, and even Bruce, cousins to her former husband—all came to Raith. She entertained the Duchesses of Gordon and Roxborough and Lady Jane Montague at Archerfield. The Russells, who were stepcousins of Mary's (their antecedent was Catherine Russell, the second Duke of Rutland's first wife; Mary's great-grandmother Lucy who had purchased Bloxholm Hall, where she and Robert married, was the duke's second wife), followed her from Raith to Archerfield to Biel and back again. Sir William Russell, the younger brother of the Duke of Bedford, frequently brought his young nephew Sir John Russell along. Sir John, who held the seat for Tavistock in Parliament, shared his keen interest in politics with Robert Ferguson. Sir John Russell would become prime minister of England in 1846; almost every future prime minister elected by the Whigs would at one time or another visit the Fergusons of Raith. Sadly, William Russell would be murdered by a servant in 1840. Mary was very fond of both Russells, and it was clear by their frequent visits to wherever she was that they adored her company.

She continued to fascinate. Sir Walter Scott based his 1819 *The Bride of Lammermoor* on Mary. Although the story was set in the seventeenth century, its heroine, Lucy, the richest girl in East Lothian, is involved in a love triangle. She is the object of affection for both a Jacobite (Tory) and a nouveau riche Whig. Scott was obsessed with the Countess of Elgin's famous divorce trial, which pitted ideological adversaries against each other, and Mary was the widely known princess

of East Lothian. As Mary neither goes mad nor does she kill her husband, it was Scott's imagination that brought the story to an operatic climax and, in fact, inspired Donizetti to compose *Lucia de Lammermoor.*

Robert Ferguson was less controversial a character than Mary's first husband, but he shared the collector's mania. In his passion—that of collecting minerals—however, he made no enemies and, in fact, was also honored by groups of scientists and his constituents. During the summer of 1812, he and Mary took young Henry to row on Loch Lomond of the famed "bonnie banks" in the well-known Scottish tune. They also visited the tiny island of Staffa in the Hebrides and rowed into Fingal's Cave, immortalized in Felix Mendelssohn's music. In the cave there was an impressive quantity of an unnamed mineral that would later be named "fergusonite" by Wilhelm Haidinger in his article "Description of Fergusonite, a New Mineral Species." In the 1825 article, Haidinger stated that he was calling this dark mineral consisting of yttrium, erbium, and cerium "fergusonite," "in honor of a gentleman too well known to the mineralogical world." In 1820, Jameson dedicated his book *System of Mineralogy* to Ferguson "in testimony of his distinguished talents as a mineralogist, by his faithful and sincere friend the author." The mineral fergusonite is found from China to Colorado. It was used by Madame Curie in her Nobel Prize–winning discovery of radium and by the chemist Sir William Ramsay—whose family hailed from Haddington, Robert's eventual political seat—in his work on inert gases, which also earned him a Nobel Prize (1904). Over the years, Robert had amassed one of the finest and most rare collections of minerals on earth. He brought his son and his bride to places where they could observe rock formations and learn to share his interest.

In 1812, Napoleon destroyed Moscow and Tory prime minister Spencer Perceval was assassinated by a madman who appeared at the

House of Commons. It was a time to stay close to home. Mary and Robert lived among three of Scotland's most fabulous homes: Raith, Biel, and Archerfield. Robert's brother, General Ronald Ferguson, on the other hand, was away a good deal of the time traveling to locations in Africa, Portugal, and India, where he distinguished himself in battle. For much of the time that Ronald was abroad, Mary and Robert looked after Ronald's wife, Jean, who went with them from Raith to Archerfield to Biel and back. Jean was the daughter of another famous general—Hector Munro—who had wrested Pondicherry from the French, and she endured Ronald's absences with the understanding of a military daughter. Jean's two brothers, who had bravely followed their father into far-flung military posts, died famously grizzly deaths—one killed by a shark and one mauled to death by a tiger.

Mary adored Jean, and they became inseparable, and she also loved having Jean's son, Robert, around to liven the party. Young Robert was born in 1802, making him only two years younger than Mary's own Bruce. As her nephew, Robert, and her stepson, Henry, grew older, she often invited them and their school friends to dine with her in restaurants, to accompany her to her grandmother's house in London, and to attend the theater in Kirkcaldy, Edinburgh, and London. Henry's closest friends were John Davie and John Glennie; when the boys came home with him for the holidays, they all knew they were in for a treat. In 1811, she invited Henry and his friends, an entire group of thirteen-year-old boys to see the play *Blue Beard* about the infamous pirate. Mary indulged these boys as she simply could not her own children, and all of the boys remained attentive to her throughout her life. As she journeyed from her thirties into middle age, they continued to gather around her, introducing her to their brides, their children, asking for her advice on careers, and spending time with her—not just because she was rich, not out of pity because she had lost her own children, but because she never lost her sense of fun, and she remained charming,

sensitive to people, and perennially young at heart. Even in her own country, she was always a tourist, enthusiastically learning every day. In 1816, she saw Melrose Abbey, Chatsworth—home of the Dukes of Devonshire—and in London, with great fascination, went to visit "The Jews Synagogue" twice. In 1817, when Henry turned twenty, he embarked on the Grand Tour of Europe, which was now, finally, at peace. After his trip, he returned directly to Biel to see Mary and share every detail of his travels.

The Fergusons lived an enviable life of material ease, as neither Mary nor Robert had any financial constraints. She commissioned furniture by Bullock, the well-known furniture craftsman from Liverpool, and she purchased pieces by Chippendale and Hepplewhite, paintings by Canaletto, Van Dyke, and Caravaggio, and a clock once owned by Marie Antoinette. True to his word, Robert Ferguson offered Mary unwavering devotion and a life free of the constant criticism and correction she had found so unbearable and corrosive; and by 1813, it seemed that society was also ready to treat Mary kindly. It may have been her charisma, but more likely it was the house, proving true the maxim "Living well is the best revenge." The highest echelon of society flocked to Biel, which had become one of the most talked about showplaces in Europe; and in 1814, when Mary's paternal grandmother died, Belhaven and Pencaitland widened the Nisbets' East Lothian holdings. Mary was the principal landlord in the region, set to inherit about two-thirds of all of East Lothian.

Gossips were busy on a new subject in the teens, and they now focused their attention instead on the extravagant and questionable behavior of the regent, the future King George IV. The regent and his wife, Caroline of Brunswick, were unable to get along, and they lived completely separate lives. Despite the royal couple's well-known infidelities and their own status as a separated couple, not surprisingly, hypocrisy ruled the day, and divorced women were still not permitted at

Court. In 1817, the couple's only child, the beautiful young Princess Charlotte, long neglected by her selfish parents, tragically and suddenly died. Princess Charlotte's only source of childhood affection, except for her grandfather, King George III (and he went mad while she was quite young), was the Dowager Lady Elgin, her "Eggy." Charlotte was, to many people, a sad figure, the poor little rich girl. She was the lone innocent symbol of the Regency, and her death stunned even the most jaded courtiers.

At a very early age, perhaps prematurely, Mary had been thrust into the same aristocratic, international circles, which undoubtedly prepared her to be completely at ease, even a bit blasé, in any royal court. Although that was a welcome asset for a woman in public life, in private many in her set suffered from ennui—but not Mary. She was intrinsically a Scottish lass, a country girl—albeit a very rich one. As a girl, she had taken pride in her chickens' eggs and had delighted in watching birds swoop overhead. She had laughed as she danced in the wind on the shores of Aberlady Bay and had grown giddy with abandonment riding her ponies, hiding in her very own castle ruins, and playing pranks on her parents. Everywhere that Mary went, her innate sense of fun, her ever present curiosity, her dry sense of humor, her exuberance and verve were sure to go. In fact, these qualities constituted the essence of Mary Hamilton Nisbet Bruce Ferguson, and they would serve as her port in every storm.

When Robert Ferguson first met the Countess of Elgin who, through no fault of her own, was stuck in a political mire in France, the mineralogist believed that he had discovered his most precious gem. Like a diamond, she gallantly maintained her toughness and sparkle in a situation that would have made others crumble. Later, she stood her ground against her husband; and once again, while other people were raising her children, Mary appeared radiant and strong. Robert, however, knew the sacrifice that Mary had made and the toll it took on her

heart. In Robert, Mary found a shelter, a safe and welcoming harbor. This once daring and vital woman had developed a real terror, a phobia of any further pregnancies. She wanted no more pregnancies, and though the Fergusons would have no children, they enjoyed an ardent and amorous relationship nonetheless.

Chapter 24

A BEACON

In 1816, Mary's beloved Aunt Mary Campbell of Shawfield died. Mr. Berry, Robert's uncle, died the following year. Mary's father was in frail health, and it would not be long before she would be solely in charge of her vast estates. To comprehend the extent of her fortune, it must be measured and compared: at that time, there were 12 pence ("d") to the shilling, 20 shillings to the pound (£) sterling. A typical loaf of bread might cost 6d in 1793 and 8d in the early nineteenth century. A person would be considered a gentleman if he had an income of £150 a year; a middle-class family with an income of £250 a year could employ a maidservant who might receive about £10 a year. Mary's estate was heading toward the annual income it would arrive at by the 1850s, a staggering £400,000, which today would equal an annual income of approximately £256,010,854, or 400 million U.S. dollars.

If there was one positive aspect to the devastation caused by Napoleon, it was the growing prosperity in Scotland that resulted from the need for clothing, food, coal, lime, and tobacco for the troops and for European countries that imported these goods. Although the national debt for England had ballooned from £228 million in 1793 to £876 million in 1815, the Lowlands, where both Mary's and Robert's properties and holdings were, had only increased in value. Because

wages in Scotland remained lower than in England, manufacturers often favored locating businesses there. Edinburgh had become a city with a very large professional class, and those lawyers, doctors, and bankers liked to spend their money; the Bank of England had forced other English banks out of business, but Scottish banks were publicly owned, and they too were examples of success. The textile mills hummed, the coal mines thrived, and the farms, employing many women and children owing to the absence of men recruited to the militia, had become models of efficiency.

Conversely, the end of the war brought a serious economic downturn. When men returned from the war, they found that jobs were in short supply. Wages tumbled, and a couple of bad years for crops also sent prices out of range for the average working family. Wealthy landowners campaigned for and got relief from Corn Laws protecting the prices of homegrown crops from foreign competition; poor families suffered, and there was a growing resentment of the powerful. Landowners openly worried that what had happened in France could happen in England: the peasants would storm the castle doors and lop off the heads of the aristocracy.

Mary, ever the public relations tactician, realized that her own visibility was important. Her tenants needed to see her; she became, once again, a public figure, taking part in local, colorful events with the peasantry. These people farmed her land, tended her sheep, bred racehorses, and milled her grains in the magical countryside of East Lothian in places like Dirleton, a Brigadoon-like village in the shadow of its castle; Gullane, where witches were rumored to congregate in the Middle Ages; and Haddington, in the shadow of Traprain Law, a dome-shaped hill hiding buried treasure, silver, and lots of it, hidden by early Roman invaders. In 1818, Mary was very likely to be seen by the townspeople at the Bartholomew Fair, at church, presiding over the Auld Handsel Monday curling contest on Gullane Pond—a tradition for the handloom weavers of Dirleton since 1650—or hosting the annual "silver

club" golf contest on her property. The Honorable Company of Edinburgh Golfers, the world's oldest golf association, founded in 1744 in Leith, enjoyed playing in Gullane and in fact bought some of Mary's property, known as Muirfield, meaning marshy, open land.

Once she established her presence as the future landlord, and not just the little girl they had known, Mary and Robert decided that it was time to return together to the place where they had met. It had been fifteen years since they had been in Paris, and now that their former jailor, Napoleon, was himself imprisoned on an island, they determined it was safe to return to France. They departed on Friday, June 18, 1819, and this time they toured as husband and wife. They went to the Cathedral at Amiens and visited the grand stables at Chantilly. In Paris, they attended the theater and the opera. General Sébastiani warmly welcomed Mary and Robert to his home, as did their longtime friend the comte de Bournon. The comtesse de la Rochefoucauld, one of Paris's leading hostesses, gave a dinner in their honor. Together they watched the beautiful fireworks at the Fête de Saint-Louis on August 25. They reminisced in the Tuileries Gardens and at Saint-Cloud and Fontainebleau. It was a romantic five months, and then they left. On the way back to Scotland, they stopped in London for a few days to see family.

Mary's children had been living in France with their father and stepmother; she had been legally precluded from having contact with them, and not one of them had contacted her until 1821, when one of her children expressed the wish to see her. It was the child who remembered her best. On the thirtieth of January, Mary left Biel and had dinner with her cousins at Berwick. She traveled slowly: Browbridge, Ferrybridge, Sheffield, Derby, Lichfield, Birmingham, Tewkesbury, Rockborough, and on to Bath where on February 5, 1821, she reunited with "my own Bruce." It had been fourteen years since she had seen her little boy. Bruce, who had been her obstreperous, robust, witty little boy, was now a very ill young man. He stood before her frail and epileptic, a

victim of mercury poisoning. She was thrilled and devastated at once. They spent a month together, and during that time she realized what Lord Elgin and his second wife, Elizabeth, already knew. The line of Elgin would not descend from Mary; Bruce was simply too ill to bear children, and it was highly likely that he would not survive his own father. It was sadly obvious to all that the dream of a dynasty merging the Nisbets' estates and the Elgin title was improbable.

Mary left her son taking the cure in Bath after the month they spent together. She traveled home to Scotland slowly, as if every inch away from him was once again tearing them apart. She stopped at Lichfield for a week, at Wetherby, Durham, and again at Berwick before she arrived at Biel. In May, she turned around and headed right back to Bath to be with him again. He had to remain there for his health, and she spent another month with him before she left for London to witness the coronation of King George IV on July 19. In London, she tried to amuse herself with lighthearted activities. She went to see Sheridan's classic comedy *The School for Scandal* and Tom Thumb at the Haymarket.

Although her daughters were also coming of age, none had contacted her, so angry were they at their mother. She did, however, hear from her former husband upon the death of her father in 1822, on behalf of Lucy, their youngest daughter, the child Elgin had falsely claimed was not his own. It was not a condolence call. Now that William Hamilton Nisbet had died and Mary had inherited his fortune outright, Lord Elgin, once again, attempted to get his hands on Mary's money. He claimed that as *their* daughter, Lucy, was still a minor, he was suing her mother as the child's guardian. Elgin asserted in his papers that according to old inheritance laws of entail, it was Lucy, not Mary, who should be Mr. Nisbet's heir and that Lucy should not only receive the properties but substantial sums of rent money that had been collected over the years. He asked the court, once again, to give him control of Mary's inheritance, and once again, Mary hired lawyers to

tangle with him. Mary's lawyers explained that she had only inherited her property recently, that Lord Elgin had divorced her fifteen years earlier, and that she was married to another man, who might assert his own legal right to her money. The court ruled that Elgin's petition was extraordinarily irregular and improper; the judge declared it "one of the most singular cases I have ever seen since I was a member of this Court" and dismissed the case.

In August 1822, King George IV came to Edinburgh, making him the first British monarch since Charles II in 1651 to do so. For two weeks, King George was honored with great pageantry and fanfare, a program designed by Sir Walter Scott. Scott, who understood that the king wanted to be entertained, encouraged the Scots to wear their clan tartans, long forbidden to them as a punishment for their Jacobite rebellions. As a symbolic and conciliatory gesture, King George IV donned a complete tartan costume, which delighted the Scots. The climax of the two-week celebration was the procession from Holyrood Palace to Edinburgh Castle when the crown, scepter, and sword of state, carried in solemn ceremony by a member of the once outlawed Gregor clan, were offered to the king. The king's fashion statement created an immediate craze that spread around the globe and continues to this day: the penchant for wearing tartan plaid.

Mary's status as the largest landowner in East Lothian gave her considerable political clout, as only landowners could vote; but, of course, women could not. As Robert pursued reform, encouraging politicians to change voting laws, property laws, and the like, Mary did what she could within her rights as the country's largest landowning nonvoter. She started with the parish churches. The churches had, for hundreds of years in Scotland, been in control of administering money to the poor. Mary endowed both the Dirleton and Stenton churches with new buildings, schools, and generous funds to help those who had been hurt by the downturn in the economy. Her dear father was buried in the Stenton churchyard, and on the wall of the Dirleton church, a

small plaque thanks Mary for her good work and discloses that she built a properly completed tower, "a vestry added for the minister and a new imposing Manse. . . . The castle wall, the Inn, the characteristic gables of the cottages are evidence of her good taste and interest in the village." In other words, if Mary Hamilton Nisbet could live with style and beauty, why not her neighbors? She was certainly a pioneer in the tradition of beautification for the public good. It was no secret that Robert harbored an unswerving political vision, and he brought his wife to the homes of leading Whigs—Lords Holland, Balfour, and Walpole. Both Robert and Mary felt a duty to improve life for the people who lived on their properties and for the citizenry in general; the Fergusons well understood that laws created unfairness and needed to be reformed. King George IV is reputed to have asked the stalwart Whig, "Have you ever heard a speech that has changed your opinion?" to which Ferguson replied, "My opinion often, sir, my vote, never."

In 1823, Henry Ferguson married John Davie's sister, Frances, called "Frannie." He and Frannie traveled from southern England—as Frannie's home, Creedy Park, was in Devonshire—to Archerfield in July. Mary received them warmly, and all of her homes became the center for all-important family occasions. In August, Mary hosted a twenty-first birthday party for Frannie, whom she called "Fanny," and the following August, a christening party for their firstborn child, Harriet Ann. Fanny and Henry filled the house with their children, born two and three years apart. Harriet Ann Ferguson was followed by brothers Henry, John—named for Fanny's brother and Henry's best friend—William, and Charles Robert, named for Henry's older brother, the German baron. After Fanny's brother John died in 1846, Henry merged the family name to "Ferguson-Davie," and he became the first baronet of Creedy Park. Although some genealogical directories, including the 1895 Ferguson Clan book, list Henry's parents to be "John Ferguson and Jean Arnot," they were not; Henry Ferguson-Davie, 1st Baronet of Creedy Park, was the illegitimate offspring of the

forbidden love affair between Robert Ferguson of Raith and his married German baroness, and although Robert loved him, Henry would never inherit Raith. Robert's brother, Ronald, would. Henry would, however, inherit a legacy of political life and experience the abundant joy of many grandchildren.

In Britain at the time, although there were close to seventeen million people, only around four hundred thousand could vote. Voting was not done in secret, and people were often paid to cast their ballot for a particular candidate. Mary, although she controlled huge amounts of land, as a woman, could not vote. The new middle class based in the industrial cities had disproportionate representation, as the distribution of seats in Parliament was based on property and not on population. Robert Ferguson, ever the people's champion, could no longer resist his true calling. He went back into public life. It had been twenty-six years since the Whigs had controlled Parliament and twenty-four since he had been forced to resign his seat amid the scandal of the love affair. As Mary's family dwindled—her father and dear uncles the General and "Georgie" had died—an entire way of life was disappearing in the country. Railroads had begun to transport people and things around Great Britain, fashionable people were eating at hotels and in restaurants, and the mood of reform was in the air. In 1830, another revolution in France stirred reform in England, and with the promise of revised voting laws, the Whigs returned to power.

On May 23, 1831, while his wife remained in London—quietly away from election commotion—Robert Ferguson was elected Member of Parliament for Kirkcaldy. Robert timed his reentry into politics at the precise moment when he thought his ideas would not be blunted by the opposing party, and in 1832, a dream would be realized when he would participate in passing the Reform Act, legislation that set a new path for the future of elections in Britain. As the middle class and laborers considered the kind of revolution known in France, voting reform became essential. Large landowners like Mary who constituted

the aristocracy were for the most part despised by the common man; this was certainly no different elsewhere. After the Reform Act was passed, corruption was still possible, but the gesture toward the populace served as a temporary stay from possible revolt. Mary's former husband, who despite a brief early flirtation with an independent point of view, remained a strong Tory, and when he received a lifetime peerage in 1820, he voted consistently against the Whigs. Lord Elgin was as vehemently against the new, more liberal voting laws as Robert Ferguson was a proponent of them.

Mary remained in London for the summer of 1831, when she saw her husband enter the House of Commons. On June 21, King William IV went to the House of Lords, and on Monday, August 1, she saw the king open the new London Bridge. She and Robert attended the opera, the theater at Drury Lane, the ballet *La Bayadère,* and dined with the Berrys, Belhavens, Mannerses, and the Henry Fergusons. It was an exciting time, and in the fall they returned to their constituency, together very much in the public eye, appearing at the Haddington, Whittingham, and Gilmerton balls. Ferguson went to Edinburgh to attend the Caledonian Hunt. They were clearly a political couple enjoying the local scene. The following spring, after spending the winter between Raith, Archerfield, and Biel, they returned to London for the parliamentary session. Mary went to the theater, where she saw the renowned Fanny Kemble, and once again her vivacious charm drew the world to her door. That year, they entertained important politicians like the chancellor. Robert expanded his influence, gaining an additional power base when on December 18 he was elected MP for Haddington, a town in East Lothian, where his wife was the largest property owner. That was a testament to his skills and good reputation as well as to her popularity. In 1833, the couple was acknowledged with the greatest honor that could befall a politician: the prime minister, Earl Grey, came to dinner at their London home.

Although by nineteenth-century standards all of Mary's "old

guard"—her grandmother Lady Robert Manners; her aunts Mary and Bluey—had lived to a very old age, by 1834 Mrs. Nisbet was in fragile health. Mary made a concerted effort to take good care of her elderly mother. She and Robert changed their London routine, staying at Portman Square instead of Nottingham Place; they visited Mrs. Nisbet more frequently to dine or simply to take her out for a drive. Mary often brought along fun company to keep her mother's spirits up, like Jane Ferguson, Henry Ferguson, and Fanny. Mary was a dutiful daughter who never forgot the toll her own actions had taken on her mother's peace of mind; her infinite respect and love for her mother never waned. All through Mary's most difficult moments, even when Mrs. Nisbet may have lost patience with her daughter, she had always been her closest ally, and when Mrs. Nisbet died on Mary's fifty-sixth birthday, Mary was filled with unspeakable sadness. When Aunt Bluey died the following year, on February 14, 1835, an era had truly ended for Mary.

She poured her heart into the plans for remodeling the Dirleton church while Robert became the first county member for East Lothian. She enjoyed dinners with the Dukes of Sussex and Norfolk and spent time with Jean and the Berry sisters, but for Mary her mother and Aunt Bluey were irreplaceable. Suddenly, her life took a surprising turn: for the first time in nearly thirty years, Mary saw her own daughters.

So indoctrinated with the notion that their mother's scandal would spoil their chances of making good marriages, they had not even invited her to their weddings. That fear was misplaced, since all of the girls married men from very fine Scottish families. Mary Bruce married Robert Dundas, the great-nephew of Lord Melville; they would have one daughter, Mary Georgina Constance, known as Constance, or "Connie," to those closest to her. Matilda would at nearly forty marry Sir John Maxwell of Pollock, and they would remain childless. Lucy, the child who was only one and a half years old when she was forcibly removed from her mother, married John Grant of Kilgraston, and they had thirteen children. One of their daughters, Anne, married Captain

John Brooke, eldest son of Sir James Brooke, the fabled White Rajah of Sarawak. In 1841, Brooke, an English soldier, was named ruler of Sarawak by the sultan of Borneo as a reward for his military exploits. Sadly, Anne died very young in Sarawak, and her husband predeceased his own father, leaving the title to his brother, Charles.

In 1835, the girls extended the olive branch toward their estranged mother—after all, there was a fortune involved. Mr. Dundas, married to the eldest of the girls, Mary, would even change his name eventually to receive the inheritance. If the girls were worried about how their mother would respond to their years of indifference, neglect, and even ill treatment, they need not have done so. Once the door opened, Mary flung it open wide. She had always embraced strangers and these strangers were her beloved babies. As she had reclaimed Bruce as "my own" in 1821, when they had reconciled fourteen years earlier, she did the same with her girls. On Thursday, January 29, 1835, she entered in her diary that "My Matilda dined with me at Douglas's Hotel" in Edinburgh; on March 7, she "went to my own Mary in Eaton Square" in London; on August 31, Mr. Grant of Kilgraston, Lucy's husband, came to Archerfield; and on September 3, "Matilda, Mr. Grant & Lucy and me came to Biel." The following spring, on March 5, she noted, "My Matilda and Lucy came to London."

Surrounded by the next generation, Mary and Robert looked toward the future. She was nearing her sixtieth birthday, and although political reform benefited the masses and not the large landowners, she and Robert continued to work together for what they perceived to be positive change. In 1837, Robert became the Lord Lieutenant of Fifeshire, a position long coveted but never achieved by Mary's former husband, Lord Elgin. With her usual verve, Mary hosted Ronald Ferguson's entire Seventy-ninth Highlander regiment at Biel, a truly colorful experience, and she continued her busy life, traveling to London, Edinburgh, and home, often in the company of Henry or Jane; she attended the theater, went to dinner parties, and in 1838, she saw Stonehenge and visited Ireland.

Mary Nisbet of Dirleton had been born when George III was king. She had lived through the birth of American independence, the French Revolution, and had known firsthand tyrants like Selim III and Napoleon Bonaparte. She had witnessed the exotic world of the fading Ottoman Empire and the waning world of the eighteenth-century aristocracy; now, in 1837, with the accession of Queen Victoria, she became part of the new age that was coming fast upon the British Empire. The telegraph, the railroad, the photograph, were making the world a smaller place; the young girl from Dirleton who had mounted a horse, an ass, and a gold chaise boarded her first railroad car on July 13, 1839, and traveled from London to Birmingham, from Birmingham to Manchester, and home to Scotland.

That same year, the Custody of Infants Act was passed in Parliament, allowing a woman who chose to live separately from her husband the right to apply for custody of her own children under the age of seven. All three of Mary's daughters had been under the age of seven at the time they were removed from her custody. Over the years, while her former husband grew deeper and deeper in debt and lived abroad to evade a growing army of creditors, Mary proved herself to be a fiscally responsible woman with a social conscience as well as a kindhearted stepmother. To her credit, Elgin's second wife, Elizabeth, was very good to Mary's children and worked hard to meld the two families; extraordinarily, shy as she was, she personally arranged for a number of successful commercial ventures that would benefit Broomhall and offer some relief to her family's downward-spiraling finances.

On January 10, 1840, Mary saw a dramatic version of the recently published Dickens novel *Nicholas Nickleby* in Edinburgh. The Fergusons remained at Archerfield until the end of January, but at the beginning of February they left for their home on Portman Square in London; it wasn't every day that the queen of England was to marry her consort, and they wanted to witness history. On February 10, Queen Victoria married her prince, and the festivities included a grand

ball. London was the most exciting place to be that year, and although Robert was turning seventy-one and Mary sixty-two, they were two of the most vital and energetic people in town. They remained in London for the year which, sadly, did not end as happily. "I lost my poor Bruce about 6 o'clock Tuesday Evening 1st Dec.," she wrote in her diary, and that tragedy was followed two days later when on Thursday, December 3, Mary added, "I lost my beloved Ferguson at half past 2 in the morning." Robert's funeral was on December 9, and Mary stayed in town to receive various Fergusons and politicians who mourned her husband. He was so beloved by the people of Haddington that they erected a statue of him in his honor. The figure of Ferguson stands on a column perched on a base bearing symbols representing justice, geology, and art; the inscription reads: "to a kind landlord, a liberal dispenser of wealth, a generous patron of literature, science and art."

Robert Ferguson was buried at the Kensal Green Cemetery, which at the time was on the quiet outskirts of London. In the 1820s, the population of London had increased by some 20 percent, resulting in overcrowded churchyards. By the 1830s, there was a growing trend to bury the dead away from the city. Kensal Green Cemetery, based on the design of la Cimetière du Père-Lachaise in Paris, was authorized by an Act of Parliament in 1832. Three years after Robert's interment, Prince Augustus Frederick, the Duke of Sussex, the sixth son of King George III, was also laid to rest there; his sister the Princess Sophia followed in 1848. This cemetery, in fact, became the Père-Lachaise of London, containing the graves of such diverse celebrities as Anthony Trollope, William Thackeray, Fanny Kemble, and Freddie Mercury.

Lord Bruce predeceased his father by less than one year; Elgin died in Paris on November 14, 1841, leaving his family £120,000 in debt. His and Elizabeth's son, James, who, coincidentally had been born on Elgin's own birthday in 1811, inherited the titles and Broomhall. Another parallel occurred when James's first wife bore him only daughters and his second wife provided him with sons and heirs. James dis-

tinguished himself in diplomacy like his father; he became governor of Jamaica, governor general of Canada, and the first English viceroy of India, and was widely known as an incomparable negotiator, having successfully brought about the Reciprocity Treaty between Canada and the United States and several trade agreements with China and Japan. Elgin County, Port Elgin, and the village of Elgin all in Ontario, Canada, were named for him, and his name is carved in the Canadian Parliament among Canada's founding fathers. James Bruce, the 8th Earl of Elgin and 12th Earl of Kincardine, died in India and was buried in the Himalayas. He was said to be Queen Victoria's personal favorite ambassador and certainly carried on the dynasty as his father had wished. Sadly, Mary's son, Bruce, never achieved any kind of professional success, as he was ill most of his adult life. Mary never even acknowledged the death of her onetime husband in her diary, and although their dynasty may have been evanescent, their marriage, certainly meteoric, left a lasting legacy.

STARBOARD HOME

Mary, now a widow, nonetheless maintained an exhausting social calendar. Henry, Fanny, their children, Jane, the Berry sisters, and all the Fergusons formed a tight circle around Mary, as did Robert's political allies. One frequent visitor was Sir Benjamin Hall, commissioner of works and public buildings. Hall, known for his corpulence, was unofficially honored as the namesake for the new bell that chimed the hour and became known as Big Ben. He liked to dine at Mary's. Although her life was as always full, she found it important to visit Robert's grave and did so in March before she left for Europe.

Traveling with Henry, Fanny, and their children, Mary went to Waterloo, Brussels, and Antwerp, returning to London via Calais. Raith was no longer her home, as it had passed to Ronald, so she spent the summer traveling between Archerfield and Biel. Mary took other trips abroad in the 1840s, traveling as a dowager without a husband. She returned to Italy in 1845 and spent Good Friday and Easter Sunday at St. Peter's Cathedral in Rome, enjoying the pageantry as the king and queen of Naples appeared before the pope and throngs of worshippers. She went exploring old villas around Florence and visited the Pitti Palace and the Palazzo Vecchio; she also attended local horse races. She continued on to Pisa and Genoa and then to Switzerland, where she

saw Zurich, Lucerne, Interlaken, Berne, and Lausanne, viewed Lake Geneva, and noted in her diary that she "crossed the Rhine." Over the Alps into France, she went through Evian and Chamonix and then set out for Paris, where she stayed at the Hôtel Bristol. She had been traveling for almost the whole year when in November Henry joined her in Paris. Together they visited the Cimetière du Père-Lachaise, the Louvre, and the Church of the Madeleine.

Mary returned home to London just in time to see her longtime friend Lord John Russell become prime minister. Mary's daughter Mary, and her husband, Robert, now going by the surname Christopher after receiving Bloxholm Hall, visited her, as did Henry and Fanny. Sir Benjamin Hall continued to come for dinner quite frequently, and Mary helped Miss Berry celebrate her eighty-fourth birthday. For the first half of 1847, Mary's stay in London included evenings at the opera, the theater, and visits to Dulwich College, Covent Garden, Westminster, and the Royal Academy, but in August, she went back to East Lothian with a purpose. Henry Ferguson-Davie was running for his father's seat in Parliament, which with Mary's help he won. On August 29, Henry became MP for Haddington; Mary's daughter Matilda, her husband, Sir John, and Benjamin Hall were all on hand for the victory.

In 1848, as she turned seventy, Mary lived as audaciously as ever. She continued, for the next few years, to be at interesting and important events in London and Edinburgh, and influential people continued to come to her homes. On November 4, 1849, the Lord Advocate came to Biel. That same year, on January thirteenth, Lucy's thirteenth and youngest child was born in Edinburgh. Once the beautiful, young, glamorous Countess of Elgin, Mary was now a grande dame and the formidable matriarch of a growingly powerful and political family. Her own extended dynasty included son-in-law Robert Christopher, who had entered Parliament for Bloxholm and would become a member of the Privy Council, and Henry, who would prove a formidable represen-

tative for his constituency. On December 8, 1851, Anne's father-in-law, the great Rajah of Sarawak, visited Mary. She became used to greeting and saying farewell to Fergusons, Brookes, and Grants as they departed and returned from military posts all over the globe.

Some fifty years earlier, when Mary had lived in Constantinople, her letters took months to arrive in England and months to reach her with news. She had known firsthand the agony of uncertainty that accompanied long spells without information, and she had witnessed the fact that a lag in communication could change history. How many blunders and fiascos had occurred while people had waited for instructions or had news to impart that would contradict existing orders? Tens of thousands of people had been killed and regimes had been destroyed because of the inability to deliver timely messages; and now, the telegraph enabled people to cross divides in minutes. As she and her children traveled the globe, by sea or rail, cable wires were being laid at a frantic pace. While she stayed at her house on Portman Square in London in 1851, the whole world had its eyes on the Great Exhibition, held in the spectacular Crystal Palace in Hyde Park, which heralded the inventions to come.

Mary's optimism and energy personified and predated the new age, and she would not allow her advancing years to serve as an excuse to close her doors to either the public or her family. Whether she was in London or in the country, her home became a home for her children and their children, and for the many longtime and loyal friends she had known over the years. As she entered her late seventies, the Maxwells, the Grants, and the Christophers, with an eye on her fortune, became a constant presence wherever Mary went. Little Constance, Mary's main heiress, born in 1843, would prove, in action and spirit, to be an echo of her grandmother. In the early 1850s, Mary often traveled by rail to London from Berwick-upon-Tweed and added an additional stop on her rounds—Creedy Park, Henry and Fanny's estate, where Mary was always welcomed as the matriarch. Henry and Fanny, in turn, made

frequent pilgrimages, along with grown children and grandchildren, to Scotland and London to be with Mary.

Throughout her long life, she had traveled great distances, and when, toward her journey's end, she returned to the home in which she had been born, she faced her old age with the same irrepressible spirit as she had the Ottoman sultan and the ferocious French emperor. In the mid-nineteenth century there were only some six hundred people who owned 80 percent of the land in Scotland, making it the country with the highest concentration of landownership in the fewest hands in all of Europe, and Mary remained among the first on that list. She, too, had kept an eye on her fortune, one of her farmers being George Hope of Fenton Barnes, widely known as one of Scotland's most successful and innovative farmers. The growing efficiency of the farms on her land made her property more valuable than ever before. Her great practicality was, fortunately for others, tempered by her great sociability. Her gracious hospitality remained her hallmark until her dying day. She opened her home to the local servants for their "Ball Bellow Stairs" and to the members of the Curling Club for their dinner. Five days after her seventy-seventh birthday, on April 23, 1855, recovering from an arduous winter, Mary wrote in her diary with excitement that she got to take "My first Drive for nearly 6 months!" Although other elderly women had chosen to live in seclusion, Mary never even considered that an option. On June 30, 1855, she hosted, of all groups, the Total Abstinence Party, whose guest speaker was her cousin, William Belhaven. Mary's father, William Nisbet, a lover of great wines, whose fields of grain had produced untold barrels of ale, would have laughed at the delicious irony of this event. It was Mary's final entry in her diary; it was her last party and her last practical joke. She died at Archerfield on July ninth.

Epilogue

Mary's body was carried from Archerfield to Kensal Green and placed beside Robert Ferguson's. As eager as they were to inherit her fortune, her children were equally anxious to bury their mother's notoriety and wash away its stain. Her grave remained without a marker for some sixty years until World War I, when a family member decided to commemorate her life and death. An incorrect birth date on the headstone offers a telling glimpse of a long-forgotten woman. In an attempt to disguise their legacy, Mary and Robert Dundas Christopher, upon inheriting the Nisbet fortune, chose not to live at Archerfield but at another estate called Winton, and they re-created themselves as the "Christopher Nisbet Hamiltons," removing the emphasis away from the name Nisbet. As Mary wore her name proudly all of her life, that snub would have stung. Although her father was indeed part Hamilton, he never chose to bear the Hamilton standard, colors, and accoutrement, as did Mary and Robert Christopher Nisbet Hamilton.

By the 1880s, Mary's granddaughter Constance had inherited the bulk of the fortune. In his book *When Squires and Farmer Thrived,* A. G. Bradley recalled his own visit to the East Lothian farms where the level of prosperity was unrivaled in all of Europe. Having seen her father rule her mother with an iron fist, Connie decided that she would

control her own fortune, much as her grandmother had, and would therefore remain unmarried. As she was the richest young woman in Scotland, there were many suitors. One story told was based on the August 20, 1859, visit to Dirleton by the Prince of Wales. Apparently, the prince arrived at Constance's doorstep to offer his hand in marriage and just as he was about to "pop the question," a telegram arrived from his mama (Queen Victoria) reading "Get off your knee. We've got a better offer." Despite the fact that she did not become the Princess of Wales, Constance, hosted spectacular festivities reminiscent of her grandmother's extravaganza for King George III, at every one of her East Lothian estates in honor of the queen's Golden Jubilee on June 21, 1887. The *Haddington Courier* reported on June 24:

Innerwick Yesterday, the first of the series of festive gatherings, given on her East Lothian estates in honour of the Queen's Jubilee by Miss Nisbet Hamilton, took place, not fewer than 500 people being entertained in the beautiful glen, the green sward of which during the afternoon, presented a most animated appearance. The sports began about two o'clock, when all kinds of games were engaged in, young and old vying with each other in the exhibition of their loyal attachment to the Queen. Refreshments of the most substantial character were provided, copious libations of tea being accompanied by meat sandwiches, mutton pies, and a liberal allowance of delicious cake. The East Linton brass band was in attendance, and provided excellent music, the livelier strains of which the younger portion of the company engaged with much spirit in reels, polkas, and other favourite dances.

Afterward, some four thousand people were entertained at Dirleton, Winton, and Biel, and others in England on her estates at Bloxholm. In 1882, seventy-four years after Mary Nisbet waged an unprecedented battle for her own property, England finally passed the Married

Woman's Property Act, enabling a woman to control her own proper-
ties regardless of her marital status. With her fortune no longer threat-
ened by a possible marriage, Connie decided to marry, and at the age of
forty-five she married Henry Ogilvy on September 11, 1888.

It was the wedding of the year. The press turned out as if Constance
had in fact become the Princess of Wales. The bride had commissioned
a brand-new chapel to be built by Rowland Anderson for the wedding
at Biel. The chapel was dedicated to Saint Margaret of Scotland. The
local populace gathered along the roads by seven-thirty in the morning;
some had traveled in the middle of the night to get there. Constance
wore white velvet brocade and satin trimmed in Brussels lace with five
diamond stars that served as buttons. She wore a sparkling diamond
tiara whose brilliance reflected the two rows of altar candlelight and
glistening silver sanctuary lamps. A full choral service was conducted
by Bishop Dowden of Edinburgh, who used the prayer book once
owned by Lady Robert Manners, the bride's great-great-grandmother,
and used by Archbishop Socker at King George III's wedding. Arches
of white heather filled the church.

After the wedding the bride's Hamilton standard, which had flown
over Biel, was replaced by a new flag bearing the new arms of Nisbet
Hamilton Ogilvy. All around East Lothian bonfires, fireworks, and even
tar barrel rolling expressed the infectious joy of the day. The townspeople
regaled the bride with extraordinary gifts, digging deeply into their very
limited finances to demonstrate their considerable affection for her. The
people of Dunbar purchased a beautiful Boulle clock; the children of the
Gullane School presented a prayer book bound in ivory. Everyone knew
that all of Constance's homes were resplendent with incomparable paint-
ings, antiques, silver, and jewelry. These relatively extravagant offerings
from ordinary people would not impress her for their material value, but
they served as a reflection of the generosity that she had shown people;
she was Mary Nisbet's granddaughter and had learned gracious hospital-
ity and the knack for pleasing crowds at her grandmother's knee.

In 1889, Constance once again proved a lavish entertainer when she held a great New Year Fete at Biel for one thousand people. Toward the end of her life, however, she chose to live more quietly at Winton.

Mary's grand estates and family tree have undergone varying transformations. The golf course in Gullane known as Muirfield was completed in 1891 and the following year was the site of the British Open. Muirfield, considered one of the greatest golf courses in the world, has hosted many British Open championships and, ironically, remains to this day an "all-male" bastion. True to the colorful locale, sheep were allowed to continue grazing on the links in the presence of world-famous golfers until 1956.

Upon her death, Constance left Winton and Pencaitland to her nephew Henry Ogilvy and the remainder of her East Lothian properties to Lucy's grandson, Colonel John Patrick Grant. Colonel Grant, who never married, lived at Biel with his also unmarried sisters, dividing the house to avoid any scandalous conjecture. He left the estate to a Brooke nephew, who sold it to its tenant farmer. Mary's beloved Archerfield was leased at one time to Prime Minister Asquith and became the Scottish 10 Downing Street, welcoming politicians like Sir Winston Churchill through its doors. For many years after that time, Archerfield stood in majestic disrepair, horrifically used in the 1960s as a grain storage facility. The estate has recently been developed into a premier golf resort, including a five-star hotel and houses along the greens, the manse itself converted into condominiums.

At the beginning of the twentieth century, Henry Ogilvy's brother, Frederick, fell in love with a young English beauty, Gertrude Sherbrooke, with whom he had a daughter, Ann; after Frederick's untimely death from eating a bad oyster, Gertrude married again. Her second husband was the widowed 9th Earl of Elgin and 13th of Kincardine, James Bruce's son, Victor. The Earl of Elgin and Gertrude Ogilvy together had one son, Bernard, but Victor died before Bernard's birth. This young mother of two children reunited the Bruce and Nisbet-by-

marriage clans, but she was not the only one to do so. Victor's own daughter, Lady Christian, married another Ogilvy brother, Herbert.

It has been six generations since Mary Nisbet of Dirleton and the Earl of Elgin battled over the destiny of their dynasty, and today it seems that all has been forgiven. Boisterous family reunions are often held at Winton House where children dash about in the very evident presence of Mary's portraits and possessions on respectful display. Perhaps the passionate dialogue provoked by the Elgin marbles has taught us a lesson about preserving the past and the very sad consequences of neglecting our historical treasures.

APPENDIX

Letter from Philip Hunt to Mrs. William Hamilton Nisbet, written while he was still detained at Pau, February 1805.

Dear Madame,

I have more than once felt ashamed at having recourse to Lord and Lady Elgin to be the interpreters of my sentiments to You, on subjects that required the interference of some friend in England: but my situation in this country may perhaps plead my excuse for having hesitated to commence a correspondence in which I could hope to offer you so little amusement.

The commission you lately undertook with your usual goodness respecting the manuscripts collected in Turkey by Mr Carlyle and myself, appeared likely to lead to discussions I was far from anticipating: I have therefore written to Miss Carlyle in order to prevent your having any further trouble on the occasion. In attempting to express my thanks for so much goodness, I cannot forbear availing myself of the opportunity it affords, of sending you a sketch of what was done by Lord Elgin's Artists at Athens and other parts of Greece, after you left us. The enthusiasm you felt on the spot, and which I so often witnessed in our walks on the Areopagus, the Pnyx, and the Acropolis, convinces me that none of the details will appear trifling or minute, that relate to monuments you studied with so much attention; respective merits you appreciated with so correct a taste—and with which Lord Elgin's name is now so intimately connected. The project that has been suggested to his

Lordship of forming his collection of original marbles, as well as the models, drawings, and plans, into a public exhibition at London, has made us endeavour to recollect the principal objects it contains. Our conversation on this subject has not only beguiled many a long hour of captivity and seclusion, but it has also given much more precision and arrangement to the ideas we had formed in the hurried moments of travelling, and during the rapid succession of monuments erected at intervals widely remote from each other, and in styles of very different merit.

The names of Cimon, Pericles, Phidias, etc., to whom we owe the chefs d'aeuvre of architecture and sculpture at Athens, have so strongly interested Lady Elgin, that not satisfied with the light and amusing descriptions in the Travels of Anacharsis in the Athenian Letters, or in the Thousand and one *Voyages en Grece,* she has studied the works of Herodotus, Plutarch, and other original Historians, with an eagerness I have seldom witnessed: and I am sure you will read with interest the extracts and observations she has made on every passage that throws light on the scenes she saw with so much delight, and which she now recollects with increased fondness. In addition to the usual resources of a well cultivated mind, how happy a circumstance has it proved to Her, to be able to turn her attention from the solitudes of the Pyrenees to the classic ground she trod in happier moments, and to anticipate the satisfaction She is one day to enjoy in comparing notes with the Parent who formed her taste, directed her studies, and who visited a few months before her, many of the same magic spots, on the shores of the Hellespont, the Agean, and the Mediterranean.

The first ancient monument procured by Lord Elgin was the famous Boustrophedon inscription from the promontory of Sigaeum in the Troad, which almost every Ambassador from Christendom to the Porte, and even Louis XIV, in the zenith of his power, had ineffectually endeavoured to obtain: It is the most ancient and curious specimen extant of Greek writing— at an epoch when the Alphabet was very imperfect, and when the lines went alternately from right to left and from left to right; like the furrows made by oxen in ploughing, to which the word *Boustrophedon* alludes. This marble alone, so long a desideratum in Europe, is surely sufficient to place Lord Elgin's name in a conspicuous rank with the Arundels, the Sandwiches and Wortleys; to whom Greek literature is so much indebted. From the ruins of the Temple of Minerva at Sigaeum, His Lordship also procured a most beau-

tiful Alto-rilievo in Parian marble, containing a procession of Trojan matrons presenting and dedicating an infant to Minerva, with the accustomed offerings. General Koehler had also obtained for Lord Elgin a statue and bas-relief from the ruins of the Temple of Apollo Thymbrius in the Troad; neither of which I have seen, but if the Sculpture be in a style resembling that of the Sigaean procession, they are valuable indeed. At a subsequent visit I paid to the Troad with Mr Carlyle, we procured some interesting inscriptions, and I afterwards had the good fortune to discover and obtain a Statue of Minerva Iliensis near Thymbria, the drapery of which is exquisite.

The Ferman of the Sultan, which I took with me on my second visit to Athens was expressed in very forcible language, and obviated all the difficulties under which you saw the Artists suffer, and their plans suspended, during your stay there. It even authorized them to make excavations, and to secure for Lord Elgin any fragments of inscriptions or sculpture they might find. With such authority backed by the success of our arms in Egypt, I conceived that an extension might be given to the words of the ferman; which the Vaivoide did not oppose: and the first acquisition we made was the most perfect of the Metopes from the ruins of the Parthenon, on which I recollect Mr Nisbet and yourself rivetting your eyes with so much admiration. This was the first of them that had been so successfully lowered. M. de Choiseul-Gouffier's attempt to secure one had merely been connived at; and for want of time, and cordage, and windlasses, it fell from a considerable height, and was broken into fragments. I do not recollect to have ever felt my heart throb with greater violence, than when I saw this treasure detached from the entablature of the Parthenon, and depending on the strength of Ragusan cordage; nor did my anxiety cease till I had got it on board an English frigate at Alexandria, to be forwarded to England. The subject of the sculpture appears to be Theseus or his friend Pirithous victorious over a Hippo-Centaur: the attitude of the Hero strongly reminded me of the Belvidere Apollo, by the boldness and dignity with which it seems to be advancing: the figures are about four feet high.

Our success in obtaining this precious specimen of sculpture, executed under the eye, and perhaps by the chisel of Phidias himself, impressed Lord Elgin with a will of forming as complete a collection of similar objects, as his influence at the Porte seemed to render practicable: and in compliance with that view, I succeeded in obtaining some other Bas-reliefs and ancient

Inscriptions. But his Lordship has since prosecuted the plan with so much enthusiasm, and on so vast a scale, that he now possesses more original Athenian sculpture in statues, alti and basi rilieve, capitals, cornices, friezes, and columns, than any cabinet in Europe contains. These, with the moulds fill about two hundred and fifty cases, many of which are extremely large.

The first Metope we obtained from the Temple of Minerva on the Citadel of Athens, has been followed by the acquisition of eight or ten others, representing a continuation of the Battle between the Centaurs and Lapitho at the nuptials of Pirithous. Each Metope contains two figures grouped in various attitudes; sometimes the Lapitho victorious, sometimes the Centaur. The relaxed muscles of one of the Lapitho who is lying dead and trampled on by a Centaur is amongst the finest productions of art; as well as the groupe adjoining it of Hippodamia, the bride carried off by the Centaur Eurythion, and struggling to throw herself from the Monster's back: while he is grasping her with brutal violence, with one hand twisted into her dishevelled tresses: the furious style of his galloping, in order to secure his prize, and his shrinking from the spear that has been hurled after him are expressed with prodigious animation. How great a misfortune it is that many of these should be so much mutilated; but even in that condition they are much superior to anything that modern restoration could effect, were the attempt made even by the hand of Canova. They are all in such high relief as to be absolutely groupes of statues, and they are in general finished with as much attention behind, as before, in order that they might strike the eye of the spectator with effect, in whatever direction he approached the Acropolis, from the plain of Athens. They originally ran all round the entablature of the Parthenon and formed ninety-two groupes. The zeal of the early Christians, the barbarism of the Turks, explosions when the Temple was used as a Gunpowder magazine, have demolished a very large portion of them, so that except those snatched from impending ruin by Lord Elgin, and secured to the arts, it is in general difficult to trace even the outline of the original subject.

The frise which runs round the top of the walls of the Cell is full of sculpture in bas relief, designed to occupy the attention of those who were waiting in the vestibule and ambulatory of the Temple till the sacred rites commenced. This frise, being unbroken by triglyphs, presents much more unity of subject than the detached and insulated groupes on the metopes of

the peristyle. It represents the whole of the solemn procession during the Pan-Athenaic festival: many of the figures are on horseback; others are just going to mount; some are in Chariots; others on foot; oxen and other victims are leading to sacrifice. The nymphs called Canephora, Skiaphora, etc. are carrying the sacred offerings in baskets and vases; Priests, Magistrates, Warriors etc. etc. forming altogether a series of most interesting figures, in all the variety of costume, armour, and attitudes. Some antiquaries who have examined this frize with minute attention, seem to think it contains portraits of many of the leading characters at Athens during the Peloponnesian war, particularly of Pericles, Phidias, Socrates, the young Alcibiades, etc. This frize was originally near six hundred feet in length and by being protected from the objects of weather and other injuries by the shelter and projection of the Colonnade, those parts that had escaped the explosions of gunpowder are still in high preservation, literally wanting nothing but the gilded bronze ornaments, which one may see were once fixed to them, such as reins and bits for the horses, and other minute objects that could be more easily executed in metal. The whole frize is of Pentelic marble, superior to Parian for Bas reliefs; many large blocks of it are in Lord Elgin's possession; some taken from the wall itself, others recovered by excavating under the ruins.

The Tympanum of the two Frontispieces of the Parthenon were also adorned with groupes in alto-rilievo. That over the grand entrance of the Temple, contained the Mythological history of Minerva's birth from the brain of Jove. In the centre of the groupe was seated Jupiter, in all the majesty the sculptor could give to the King of Gods and Men. On his left were the principal Divinities of Olympus, among whom Vulcan came prominently forward with the axe in his hand, which had cleft a passage for the Goddess. On the right was Victory in loose fitting robes, holding the horses of the Chariot which introduced the New Divinity to Olympus. Unlike all other statues of Minerva, she was here presented with the captivating graces of Venus; the ferocious Spartans had given the Queen of Love a helmet and a spear. The elegant, the amiable people of Athens delighted to see the warlike Pallas with the cestus of Venus. When Athens lost her freedom she shewed her adulation and servility to the Roman Power by adding the Statues of Hadrian and Sabina to this groupe of Phidias. One of the bombs fired by Morosini, the Venetian, from the opposite hill of the Musaeum injured many of the figures on this fronton, and the attempt of General Konigsmark to

take down the figure of Minerva ruined the whole. By purchasing the house of one of the Turkish Janissaries built immediately under it, and then demolishing it in order to excavate, Lord Elgin has had the satisfaction of recovering the greatest part of the Statue of Victory, in a drapery which discovers all the fine form beneath, with as much delicacy and taste as the Flora Farnese. We also found there the Torso of Jupiter, part of Vulcan, and other fragments. I believe his Lordship has also had the Hadrian and Sabina taken down and sent to England.

On the other frontispiece was the contest between Minerva and Neptune about giving a name to the city. The Goddess of Wisdom had just gained the victory by proving how much greater a benefit she should confer by the peaceful and productive olive, than the God of the Ocean by his warlike gift of a horse.

In digging beneath this pediment some beautiful pieces of sculpture have been procured; and from ye ruin itself has been lowered the head of a horse, which far surpasses anything of the kind I have seen, in the truth and spirit of the execution. The nostrils are distended, the ears erect, the veins swollen, I had almost said throbbing. His mouth is open, and he seems to neigh with the conscious pride of belonging to the Ruler of the waves. Besides this inimitable head, Lord Elgin has procured from the same pediment two or three colossal groups each containing two female figures, probably Sea Deities. They are formed of single massive blocks of Pentelic marble, and are reclining in most graceful attitudes. From the same place has also been procured the Statue of a Sea or River God attendant on Neptune, which is in great preservation. He is in a sitting posture with one leg extended, the other bent. Their size and weight were such as to force us to construct a car on purpose to convey them to the Piraeus, and there, Captain Clarke of the *Braakel* Man of War (brother of the Eleusinian Dr Clarke) had the goodness to make a huge float or raft to take them on board, his launch being unequal to so heavy a freight.

From the Posticum or Opisthodomum of the Parthenon I also procured some valuable inscriptions, written in the manner called Kionedon of columnar, next in antiquity to the Boustrephedon. The letters of each line are equal in number, without regard to the sense: even monosyllables being separated into two parts if the line has had its complement; and the next line begins with the end of the broken word. The letters range perpendicularly as well as

horizontally; so as to render it almost impossible to make any interpolation, or erasure of the original text. Their subjects are public decrees of the People; accounts of the riches contained in the Treasury, delivered by the Administrators to their successors in office: enumerations of the statues, the silver, gold, and precious stones deposited in the Temples—estimates for the public works, etc.

The Parthenon itself, independently of its decorative sculpture is so exquisite a model of Doric architecture, that Lord Elgin has conferred an inappreciable benefit to the Arts by securing original specimens of each member of the Edifice—these consist of a capital of a column, and of one of the pilasters of the Antae-assises of the columns themselves, to shew the exact form of the curve used in channelling,—a triglyph, a motule from the cornice, and even some of the marble tiles with which the ambulatory was roofed. So that not only the Sculptor may be gratified by studying every specimen of his art, from colossal Statues down to Bas-reliefs, executed in the golden age of Pericles, and under the inspection of Phidias; but the practical Architect may examine into every detail of the building, even to the mode of uniting the tambours of the columns without the aid of mortar, make the shafts look like single blocks to the most scrutinizing eye. This, Madam, is, as nearly as I can recollect a list of the original articles in Pentelic marble that have been procured from the Parthenon, and sent to London. But beside them, every detail of the Temple has been moulded into what the Italians called Madre forme, in a hard composition of wax and gypsum as to enable Lord Elgin to make plaster casts at pleasure, of the sculpture and the architectural ornaments, the exact size of the original. The Temple has also been planned, and its elevations, and restorations made by Signor Balestra. You had an opportunity of appreciating his merit during your stay at Athens; but Lord Elgin's choice has received a most flattering approbation, in the Pope's having since selected that artist to superintend the works of a similar kind carrying on at Ostia and in the Forum of Rome. M. Lusieri's magic pencil will now, I trust, have finished the picturesque views of the Parthenon, which we saw commenced with so happy a choice of the points of view; and the Calmuc Theodore who had completed his drawings of the Sculpture on the Metopes, frize, and pediments, with so much truth, and in so exquisite a style, has since made a restored copy of the groupe on the Western Pediment and on the entablature, in the grand elevation. I have thus exhausted the list

of Lord Elgin's successful labours on the Parthenon, or at least of such parts of them as my memory, unaided by notes, can now recall. Is there any thing that the most enthusiastic lover of the Arts could suggest in addition, or that perseverance and munificence could hope to surpass?

The same works have been executed on the Temple of Theseus, but not a morsel of sculpture has been displaced, nor the minutest fragment of any kind taken from the building itself. Where indeed can be found a Being endued with the least feeling or taste, who would think of defacing that exquisite structure; which after an interval of 2,200 years, still retains the beauty and brilliancy of its first days? The Metopes in mezzo rilievo containing a mixture of the labours of Hercules and Theseus have been modelled and drawn; as well as the frize representing the Battle between the Centaurs and Lapitho, some incidents of the Battle of Marathon, and some Mythological subjects. The temple itself you recallect to be very inferior in size, and in decorative sculpture to the Parthenon; having been raised by Cimon the son of Miltiades, before Pericles had given his countrymen a taste for such magnificence and expense as he displayed in the edifices of the Acropolis.

Let me now return to that favourite Hill of Minerva, and resume the list of Lord Elgin's labours and acquisitions there. The original approach to it from the plain of Athens was by a long flight of Steps, commencing near the foot of the Areopagus and terminating at the Propylaea. That was the edifice of which Pericles was most proud, and which cost so prodigious a sum, that the Athenians hesitated about granting him the supplies he demanded for it: "Let it then be inscribed with my name," replied the haughty Pericles, "and I will advance the money," a proposal of which he well anticipated the effect. Its front was a hexastyle colonnade, with two wings, surmounted by a pediment. Whether the Metopes and tympanum were adorned with sculpture, cannot now be ascertained; as the pediment and entablature have been destroyed, and the intercolumniations built up with rubbish, in order to convert it into a battery of fine guns. Altho' the plan of the edifice contains some deviations from the pure taste that reigns in the other structures of the Acropolis, yet each member is so perfect in the details of its execution, that Lord Elgin was at great pains to obtain a Doric and an Ionic capital from its ruins.

On the right hand of the Propylaea was a Temple dedicated to Unwinged Victory, an epithet to which many explanations have been given. It probably alludes to Theseus's reaching Athens himself, before the news of his triumph

over the Minotaur, and the abolition of the odious tribute, had got there. Or perhaps it was to flatter themselves with the notion of Victory having taken up so permanent a residence with them as to have no further occasion for wings. It was built from the spoils won in the glorious struggles for freedom at Marathon, Salamis, and Plataea. On its frize were sculptured many incidents of those memorable battles; in a style that has been thought by no means inferior to the Metopes of the Parthenon: The only fragments of it that had escaped the ravages of Barbarians were built into the wall of a Gunpowder Magazine near it, and the finest block was insetted upside downwards. It required the whole of Lord Elgin's influence at the Porte to get leave to remove them, but he at length succeeded. They represent Athenians in close combat with the Persians; and the Sculptor has taken care to mark the different dresses and armour of the various forces serving under the Great King. The long garments and zones of the Arabians had induced former travellers from the hasty and awkward view they had of them, to suppose the subject was the battle between Theseus and the Amazons who invaded Attica under the command of Antiopxe, but the Persian tiaras, the Phrygian bonnets and many other particulars clearly point out the mistake. The contest of some warriors to rescue the body of a dead comrade is expressed with uncommon animation. These bas-reliefs were put on board the *Mentor* which was so unfortunately wrecked off Cerigo: but they have been all recovered by expert divers from the islands of Syme and Calymna near Rhodes. I shall be most happy to hear that the Gymnasiarch's throne which you procured at Athens, and which shared the fate of these sculptures, has like them been got up again.

Near the Parthenon are three temples so connected in their structure, and by the rites celebrated in them, that they may be almost considered as a triple temple. They are of small dimensions, and of the Ionic Order. One of them dedicated to Neptune and Erectheus; the second to Minerva Polias the Protectress of Citadels; the third to the Nymph Pandrosos. It was on the spot where these temples stand that Minerva and Neptune are supposed to have contended for the honour of naming the city. Athenian superstition long shewed the mark of Neptune's trident, and a briny fountain, that attested having there opened a passage for his horse; and the Original Olive tree produced by Minerva was venerated in the Temple of Pandrosos as late as the time of the Antonines.

This Temple of Minerva Polias is of the most delicate and elegant pro-
portions of the Ionic Order: the capitals and bases of the columns are orna-
mented with consummate taste; and the sculpture of the frize and cornice is
exquisitely rich. One has difficulty to conceive how marble has been wrought
to such a depth, and brought to so sharp an edge; the palmetti, onetti, etc.
have all the delicacy of works in metal. The Vestibule of the Temple of Nep-
tune is of more masculine proportions, but its Ionic capitals have infinite
merit. It was to examine the roof, that you had to climb with so much diffi-
culty, and to creep thro' an opening made in the wall which has since been
closed. Future travellers will thus be prevented from seeing the inner door of
the Temple, which you so much admired, and which is perhaps the most per-
fect specimen in existence of Ionic ornament. Both these temples have been
measured, and their plans, elevations, and views made with the utmost accu-
racy. The ornaments have all been moulded, some original blocks of the frize
and cornice have been obtained and I believe a capital and a base.

The little adjoining chapel of Pandrosos is quite a concetto in architec-
ture: instead of Ionic columns to support the architrave, it has six statues of
Carian Women (or Caryatides). The Athenians endeavoured by this device
to perpetuate the infamy of the inhabitants of Carias, who were the only
Peloponnesians favourable to Xerxes in his invasion of Greece. The men had
been reduced to the deplorable state of Helotes, and the women not only
condemned to the most servile employments; but those of rank and family
forced in their abject condition to wear their ancient dresses and ornaments.
The drapery is fine; the hair of each figure is braided in a different manner,
and a kind of diadem they wear on their head forms the Capital. Besides
drawing and moulding all these particulars, Lord Elgin has one of the origi-
nal marble Caryatides. The Lacedemonians had used a similar vengeance, in
constructing the Persian Portico which they had erected at Sparta in honour
of their victory over the forces of Mardonius at Plataea; placing statues of
Persians in their rich Oriental dresses, instead of Columns to sustain the
entablature.

The architects have also made a ground plan of the Acropolis, in which
they have not only inserted all the monuments I have mentioned, but have
likewise added those whose position could be ascertained from traces of their
foundations. Among these are the temple and cave of Pan, to whom the
Athenians thought themselves so much indebted at the battle of Marathon

as to vow him a temple. It is now nearly obliterated, as well as that of Aglau-ros who devoted herself to death to save her Country. In it the young Citi-zens of Athens received their first armour, enrolled their names, and took the oath of fighting to the last drop of their blood for the liberties of their Country; near this was the spot where the Persians scaled the walls of the Citadel, when Themistocles had retired with the principal forces of Athens and all her navy, to Salamis. But how small is the portion that *can* now be ascertained of what the Acropolis once contained!!

Plutarch tells us that all the public structures raised in Rome from the foundation of the City till the age of the Caesars could not be put in compe-tition with the edifices erected on the Acropolis during the administration of Pericles; and tho' built in so short a period, they seem built for eternity. Heliodorus had written a description of the buildings and statues on the Citadel, which took up fifteen books; but far from having exhausted the sub-ject, Polemon Periegetes added four more as a supplement. Even after the plunder carried off by Lysander, Sylla, Nero, etc. there were above three thousand statues remaining in the time of Pliny. The remains of the original walls may still be traced in the midst of the Turkish and Venetian additions, and are distinguishable by three modes of construction at very remarkable epochs:—the Pelasgic, the Cecropian, and that of the age of Cimon and Per-icles. It was at that brilliant period that the Acropolis in the whole extent was contemplated with the same veneration as a consecrated Temple; consistent with that sublime conception, the Athenians crowned its lofty walls with an entablature of grand proportions, surmounted by a cornice. Some of the massive Triglyphs and motules still remain in their original position, and produce a most imposing effect. Separated as I unfortunately am from the notes I made in Athens, and on the Acropolis itself, I only venture to send this sketch as a preparation for what you are to expect when the marbles are unpacked and arranged.

I must now quit the walls of the Acropolis, and attempt a concise account of what has been done in the Town of Athens, and in other parts of Greece, and Asia Minor, during Lord Elgin's Embassy at the Porte. The ancient walls of the Town of Athens, as they existed in the Peloponnesian War, have been traced in their whole extent, as well as the Long Walls that led to Munychia and Piraeus. The Gates, so often mentioned in the Greek Classics, have been ascertained, and every public monument that could be recognised has

been inserted in a General Map, as well as detailed plans given of each. Extensive excavations were necessary for this purpose, particularly at the Great Theatre of Bacchus; at the Pnyx where the assemblies of the people were held; where Pericles, Alcibiades, Demosthenes and Aeschines delivered their animated harangues, "those thoughts that breathe, and words that burn." The Theatre built by Herodes Atticus to the memory of his wife Regilla, and the Tumuli of Antiope, Euripides, etc. have also been opened, and from these excavations, and various others in the environs of Athens, has been procured a complete and invaluable collection of Greek Vases. The Colonies sent from Athens, Corinth, etc. into Magna Graecia, Sicily, and Etruria carried with them this art of making vases, from their Mother Country, and as the earliest modern collections of vases were made in those Colonies, they have improperly acquired the name of Etruscan. Those found by Lord Elgin at Athens, Aegina, and Corinth will prove the indubitable claim of the Greeks to this art. I may venture to say that none of those in the collection of the King of Naples at Portici, or in those of Sir William Hamilton, can be compared to some Lord Elgin has procured, with respect to the elegance of the forms, the fineness of the materials, the delicacy of the execution, or the beauty of subjects delineated on them, and they are in perfect preservation. A Tumulus into which an excavation was commenced under Lord and Lady Elgin's eye during their residence at Athens has furnished a most valuable treasure of this kind. It consists of a large marble vase, inclosing one of Bronze five feet in circumference, of beautiful sculpture, encircled with a wreath of myrtle wrought in gold; near it was a smaller vase of Alabaster beautifully ribbed. The position of this tumulus is on the road that leads from Port Piraeus to the Salaminian ferry and Eleusis.

From the Theatre of Bacchus Lord Elgin has obtained the very ancient Sun Dial, which existed here during the time of Aeschylus, Sophocles, and Euripides,—and a large Statue of Bacchus dedicated by Thrasyllus in gratitude for his having obtained the prize of Tragedy at the Pan-Athenaic Festival. A Beautiful little Corinthian Temple near it, raised for a similar prize gained by Lysicrates, and commonly called the Lantern of Demosthenes has also been modelled and drawn with minute attention: it is a most precious little bijou in architecture. Your visit to it, renders it perhaps superfluous for me to mention its vaulted roof formed of a single block of marble, or the delicate Bas-relief that runs round the frize, representing some Bacchanalian

Orgies. The elevation, ground plan, and other details of the Octagonal Temple raised by Andronicus Cyrrhestes to the Winds, have also been executed with care, but the sculpture on its frize is in so heavy a style, that it was not judged worthy of being modelled in plaster. My friendship with the Bishop of Athens, gained me permission to examine the interior of all the Churches and Convents in Athens. This search furnished many valuable bas-reliefs, inscriptions, ancient dials, a Gymnasiarch's chair in marble, on the back of which are figures of Harmodius and Aristogiton with daggers in their hand, and the death of Leona, who bit out her tongue during the torture rather than confess what she knew of the conspiracy against the Pisistratidae. The fountain in the courtyard of our Consul Logotheti's house, was decorated with a bas-relief Bacchantes, in the style called Greco-Etruscan, which he presented to His Lordship, as well as a Quadriga in Bas-relief, with a Victory hovering over the Charioteer, probably an *ex voto* for some victory at the Olympic games. Amongst the funeral Cippi' found in different places are some remarkable names, particularly that of Socrates, and in the Ceramicus itself Lord Elgin discovered an inscription in Elegiac verse, on the Athenians who fell at Potidaea, and whose eulogy was delivered with such pathetic eloquence in the oration of Pericles.

You must frequently have remarked in your walks about Athens that the peasants generally put into a niche over the door of their cottage, any fragments they discover plowing the fields. Out of these we selected and purchased many curious antique votive tablets, with sculpture and inscriptions. A complete set has been formed of Capitals of the only Three Orders in Greece, the Doric, the Ionic, and the Corinthian, from the earliest dawn of art in Athens, to the zenith of Taste under Pericles; and from thence thro' all its degradations to the dark ages of the Lower Empire.

At a Convent called Daphne, about half way between Athens and Eleusis, were the remains of an Ionic Temple of Venus, which for the brilliancy of the marble, the bold style of the ornaments, the delicacy of the finish, and the high preservation, cannot be surpassed. We procured from thence two of the Capitals, a whole fluted column, and a base.

Since I left Turkey, Mr. Hamilton has been twice at Athens, and has had the opportunity of suggesting any additions he might think requisite toward completing the researches and acquisitions that had been made there. You must feel how fortunate he has been that he had the means of speaking on

the subject to Lusieri. No one knows better than yourself the enthusiastic ardor of his mind, the classic elegance of his taste, and the extensive knowledge of ancient art that he had acquired during his travels into Italy, Sicily, Upper Egypt, Syria, Asia Minor, and Greece. I have not however had an opportunity of hearing the result of his visits to Athens, and therefore can only presume from his silence, that he has either not found or not left any desirable or attainable object, that the state of the ruin would authorize any Lover of the Arts, to remove. For I must here beg leave to observe that every marble I know to be in Lord Elgin's possession was rescued from a situation that exposed to imminent danger and that it is to his persevering exertions we owe the preservation of so many valuable productions of Sculpture and Architecture.

If this letter has the fortune to reach you, and meets a wish for my continuing the subject, I shall be happy in furnishing such a sketch as my memory can supply, of what has been done in a similar view, at Eleusis, Sunium, Salamis, Aegina, Piraeus, Marathon, Thebes, the Cave of Trophonius at Lebadea, the isthmus of Corinth,—at Argos, at the Tomb or Treasury of Agamemnon at Mycenae, at Tyrinthus, Epidauria, Mantinea, Phigalia, Olympia, and Elis—on the plain of Troy, on the Promontory and Isthmus of Mount Athos—In the Cyclades, and Ionian Islands; at Cnidus, Halicarnassus, etc. etc. *etc.* Should you think, Madam, that the communication of what I have taken the liberty of sending you, may amuse or gratify any of your friends, I beg you may consider yourself at liberty to shew it. I trust you will not suspect me of flattery, when I add, that there are few whose approbations are so solicitous to obtain as your own, with respect to the pursuits and acquisitions that were entrusted to me during Lord Elgin's Embassy.

With my most respectful Compliments and best wishes to Mr. Nisbet, and my little fellow Travellers, I have the honour to be, Dear Madam, with the utmost respect, your most faithful, humble Servant.

Philip Hunt.
Pau, February 20 1805

NOTES

Chapter 1: Launched from a Safe Harbor

1. There were, of course, occasional complaints issued by marginal groups. The famous Scottish Treason Trials (1793–94), however, resulted not from a desire for Scottish separatism but out of intrigue with the French Revolution and distaste for monarchy in general. The fringe group responsible for the so-called treason (the charges were actually reduced to sedition) included both Englishmen and Scottish rebels.

In addition, both King George III (by increasing greatly the number of Scottish peers during his reign) and Parliament (by enforcing more liberal rights among hereditary Scottish peers in the House) demonstrated notable public conciliatory behavior.

2. The 1st Earl of Rutland had been chamberlain to both Jane Seymour and Anne of Cleves when they were queens of England. Later, the title was elevated to a dukedom.

3. The Nisbet family included Sir Patrick Nisbet of Eastbank, who was a knight and the third son of Henry Nisbet, provost of Edinburgh from 1597 to 1598. Patrick was a strong supporter of King James VI and King Charles I. Patrick's son, John, was a famous lawyer and was so admired for his intelligence that he became advocate to King Charles II from 1663 to 1677. Upon this appointment by King Charles, John purchased the estate of Dirleton in

1663. The matriculated family arms in the Lyon register bears the motto *Discite justitiam.* In 1801, William Hamilton Nisbet altered the family's coat of arms, quartering the coat of Nisbet of Dirleton, as previously registered by John Nisbet, with those of Hamilton of Pencaitland and an additional motto, "Ride Through."

Sir John had no surviving sons and left the estate of Dirleton to William Nisbet, son of Alexander Nisbet of Craigintinnie. John's daughter, Lady Harden, sued to have the will overturned, claiming injustice as his only child. Although she was successful in receiving monetary payments, the estate of Dirleton remained in the line of William. William's son, William, added the name "of Craigintinnie and Dirleton" to his title. The third William in the line became "William Nisbet of Dirleton," totally dropping Craigintinnie from the title. This William married Mary, the only child and heiress of Alexander Hamilton of Pencaitland and Dechmont. Mary was also the heiress of entail of James, 5th Lord of Belhaven. Their son, William Hamilton Nisbet of Belhaven and Dirleton, Mary's father, was born in 1747.

4. In the twentieth century, celebrated socialite and writer Lady Diana Cooper, born Diana Manners, added another public face to this illustrious family.

Chapter 2: New Horizons

1. In 1536, when French king Francis I and Ottoman sultan Suleiman the Magnificent joined forces against the mighty Hapsburg Empire, the French and the Turks enjoyed an unparalleled merging of riches. Suleiman's empire stretched from the East through Egypt, controlling commercial and military traffic, while the French gained strength in the West Indies. When England and France went to war over the American colonies and France lost its edge in the New World, Napoleon and his Directory decided that they could recoup their losses by exploiting what seemed to be chaos in the Middle East. In addition, if they could cut England off from India, it would be sweet revenge.

2. "The Ottomans have no connexion with your king, nor your country: we never sought for your advice, your interference, or friendship: we have no minister, no agency, no correspondence with you. . . . We want not your friendship, aid, or mediation. . . . Avarice, if we are well informed is your chief

characteristic. You would buy and sell your God. Money is your deity; and all things are commerce with your ministry, with your nation. . . . The grand signor has no public intercourse with your court; he wants none; he wishes for none. . . . You have no religion but gain. Avarice is your only god; and the christian faith you profess, but a mask for your hypocrisy." (*Public Characters*, 267–69).

3. James Boswell's mother, Elizabeth Bruce, was the youngest sister of Alexander Bruce, the 3rd Earl of Kincardine.

4. Henry Dundas had a long and distinguished parliamentary career representing the county and city of Edinburgh. In 1782, he was appointed secretary of the navy, and in 1791, he became a member of the cabinet. When he retired in 1801 and refused a pension, £2,000 per year was forced on his wife. Greatly admired, he was given the titles of Viscount of Melville (Edinburgh) and Baron of Dunira (Perth) in 1802.

Chapter 5: Letters: A Lifeline

1. Katie Hickman, whose mother was a British ambassador's wife, relates in her book, *Daughters of Britannia,* the important role of the mail to the diplomatic wives so isolated and far from home.

> Even though they are separated by nearly 200 years, when the anguished Countess of Elgin writes about her longing for news from home, it could be my own mother writing. . . . Messengers were frequently attacked and robbed, and every single precious letter either destroyed or lost. Amazingly, even in the late twentieth century the non-arrival of the bag has been the cause of as much disappointment and pain. (xxvi–xxvii)

2. Selim III was assassinated in 1807 after his fierce Janissary soldiers refused to accept his "New Order" policy based on Western military procedures. His nephew, Mustafa IV, succeeded him for one year until he, too, was assassinated. Mustafa's brother, Mahmut II, then ruled from 1808 to 1839.

3. Wittman, 64–65. Dr. Wittman, who attended Mary on the birth of her first child, actually dedicated his *Travels* to Lord Elgin with the following inscription:

> The attention, so honourable to your Lordship's feelings, with which I as well as others of our countrymen, was favoured by your Lordship, while in the dominions of the Grand Seignor, has excited in me sentiments of gratitude for the public expression of which I hope to be forgiven.
>
> It is under this impression that I have presumed to prefix your Lordship's name to a work, which is the result of my observations and inquiries while in those countries. If it should serve to record the hospitable and liberal conduct of your Lordship, in your public capacity, and the respect and esteem which that conduct could not fail to excite in its Author; and if, at the same time, it should in any degree, contribute to your Lordship's amusement, it will be a subject of permanent satisfaction to MY LORD, your Lordship's obliged Servant, THE AUTHOR.

Chapter 6: Constantinople: "Ambassadress Poll" Makes Waves

1. Although the palace burned down in the nineteenth century, the street remains, renamed Istiklal Caddesi.

2. In his 1805 memoirs, French officer Pouqueville remarks that it was Elgin who obtained the firmans to get the French released from the awful Seven Towers section of Yedikule prison.

3. A midcalf or longer short-waisted coat. (In Mary's case, she meant *fur*.)

4. Shankland pleads the Smith brothers' case in *Beware of Heroes* with the comment that Selim III pronounced the name Elgin (correctly pronounced with a hard *g*) with a soft *g*, "El Jin," which meant "the devil" in his language; he does, however, admit that Elgin's charge that "Sir Sidney's interference in the internal affairs of Turkey, and particularly about his intervention in

Cyprus" was "'without parallel in diplomatic history'" (Shankland quoting Elgin) "was certainly true" (Shankland, 115).

Chapter 8: Captain of Her Ship

1. Now known as "The Biel Chair," it is in the British Museum.

2. This letter to Menou's *commandant de cavallerie* was found in the private papers of Lady Elgin.

Chapter 10: The Stronger Vessel

1. Mr. Pisani, from an old Venetian family, was the chief interpreter to the British Embassy. Muslims were forbidden to learn foreign languages. As Venice had been part of the Ottoman Empire, sultans often relied on their Italian citizens to deal with Westerners. Many official Ottoman documents were written in Italian, and the Pisanis were extremely useful to Elgin in his correspondence with the Turks. Visitors, traders, and foreign diplomats came into contact with Italians, Russians, Slavs, Greeks, and Jews in Constantinople as frequently as they did Turks.

2. Daunt, "Palaces of Diplomacy," 70.

3. The Treaty of Amiens was signed on March 25, 1802, returning Egypt to the Ottoman Empire.

Chapter 13: The Acropolis: Caution to the Wind

1. McNeal, 112.

2. Schama, 105.

3. Hazlitt, "Exhibition of Living Artists."

Chapter 16: Shanghaied

1. Here is Mary's letter to Bonaparte concerning this agreement:

Citizen First Consul
Told that you had consented to the exchange of my husband for General Boyer, I hurriedly wrote England to tell of your intentions.

I console myself with the hope that Lord Elgin will obtain his liberty, as I have just learned that he has been transferred from Pau to the fortress at Lourdes, unhealthy place, even more so for someone in the state of health my husband sadly finds himself.

I have no doubt that this exchange will not be agreed to in England. I presume to ask, Citizen First Consul, that the grace you have generously accorded him will not be for naught. The state of his health, if he must remain for any time at Lourdes, will preclude him from participating in the exchange that you have so wished to authorize. This is the opinion of people who had seen him during the summer. I beg you then Citizen First Consul to permit him to remain in Pau under whatever kind of surveillance that pleases you until news of the exchange arrives.

Please, Citizen First Consul, give serious consideration to my request; you will alleviate the severity of my tribulations.

Accept my most sincere and respectful good wishes.

I have the honor to be

[The letter remains unsigned, as it is a copy that Mary retained.]

Chapter 22: Shipwrecked

1. Scott, *Familiar Letters*, 92.

2. "Domestic Intelligence," 71.

3. Scott, op. cit., 115.

4. St. Clair, 129.

BIBLIOGRAPHY

My primary sources include the unpublished letters and diaries of Mary Hamilton Nisbet Bruce Ferguson belonging to Mr. Julian Brooke, Mr. Richard Blake, and Andrew, Earl of Elgin and Kincardine; the unpublished letters of Thomas Bruce, Earl of Elgin, belonging to Andrew, Earl of Elgin; the unpublished journals kept by Robert Ferguson belonging to Richard H. L. Munro Ferguson of Raith; and the unpublished letter from the Reverend Philip Hunt to Mrs. William Hamilton Nisbet belonging to Mr. Julian Brooke.

Acton, Harold. *The Bourbons of Naples (1734–1825)*. London: Methuen and Co. Ltd., 1956.

Ancient Physician's Legacy to His Country, Thomas Dover, 1660–1742. History of Medicine Series, no. 44. Metuchen, N.J.: Scarecrow Press, 1974.

Balfour, Patrick (Lord Kinross). *The Ottoman Centuries*. London: Jonathan Cape, 1977.

Beard, Mary. *The Parthenon*. London: Profile Book, 2002.

Beattie, George. "The Story of Broomhall." *Scots Magazine* 26 (February 1937).

Boardman, John. "The Elgin Marbles: Matters of Fact and Opinion." *International Journal of Cultural Property* 9, no. 2 (2000).

Bunyan, Stephen. *Two Ladies of Dirleton*. Publication no. 9. Cambridge: Nesbitt/Nisbet Society, 1995.

Butler, Marilyn. *Romantics, Rebels and Reactionaries.* Oxford: Oxford University Press, 1981.

Chamberlin, Russell. *Loot! The Heritage of Plunder.* New York: Facts on File, 1983.

Checkland, Sydney. *The Elgins, 1766–1917: A Tale of Aristocrats, Proconsuls and Their Wives.* Aberdeen: The University Press, 1988.

Cocek, Fatma Muge, and Mark David Baer. "Social Boundaries of Ottoman Women's Experience in Eighteenth Century Galata Court Records." *Women in the Ottoman Empire.* Edited by Madeline Zilfi. London: Brill, 1997.

Cook, B. F. *The Elgin Marbles.* London: The British Museum, 1997.

Craven, Lady Elizabeth, Countess of. *A Journey Through the Crimea to Constantinople.* Dublin: H. Chamberlaine, 1789.

Daunt, Lady Patricia. "Palaces of Diplomacy." *Cornucopia* 1, issue 5, 1993–94.

———. "The Summer Palaces of Istanbul." *Cornucopia* 1, issue 6, 1994.

Davis, Fanny. *The Palace of Topkapi in Istanbul.* New York: Charles Scribner's Sons, 1970.

de la Tour du Pin, Madame. *Memoirs.* London: The Harvill Press, 1999.

Devine, T. M. *The Scottish Nation: A History, 1700–2000.* New York: Penguin Books, 2001.

Dolan, Brian. *Ladies of the Grand Tour.* New York: HarperCollins, 2001.

"Domestic Intelligence." *European Magazine and London Review* 53 (January 1808).

Duloum, Joseph. *Les anglais dans les Pyrénées et les débuts du tourisme pyrénéen (1739–1896).* Lourdes: Les Amis du Musée Pyrénéen, 1970.

Duncan, Andrew. *Observations on the Operation and Use of Mercury in the Venereal Diseases.* Edinburgh: A. Kincaid and W. Creech, 1772.

"Earl of Elgin." *Public Characters.* London: Phillips, 1807.

Foreman, Amanda. *Georgiana: Duchess of Devonshire.* New York: Random House, 1998.

Freely, John. *Istanbul: The Imperial City.* London: Penguin Books, 1998.

Friendly, Alfred. *Beaufort of the Admiralty: The Life of Sir Francis Beaufort, 1774–1857.* New York: Random House, 1977.

Gentleman's Magazine 78 (April 1808).

Grant, James. *Old and New Edinburgh*. London: Cassell & Company, Ltd., 1888.

Habershon, Samuel Osborne. *On the Injurious Effects of Mercury in the Treatment of Disease*. London: John Churchill, 1860.

Haslip, Joan. *The Sultan*. New York: Holt, Rinehart & Winston, 1958.

Hazlitt, William. "The Elgin Marbles." *Examiner,* June 16, 1816.

———"On the Elgin Marbles." *London Magazine,* February 1822.

———"Exhibition of Living Artists." *Scotsman,* April 20, 1822.

Herold, J. Christopher. *Bonaparte in Egypt*. New York: Harper & Row, 1962.

Hickman, Katie. *Daughters of Britannia: The Lives and Times of Diplomatic Wives*. London: HarperCollins, 1999.

Himes, Norman Edwin. *Medical History of Contraception*. New York: Schocken Books, 1970.

Hitchens, Christopher. *Imperial Spoils: The Curious Case of the Elgin Marbles*. New York: Hill and Wang, 1987.

"Law Report" (matters occurring on Tuesday, December 22, 1807). *Times* (London), December 23, 1807.

Leach, Terence R. *Lincolnshire Country Houses and Their Families,* part 2. Lincoln, U.K.: Laece Books, 1990.

Levin, Harry. *The Broken Column: A Study in Romantic Hellenism*. Cambridge, Mass.: Harvard University Press, 1931.

Lewis, Michael. *Napoleon and His British Captives*. London: George Allen & Unwin Ltd., 1962.

"The Loiterer," letter dated December 10, 1807. *The Satirist or Monthly Meteor* 1 (January 1808).

Mayhew, Nicholas. *Sterling: The Rise and Fall of a Currency*. London: Penguin Press, 1999.

McNeal, R. A., ed. *Nicholas Biddle in Greece: The Journals and Letters of 1806*. University Park, Penn.: Pennsylvania State University Press, 1993.

Mirza Abu Talib Khan. "Vindication of the Liberties of the Asiatic Women." *Asiatic Annual Register for the Year 1801*. London: J. Debrett, 1802.

Nisbet, Mary. *The Letters of Mary Nisbet, Countess of Elgin*. London: John Murray, 1926.

Peirce, Leslie P. *The Imperial Harem: Women and Sovereignty in the Ottoman Empire.* Oxford: Oxford University Press, 1993.

Phelps Brown, Henry, and Sheila V. Hopkins. *A Perspective of Wages and Prices.* New York: Methuen, 1981.

Records of the Clan and Name of Fergusson, Ferguson and Fergus. Edited by James Ferguson. Edinburgh: David Douglas, 1895.

St. Clair, William. *Lord Elgin and the Marbles.* Oxford: Oxford University Press, 1998.

Schama, Simon. *A History of Britain.* Vol. 3, *The Fate of Empire, 1776–2000.* New York: Miramax Books, 2002.

Scott, Sir Walter. *Familiar Letters.* Boston: Houghton, Mifflin & Company, 1894.

———. *The Life of Napoleon.* Philadelphia: E. L. Carey & A. Hart, 1839.

Shankland, Peter. *Beware of Heroes: Admiral Sir Sidney Smith's War against Napoleon.* London: William Kimber, 1975.

Sinclair, Sir John. *The Statistical Account of Scotland.* Vol. 3. Edinburgh: William Creech, 1792.

Singh, Simon. *The Code Book.* New York: Anchor Books, 2000.

Stern, Bernard. *The Rise of Romantic Hellenism in English Literature, 1732–1786.* New York: Octagon Books, 1969.

Stoneman, Richard. *Across the Hellespont.* London: Hutchinson, 1987.

The Trial of R. J. Fergusson, Esquire. London: J. Day, 1807.

Therold Rogers, James E. *A History of Agriculture and Prices in England, 1703–1793.* Vol. 7. Oxford: The Clarendon Press, 1902.

Tillyard, Stella. *Aristocrats.* New York: Farrar, Straus & Giroux, 1995.

Vrettos, Theodore. *The Elgin Affair.* London: Secker & Warburg, 1997.

Wittman, William, M.D. *Travels in Turkey, Asia-Minor, Syria and Across the Desert into Egypt.* London: Phillips, 1803.

Wortley Montagu, Lady Mary. *Letters.* New York: Alfred A. Knopf, 1906.

INDEX